PRAISE FOR **NARCOCORRIDO**

"Elijah Wald's *Narcocorrido* is more than an exposé of a musical genre and a contemporary problem, it is a journey into the complex nuances of Mexican social and cultural history. His book is a most significant contribution to the bibliography on travel literature by foreign observers to Mexico since colonial times. It will be of interest to a wide range of specialists in diverse fields, as well as to the casual reader who will enjoy the pleasure of a rich narrative of adventure and detective work."

—Guillermo E. Hernández, Ph.D.,
DIRECTOR OF THE UCLA CHICANO STUDIES RESEARCH CENTER

"Through the stories of the corrido-crafters themselves, Wald uncovers a world desperate for heroes. At once tragic and hopeful, the results of his journey hold a mirror up to life on both sides of the border."

—Louie Perez of LOS LOBOS

"Half enthusiast and half ethnomusicologist, Wald offers an engaging, fascinating, and well-written account of a much-neglected musical style that will be irresistible to readers of all types."

—*Library Journal*

"It is a huge business, drugs, drug-fueled revolution, and singing about them, and Wald does a superb job of taking his readers into that world."

—*Kirkus Reviews*

"Wald's book is most useful in providing a forgotten perspective on the War on Drugs—that of ordinary Mexicans who have to grow or smuggle drugs to get ahead or even survive, and [who] see Washington's bellicose rhetoric as a bunch of hypocrisy."

—*High Times*

"Larger-than-life legends and tragic heroes aplenty, such as Chalino Sánchez, whose rise . . . is 'a Mexican version of the Tupac Shakur story.' A worthy shelf mate for Michael Eric Dyson's brainy Shakur study, *Holler If You Hear Me*."

—*Booklist*

"Wald is an engaging writer, and *Narcocorrido* [is] a must-have for those wanting an introduction to the genre."

—*Austin Chronicle*

"A skillful and entertaining examination of a music genre, its history and the key people who made it happen."

—*New Times* (LOS ANGELES)

"The evolution of Mexico's narcocultura and its music, the narcocorrido, is brilliantly captured in Elijah Wald's *Narcocorrido*."

—*Orange County Weekly*

"In his addictive history of the musical phenomenon, Elijah Wald braves the not-inconsequential danger of venturing to the music's home turf."

—*Maxim Blender*

"Insightful. . . . An enlightening rendezvous. . . . Wald patiently explores the half-accomplished modernity that colors northern Mexico. . . . [His] detours are a midrash to understand the overall context that nurtures this kind of transnational phenomenon."

—Ilan Stavans, *The Nation*

"A unique book about a unique subject. . . . Fascinating reading."
—*Fort Worth Star-Telegram*

"One has to admire Wald for his courage and his curiosity. Not only is he a fearless explorer, he's a masterful explainer. These talents converge effectively in this loving interpretative overview of a popular and populist musical genre far more representative of contemporary Hispanic culture than the trendy dilutions that pass for the real thing on U.S. radio and television."

—*Boston Globe*

"A fast-paced blend of music, history, personal travel memoir, and reportage."

—*Los Angeles Times*

"An incisive, unprecedented, and often enthralling history of a hugely popular musical style."

—*San Jose Mercury News*

"A well-written, comprehensive, colorful account. . . . Not since Michael Tisserand's *The Kingdom of Zydeco* have I read a book that gets into a musical genre and its supporting culture so thoroughly and entertainingly. Solid research, superb interviews, and compelling narrative with a nonjudgmental cultural sensitivity are all essential to carrying off a book like *Narcocorrido*, and those of us north of the Rio Bravo should be glad Elijah Wald has opened the door to this bizarre and fascinating world for us."

—*Wall Street Journal*

Theo Pelletier

ABOUT THE AUTHOR

ELIJAH WALD is a writer and musician with twenty years' experience covering roots and world music. He was writer and consultant on the Smithsonian multimedia project *The Mississippi: River of Song* and is the author of the award-winning biography *Josh White: Society Blues*. An overview of his work is available at www.elijahwald.com.

NARCOCORRIDO

Elijah Wald

NARCOCORRIDO

A JOURNEY INTO THE MUSIC OF
DRUGS, GUNS, AND GUERRILLAS

rayo An Imprint of HarperCollinsPublishers

Dedicated to all the corridistas
who should have been covered in this book,
but are not. Especially to Rafael Buendia,
Reynaldo Martínez, Beto Quintanilla,
Enrique Valencia, and Juan Villareal.

ACKNOWLEDGMENTS

I began this project in a state of almost total ignorance. I had spent only a few months in Mexico, enough to fall in love with the country but not enough to even begin to understand it. I had no real grounding in Mexican history or culture, and only the vaguest acquaintance with the history or current state of the Mexican corrido. To make things still more difficult, I spoke competent but by no means perfect Spanish. Thus, I was dependent from beginning to end on the help of others, and if this book is worthy of its position as the first survey of the contemporary corrido scene it is due to their generosity. If not, it is my own fault; I could not have asked for more thorough and enthusiastic cooperation.

Obviously, the first people I must thank are the corridistas themselves, who not only talked to me at length about their lives and work, but in many cases invited me into their homes and treated me as a friend, giving me an invaluable insight into their world. I hope they are happy with the way I have described it and them.

There are also all the music fans I met along the way without whose help this book would be much poorer: the truck drivers and bus drivers who played me cassettes of their favorite corridos, the record store owners who guided me to appropriate selections and answered so many questions, and the many passing acquaintances in bars and cafés. They are the real experts in this field and, while I do not know most of their names, I could not have written this book without them.

Various people were involved in the gradual growth of this project. I must especially thank Chris Strachwitz, whose releases on Arhoolie Records first introduced me to norteño music and who was a constant source of encouragement and information. Without his enthusiastic

urging, I would never have started down this path. The people of
Ybarra, Chiapas showed me that the corrido was still alive as something
more than entertainment. Suzannah Maclay brought me the cassette of
Jefe de Jefes, which sparked the article that sparked this book, and Scott
Powers at the *Boston Globe* let me write that article although it had no
local hook.

While most of this book is based on my conversations with musicians
and composers, I also did my best to take advantage of previous investi-
gations into the corrido, and am infinitely grateful to the many
researchers who were willing to answer my queries and treated me,
despite my lack of qualifications, as a fellow worker rather than an
upstart interloper. I must especially thank Guillermo Hernández, Anto-
nio Avitia, Jaime Nicolopulos, Alvaro Ochoa, Guillermo Berrones, Luz
María Robles, Francisco Ramos, Luis Astorga, Helena Simonett, and
Sam Quiñones, all of whom gave time and energy above and beyond the
call of duty.

I owe an overwhelming debt to Los Tigres del Norte for their music,
and for the assistance and encouragement they gave me from the
moment we met. Also thanks to all the people who work on their team
for their cooperation, especially to Alfonso de Alba. Going through this
book chapter by chapter, I must especially thank the following: Pepe
Cabrera for putting me in touch with Ángel González. (Pepe's name
kept popping up throughout my research, and after a while I began to
think of him as the ultimate man behind the corrido scene.) Matthew
Barton for playing me the Hellmer recording of Paulino Vargas. Ramiro
Ayala, Aleida Rojo, Arturo Santamaria, and Jorge Luis Garate in
Mazatlán, Mauricio Barrón Couret, Elmer Mendoza, Miguel Alberto
Ortiz, Victor Manuel Achoy, Oscar García, and Lenin Marquez in Culia-
cán, and Ricardo Corral in Los Mochis. Pedro Rivera and Nacho
Hernández for their remembrances of Chalino. Carmen (not her real
name) in Badiraguato, despite my suspicions. Everyone in Los Tucanes'
offices in California and Mexico City, for their consistent cooperation.
The members of Grupo Exterminador, for putting me in touch with
Francisco Quintero. Cheryl Devall, for her friendship and hospitality in
Los Angeles. Guillermo Santiso and everyone at Fonovisa, who allowed
me unexpected access and have encouraged me throughout. Reynaldo
Martínez, Beto Quintanilla, and Juan Villareal in Reynosa, who are
among the most important corridistas currently writing and who had
their own chapter until I had to cut it for space reasons. Eduardo Sal-
cedo, who has been my host and a constant help in Mexico City. Oscar
Chávez and the people at Discos Pentagrama. Victor Cardona, Lau-

rentino Santiago and the members of the Coalición de Ejidos, Rubén Ríos, and Fabio Tapia in Atoyac, everyone in El Quemado, and also Mario Castillo of the Dueto Castillo, the folks at Discos AMS, and Mary Farqharson and Eduardo Llerenas at Discos Corason. Salvador Magaña Ortiz, Leonardo Avalos, Rudolfo Jiménez, and Rafael Álvarez Jiménez in Apatzingán, and Juan Pérez Morfín in Nueva Italia.

For making this book a reality, I must first thank Diana Ayala, who transcribed all of my Spanish-language interviews, a long and often daunting task, and remained cheerful throughout, and Janet Malone, who transcribed the interview with Lupillo and Jenni Rivera. Andrés Elenes has been a friend and advisor, and also provided a scanner when one was needed, as did Sandrine Sheon, who also made me a website and provided hospitality, support, and loving friendship. Jeff McLaughlin was the man who first got me started as a writer, and he gave unstintingly of his time once again; his editorial help on this book was thorough, thoughtful, and an education, as always (and that semicolon is my special gift to him). My deepest thanks to all the friends who have let me talk endlessly about corridos, and who inspired me to keep going in the days before this project had a publisher.

My agent, Richard McDonough, has stood by me when I had books that were not finding takers, and he found a perfect home for this one. At HarperCollins, I have been lucky enough to be working with Rene Alegria, the always-enthusiastic helmsman of Rayo, who gave this book a home, provided keen editorial suggestions, and has put up with more than any of us will ever know. Josette Haddad did an excellent job of copyediting. Cathleen O'Connell did much of the painful work of hunting down song rights and was a sweetheart about it, as is her wont. Meanwhile, Deborah Huacuja is the translator of every writer's dreams, and anyone who reads Spanish should check out the Spanish version of this book, which has all the interviews in their original form.

There are surely others I am leaving out, but let me add Jaime Vázquez, Ramiro Burr, Oscar Otanez, Isabel Hernández, Rocio Pérez Solano, Laurel Chiten, Peter Keane, Steve James, Ángel Cano, Oscar Sánchez, Sebastián Cruz, Ramiro Cavazos, Joel Huerta, and my mother, Ruth Hubbard. For those of you who did not find your names here, please forgive me.

CONTENTS

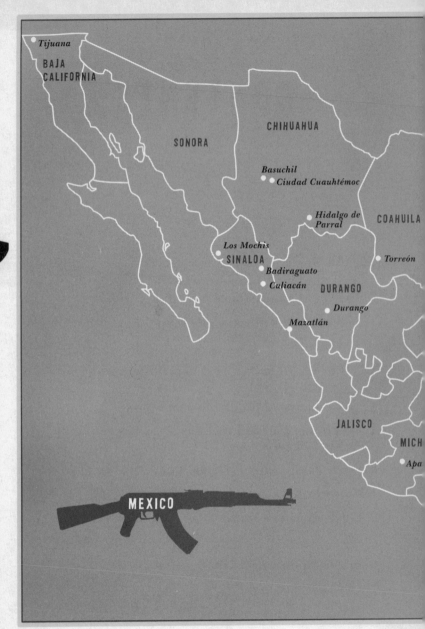

Tijuana

BAJA CALIFORNIA

CHIHUAHUA

SONORA

Basuchil
Ciudad Cuauhtémoc

Hidalgo de
Parral

COAHUILA

Los Mochis

SINALOA

Torreón

Badiraguato

Culiacán

DURANGO

Durango

Mazatlán

JALISCO

MICH

Apa

MEXICO

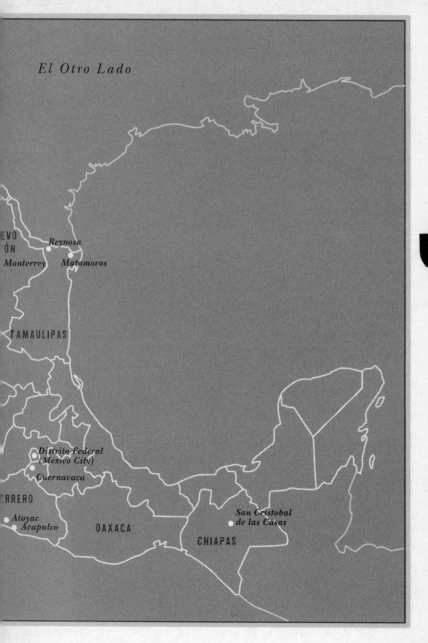

El Otro Lado

XV

EVO
ÓN
Monterrey

Reynosa

Matamoros

TAMAULIPAS

Distrito Federal
(Mexico City)

Cuernavaca

RRERO

Atoyac
Acapulco

OAXACA

San Cristobal
de las Casas

CHIAPAS

NARCOCORRIDO

INTRODUCTION

"I like corridos because they are the real deeds of our people."
"Yes, I like them as well, because what they sing is the pure
 truth."
"So, put 'em on!"
"Okay, here goes . . ."

—*Dialogue beginning Los Tigres del Norte's*
Jefe de Jefes *album*

In December 1999, I was standing at the back of a stage in the Zócalo, Mexico City's main square, looking out over a mob of 150,000 screaming fans of Los Tigres del Norte (the Tigers of the North). Los Tigres are the kings of *norteño,* the Mexican country music that is one of the most popular styles in the United States and Central America. Though the Anglo media act as if the current Latin music boom were driven by Afro-Caribbean styles like salsa and merengue, Mexicans and Mexican Americans are by far the largest group of Spanish speakers in the United States, and Mexican bands account for roughly two-thirds of domestic

Latin record sales. In this world, Los Tigres are like Willie Nelson and the Rolling Stones combined, the enduring superstars of down-to-earth, working-class pop. Their records sell in the millions, their concerts pack halls throughout the North American continent, and their songs have become part of the Mexican cultural heritage. They have never crossed over to Anglo fans for several reasons: First, their style is based on accordion-driven polkas and waltzes—not generally considered a sexy sound. Second, their music is old-fashioned and rurally rooted, a style disrespected by most trendsetting intellectuals and hipsters. Third, their most popular hits are *narcocorridos*, ballads of the drug traffic.

The narcocorrido is a startling anachronism, a medieval ballad style whose Robin Hoods now arm themselves with automatic weapons and fly shipments of cocaine in 747s. Since the rise of Los Tigres in the early 1970s, the narcocorrido has been taken up by thousands of bands and singers, first in Mexico and the United States, but now as far afield as Colombia and wherever the Latin American drug traffic thrives. Many *corridistas* (corrido singers and composers) are still rural artists whose popularity scarcely extends beyond their home villages. Others have become international stars—Los Tucanes de Tijuana, Los Originales de San Juan, Grupo Exterminador, Luis y Julián, and dozens more—recording for major labels like Sony and EMI, as well as for the Mexican giant Fonovisa. They are carrying on an archaic folk tradition in a world of beepers, cell phones, and high-powered SUVs, at once as old-fashioned as Appalachian ballad singers and as contemporary as gangsta rappers.

I became interested in corridos over twenty years ago. At the time, I was a traveling guitarist, earning my living wherever I could find a crowd of people who would throw me some change or invite me for a meal. I was based in Europe and had headed south to Morocco for the winter, and it was there, on the road out of Agadir, that I got a ride from my first corrido fan. Rudy Leal Villareal was a hashish smuggler from San Antonio, Texas, a charming and occasionally threatening character who picked me up, bought me lunch, then took me home to the house he shared with his girlfriend and a motley crew of street musicians and off-beat characters. I stayed there for several weeks, and after he had heard me play some old folk songs, Rudy began singing me his family ballad. It was a corrido called "Los Tres Tequileros" (The Three Tequila Smugglers) and told the story of three Mexican bootleggers who were killed in a cowardly ambush by the Texas Rangers. As Rudy explained it, one of the three was his grandfather, and the song was known to everyone in south Texas. He added that his aunts and uncles had always said that

he looked just like old man Leandro, his famous relative. Now, as he ran drugs north to Scandinavia, he felt that he was carrying on the family tradition. The corrido was his link to a Mexican border heritage he had left halfway around the world.

Back home in the United States, I continued to play guitar and also began to write about music and musicians, and over the years I read a fair amount about the history of the corrido. Rudy's song, which was commonly called "Los Tequileros," had been composed during the Prohibition era of the 1920s and early 1930s, at the end of a golden age in which corridos were the voice of all Mexico. The experts generally agreed that corridos had evolved from earlier Spanish ballad styles, and that they arose as a uniquely Mexican form sometime in the nineteenth century, probably in the Texas-Mexico border region. The early corridos mostly told the stories of heroic outlaws and gunmen, or of trail drives and horses—the same subjects that filled the cowboy ballads of the region's English-speaking population. The corrido took on a new importance and achieved national popularity during the Mexican Revolution (1910–1920). Hundreds of corridos still survive from this period, lauding the heroism of all the generals and giving details of virtually every major battle. As soon as the war ended, though, the style seemed to go into a decline. There was a spate of *tequilero* corridos during Prohibition, and ballads continued to be written along the border about murders and other spectacular crimes, but folklorists tended to agree that the form was dying out, unlikely to survive the century.

Having read these prophecies of doom, I was surprised when I made my first trip through Mexico in 1987 and found the corrido very much alive. Even "Los Tequileros" was still being recorded occasionally, and the old bootlegger ballads had paved the way for a new wave of smuggler songs. Los Tigres had started this wave with two hits, "Contrabando y Traición" (Smuggling and Betrayal) and "La Banda del Carro Rojo" (The Red Car Gang) in the early 1970s, each of which was made into a hit movie and spawned a series of sequels.

That trip introduced me to the world of Mexican norteño music. Before that, I had not connected Rudy's ballad with the hard-driving, accordion-powered style that I knew only as "Tex-Mex." I was familiar with the sound from Flaco Jiménez, the San Antonio accordion virtuoso who had crossed over to rock and blues audiences on recordings with Doug Sahm and Ry Cooder, but I thought of it as a regional roots style like Chicago blues or Louisiana Cajun music. In Mexico, I found that it was contemporary pop, made by gaudily dressed superstars whose image and appeal reminded me of the fringe-jacketed, big-hatted idols

3

of the Nashville country scene. I found that Jiménez was completely unknown in Mexico—and even in Texas was only at the top of the bar-band level—while the stars of the genre were groups I had never heard of: Los Tigres, Ramón Ayala y los Bravos del Norte, Los Cadetes de Linares, Los Alegres de Terán, and a flood of other names. When I got home to Boston, I tried to order their albums but found it was no easy feat. The problem was not that they were unpopular, but that they were on major labels that distributed only to the big chain stores and regional outlets serving Latino populations. They were outselling Jiménez and his compatriots by several orders of magnitude, but did not even exist on the Anglo radar screen.

I did manage to get a few records, though, and began to have a slight feel for the scene. At that time, the corrido was not yet its own genre. Most norteño bands included the songs in their repertoires, and some had issued corrido collections, but I do not think anyone would have identified him or herself specifically as a corrido fan. Corridos were just one of several song styles, mixed in with romantic ballads and various kinds of dance numbers: the romping border polkas adapted from Central European immigrants were most popular, along with waltzes and the bouncy *cumbias* that had come up from Colombia and mutated into *cumbia norteña*.

By the time I went back to Mexico in 1995, all of that had changed. I went as a peace observer in the Zapatista rebel region of Chiapas, and found corridos everywhere. Once again, Los Tigres had been catalysts for the trend, sparking an explosion of corrido albums with the success of their 1988 release *Corridos Prohibidos* (Prohibited Corridos), for which they doffed their fancy cowboy duds to appear as a bunch of street toughs in a police lineup. At roughly the same time, a singer named Chalino Sánchez had appeared in Los Angeles as the personification of the underworld gunslinger and corridista, writing some two dozen albums of raw, nasty songs before dying in an underworld execution. Suddenly, the conservative world of *ranchera* (the generic term for Mexico's country pop styles, from norteño to sentimental, trumpet-and-violin mariachi) had become a hotbed of gangster songs.

I found that educated Mexicans were horrified by the narcocorridos, bemoaning the decline of a once noble form. To me this made little sense. Many of the earliest corrido heroes had been border outlaws, and the traffickers were simply continuing that tradition, going out with their guns on their hips and sticking it to Uncle Sam. Besides, while the corrido's new popularity was intimately tied up with the drug world, the revival had also spurred songwriters to revive the style's earlier function

as a musical newspaper. Along with the *narco* songs, I found that groups in Chiapas were making up corridos of the Zapatista uprising, and these were the most popular music in the rebels' mountain encampments. It was unlike anything I had experienced in the folk music world back home, where people like Pete Seeger and Bob Dylan had sung political songs to old folk tunes, but without reaching many people outside the college crowd. Here, Indian peasants were living in tents made from plastic sheets and cooking over open fires, while listening on a boom box to "El Corrido de Comandante Marcos." A long ballad of the local guerrilla leader, this song was performed by a group calling itself Los Zapatistas del Norte, on a tape that also included covers of recent Tigres hits.

Los Tigres themselves were well aware of this new wave. Along with their drug songs, they had established themselves in the 1980s as Mexico's conscientious corridistas, recording a string of songs about the lives of immigrants in the United States, or as it is known in Mexico, *el otro lado* (the other side). Now they began a series of political corridos that attacked corruption in the Mexican government, first with a hit called "El Circo" (The Circus), then on a two-CD corrido set, 1997's *Jefe de Jefes* (Boss of Bosses). The finest album yet to come out of the corrido boom, *Jefe de Jefes* was like a panoramic portrait of modern Mexican culture, painting the lives of peasant farmers, successful immigrants, greedy politicians, and all the varied denizens of the drug world in lyrics full of unpretentious but powerfully moving poetry. After hearing it, I had to know more, and I set out to find and interview the composers who had turned the corrido from a dying folk style into one of the most vibrant and relevant art forms in the Americas.

This was largely uncharted territory. While corridos have become a fairly popular field of research, most academic scholars and folklorists still seem to be concentrating on the songs of the nineteenth century and the Revolution. Meanwhile, the pop music media have produced nothing but fan-mag biographies and interviews of the top singers and bands. Songwriters are not interviewed unless they are also bandleaders, and then the questions are more likely to be about their favorite color than their inspiration as composers. When I left for Mexico early in 1999, I had only a hazy idea of which composers were most important— aside from those I knew from Los Tigres' recordings—and virtually no idea where to find them. As I hung out in record stores, listened to hundreds of tapes, went to concerts, and attempted to submerge myself in the milieu, I began to have a clearer picture, and I was ready to go on the quest that makes up this book.

I spent most of the next year traveling in Mexico and the southwestern United States. I was hitchhiking most of the time, profiting from the knowledge and cassette collections of the Mexican truck drivers and getting a glimpse of a Mexico and a Mexican view of things that are rarely seen by outsiders (including most educated Mexicans). Everywhere I went, I found the corridistas eager to help me. They had long ago realized the importance of their work and had been waiting for someone else to come along and confirm their judgment. Despite their successes, many feel underappreciated, both by the corrido fans who know their songs but not their names and by the intellectuals and writers who have dismissed their work as *música naca,* music for hicks. Though I arrived as a hitchhiker with a guitar on his shoulder, they understood that I was sincere in my devotion to their work, and trusted me to complete a book and get it out into the world. Whether they were singers on rural buses or superstars performing on national television, they treated me as a friend, sharing meals and drinks with me and spending hours telling me about their lives and music.

On the whole, the corridistas lived up to my wildest expectations. They combined the rootsy iconoclasm of the early rock 'n' rollers with an equally passionate traditionalism, and took pride in both their flashy new accoutrements and their links to the medieval minstrels. I found most of them to be immensely likable, intelligent, humorous, and conscientious about their work. Nonetheless, I have tried not to romanticize them. They are, by and large, commercial songwriters. The most successful are selling millions of records on major international labels and are very much part of the mainstream entertainment world. If corridos were not making money, a lot of them would be writing love songs or disco hits. While they like to feel that their songs provide "a voice for the voiceless," they also write commissioned paeans to some very nasty characters, vicious thugs who buy corridos as status symbols alongside big cars and beauty queens.

To me, these contradictions just make the story more interesting. The corrido world provides a street-level view of all the surreal juxtapositions of modern Mexico: the extreme poverty and garish wealth, the elaborate courtesy and brutal violence, the corruption and craziness, sincerity and mythologizing, poetry and excitement and romance.

My journey was capped by that final concert: Los Tigres performing in the Zócalo, with what seemed like half of Mexico crowding the crumpling chain-link fence in front of the stage. I had already finished the research for this book, and ended up there more or less by accident— Los Tigres just happened to be playing in Boston the previous week, I

6

went to interview their leader and accordionist, Jorge Hernández, and he invited me to fly to Mexico City as his guest. His outsized gesture seemed a fitting finale for a trip that had already carried me to so many unexpected places, so I immediately agreed. And it served its purpose. Looking out over the largest audience ever gathered in Mexico's central square, with all traffic shut off for blocks in every direction and towering amplifiers bouncing accordion rhythms off the Spanish colonial buildings, no one could doubt the power of this music. Los Tigres ranged the stage in their gleaming leather cowboy outfits, and as the crowd cheered each hit I felt proud to have been able to provide some kind of history and forum for the songwriters who remain the voices and chroniclers of modern Mexico.

SECTION 1

CORRIDO RENAISSANCE

THE FATHER OF CAMELIA

Ángel González

I was hitching out of Ciudad Cuauhtémoc when the police pulled over. It was 3:00 in the afternoon, the rain had just stopped, there was no bus, and I had an appointment in two hours with Ángel González, the father of the *narcocorrido*.

There were two policemen, driving in a pickup truck, and they started with the usual questions: Where was I going, how long had I been in Mexico, could they see my papers. They kept me a couple of extra minutes, calling my description in to headquarters, because a Mexican had recently been robbed by a gringo. Then they drove off,

only to return some ten minutes later. I still had not gotten a ride, and was beginning to worry that I would be late for my appointment, so I was mildly irritated when they said that they would have to keep me there for a while until the victim could be brought to look at me. From my occasional experiences with Mexican police, I expected a long wait.

But no. It was not five minutes before another pickup pulled up, with two more policemen and a guy with dirty blond, shoulder-length hair, a limp mustache, and a really impressive black eye. The truck had barely stopped when the longhaired guy leapt out, pointing at me and yelling: "That's him! That's the *cabrón* who robbed me! He's cut his hair, but that's him!"

In an instant, I was slammed face-forward against the first pickup, with hands all over me. Someone was patting me for weapons, two others were pulling my arms down to handcuff me, while the fourth was shouting, "Keep your hands up!" I was trying to remain calm, repeating, "I can prove I just got to town. I was in Chihuahua this morning." No one was listening to me, but the victim seemed to be having second thoughts. He pulled up my sleeves, looking for track marks, and when he could not find any he began yelling that no, I was not the guy. By now, though, the cops were having fun. They had opened my pack and were asking the victim if the cassettes I had were his. He said no. Then they found my small stash of dollars—a couple of twenties, a ten, and some ones.

"Is this your money?" they asked the victim.

"No, mine was all hundred-dollar bills."

That was pretty much the end of it. The police removed the handcuffs, murmured an apology, and drove off, and I caught a ride out toward Basuchil. I did not feel like asking what business the longhaired guy was in.

In 1972, a new record swept Mexico. It featured a bunch of unknown teenagers called Los Tigres del Norte, who sang with the raw, country twang of the western Sierra Madre, backed by a stripped-down, accordion-powered polka beat, and it had a lyric unlike anything else on the radio. Called "Contrabando y Traición" (Smuggling and Betrayal), it told the story of a pair of lovers on a business trip:

> *Salieron de San Ysidro, procedentes de Tijuana,*
> *Traían las llantas del carro repletas de hierba mala,*
> *Eran Emilio Varela y Camelia la tejana.*

(They left San Ysidro [a California border town], coming from
 Tijuana,
They had their car tires stuffed full of "bad grass" [marijuana],
They were Emilio Varela and Camelia the Texan.)

The couple make it safely across the border, are briefly stopped and
questioned by immigration authorities in San Clemente, but pass with-
out any problem and drive on to Los Angeles. Arriving in Hollywood,
they meet their connection in a dim alleyway, change the tires, and get
their money. Then Emilio gives Camelia her share and announces that
with this money she can make a new start, but as for him, he is going up
to San Francisco with *"la dueña de mi vida,"* the woman who owns his life.
Camelia, who has already been described as "a female with plenty of
heart," does not take this farewell with good grace:

Sonaron siete balazos, Camelia a Emilio mataba,
La policía solo halló una pistola tirada,
Del dinero y de Camelia nunca más se supo nada.

(Seven shots rang out, Camelia killed Emilio,
The police only found the discarded pistol,
Of the money and Camelia nothing more was ever known.)

"Contrabando y Traición" was not the first *corrido* about the cross-
border drug traffic. There had been ballads of border smuggling since
the late nineteenth century, when import duties made it profitable to
carry loads of undeclared textiles south to Mexico and a Mexican gov-
ernment monopoly tempted freelancers to sell homemade candle wax
to North Americans without going through official channels. The
smuggling business really took off, though, with the imposition of the
Eighteenth Amendment, which prohibited the sale of alcoholic bever-
ages in the United States. Prohibition was a terrific boon to border
commerce. *Tequileros* swam the Rio Grande pushing rafts full of booze,
drove trucks across desert crossing points, or used boats to cruise up
the coast.

When Prohibition ended in 1933, the tequileros turned to other
products. (They were not alone; the Prohibition-era gangster Lucky
Luciano also went on to smuggle Mexican heroin.) One year later, on
October 13, 1934, what seems to be the first narcocorrido was recorded
in San Antonio, Texas. Written by Juan Gaytan, of the duo Gaytan y
Cantú, it was called "El Contrabandista" and told of a smuggler who has

13

fallen into the clutches of the Texas lawmen after switching over from liquor to other illegal inebriants:

> Comencí a vender champán, tequila y vino habanero,
> Pero este yo no sabía lo que sufre un prisionero.
> Muy pronto compré automóvil, propiedad con residencia,
> Sin saber que en poco tiempo iba a ir a la penitencia.
> Por vender la cocaína, la morfina y mariguana,
> Me llevaron prisionero a las dos de la mañana.

> (I began selling champagne, tequila, and Havana wine,
> But I did not know what a prisoner suffers.
> Soon I bought an automobile, property with a house,
> Without knowing that in a short time I would be going to jail.
> For selling cocaine, morphine, and marijuana,
> They took me prisoner at two in the morning.)

There would be other such songs through the years. The most famous was "Carga Blanca" (White Cargo), a ballad of two Mexicans who travel to San Antonio with a load of heroin or cocaine, which they sell for twenty-eight hundred pesos, then are hijacked on their way home and killed, the money being returned to the man who paid them. Written in the 1940s, "Carga Blanca" became a border standard. The most popular recording was by Los Alegres de Terán, the duo that set the pattern for what was becoming known as *norteño* music with their close harmony singing, solid rhythmic accompaniment on the low-tuned twelve-string guitar known as the *bajo sexto,* and sprightly accordion breaks. The song was an oddity, though, and few other trafficking ballads would gain any popularity until the arrival of Los Tigres and Camelia.

The Tigres were three brothers, Jorge, Raúl, and Hernán Hernández, and their cousin Oscar Lara, from the village of Rosa Morada in Mexico's west coast state of Sinaloa. Jorge, the leader and accordionist, had been singing professionally since age eight, when he and a school-girl companion began performing in cantinas for tips, and he brought the quartet up to the United States to sing at a Mexican Independence Day celebration in 1968. They decided to stay on in San Jose, California, where they caught the ear of Art Walker, an Englishman who signed them as the flagship group for his new Fama Records label. Los Tigres' first three albums had some local success (the second included a nice version of "Carga Blanca"), but they were only one of many good young

groups. Then Walker and Jorge Hernández made a trip to Los Angeles in search of new material and happened to hear a mariachi singer named Joe Flores singing "Contrabando y Traición." Jorge was immediately struck by the novelty of the lyric—the woman turning on the man and killing him, then taking off with the loot—but felt that there was something missing. The mariachi style, with its swirling violins and mellow trumpets, and Flores's polished vocals, did not seem to match the sharp, action-packed story.

At seventeen, Jorge had dreams of being an actor, and this was a song that demanded an actor's gifts. With Walker's support, he spent the next year cutting and recutting it, trying to get it just right. Then Flores's recording began to take off, and he realized that he had to move fast. Los Tigres went into the studio, the harmonies still were not working, and finally Hernán, the second vocalist, stormed out—"We were just kids, we didn't have any experience or anything," Jorge says—and Walker had Jorge do it on his own. Somehow, everything clicked, the record came out, and within four months orders were coming from all over southern California and on into Mexico. Realizing that they were finally on their way, Los Tigres went into the studio one more time and cut the final version, with Hernán's harmony back in the mix. It took off, Los Tigres became the new young idols of *ranchera* music—Mexico's equivalent of country and western—and the narcocorrido boom had begun.

Basuchil does not look like the sort of place where one would find a successful composer. It is something between a small town and what is known as a *rancho*, a dusty desert hamlet indistinguishable from hundreds of others. The only paved street is the main road to Ciudad Guerrero, itself no more than a country byway, and the town runs along one side of it. On the other side is an expanse of yellow plain, divided by lines of barbed wire strung on scrap wood and broken by an occasional patch of green trees, stretching out to a line of black mountains on the horizon. I rode into town in the back of a pickup, along with a bunch of locals from another rancho further on. No one seemed to think it strange that a gringo would be hitchhiking; there was no other way for someone without a car to get around between buses, and few buses travel this route.

I had called Ángel González the previous afternoon, from Chihuahua. Or rather, I had called the telephone office, the only way to reach anyone in Basuchil, and the operator had sent a boy out to get

him. Half an hour later, we spoke for the first time and made an appointment for an interview. He did not seem particularly surprised to get the call: he simply announced that he was *"a sus órdenes"* (at your orders), and invited me to come to his house.

He did not give me an address, but that was no problem. As the driver who took me from Ciudad Cuauhtémoc to the Ciudad Guerrero turnoff explained, "Don Ángel is very well loved around here." The pickup dropped me off across from a roadside restaurant that, though closed, seemed to constitute the town center, and after a few minutes a car came out of a side street and I flagged it down and asked the way to Ángel's house. "Oh, *sí*, the composer—he lives down all the way, and then to the right." The town was bigger than it looked from the road, and I walked five blocks, past lines of adobe houses painted in cooling whites and pastels to deflect the harsh desert sun. The bigger ones were surrounded by high walls, and I could hear chickens everywhere. An old lady standing in a doorway gave me further directions, and at the southwest corner of town I came to Ángel's house, a small, white building much like the others.

Ángel met me at the door, a balding, slightly stooped man, dark as a full-blooded Indian but with European features. He invited me into his living room, a rather cramped space divided from the kitchen area by an L-shaped couch-and-armchair suite. He called for his son to bring me a beer and seated himself beside me, sipping a dark liquid out of a liqueur glass.

"I was born right here, in Basuchil," he began, speaking so quietly that I had to take my microphone off the low table and hold it near his head. "My grandfather was a musician, he was an accordionist, but that was many years ago. He would play at dances and that sort of thing. They tell me that he had the gift for composing, though I think he just composed a lot of silliness—he would just get drunk and begin to say a lot of rubbish and that would be that. But he was also a composer, in his way.

"Ever since I was small I had the itch to compose, and I began when I was around fourteen or fifteen. Not with the hope of getting rich—any composer who starts out thinking that he will get rich doing this, that guy will never make it. One does a thing like this (at least in my case I did it, and I do it) because I enjoy it."

Ángel is an introspective man, and I can easily imagine him as a teenager, retiring to a quiet place and making up songs for his private pleasure. What puzzles me is where he developed his confidence, the absolute faith that sent him out into the world to sell his creations. He certainly received little enough encouragement. As he tells the story, he spent

twenty-one years *"peregrinando"* (pilgriming), wandering around Mexico in search of someone who would appreciate his work.

"I was in Mexico City, in Monterrey, Guadalajara, all those places. Here in Chihuahua I kept going to the local performers and giving them my songs, but I was very young, so it went nowhere—all I managed to do was to make them think I was crazy.

"In '51, I went to the Distrito Federal [Mexico City], promoting my music, asking around to see who would record one of my songs, and I found nobody, nobody. After three days I was out of money, and I spent about a month without eating hot food. I went to the markets, found discarded fruit, washed it, and ate it, and I slept wherever I was when night came. I spent a month like that, and then I began to work as a laborer, a peon. But I had to work through Saturday, and then on Sunday I would go see what was up, and I couldn't get anywhere, because if someone gave me an appointment for Wednesday or Thursday I couldn't go, or I would go and leave my job and I would be back wandering again. It was hard, very hard."

He was a country boy in a huge city, a ragged peon trying to attract the attention of a musical world then in its golden age. There was one brief moment when the dream seemed about to come true: Pedro Infante, the singer and movie star who was the idol of all Mexico, was appearing at the Teatro Blanquita, and Ángel managed to get backstage.

"I just stood in the doorway, holding my song. . . .

" '*¿Que pasó?*' Pedro said to me. He was in the bathroom with two guys, chatting. 'What's up? Cat got your tongue?' "*

"So I went in and I said to him, 'Pedrito, look, I have some songs, I'm from Chihuahua.'

" 'Look here, you go and see Rubén.' (Rubén Fuentes was one of the mariachis, and I think he was also a composer. He was with the mariachi that accompanied Pedro, the Mariachi Vargas.) 'Tell him I sent you.'

"So off I went. And what a musician! Rubén took the music in one hand and the lyric in the other, and then he just glanced at the music and began to sing it, the cabrón! Well. . . .

" 'That's nice, that one. Do you have more?'

" 'Yes.'

" 'I'll see you tomorrow at Peerless [one of Mexico's major record labels].'

* Infante's actual phrase was the more expressive "¿Que eres de Penjamo?" Literally this means "Are you from Penjamo?" Penjamo is an archetypal hick town, home of humble little peasants, so the idea is that Ángel need not act like such a shy country guy.

"And I didn't have a single centavo, I had no work, I had spent more than a month sleeping on benches. How was I going to get from one side of Mexico to the other, when I didn't even know where Peerless was, or how to pay the bus fare, or anything about anything about anything? So I didn't go, and when I didn't go, well, I had done the wrong thing and I never got close to him again."

So it went, year after year. Ángel would go home to Basuchil for a while and do farm work, but then the itch would get to him and he would be off again. In the mid-1960s, he was living in Nogales, on the US border, and this time he decided to try his luck in Los Angeles. Finally he was in the right place at the right time.

"I went there with the idea of recording my songs—by then I had some thirty or forty songs done—because people had told me that there was plenty of local talent there, and that it was easy to record and to introduce new songs because there was not much competition with other composers. And I have a married sister there, so I went. And I had the good luck to enter with the right foot. That's one of the great things about the United States, that there an inventor who has invented something can get people to hear what he has to say, to listen to him and pay attention to him. Here they don't. In these Latin American countries, and probably in others as well, they think that to be a composer you have to wear a tie and go around smelling of lotion. So there it was: I struggled for twenty-one years, and in the United States, the first time I met Joe Flores he liked my song and he recorded it."

Flores was quite popular in Los Angeles, though his career never extended much beyond the city limits. "He was a good singer," Ángel says. "Only, he was also a good father—he was very attached to his family, to his children, so he didn't want to travel very far. He was recording for Tony de Marco, who had a radio program advertising a furniture store, and I went to see it, the show, and Joe Flores came to sing. I showed him the song, he liked it, he took it with him, and he recorded it. I didn't have to struggle at all, not even a little, little bit."

Flores's recordings were the turning point in Ángel's career. He recorded three of Ángel's compositions, and each became a substantial hit in the LA area. The first two were heartfelt ranchera laments, "Sin Fortuna" (Without Fortune), which went on to greater popularity after it was covered in Mexico by Gerardo Reyes, and "La Silla Vacía" (The Empty Chair). Then came "Contrabando y Traición." It was the only corrido Ángel had ever written, and utterly unlike his other work: "My other songs are about social problems," he says. "Problems in a marriage, the problems a son has with his parents. That's the sort of thing I

like to write about. The only song of mine which doesn't have any message is 'Contrabando y Traición.' "

He adds that it was not a serious effort, just something he tossed off as an afterthought: "When I wrote that corrido, I was working on another project, on another song, and it wasn't coming. So I put that one aside, and then the rhymes began coming to me, and it just came and came and came."

I cannot help thinking that the success of Ángel's song was due, at least in part, to the fact that he was not a corrido writer. The corrido tradition had always been based on recounting real events, with all the names and dates right, and most corridos gained their popularity from the importance of their subjects. "Contrabando y Traición," by contrast, was openly fictitious, and it had the colorful, larger-than-life feel of a Hollywood movie. Ángel says that the names of his characters were taken from life, but had nothing to do with the story in which he placed them: "In Los Angeles I met a friend named Camelia, but she isn't from Texas. And there is an Emilio Varela in my family, but they don't even know each other." Nor, he hastens to add, did either have any connection with the drug world.

Though the story was pure invention, it was very much in tune with current events. The early 1970s were a peak period for Mexican drug trafficking, and the public was eager for tales of daring border smugglers. Still, Ángel insists that the song's overwhelming success was due not to its topicality but to the personal appeal of his central character. All the previous smuggling corridos had featured ordinary border types, poor men who were trying to make a little money by carrying a small load of contraband to "the other side." Women in corridos tended to be murder victims or deceitful lovers, not dashing bad girls in the tradition of Bonnie and Clyde. Camelia la Tejana was something out of a flashy modern action film, and also a revival of a north Mexican archetype: although in a surprising context, she recalled the legendary Valentina, the Revolutionary heroine who bravely fought alongside the male soldiers.

"I am a feminist, five hundred percent," Angel says. "Maybe you don't know what that means. A feminist is a man who knows what a woman is worth, who knows that woman is the greatest. Why is woman the greatest? Because woman is half the world, and what's more she's the mother of the other half. In my songs, I always have the woman come out ahead. 'Contrabando y Traición' was the first song like that, and then, it was also the first song about the drug traffic. There was nothing like it."

While there had in fact been earlier drug corridos, the freshness and excitement of Ángel's song set it apart, and the success of Los Tigres' recording not only breathed new life into the corrido style but took norteño music to new heights of popularity. "Contrabando y Traición" was adapted into a movie script, Camelia became a legend, and soon there were dozens, then hundreds of songwriters trying to replicate Ángel's formula, each vying to be more colorful and violent than his predecessors. To his surprise, Ángel found himself not only a popular songwriter, but the father of a genre. Thirty years later, he still has not come to terms with his corrido's popularity, longevity, and influence.

"That song, I wrote it without thinking, I had no idea what would happen afterward. After my corrido, along came that whole pile of songs about drug traffickers, but I wrote it without any idea of that. It was a problem which I brought to light, but not something I knew much about. I hadn't seen any smugglers or anything. This traffic is something that was, is, and is going to continue being a problem on all the borders of the world, that's how it is, but I never, never ever, thought that the song would make it big. Because my songs are something else, they are songs with a message, things from people's daily lives, and those songs aren't."

Ángel is certainly an unlikely person to have spawned Mexico's most violent and reviled musical form, and his discomfort was increased by the reaction of the press: "In Tijuana, some newspaperman with nothing to do began going on about 'Ángel González this,' and ' "Contrabando y Traición" that,' and how it was an insult to Tijuana. Now, the newspapermen are the ones who keep the best tabs on the narcotraficantes—where they live, what they do, how much they have—but still they never say anything, and then a poor unfortunate, Ángel González, writes a song and they jump all over him. They said I was promoting the drug traffic."

In fact, Ángel says, he knew hardly anything about the drug business and certainly was not associated with any traffickers. Unlike some later *narcocorridistas,* who have become notorious for insider stories of corruption, murder, and underworld intrigue, he knew of the subject only by hearsay. The Chihuahuan desert was not ideal for growing drugs—at least not until a few years later, when Rafael Caro Quintero pioneered the use of modern irrigation techniques for the cultivation of marijuana. Still, the semitropical mountains and valleys to the west had long been fertile drug country, and the border region between Nogales and Ciudad Juárez was full of easy crossing points. There were plenty of stories flying around, and Ángel added his own touches. He says, for exam-

ple, that he simply invented the idea of smuggling the drugs in car tires, but assumes it must have been tried. "There was no earlier example of someone doing that, but, if you use your head, where can the grass be most completely hidden? It must have occurred to someone to smuggle it in the tires. The smugglers are like the *mojados* [literally "wetbacks," illegal migrants]; they know all the tricks and try out every possibility."

In the end, Ángel's abilities as a songwriter and storyteller made up for any deficiencies in his smuggling lore. His romantic picture of a high-living female buccaneer was imitated throughout the norteño world. In San Antonio, Steve Jordan, "the Jimi Hendrix of the accordion," whipped off a song called "La Camelia," in which Camelia returns to Texas, falls in love with a local trafficker, carries another load of marijuana across the border, then discovers that her lover is an undercover cop, and ends up in jail. Other writers rushed out songs about their own high-powered heroines, "Margarita la de Tijuana," "Carmela la Michoacana," "Josefa la Canadiense," and then, after Los Tigres followed up with "La Banda del Carro Rojo" (The Red Car Gang), ladies who combined their appeal with that of their cars: "La Dama del Montecarlo" and "La Dama de la Suburban."

Los Tigres themselves recorded two more Camelia songs: "Ya Encontraron a Camelia" (They Already Found Camelia), in which Camelia is hunted down in Guadalajara by members of Emilio Varela's gang and dies in a hail of bullets, and "El Hijo de Camelia" (The Son of Camelia), in which her brave son appears, shoots five members of the Tijuana gang, and can still be seen driving up and down the highways of Mexico in search of his mother's killers. These songs list Ángel's name as composer and are considered among his most popular work, but to my surprise he insists that he had nothing to do with them. After twenty-one years of hardship, most songwriters would have been happy to capitalize on their success, but he had been following his own tastes for too long to change now: "I like for each of my songs to be original, to be unique," he says, with obvious pride. "I have no interest in writing 'answer songs.'" Instead of composing more drug corridos, he went back to exploring social issues, and Los Tigres hired someone to ghost-write the rest of the Camelia saga, using Ángel's tune and imitating his rhyme scheme.

Despite all the sacrifices that went into building his career, Ángel seems to be only tangentially interested in popular or economic success. He is glad to be able to take care of his family, and to have his songs heard, but in recent years he has devoted little effort to selling his material. After his breakthrough in Los Angeles, he felt he should move to

Mexico City and cement his reputation, but after six or eight months he decided that city life was too rushed and pressured, too full of mistrust and shady business deals. So, rather than pushing ahead, he moved back to Basuchil and bought himself an apple orchard. He continued to be interested in music, even recording an LP on which he recited his lyrics over the backing of a local band, and pop groups still sometimes visit him in search of material, but he pays little attention to the contemporary entertainment world. Instead, he has gone back to writing for his own pleasure.

"I still like to compose, I do it all the time," he says quietly. "But as I told you, to compose for the sake of composing, not with the dream that it will make me rich. Now, if riches come, fine, they're welcome, but there's no point in fooling oneself. Why? Because then you'll get something you weren't looking for. One thing is for sure: I don't know if you've noticed, but if you analyze the work of composers, you'll see how in the beginning we are very good, but afterward we begin to commercialize ourselves, we try to write every kind of thing and see what works. And that has not happened to me.

"Los Tigres del Norte have been here in this house three or four times, they take my material and they record it. And other people come too. Just a few days ago Los Renegados de Ojinaga were here, they took some material, and now I have material for another group that is coming, Grupo Primavera. I have a very good relationship with all of them. If a group comes that sings ranchera music, I show them some ranchera songs, they listen, and they say, 'I like that one, and this one.' I re-record them on another cassette and they take them. And if it were a *baladista,* who was looking for a romantic song, I would play them some *baladas* and see which they like.

"Over there in my chest I have five or six hundred songs, because during the night I get up and start writing. But I don't have any pressing need to get them recorded. I write because the songs come to me, period. If someone wants to record my stuff, they can record it, and if not, it's the same to me. If that weren't the case, I would have to go off to Mexico City, Guadalajara, Monterrey, to the United States, promoting my material, and no, no. . . .

"I'm not rich, but I have an inheritance to leave my family—that boy there is my son, I have my wife, and we are the whole family—I have an orchard here with thirteen hundred apple trees, and I go out and walk through the orchard. I don't work anymore, but I like to walk out and look at it. It's very quiet here. You have the local gossip like in any small town, but it's very peaceful. I prefer it to the big city; it's calmer, for

example, for my son, cleaner and safer with regard to drugs and all of that."

It is almost dusk, and Ángel seems tired. I thank him for his time, and he calls to his son and tells him to drive me out to the road, where I can catch a ride back to Ciudad Cuauhtémoc. The son gets his car, a new SUV, and Ángel walks me to the gate, then stands watching as we drive away.

23

EL MAESTRO

Paulino Vargas

Paulino Vargas, to me and to the majority of musicians and composers who know this business, is a genius, a philosopher, a poet. He is a complete man, despite coming from a rancho. And he is a great composer. As a corrido composer, Señor Paulino Vargas is a truly worthy gentleman.

—*Pepe Cabrera, corrido singer and composer*

From Ciudad Cuauhtémoc, my path led south along the inland foothills of the Sierra Madre Occidental, the "Western Mother Mountain Range." It took over an hour to get out of town, as it was Sunday morning and there was very little traffic, but I was in no hurry. The air was fresh and clear after the previous day's rain, and I walked along the broad, recently tarred highway, picking an old blues song on my guitar and enjoying the cool breeze off the mountains. On the edge of town, I stopped in the minimart attached to a filling station and bought a large bottle of grapefruit juice, and I had just finished drinking it when

a pickup pulled over. The driver was only going a few miles down the road, but I soon had another ride from a trucker who took me to the southbound turnoff. There, I found a bus full of baseball players waiting to meet a car with the remaining members of their team. They were Los Venados (the Stags) of Madera on their way to play a three-game series with Los Mineros (the Miners) of Parral. As soon as they saw my guitar they made me part of their company, giving me a seat in the front of the bus, where I would have plenty of room to play, and passing me a couple of thick burritos, still warm in their wrappings of tinfoil.

All I knew of Madera was that a driver the previous day had told me that it was a town of *"puros mariguaneros"* (nothing but marijuana growers, sellers, traffickers). Naturally, I mentioned this fact to my hosts, and it was taken in the best of humor. They were not corrido fans, though. They were interested to hear that I had met the creator of Camelia la Tejana, and that he lived so close to their region, but the closest they came to singing a corrido was the first baseman barking a punk version of Ángel's song, as recorded by the alt-rock band La Lupita. Their taste in music ran more to romantic pop numbers and rock 'n' roll. After much prodding, one guy took my guitar and sang a lovely song he had written bilingually in Spanish and Tarahumara, after which I sang Elvis and Chuck Berry hits until my voice gave out from yelling over the noisy motor. Then, of course, a tire blew and, while we waited for someone to come along with a jack, the team clown invited me off into the bushes to smoke a joint. I declined, but was pleased to find that my source had not been entirely faulty.

As we drove on toward Parral, the country got steadily wilder, the hills higher and more jagged. On our right, the Sierra Madre beckoned me. Mexico's largest range, running from the Arizona–New Mexico border down toward Mexico City, it is the cradle of the Mexican drug trade, and the richest area for modern-day corrido heroes. Its steep mountains and deep valleys offer concealment for marijuana and opium fields, and for primitive landing strips where small planes can rest on the way from Colombia to the United States and pick up or drop off cargo. The mountain folk are famous for their toughness, their ability to walk long distances on little food or water, and their willingness to fight. Many of Mexico's most famous drug lords grew up running barefoot along the mountain paths, and entered the business as isolated growers before getting up their nerve to come down out of the hills. Illegal drugs have been a way of life here for decades, but have tended to be seen as a cash crop rather than a social ill. For the folks in the hills, growing marijuana or opium poppies is not a moral issue, it is an eco-

nomic necessity. Life in the mountains is hard, and there are few crops that are worth the effort of shipping over the rutted dirt roads, or flying out in planes. Fortunately, Mexico's northern neighbor has provided an inexhaustible and consistently lucrative market for the local produce. Unfortunately, from the point of view of the farmers, it has also sponsored eradication programs that have periodically turned sections of the sierra into war zones (though without having any appreciable effect on the international drug trade). The result has been a view of the *narcotráfico* that is quite different from views in the cities north of the border: It is a dangerous business, but the danger is not of addiction and social decay. It is of dying at the hands of organized gunmen, whether uniformed officials of the state or henchmen of the drug lords—or both, as these categories often overlap.

Parral is the largest town between Chihuahua and Durango, a sort of port city for the sierra, where hill dwellers come for store-bought goods, and mountain produce is resold to dealers who will carry it to the outside world. We got into town in the midafternoon, with a cold drizzle falling. The Venados let me off beside the motel where they were staying, across the road from the ball field, and I walked down the winding, narrow streets until I found a small hotel on the main square. It was no weather for hitchhiking, and anyway I was happy to spend a night in Parral. I had nothing to do there, but I enjoyed the chance to pay at least a symbolic tribute to the greatest corrido hero of them all: Parral is where Pancho Villa was assassinated, riddled with bullets as his car drove out of town on July 20, 1923.

Villa is a protean figure in Mexican history and mythology: one of the most brilliant generals of the Revolution, a fine horseman, a great womanizer, an astute tactician, and a bloodthirsty bandit. There is no way of knowing how many songs have been written in commemoration of his exploits, but, assuming that the ones that have been preserved are only a sample of what was sung at the time, they certainly numbered in the hundreds, and many have remained popular. As recently as 1999, Los Tigres included two Villista corridos on their *Herencia de Familia* album. Many of the Villa corridos read like news dispatches in song, giving precise information about his military campaigns, battle by battle, but the ones that are still sung tend to be more generalized and romantic. Historians celebrate Villa as a great general, but the singers remember him as a man, the bravest of the brave, the finest horseman, the irresistible lover, and the most macho character of a singularly macho time. Though respectable Mexicans tend to hold up the Villista corridos as examples of a noble form that has devolved into cheap *narco* trash, a lot of the people buying Tigres albums would consider Villa a natural

predecessor to today's dashing bandit kings. Of course, all agree that he was a more heroic, self-sacrificing, and patriotic figure than Rafael Caro Quintero, Amado Carrillo Fuentes, or the other famous narcos. Still, it is easy to believe that if Villa had been born a poor boy in the mountains of Durango in 1978 rather than 1878, he would have turned his talents to the drug traffic. He was a man who had little respect for the law and enjoyed living by guts and guns. Furthermore, drugs were not foreign to his world. The chorus of the most famous of all Villista songs, "La Cucaracha" (The Cockroach), says that the cockroach cannot walk because he lacks marijuana to smoke.

Villa's life story, at least as it is told and believed by the average working-class Mexican, includes many of the key attributes of later corrido heroes. Raised an illiterate peasant, he became an outlaw after shooting the farm boss who had attempted to rape his sister. Caught and imprisoned, he knocked down a jailer and took to the hills, joining a bandit gang. While some reports have him settling down to a respectable life as a butcher in Parral and then Chihuahua, others tell of daring raids and brutal killings. Then came the Revolution.

Villa joined up on the side of the revolutionaries and shortly found himself in prison again, this time in Mexico City. He spent his stay learning to read, then escaped once more, fleeing to El Paso, Texas. A few months later, early in 1911, he crossed the border with seven companions and formed his legendary División del Norte (Northern Division), which won northern Mexico for the revolutionaries. The dictator, Porfirio Díaz, fled the country, but the revolutionaries would spend the next nine years fighting among themselves. It was during this period that Villa staged one of his most celebrated raids, the 1916 capture of Columbus, New Mexico—the only time since the War of 1812 that a foreign army has invaded the United States.

Villa was a uniquely flamboyant character, his military talents matched by a flair for publicity and showmanship. As he rode across the desert at the head of his ragtag troops, winning battle after battle, he became a popular celebrity on both sides of the border. In January 1914, he signed a twenty-five-thousand-dollar contract with the Mutual Film Corporation in which he agreed to hold his battles in the daytime, carry out fake raids for the camera, and bar competing film companies. He is even reported to have rescheduled executions so that they would take place when the light was at its best. A largely fictionalized film, *The Life of General Villa*, combined this footage with dramatic scenes played by actors, and portrayed him to North American audiences as a Mexican Robin Hood who, in the end, becomes his country's president.

Villa's heritage is one of the things that sets Mexico apart. He is a

very different kind of national hero from George Washington, Robert E. Lee, or Simón Bolívar—suave, gentlemanly leaders who could charm in a drawing room as well as lead troops in the field. Whatever his intelligence and nobility, he was a wild, sierra-bred ruffian, with a rich vein of earthy humor, and to the average worker or peasant he feels like a familiar character. This is what links him to the modern freebooters of the corrido craze. His image combines immense power with small-town, barroom normality. The average cassette buyer would not know how to behave around a taciturn, bookish leader like Benito Juárez (the nineteenth-century father of Mexican democracy), the Ivy League–educated politicians running present-day Mexican politics, or the wealthy hacienda lords who have constituted Mexico's rural aristocracy, but he can imagine himself laughing at Villa's jokes or sharing a drink with a backcountry drug king. In the sierra, Villa remains a favorite son, and the craggy peaks around Parral give a taste of the harsh country that once gave him shelter.

The next morning the sun was out, and I hitched on south to Durango. More than in any other town in the region, Durango still felt to me like the old Wild West. Not so much in the main square, which is typically Spanish colonial, a large, paved plaza with an ornate bandstand surrounded by weathered stone buildings, where hawkers sell ice cream, peanuts, and corn on the cob. The western feel really took over as I entered the bustling market. There, in a maze of narrow passageways covered by plastic tarpaulins or corrugated tin roofs, stalls displayed the latest corrido tapes alongside an array of cowboy gear: boots made from exotic leathers, heavy belt buckles, walls hung with all shapes and sizes of hats, high piles of blue jeans, and all sorts of horse gear. There was also an abundance of narco chic: shirts, wallets, and baseball caps embroidered with marijuana leaves, AK-47s, naked women, and *los tres animales,* the three animals that in Mexican slang have come to represent the most popular drugs: the parakeet (cocaine), the rooster (marijuana), and the goat (heroin).

Durango is where I hoped to pick up the trail of Paulino Vargas. Back in the 1950s, a folklorist named José Hellmer had come through town and happened to record a norteño duo singing the Revolutionary-era corrido of General Benjamín Argumedo. Though neither Hellmer nor the musicians could have imagined such a thing, the duo's teenage singer and accordionist would become the most important corrido composer of the modern era.

I had come across the Hellmer recording in New York, in the office of the American folklorist Alan Lomax. I was going through the notes for an unreleased album of traditional Mexican music and was startled to see Paulino's name. At first I wondered if it might just be coincidental—another musician with the same name—but I checked around and found not only that it was the same Paulino Vargas but that he and his partner on the Hellmer tape, Javiér Nuñez, had gone on to become Los Broncos de Reynosa, the most popular norteño duo of the 1960s. Nuñez died some years ago, but Paulino continues to lead a version of Los Broncos, and I was told that he still lived in Durango. As it turned out, this last bit of information was wrong: Paulino moved to Mexico City back in the 1960s, and I finally tracked him down through the Sociedad de Autores y Compositores Mexicanos (Society of Mexican Authors and Composers). The phone number SACM provided was long out of date, but they also gave me an address, which turned out to be a corner store in a bustling neighborhood near the university. There, a pleasant young woman agreed to pass a message to Paulino and said I should call her at the store later in the evening. When I did, she put him on the phone. I explained that I was doing a book on the contemporary corrido and could not do it without talking to the master. "Oh, there are plenty of better writers," he said, sounding pleased. "But you're welcome to come on over." We made a date for the following afternoon.

The shopkeeper turned out to be Paulino's daughter, and when I arrived she called him and he ushered me into his modest apartment on the second floor of the same building. His living room is comfortably furnished, with a small wooden bar in one corner and family photographs on the walls. Paulino must be in his mid-sixties, only a few years younger than Ángel, but he could hardly be more different. A little man, wearing a cowboy hat and boots with side panels of rattlesnake skin, he is feisty and funny, a ball of nervous energy. He bounces around the room, or perches, leaning forward on the edge of his chair, talking a mile a minute. I slipped a cassette of the Hellmer recording into his boom box and, as soon as he heard the first notes, he leapt up and ran across the room, pulling me by the arm, to show me a large color portrait of Los Broncos. "That's my friend!" he shouted, "*¡Mi amigo Javier!* You hear, he's just playing a guitar, he didn't yet have a bajo sexto."

Paulino spends the next half hour telling the story of his early life and the arrival of Hellmer's crew. "He told us to sing a corrido, one of the old, authentic ones—in those days I didn't compose corridos, I didn't know how to write in those days. Where I come from there were no schools. That's up in the Sierra Madre, on El Espinazo del Diablo

[the Devil's Backbone], the road that goes to Mazatlán. I was born in Promontorio, but I lived a long time there on El Espinazo, in San Andrés. My father played accordion, I remember seeing him, but I was very young, I don't know how he played—but forty-five years after his death, when I go up there, the people say that I'm not good enough, that he was the good one."

Paulino pulls me over to the wall by the television, where he has a sepia-tinted photograph showing Pancho Villa sitting with a small group of men under some trees. He explains that it was taken near the ranch where he grew up: "There are no cabrones born there—just real men." He says that the boy sitting in the background is his grandfather, who had gone along to take care of some horses Villa had purchased from the family. "We raised livestock, cattle, we had horses, and we also had mines. When my father died, my mother remarried and I didn't get along with the new daddy, so I left. I even went to the United States— but *no speak in English, you know?* I bought an accordion in Texas, in San Benito, then I tried to hitch a ride to San Antonio, but the highway patrol brought me back to the border. I left there and began to play, and from then on I just kept playing. I started out in the cantinas, at street parties, in churches after the mass. After that, I came back home and I met Javiér near my rancho and I invited him—he was rich, he had a lot of cows, plenty of livestock, and he wanted to go traveling—and he went with me to Torreón. They hired me in a radio station as a child prodigy, I was twelve, thirteen years old. Then we picked cotton in the Comarca Lagunera [near Torreón], our money ran out and Javiér was ashamed to go home, so he bought a guitar and began singing with me, and a little while later we were hired as Los Broncos de Reynosa."

When Paulino gets on a roll, it is often hard to follow exactly what happened after what, or when he is skipping to a different decade. As he talks, his inclination is to jump up and pace, gesturing with his arms, snapping his fingers as he sings a few lines, miming an accordion riff, and acting out the stories he is telling. As best I could follow, he and Javiér made their first commercial recordings for the Ideal record company in Texas, though the record simply listed the performers as "*dueto mixto*" (mixed duet), without giving their names. Then came the Hellmer tape, and then there was some sort of aborted deal with the Mexican division of Columbia Records. As Paulino tells it, the Columbia story starts out sounding a bit like Ángel's sad tale of frustration, but it ends quite differently:

"We came to the DF [Mexico City] to do an audition, because there was a program called *Fogata Norteña* that had a lot of listeners and we

came to sing for them. The main company at that time was Columbia Records, and they asked us if we wanted to record, so we said sure, but we were already out of money and they told us to come in eight days, and we took a bus from San Bartolo or Santa Julia to the neighborhood of Cuitlahuac, but a train was passing and wouldn't let us get by. Then there was a rainstorm and we climbed under the train and walked the whole length of the Calle de Mariano Escobedo, and there was a sign saying 'Discos Peerless.' I said, 'This is where Pedro Infante recorded. Let's ask them to give us a chance.'

"We went in, and yes, they let us play. We recorded two songs, 'Ausencia' and 'Paso del Norte.' They told us it was just a test, but then they released it commercially. It got a lot of play, and on the label they had put the name 'Los Broncos de Reynosa.' We thought they had ripped us off, and went to complain, but no, it was us—and me neither a *bronco* [wild guy] nor from Reynosa—and the two songs were in first place in the *rating* on the *hit parade*."

Los Broncos were a slicker, more polished variation on the pattern developed in the Texas border region by duos like Los Alegres de Terán and Los Donneños (a pioneering norteño duo from Donna, Texas) Paulino, uniquely among Mexican accordion stars, is equally comfortable playing either the three-row diatonic accordion favored by norteño musicians or the more harmonically versatile piano accordion, and he uses both hands where other norteño players tend to disconnect the bass buttons at their left and just play melodic leads. This means that he could play pretty much any music that came his way, from Mexican folk tunes to ragtime to rock—a fact he demonstrates by leaping from his chair, strapping on a piano accordion, and playing a solid boogie-woogie bass line with his left hand while tossing in funky blues riffs on the piano keys. Then, just for contrast, he switches to a diatonic instrument and plays a few bars of a *redova*, an old-time, northern country dance, kicking up his boots in a sprightly cowboy step. No matter how small the audience, Paulino enjoys putting on a show.

Los Broncos were wildly popular, but there is nothing on their albums to suggest that the peppy young accordionist had much potential as a composer. They recorded flashy instrumentals, classic ranchera songs, and corridos, but almost none were original compositions. This is all the stranger when one considers that Paulino had begun writing even before Los Broncos started their run.

"My first corrido is called 'Contrabando de Juárez,' " he explains. "I was living in Juárez and a gentleman gave me permission to play in his cantina, it was called the El Paso Bar. This gentleman, I don't know what

he did for a living, but they took him prisoner on the American side and he didn't get out. And since he was giving me my food—he paid me fifteen pesos a day, but from two in the afternoon till five there was no band, so I played my accordion and I rigged some maracas up on it, and made some music with my mouth, and I made seven, eight, ten dollars, like thirty, fifty pesos a day, which was a lot in those days. A worker earned nine, ten pesos, and I as a child was making four or five times that—so, as a way of saying thanks, I made up that corrido."

"Contrabando de Juárez" was reminiscent of an earlier prison ballad, "Contrabando del Paso," which had been a big hit for Los Alegres de Terán, but Paulino's song had a lighter, more youthful feel. While both corridos ended up with the hero in prison, Paulino pictured him listening to the music drifting in from the nearby bars and dreaming of the cantina girls: "*Güeritas ojos azules, no les puedo dar mi mano / Porque me tenían juiciado el gobierno americano.*" (You blondes with your blue eyes, I cannot give you my hand / Because I have been judged by the American government.) It was an early effort, without the polish of his later compositions, but the song served as Paulino's introduction into the bigger music business.

"We went to a radio station—it was XEJ—and I recorded it, and they took it and wrote out a lyric sheet. Because it was just a tape, or actually an acetate, one of those old ones that went shhh, shhh, shhh. And when we were coming to the DF, I ran into Los Alegres de Terán and Los Donneños in Monterrey, so I sang it for them and they recorded it. It was the first corrido I made up, but just in my head, because I didn't have any other way of making myself understood, I still didn't know how to read or write. But it worked—almost fifty years later it's still getting played and, what's more, I'm still getting royalties for it."

Despite the song's success, Paulino did not yet see writing as a serious profession. While he composed some thirty more songs, he did not know how to protect his interests, and the songs were published under other names, so he got little or nothing for them. Anyway, he thought of himself as a performer, not a composer. In part, this was because that was how the norteño scene worked—none of the players were making much from songwriting—but he also felt handicapped by his lack of education. It was only in 1965 that he finally learned to read and write, after meeting the pretty schoolteacher who would become his wife. "I was ashamed to tell her, and she didn't suspect," he says. "Because I was already playing on television and on the radio. And I said to her, 'You know, I'm going to make a confession: I don't know how to read, I'm illiterate.' She was furious, and we didn't see each other for a while.

Then I went and talked to a priest and he told me, 'Look, I can teach you and you can also learn from the catechism.' And very, very quickly, in about fifteen days, I understood how it worked, and I could read everything. But my culture is still very rough. I never went to school, and if you haven't studied you are just a little animal—if I don't bray, it's only because I can't get the tone right."

That final phrase is typical of Paulino's conversational style, simultaneously showing his modesty and his gift for humorous rhetoric, and he collapses in giggles, asking if I understand it. Then he becomes serious again, saying that he really saw no reason to write songs at that time, because the previous generation of composers was still active. "Then the composers who really composed well began dying: Don Victor Cordero [composer of 'El Ojo de Vidrio,' 'Juan Charrasqueado,' and 'Gabino Barrera'], for me the master of corridos, of the real, beautiful corridos; Samuel M. Lozano ['Persecución de Villa,' 'Tampico Hermoso'] of the old ones; Graciela Olmos, who wrote 'Siete Leguas' and 'Benjamín Argumedo.' Those people had lived through part of the Revolution, so their work was very authentic—and mine is authentic as well, because when they died I learned to read and the first thing I did was put down on paper what I had in my head. I wrote it down and began to record it. And look, it isn't much, but yes, it does all right."

I had heard that Paulino began composing seriously during a few months spent in prison in the late 1960s, which seemed an interesting enough story that I asked him about it. He nodded, and explained that he had been arrested because the then president of Mexico (presumably Díaz Ordaz, but Paulino did not want to mention names) was descended from Santa Anna, the victor of the Alamo, and took offense at a corrido that expressed Paulino's contempt for the Treaty of Guadalupe Hidalgo, in which Santa Anna ceded away the territory that is now the southwestern United States. This explanation seems unlikely, to say the least. The late 1960s was a tense time in Mexican politics, and a lot of people went to prison, or worse, for quite minor acts of dissent, but if Paulino really was sentenced for voicing such a common opinion on such an old issue, it was a case of singularly bad luck.

Be that as it may, there was a prison stay, and it gave Paulino an insight into the Mexican underworld that he has been mining ever since. He was soon making a name as the master of the modern badman ballad, and when "Contrabando y Traición" swept Los Tigres to stardom, he quickly appeared with a follow-up. "La Banda del Carro Rojo" showed Paulino's gift for appropriating and updating images from previous generations, starting with the title: La Banda del Automóvil Gris

(the Gray Automobile Gang) had been a notorious gang of robbers in Mexico City in the teens, celebrated in a popular song and the subject of Mexico's most famous silent film. The song also showed a deep debt to the classic corrido tradition: where "Contrabando y Traición" boasted a dashing Hollywood heroine framed in a bright, B-movie action plot, Paulino's song had a gritty, down-to-earth feel that recalled the old border outlaw corridos. His opening verse sets the scene and pretty much sums up the story:

> Dicen que venían del sur en un carro colorado,
> Traían cien kilos de coca, iban con rumbo a Chicago,
> Así lo dijo el soplón que los había denunciado.

(It is said that they came from the south in a red car,
They carried one hundred kilos of cocaine, they were headed
 for Chicago,
That's what the squealer said who had informed on them.)

The smugglers make it across the Texas border, but in downtown San Antonio the police pull them over, ask for their registration, and tell them not to resist or they will be killed.

> Surgió un M16, cuando iba rugiendo el aire,
> El farol de una patrulla se vio volar por el aire;
> Así empezó aquel combate donde fue aquella masacre.

(An M16 blasted, as it roared in the air,
The light of a patrol car could be seen flying through the air;
That's how the battle began where that massacre happened.)

The gang goes down in a hail of gunfire, and the leader, Lino Quintana, dies after gasping out his last words: "Lo siento, sherif, porque yo no sé cantar" (I'm sorry, sheriff, because I don't know how to sing). The two final verses enumerate the slain, four smugglers and three government agents, ending with the assurance that one need not worry about them, as "they will all go, with Lino, to Hell."

Like "Contrabando y Traición," "La Banda del Carro Rojo" was a massive hit for Los Tigres. (It had also been previously recorded, this time by the Sinaloan singer Pepe Cabrera.) It was made into an even more popular film and spawned several sequels. Unlike Ángel's song, however, Paulino's ballad recounted a real event. "Why tell lies?"

Paulino asks rhetorically. "I'm unschooled, but I stick to the truth. Otherwise people complain and show you up as a faker. Why did you come to see me? If you wanted lies, there are enough people to tell them in your country, aren't there?"

Paulino insists that a good corridista must also be a reporter: "When I have to make a corrido about someone, I go where the incident happened. I see something on the television, the radio, in the newspaper, and if the character interests me I make a trip and see how it was, what happened, to have some idea of what I'm going to say. I investigate the story. If there are relatives, I ask their permission, and if not I just shoot it out there without permission, but I have to be sure that it is factual. I don't like to invent things, it has to be true. You know, the public knows the difference, it can tell what isn't real and what is. It's a monster that you can't fool. For me, what works best is what's closest to the truth—though of course you have to add a bit of *morbo*."*

This thought sends Paulino off on a digression about the war in Bosnia, which he has been watching on television. He is impressed by the way the Sarajevans walk around calmly despite the bombing, and says that he wants to go there and write a song about them. From there, he jumps to "Los Dos Testigos" (The Two Witnesses), a corrido he wrote after seeing news footage of the assassination of Anwar Sadat. Then comes a long, involved, and rather confusing story about meeting John Wayne in Mazatlán. It is twenty minutes before I can bring us back to "La Banda del Carro Rojo," and Paulino mentions that he actually knew the protagonist, Lino Quintana: "I knew him and he was a nice guy; what I didn't know was what he did for a living [i.e. the drug connection]. He lived there by El Cantil, in the Sierra de Durango, and he had these Cessna air taxis, little planes that went up to the mines, where cars can't go. We were playing up there once, on Holy Cross Day, the third of May, and we went in one of his planes. We were already well known at that time, and he must have had a record of 'Contrabando de Juárez,' and he asked if I was the one who had composed it. 'Why, yes sir: *Me aprehendieron en El Paso . . .*' [Paulino sings a bar of the song.]

"When we finished playing he brought us to a little hotel, the only one up there, and asked if we would play a few songs for him. He didn't look Mexican, he looked like a Uruguayan, Paraguayan, Peruvian, and he didn't talk like us.

* *Morbo* is one of those quirky, untranslatable words. Literally, it means sickness unto death, but it can also mean a weird attraction ("she's ugly, but she has a certain *morbo*"), or a particular style of speaking, a twist one gives to language.

"Anyway, I didn't hear anything more about him, except one time they called us to go and play in Parral and they said, 'Listen, Mr. Quintana says he knows you.' I didn't remember his name, but they said he was going to be in the area and did we want to play for him. But he didn't show up, and a little later I saw that he had been killed, and when I saw the photo in the newspaper I said, 'So that was him.' By that time I had done some songs that were hitting, composing was getting to be a good business for me, so I went to investigate."

I ask Paulino if he actually took a trip up to Texas, and he nods, then quickly corrects himself: "Well, actually they killed him in New Mexico, heading out toward Dexter. The highway patrol stopped him, and they didn't know that he was carrying anything, but one of the boys who was with him got scared and fired and the patrol killed them. But they killed some agents as well—altogether, it made a lot of noise, and I went and looked into it and then I wrote the song."

Clearly, for all his insistence that he is recording the facts, Paulino improved the story. While he says that it was Los Tigres who changed the setting from New Mexico to San Antonio, if the police stopped the smugglers by accident then the part about the squealer was presumably his own invention.

"There you are, sure," Paulino agrees enthusiastically when I point this out. Then he seems to change his mind again: "Well, somebody did turn them in, but it seems that the car that he had described didn't have anything in it. He had described a car of some other color, and they stopped it in El Paso. And when they were going along there, on the *freeway*, they were in a red car and that was where they were killed. And then, according to what people said there, when the sheriff arrived and asked him who had sent him, he said—it really wasn't that he said he didn't know how to sing, what happened was that he didn't know any English, he said *'I'm sorry, I don't speak in English.'* What's written there in the corrido, why I put *'Yo lo siento, sheríf, porque yo no sé cantar,'* it was a way of saying that he was very brave, but that part was my invention. You understand? This little morbo of mine sometimes turns out to be good business."

Indeed, "La Banda del Carro Rojo" was one of the biggest hits of the 1970s, and Paulino followed it with a flood of further drug-world ballads. While he continued to record albums with various versions of Los Broncos, he had now found his true métier. His corridos blended a deep respect for the tradition with a keen use of his own observations and experience, and he wrote dozens, then hundreds of them, which were recorded by pretty much every group in the norteño world. His

work is the foundation of the modern corrido, and he is widely hailed among the songwriting community as the grand master of the form.

Paulino is well aware of his importance, though he discusses it with his usual blend of self-deprecating and cocky humor: "I haven't counted them, but by now I have around a thousand songs," he says. "But it's in self-defense. It's not professional, it's an amateur thing, but people like them and buy them. I'm not a composer, I'm a little liar, but it works, it's good business. For example, these boys Francisco Quintero [another composer for Los Tigres], Julián Garza [composer and leader of Luis y Julián]—all of those guys learned from me and they're very attached to me, like to a grandfather. But they're better than I am, because they did go to school and they know what they're saying. I tell them, 'Don't imitate me. . . .' " He shakes his head modestly, then finishes the thought with a characteristic twist: "I say, 'Blessed be my imitators, for they shall inherit my faults.' "

Paulino's success soon reached beyond the norteño scene. Antonio Aguilar, Mexico's most popular *charro* movie star (the equivalent of singing cowboys like Gene Autry or Roy Rogers), had made his name with a string of corrido-inspired films in the 1950s and 1960s, Revolutionary-era epics like *El Ojo de Vidrio, Benjamín Argumedo,* and three films about the Sinaloan bandit king Heraclio Bernal. Aguilar's heroes tended to be poor country boys who were forced to take up arms after being harmed by wealthy landowners, and the stories were set in the days of fast horses and Colt revolvers. It was thus something of a coming of age for Paulino's work when, in 1984, Aguilar based a film on his "Corrido de Lamberto Quintero." While *La Banda del Carro Rojo*, despite its popularity, was a low-budget action quicky—the Mexican equivalent of a B-level drive-in film—this was the Mexican mainstream. Aguilar's record of the title song became a huge hit, reaching a respectable audience that, even today, remains contemptuous of norteño accordion music.

"Lamberto Quintero" was a perfect showcase for both Paulino's journalistic and his poetic gifts. It begins with traditional precision, giving the date of Quintero's assassination in 1976, then plunges the listener into the middle of the story: Quintero and his men are driving toward El Salado, a small town outside Culiacán, Sinaloa, when one of them notices a pickup following close on their tail. Quintero responds to this news with braggadocio, smiling dismissively and remarking, "What are machine guns for?" Then, just before they enter the town, the shooting starts. As Paulino tells it, Quintero was a special man, happy and romantic, and he was watching the *morras* (chicks) go by and not paying attention when "the well-aimed guns snatched away his life." Then the song

switches into an old-fashioned, exhortative mode, as Paulino addresses the final two verses to local landmarks. First, he cries, "Santa María clinic, you will be my witness: Two days after his death, shots were heard again, and ten men died there for the same reason." (According to other reports, there were between twenty and thirty people killed in this shoot-out, though it seems unlikely that Paulino would understate the figure.) Then he finishes with an elegiac flourish:

> *Puente que va a Tierra Blanca, tú que lo viste pasar,*
> *Recuérdales que a Lamberto lo deben de recordar.*
> *Yo por mi parte aseguro que hace falta en Culiacán.*

> (Bridge to Tierra Blanca [a Culiacán neighborhood
> known for its wealthy traffickers], you who saw him pass,
> Remind people that they must remember Lamberto.
> I, for my part, assure you that he is missed in Culiacán.)

Paulino could attest to the accuracy of that final line, as his song had been commissioned by Lamberto's mourners. Like Lino Quintana, Quintero's crowd had been Broncos fans. "They were already known figures," Paulino says. "You would go to the Pacific coast, and they would ask if you didn't want to play for the Quinteros. Then we played a dance in Los Mochis and I got up in the morning and saw in the paper that there had been a whole bunch of people killed, and that he was one of them. Some time passed, like a year or two, and then one day a gentleman came and asked me if I didn't have a corrido of so-and-so.

" 'Well no, no I don't.'

"He brought me some information, but no, the lightbulb didn't go on. Then I went back there after another three or four years, and a boy showed up and asked me how much I would charge to write a corrido for his papa.

" 'Who is your papa?'

"He said, 'So-and-so.'

"I said to him, 'Well, give me the information. And he brought me a little piece of paper, crying, and gave me a twenty-dollar bill. 'No,' I told him, 'I won't charge to do it.' But the boy convinced me, and I went to work.

"The people who had asked me to write the corrido the first time, I didn't understand how they expected me to sing the praises of a character I didn't know, so it didn't come out. But the boy painted the story for me in another way, and with him it worked. As I say, I'm not a pro-

fessional, I write what I feel—it isn't like someone can just say, 'Do this,' and I do it. I mean, I can just invent something, but if I can't convince myself that it's true, it stays cold."

Paulino's genius is to take a true story and add something—his morbo, if you will—that makes his verse into something greater than its raw material. While he occasionally writes about internationally famous figures like the Colombian drug lord Pablo Escobar, most of his heroes have been people like Lino Quintana and Lamberto Quintero, local characters who would have remained unknown outside the sierran crime world had he not made them into legends. My own favorite among his corridos is not even a narco song: "La Tumba del Mojado" (The Wetback's Grave) simply recounts the travails of an illegal migrant worker in the United States. While this theme has been more famously explored by two of Los Tigres' finest writers, Enrique Franco and Jesse Armenta, neither has captured the feelings of a poor immigrant with Paulino's directness and poetry. Los Tigres' recording frames the song in an upbeat, polka rhythm, but the lyric has a quiet dignity that transcends the perkiness of the music.

> *No tenía tarjeta verde cuando trabajé en Louisiana,*
> *En un sótano viví porque era espalda mojada,*
> *Tuve que inclinar la frente para cobrar la semana.*

(I didn't have a green card when I worked in Louisiana,
I lived in a basement because I was a wetback,
I had to bow my head to collect my week's wages.)

Referring to the border as the "tortilla curtain," the mojado points out that, while his countrymen have to sneak across and live like criminals, French, Chinese, Greeks, and Americans are respected landowners in the Mexican pueblos. The chorus is one of Paulino's masterpieces:

> *La rosa de Mexicali y la sangre en el río Bravo*
> *Son dos cosas diferentes, pero en color son hermanos.*
> *Y la línea divisoria es la tumba del mojado.*

(Mexicali Rose [a waltz famous on both sides of the border]
 and the blood in the Rio Grande
Are two different things, but in color they are siblings.
And the dividing line is the grave of the wetback.)

Paulino seems to feel a special sympathy for the poor adventurers who make their way across the border by stealth, whether they are simple farm workers or carry a couple of kilos of heroin. He grew up with people like these, and he still likes to speak of himself as a poor man like them. On one level this is an affectation: he has made a lot of money over the years and owns not only the house where we are meeting but another in Saltillo, one he is currently building in Acapulco, and the ranch in Durango where he grew up (it was sold by the family at some point, and he takes great pride in having been able to buy it back). Still, his living room has none of the garish, nouveau riche touches common to the homes of other successful musicians (and drug traffickers). Paulino's place is sparsely furnished and, while he does have the big SUV that is de rigueur for all country-bred Mexicans who have made good, he lives simply. He has an assistant, who sits quietly to one side during the interview, but not the crowd of backslappers and gofers who accompany other norteño stars, and the spareness of his lifestyle provides a stabilizing counterweight to his personal flamboyance.

After an hour and a half, the interview winds to a close, but Paulino insists that he must invite me out for a meal. His assistant drives, with me in the backseat and Paulino riding shotgun, and we wind through a maze of streets to a restaurant called Las Tres Vacas. It is a Friday during Lent, so Paulino and the assistant will not eat any meat, but, with his air of Wild West bravado, what more appropriate place to take me than a steak house? At the door, we are greeted by a fat headwaiter who welcomes Paulino with the ingratiating manner of an old family servant. Paulino tells him a joke which I cannot quite follow, but is obviously filthy, then hands him his cowboy hat, saying, "Make sure it doesn't get dirty—men have died for that." We are seated at a front table, and Paulino asks if I will have another tequila (he served me one already during the interview, though he is not drinking). I graciously acquiesce, and he calls out for the waiter to "Bring a glass of the best tequila in the house for my American friend," then orders me a steak. The restaurant looks like a rich man's hunting lodge, with animal heads on the walls and a mariachi band going full tilt by a back table. It is clearly a high-class place, and Paulino excuses his extravagance, explaining, "I have no money—but there are many banks, and there are pistols."

As the meal goes on, Paulino becomes ever more relaxed and talkative. He is the only one not drinking, and the only one who seems to be getting tipsy. He tells a string of off-color animal jokes, none of which I can follow through to the punch line, and drops names of famous people he has met: Presidents Kennedy and Johnson, General de Gaulle in

France, John Wayne, and Louis Armstrong. Every few minutes, he tosses in a phrase of English as a gesture of hospitality and brotherhood. He wants me to feel at home and assures me that "we are the same, Mexicans and Americans, only you are tall and bastards, and we are short and sons-of-bitches."* He asks about my family background, and when I say I am Jewish, he cups his hand behind his ear to ask, *"Dijiste 'judío' o 'jodido'?"* (Did you say "Jewish" or "fucked"?)

Paulino offers me a lift to where I am staying and, as we drive, the subject gets back to narcocorridos, and then to politics. Paulino is not considered a political writer, but he has occasionally touched on controversial subjects. In "Al Filo del Reloj," another corrido recorded by Los Tigres, he was the first of their writers to question the government, asking:

> *¿Cuantas horas tiene un año, y cuantas tiene un sexenio?*
> *De septiembre hasta diciembre, las cuentas pasan haciendo,*
> *Y ahí empiezan a olvidarse que son empleados del pueblo.*

41

(How many hours are in a year, and how many in a sexenio
 [the six-year Mexican presidential term]?
From September to December they get the accounts in order,
And then they begin to forget that they are employees of
 the public.)

A more recent song, "Los Super Capos" (recorded by Los Invasores de Nuevo León), deals with the CIA-Contra-cocaine affair, the "super capos" of the title including George Bush. After telling a bit about the scandal, Paulino turns to the United States' much-hated policy of "certifying" countries as compliant with US drug eradication policies before giving aid. He writes, *"Antes de certificar, primero limpien sus campos / Dondequiera hay corrupción, sean gringos o mexicanos."* (Before certifying, first clean your own fields / Wherever there is corruption, whether gringos or Mexicans.) The song goes on to say that the gringos show up in all the world's trouble spots, blockading Cuba, Iraq, and the Palestinians, while at home things get worse and worse:

> *La droga inunda sus calles, y el congreso lo sabe,*
> *Pero como es buen negocio, a los güeritos les vale*
> *Que los chamacos adictos casi no asistan a clases.*

* *"Ustedes son altos y güeyes, y nosotros bajitos y cabrones."*

(Drugs flood the [US's] streets, and Congress knows it,
But since it is good business, the little white guys couldn't
 care less
That the addicted kids hardly even go to classes.)

Some people might consider it hypocritical for Paulino to write songs about the corruption and tragedy of the drug traffic. After all, he is the man who has written hundreds of heroic ballads of narcotraficantes. As he sees it, though, his protagonists are not the cause of the problem, but simply some brave characters making their way in a hard world. They are not the guys who run things, powerful politicians or Mafia bosses out of the *Godfather* movies. They are local boys, and sometimes girls, who have managed to come out ahead for a while before being gunned down.

As he expands on this theme, I get out my recorder again and reset the microphone. "Now you are taking advantage of me," he says, laughing, "but I give you permission." After all, this is his chance to provide an explanation of his life's work. "There is so much ignorance," he says. "So once in a while on the little ranchos someone is a little more ambitious than the others, and he gets a small fortune together and begins to run things. But they don't have the scope to go to a city and get ahead there, so they just do their little business and travel along the byways until they die. I don't think you can call that a mafia, I think it's a sort of local necessity which forces them into a troublesome business. It's just a way of getting by, because there is so much neediness. For example, in these states the authorities are friends of the landowners. Someone who doesn't have property either works for them, doing what they want, or he doesn't work—or he goes over to visit you, he says, 'Hi there, cousin.'

"Most of us, I think forty percent or sixty percent, don't even finish high school, so they can't get credit even if they have some land to plant. They plant if it rains, and if it doesn't, zero. So they lose hope, and if they get together with some crook they become criminals, or at least they become tough guys. They're suffering, and they fight because they have to. They know a little bit about how to move some inebriants, and more or less where they can sell them, but, for example, the problems you find in Tijuana and Juárez [the border drug capitals], which are like a daily news item—and bad news, sad to say—there is too much money involved there for those to be stupid people. How do you explain the fact that a huge airplane or truck gets by, with all the laws and all the controls on the roads and the airspace?"

Clearly, responsibility for the drug trade lies not with the poor people growing or carrying the dope, but with those giving the orders, in whichever country. In Paulino's formulation, it is the rich and powerful who control both the illegal traffic and the borders, and he reminds me that, if Mexico is supplying drugs to the United States, the United States is the source for most of the guns being smuggled into Mexico. "You people send arms from your country to mine, and the Latinos and Asians send you all this crap, so neither you nor we are taking care of the situation. It's like I said in 'Los Super Capos': The streets are flooded with drugs, everyone knows it, but they play dumb because there's money to be made.

"It's just the same here: they say that one can't carry arms, and everyone is armed. And it isn't the fault of either the sellers or the buyers—it's the fault of those who allow this to happen and then prohibit it. They do their business, letting things in, and then when they see someone using them they lock him up. Is that just? No, no, let them prohibit the traffic and prohibit the possession, but evenhandedly. Now, everyone who has some influence carries arms here—only the poor man, he has no right to defend himself and he dies like a dog."

43

SECTION 2

THE SINALOAN SOUND

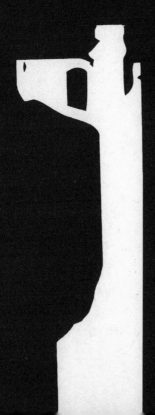

SINALOAN LEGENDS

Narcoculture, Violence, and Jesús Malverde

"Back when I was growing up in Sinaloa, a guy would pull out
 his pistol and shoot someone over nothing, over a mango.
 He'd say, 'Give me that lemon.'
" 'What lemon?'
" 'The one in your hand; give it to me or I'll split it.'
"And he'd pull out his gun and split the lemon in half, shooting
 the guy through the heart. And that would be his friend."
 —*Jorge Hernández, of Los Tigres del Norte*

From Durango, my route led through some of the most spectacular
scenery in Mexico, across the sierra to the Pacific coast and Sinaloa, the
heartland of the Mexican drug world. The road follows El Espinazo del
Diablo, a narrow mountain ridge that winds through the clouds, drop-
ping off on either side in steep slopes and hidden valleys, with sharp,
wooded peaks jutting ominously in the background. The weather was
cold and rainy, so I decided to spring for a ticket on a second-class bus
to Mazatlán, and I was lucky enough to end up in the front right-hand
seat, with an unobstructed view out the windshield. My location turned

out to have a secondary advantage: the bus driver started chatting with me, and when I explained why I was in Mexico he proceeded to play me his favorite corrido cassettes.

He was Sinaloan, and the selection ran heavily to *banda,* or brass band music, relieved by tapes of Los Tigres and their young competitors, Los Tucanes. The banda boom, which hit in the late 1980s, is one of the most surprising developments in Mexican music. Like most of the European-influenced world, Mexico has a village brass band tradition that harks back to the eighteenth or early nineteenth century, but the surviving orchestras tend to play either raucous and disorganized folk styles or a nostalgic repertoire suitable to evening strolls in the town square. In Sinaloa, though, and among young people up the West Coast to Los Angeles, brass band music is the hot, contemporary thing. The standard lineup is that of an old-time marching band—three trumpets, three clarinets, three baritone horns, three valve trombones, a tuba, and a drummer—but the repertoire features the same high-powered rhythms as the norteño groups, and the same mix of romantic ranchera and narco ballads. The history of *banda sinaloense* is complex, starting with the influence of German merchants in Mazatlán and including a brief vogue in the 1980s for a synthesized rock fusion called *tecnobanda.* Most people will agree, though, that drug money has played a significant role in its current popularity—as in almost everything to do with present-day Sinaloa—and the West Coast narcocorrido stars often sing with banda backing.

My bus driver had two tapes by Banda El Recodo, Sinaloa's trendsetting brass group since the 1940s, and also the current album from El Coyote, a banda star with the high, nasal sound typical of Sinaloan singers. Whenever a narcocorrido came on, he would turn in his seat and signal me to pay attention, cupping his hand behind his ear and glancing meaningfully toward the speakers. His favorite was a number on the Coyote tape, "La Pista Enterrada" (The Buried Landing Strip), in which an airplane coming from Colombia with a cargo of opium poppy seeds and five hundred kilos of cocaine heads for Phoenix, Arizona. The pilot, when queried by the border control tower, says, "Don't worry about anything, I'm not a terrorist, I'm just carrying *hierba mala,*" and the controller assumes he is joking and gives him permission to land. The border police are there to inspect the plane, but suddenly it disappears off the radar: "The gringos never imagined that there was a buried airstrip," El Coyote sings, and the pilot safely unloads his cargo, the moral being that the mafia has millions of dollars and, as we all know, "money can move mountains."

The bus driver explained the whole story twice over, just in case I had missed some of its fine points, laughing inordinately at the exchange between the pilot and the control tower. Then he got into a discussion with the relief driver as to whether there were actually such things as buried landing strips. The other passengers did not seem at all put out by the choice of music or conversation. Many were dark, slim men who got off in what seemed like the middle of nowhere, then set out walking along dirt tracks into the sierra. They wore jeans, boots, and either cowboy hats or baseball caps. The baseball caps were decorated with various combinations of marijuana leaves, AK-47s, and silhouettes of naked women, accompanied by a town or state name (Sinaloa, Culiacán, Durango, Nayarit) stitched in the red, white, and green of the Mexican flag.

The one passenger who was obviously not enjoying the music was, unfortunately, seated across the aisle from me, a captive audience of both cassettes and commentary. When we stopped for a lunch break, he came over and explained that he, personally, would rather listen to Pink Floyd. When I asked his profession, he said "narcotraficante," but in fact he made silver jewelry. He did add another dimension to the drug theme, since he was reading Baudelaire's *Artificial Paradises* and was interested in discussing the uses of hallucinogens by Romantic poets. Unfortunately, it was not my subject.

We arrived in Mazatlán in the early evening, and I found a hotel near the beach and settled in for a few days of rest and relaxation. I bought some books on the drug world, went to a couple of concerts, and hung out in the local record stores, absorbing music and conversation. The first thing I learned was that drug ballads here are simply called "corridos"; it would be tautological to append the "narco" prefix, since in Sinaloa there is no other corrido theme. Mostly, though, I was just killing time, swimming, walking around the old town, and eating raw clams and oysters washed down with Pacífico beer. My real destination was another three hours up the road, in the state capital, Culiacán.

If you say the words "Sinaloa," and more particularly "Culiacán" to most Mexicans, the first things they think of are drugs and violence. The state's primacy in the drug world reaches back over a hundred years: Mazatlán is Mexico's largest Pacific port and boasts a large Chinese population, and there are accounts of opium dens in both Mazatlán and Culiacán around the turn of the last century, where the drug was smoked in the traditional Chinese fashion. There was nothing

particularly illicit about this. Poppy beds brightened many town squares, and I met people in Culiacán who could still remember the clusters of pretty red flowers that used to surround the cathedral. *El Siglo de las Drogas* (The Century of Drugs), a 1996 study by the Sinaloan historian Luis Astorga, says that there are no reports of non-Chinese smokers in the early years, but some Mexicans probably partook as well. Most people, though, if they used the drug at all, would have received it in one of the standard medical preparations, such as laudanum or paregoric. (It is always worth keeping in mind that the line between "good" and "bad" drugs is a legal, not a chemical, distinction. Often, the drugs that are made illegal are not the most toxic, but rather the most common and familiar, hence the most available for overuse or abuse. Heroin, for example, first became internationally popular as a cough remedy marketed by the Bayer company.)

As a recreational drug, opium enjoyed a brief vogue in the 1920s and 1930s among the more adventurous members of Mexico City's upper classes, but in the sierra it was valued not as an intoxicant but as an export crop. A news article from 1938 tells of a formal protest by the poppy growers of Sonora (just north of Sinaloa) to the head of the Campaign Against Alcoholism and Other Noxious Drugs, arguing that the government's opium eradication program was "unjustified . . . because the opium was exclusively exported to the United States and, therefore, it was not the responsibility of the Mexican Government to repress these activities since they did no harm to Mexicans."

Any understanding of Mexican attitudes to the international drug trade must take this view into account. Mexico is, on the whole, a producing rather than a consuming nation, and the traffickers in marijuana, opiates, cocaine, and, most recently, methamphetamines are generally serving not a local demand but users in the United States, far and away the world's largest consumer. Because of this, even Mexico's moralists and antidrug forces tend to feel a certain resentment toward Washington's approach to international narcotics control. The suggestion that Mexico is somehow responsible for its northern neighbor's drug crisis—regularly made by US politicians and law enforcement officials—is seen as both absurd and insulting. It is a simple fact that if Mexico stopped serving as a supplier, that would not end or even significantly change the drug problem in the United States, whereas if the Yankees stopped buying, most of the Mexican drug trade would disappear virtually overnight. Because of this truth, even conservative Mexicans tend to resent the United States' unilateral policy of "certifying" Latin American countries as compliant with US enforcement efforts. If the Americans were serious, Mexicans keep repeating, they would deal

with their problem at home rather than pretending that they could solve it by sending troops into the highlands of Mexico or Colombia.

Naturally, this resentment is particularly strong in those highlands, especially in the Sinaloan sierra, where the US-backed Operation Condor program of the late 1970s forced entire villages of small farmers to flee the region. (One local human rights group estimates that two thousand villages were completely depopulated.) For people living back in the mountains, drugs have long been the one crop that can provide anything more than a hand-to-mouth subsistence, and the *gomeros,* so called because they originally dealt in the black, gummy form of opium, or *goma,* are part of the regional folklore. Gomeros were not drug users, they were growers and traffickers, and what they brought to the sierra was not a new kind of vice, but cash. "Indio" Nacaveva, a Sinaloan journalist who infiltrated the opium business in the 1950s and whose *Diario de un Narcotraficante* (Diary of a Drug Trafficker) covers the whole production process, from enlisting rural growers to refining heroin in a Culiacán cellar, then hand-carrying it across the border, writes of a conversation with the village elder who manages their poppy fields. After becoming friendly with Nacaveva and his partner, the elder asks them to explain something that has always puzzled him:

> "What do they do with this stuff?"
>
> Arturo [the partner] explained it: That they make powder, that they inject it, and what the people feel who use it. That it can also be smoked. . . . That it is used especially in medicine, and that in Mexico it has little use.
>
> "You don't use it yourselves?"
>
> "No, not us, we just prepare it and send it to our cousins up north, who pay us well, because there are already a lot of users there who got the habit in the war, they were wounded and doctors prescribed it to relieve their pain, and once they got the habit they used it for vice."
>
> "Well, if it provides some profit to those of us who are poor, that's good."

It is common knowledge in Sinaloa that the opium trade began in World War II, when the Roosevelt administration encouraged production for processing into morphine. Astorga, the most thorough researcher in this field, says that this is a myth, but it continues to be reprinted with some regularity, and is often quoted as an example of Yankee hypocrisy: First they asked us to grow the stuff, and now they accuse us of causing their problems.

Marijuana, the other big local crop, has been part of Mexican cul-

ture since shortly after the arrival of the Spaniards in the sixteenth century. Compared to opium, though, it was bulky and relatively unremunerative as an export product, and it only became big business in the 1960s, in response to the heightened demand on *el otro lado* ("the other side," a common way of referring to the United States). It continues to be smoked to some extent in the sierra, but, once again, is viewed less as a drug than as a commercial product. As with opiates, its use was once respectable—Astorga's book quotes an ad from a nineteenth-century Mazatlán newspaper for "patented Indian cigarettes" from Grimault and Company in Paris, which claimed to be "the most efficacious known remedy against asthma, congestion, nervous cough, catarrh, [and] insomnia." The plant grows throughout Mexico, so the Sinaloans had no special claim to its production, but their high-mountain variety was prized by connoisseurs and the connections they had built up in the opium trade gave them a head start when they turned to exporting other banned substances.

When the US Drug Enforcement Agency began to make life difficult for the Florida-based groups that were shipping cocaine via the Caribbean, the Sinaloans stepped in once again. By the mid-1990s it was estimated that some 60 percent of Colombian cocaine was coming through Mexico. Then came crystal methamphetamine, which is cooked up in laboratories on both sides of the border. Once again, the Sinaloans had no special skills when it came to production, but they were by now firmly in control of the cross-border traffic. While Mexico has several competing drug cartels, based in various parts of the republic—most famously in Guadalajara, in the border towns of Juárez and Tijuana, and on the Gulf of Mexico—the people in charge of all but the last are overwhelmingly Sinaloan.

The Sinaloan supremacy is not simply a matter of having been there first. The drug lords who have come out on top have done so through a ruthless exercise of force, and the willingness to resort to violence and killing has long been considered a Sinaloan speciality. A glance through the newspapers in Culiacán or Mazatlán reinforces this stereotype, not only because of the high murder rate, but because of the attitudes expressed by those in positions of authority. For example, I was reading the paper one morning and found a representative of the district of La Noria protesting that his area was being falsely painted as a "nest of narcos," a slander to his hardworking constituency. He went on to say that the reason there were so many murders up in the nearby mountains was not due to drug trafficking, but rather because "that's how those people solve their problems," that one could not expect the sierrans to resolve their differences by just talking.

I was regularly warned by people from other parts of the country that in Culiacán I would be in danger. They would point out the near-daily news items about killings in the city or its suburbs, many of them professional hits obviously related to the drug traffic. If I really wanted to go there, I was told, I would have to be very careful and should not ask too many questions. I could understand the logic of these warnings, but I figured I was pretty safe. I was not trying to investigate the reality of the drug scene; I was interested in its musical mythology. Since the traffickers not only approve of the narco songs but often pay corridistas to chronicle their deeds, they were obviously not averse to that kind of publicity. I figured that all I had to do was be completely open about what I was after, and I would have no problems. Of course, I would have to be careful that no one took me for a DEA agent using the corrido research as a front, but it seemed to me that the questions I was asking were pretty harmless.

Actually, my main worry was that I would not find enough material. While Sinaloa is the cradle of the drug business, and Sinaloan singers have been prominent in the narcocorrido market since the rise of Los Tigres, none of the top writers or groups is still living here. The major labels in the corrido scene are now in Los Angeles, and even the major drug traffickers are long gone, having left during the upheavals of Operation Condor. Still, this was the source, the place that so many of the songs were about, and I had to look it over. Even if I did not find much in the way of music, the corrido boom did not exist in a vacuum, and Sinaloa was the best place to get a feel for the broader narcoculture. I had two specific missions: I wanted to make contact with the local painters and writers whose work was wrapped up with the drug world, and whom I had dubbed the *narcointelectuales,* and I would be around for the annual festival of Jesús Malverde, the traffickers' patron saint.

I did not have a very clear expectation of what Culiacán would be like. The guidebooks had been useless, their Sinaloan sections devoted entirely to the beaches and nightclubs of Mazatlán, with perhaps some tips on Los Mochis as an embarkation point for the scenic train ride through the Copper Canyon. Most ignored the state capital completely, the others mentioned it in passing as a place of no touristic interest. That left me with only the town's reputation: tales of gaudy murders and streets full of toughs in gold jewelry and mirror sunglasses, their *troconas del año* (pickups or SUVs of this year's model) modified with smoked-glass, bulletproof windows. As I read in a series called "Viaje al País de las Drogas" (Journey to the Drug Country) in the respected Mexican magazine *Nexos*: "In Sinaloa one speaks of the atrocities of the drug traf-

fic in the same offhand and routine manner one would use to talk about baseball. A *Culichi* [native of Culiacán] can tell you of a chilling event that happened on his own street in the same tone in which he would complain that his beer was warm."

All in all, I had come with hopes of seeing a legendary Mexican crime capital, the menacing modern version of what a reporter in the 1950s had called "a new Chicago with gangsters in huaraches." Instead, I found myself in one of Mexico's most friendly and vibrant regional capitals. Everyone was eager to help, and I walked around town making appointments with people who I hoped could give me some insights into the local narcoculture: the director of the Frida Kahlo Gallery, who had written a brief piece on narcocorridos; the novelist Elmer Mendoza; and the painters Oscar García and Lenin Márquez. The first two were busy, but I found Oscar and Lenin in the cafeteria at DIFOCUR, the government-sponsored cultural institute, and we made an appointment to meet that evening in a café on the central square.

The square is just off Culiacán's main street, a place to relax in the shade beside the gleaming white cathedral. It is pretty and well maintained, with clean paths cutting through neatly clipped greenery. As I sat at an outdoor table, sipping a beer in the gathering shadows, a group of leggy young women walked a wooden ramp to my right, rehearsing for an upcoming beauty contest (another Sinaloan specialty). Meanwhile, on the bandstand at the street end of the plaza, a norteño band in fringed and brightly colored cowboy outfits was shooting a music video, surrounded by lights and cameras. This was more action than I was used to seeing outside a major urban center, especially on a weeknight, and it was not yet dinnertime. The evening's later entertainment could include either a concert by a moderately well known folksinger at the Kahlo Gallery or the third night of an international dance festival being held in DIFOCUR's auditorium. An international festival of short films and a national arts conference were scheduled for the weekend, along with a talk at the university by Paco Ignacio Taibo II, a popular novelist who recently published a lengthy biography of Che Guevara.

I was baffled. Nothing I had heard, even down the road in Mazatlán, had suggested that Culiacán would be a cultural mecca. When Oscar joined me (Lenin had not been able to make it), along with some friends he had picked up along the way, I asked what had spawned this wealth of activity. The answer was long and involved, including information about a previous governor's arts policies and the advantages of being a regional capital, but the key themes were the Culiacán mantra: drug money, drug money laundering, and a generalized prosperity fueled by drug profits.

Despite the absence of obvious gangsters, I had clearly come to the right place. At least, I never found a Sinaloan who did not encourage me to think so. Point out a rich field of tomatoes, and a local would explain that the irrigation system alone cost more than the crops could earn at market, but the on-paper earnings would conceal a small fortune in drug income. Note that a newspaper had reported an astonishing turnout at a concert, and it would be explained that, of course, some of the reported tickets had not really been sold, they were just added on as a way to launder another thousand dollars. All of which may or may not be true. When the *Nexos* article said that Culichis discuss drug doings as routinely as baseball scores, it did not quite capture the situation: in Sinaloa, the twists and turns of the underworld are a far more popular topic than sports events, and all discussions of them seem to be designed to showcase the speakers' familiarity with the milieu. Since that familiarity may, in fact, be nonexistent, the result is a folklorist's dream: there are stories everywhere, and one begins to feel like a visitor to the Baghdad of the *1001 Nights* or Boccaccio's Italy, a land populated by medieval fabulists.

Of course, if I had been attempting a serious history of the Mexican underworld, this would have been an incredible headache. The difficulty of separating fact from fiction on the Sinaloan crime scene is all but insurmountable, and even the most authoritative chroniclers end up having to fall back on theory and conjecture. So much of the real business is happening up in the sierra, in an illiterate, peasant world that is famously suspicious of outsiders, that even in Culiacán one is living mostly on hints and rumors. Press a Culichi for hard, firsthand experiences of drugs or violence, and one hears of the strange smell that came from the house next door, which later turned out to be a heroin lab, or of a childhood trip to the country during which some village girls got carried off by boys from the mountains in some sort of backwoods mating rite. The facts are spare, but the stories are endless, and for someone interested in the underpinnings of contemporary corrido culture, they are a constantly unfolding pleasure. In other Mexican states, most people avoid even talking about the drug world and certainly would deny any close familiarity with its workings. In Sinaloa, everyone from children to wrinkled elders shares an enthusiastic intimacy with the sierran traffic and *la nota roja,* the crime news.

Even in Mazatlán, people had constantly fed me drug stories. They would point out the discotheque that Francisco Arellano Felix, one of the brothers who formed the Tijuana cartel, had built to launder money and impress his society friends, or tell how a *traficante* had turned up during the town's famous carnival the previous year, surrounded by heavily

armed sidemen, to ensure that his girlfriend was chosen queen. The incident that really brought the situation home to me, though, was most notable for its ordinariness: I was in a small, relatively scholarly bookstore, looking for a copy of Astorga's drug history, and I mentioned something about my project to the white-haired lady behind the counter. As I was browsing through her stock, she suddenly looked up from her newspaper to say, in a cheerful voice, "Oh, here's something that will interest you. The head of the lawyers union was just shot in Culiacán." She proceeded to read me the newspaper report, and then to give me her own, off-the-cuff analysis: "You see, we just had an election, and the new governor has been talking a lot about law and order. It looks to me as if this is the underworld sending him a message that he had better go easy and not make too much trouble." What struck me was not so much her take on the incident, which was echoed in several editorials during the following week, but that she had a take at all. Anywhere else, one would expect a respectable, grandmotherly woman to simply murmur a few shocked phrases about what a dreadful place the world was becoming. In Sinaloa, everyone is ready to provide the inside story.

Sinaloans take an odd pride in their reputation as a state full of gangsters and gomeros. While the southern states of Michoacán and Guerrero are also famous for violence and drugs, in neither does one tend to come across academics, intellectuals, or serious artists dealing with either subject. In Sinaloa, by contrast, *narcocultura* is everywhere. There are novels, symposia, exhibitions, and sociological studies devoted to regional crime, and no one at the university blinked an eye when I asked for some names of professors who might be able to talk with me about the subject. I was given lists of people who had done one study or another on corridos, drugs, and violence. The name that came up most often happened to be the same one that had first sparked my interest in the narco intelligentsia: in a book Astorga wrote on the mythology of the Mexican drug traffic, he had said that, for a real picture of the Sinaloan scene, the best guide was a short novel, *Cada Respiro que Tomas* (Every Breath You Take), by a Culichi writer named Elmer Mendoza.

It was not an easy book to find even in Sinaloa, and in the rest of Mexico it was completely unknown, but in the insular literary world of Culiacán Mendoza is the éminence grise, a gifted craftsman and teacher who has trained a generation of local poets and fiction writers. He started off writing experimental short stories that fit more or less within the contemporary Latin mainstream, but with a local twist: his 1989 collection of modernist vignettes, *Trancapalanca*, has a pistol on its cover and includes a piece called "Instrucciones para Controlar a un Narco-

traficante Armado hasta los Dientes" (Instructions for Controlling a Drug Trafficker Armed to the Teeth). He then branched off with an autobiographical book, *Buenos Muchachos* (Good Boys), and hit his stride with *Cada Respiro*, which includes five short stories (including one called "Camelia la Texana") and the eleven-chapter memoir of a small-time trafficker and car thief named Chuy Salcido. As far as corridos go, Chuy disappointed me: while he mentions Los Tigres as a favorite group, they are no more treasured than another 1970s sensation, Los Creedence (as in Clearwater Revival). Astorga was right, though, when he said that the book gave an unmatched taste of the street-level Sinaloan scene. Salcido's speech is spiked with bitter humor and a dialect so thick that at times it can even confuse readers from neighboring regions. For example, here is the beginning of chapter two, as he arrives in Baja California, driving a truckload of marijuana from Sinaloa to the United States, and finds himself surrounded by a company of Federal Judicial Police:

Pinche susto. Los batos nos estaban esperando y nosotros más choridos que, pero no pa' chingarnos, sino pa'yudarnos a llevar la merca pa'l cantón. Bien a toda madre, carnal; con esos pinches enemigos pa' qué carajos quieres enemigos.

(Fuckin' scared. The guys were waiting for us, and us more freaked out than—but not to fuck us up, to help us get the stuff into the crib. Fuckin' great, bro'; with those kind of fuckin' enemies, who the hell needs friends.) [But what a gray translation: Mendoza has *pinche, chingar,* and *a toda madre,* all of which I pretty much have to translate as "fuck," though only *chingar* is a perfect fit—*a toda madre,* translated literally, would be "at all mother." I could have translated *carajo,* a vulgar word for penis, as "fuck" as well, but one has to stop somewhere. Then there is *chorido,* which my Mexican slang dictionary lists as a Sinaloan vulgarism for "wrinkled," but my friends assure me means "scared"; *carnal,* which in local usage means one's literal, blood brother—as opposed to *hermano,* which is used for cousins as well—but is also a slang term of affection; *merca,* a drug-world shortening of "merchandise"; and *cantón,* which is literally "county," but in slang means one's place, be it a neighborhood, a street, or a house.]

Cada Respiro was published in 1991, not as a popular crime novel from a commercial press, but by DIFOCUR, the official cultural institution of the Sinaloan state government, and it was followed in 1998 by Mendoza's first nationally available work, *Un Asesino Solitario* (A Lone

Assassin), the monologue of a Culichi hit man hired to kill a PRI politician modeled on Luis Donaldo Colosio, the presidential candidate assassinated in 1994. Over breakfast in an antiseptically clean hotel restaurant, Mendoza explained that, as far as he was concerned, his latest works are as experimental as any of his earlier poetry or short fiction. He spoke of them less as portrayals of modern Sinaloan characters than as exercises in style, a serious writer's attempt to capture a previously uncaptured language on paper.

Still, he is a keen observer of the local scene, and when I tried out my comparison of the Sinaloans to medieval fabulists, he agreed enthusiastically, saying that *The Canterbury Tales* was his main literary inspiration. He added that the state's vicious reputation provided certain advantages, even for law-abiding intellectuals: "When I was in college in the DF, I found that I could sit down next to the prettiest girl at any party without worrying about whether she was single or not. If her boyfriend came over to object, all I had to do was say that I was from Sinaloa, and he would back off."

When I asked just how ubiquitous drug money is in the Culichi cultural world, Mendoza replied that, if one traced it back, virtually all the local fortunes were drug related. "There are only three wealthy families here that have no drug connections in their history," he said. "And that number is not just symbolic or poetic license." How near the drugs are to the current fortunes is sometimes a complicated question. Another Sinaloan told me that his family has a chain of auto body shops, and "We think of ourselves as being kind of like the Kennedys: they made their money from bootlegging and then invested it in legitimate enterprises." I did not ask about the range of work that comes into a Sinaloan auto body shop, but between bulletproof armor plating, false bottoms on smuggling vehicles, and all the cosmetic work one might do in a state where drug gangs double as hot car rings, it is not clear to me that his family has moved very far from its financial roots. (It is just coincidence, of course, but Felix Gallardo, one of Mexico's top drug lords, opened a car dealership in Culiacán in 1985. His partner was the son of Leopoldo Sánchez Celis, Sinaloa's governor from 1974 to 1980.)

Whether due to the economic power of drug profits or the imaginative power of crime fans, Mendoza is far from the only representative of the narco intelligentsia. In Mazatlán, I had been surprised to find a half dozen drug-traffic paintings in the annual art competition that goes along with the carnival, two of which had been awarded ribbons. I fell in love with one of these narco canvases, a medium-sized, greenish brown painting titled "La Ascensión del Señor de los Cielos" (The Ascension of the Lord of the Skies), which portrayed a crucified figure

on a background field of marijuana leaves, with airplanes flying over-head. The airplanes were painted in the stylized, flat perspective of a pre-Columbian Mayan codex. It was a complex piece, with something new every time I looked at it, and the title was a wry salute to both Catholic iconography and the recently dead boss of the Juárez drug car-tel, Amado Carrillo Fuentes, known as El Señor de los Cielos because he transported cocaine in 747s. When I tracked down the artist, Ricardo Corrál, in the north Sinaloan town of Los Mochis, he explained that he was actually not a narco painter, that most of his work was more abstract, but he had noticed that at least some of the ribbons in Mazatlán always went to paintings with drug themes, so he had decided to give it a try. Along with "La Ascensión," he had entered "18 Tiros de Gracia" (18 Coups de Grace), which commemorated a drug-related massacre in Ensenada, and "Campo de Amapola" (Field of Poppies), an abstract work that had won an honorable mention.

He still had all three paintings ("La Ascensión" is on my wall as I write) and did not know who was likely to buy them, but said that the more serious narco painters, Oscar and Lenin, sold regularly to people in the drug world. As it turned out, Oscar would say much the same of Lenin—that his own work was too abstract to attract the drug people, but Lenin's paintings were often sold to underworld characters—and Lenin of Oscar. It was not clear to me whether this was an attempt to dis-tance themselves from the illegality of the drug world or simply from the philistinism of the traffickers. The drug crowd is still largely made up of guys from the sierran ranchos, famous for their country tastes. (Rafael Caro Quintero, the most popular of the drug kings, supposedly forced himself to learn to drink whiskey rather than beer or tequila, so he would seem like less of a hick.) The Culiacán intellectuals tend to classify the narcos as nouveau riche lowbrows and sneer at their mail-order Louis XIV living-room sets and kitschy sensibilities. While some drug lords have sent their children off to expensive colleges in Mexico City or the United States, and these *"narco juniors"* are coming back with more educated tastes, each painter assured me that the other painters were getting the drug money, and he was not. Still, each could recall a few sales where the purchaser did not appear in person, but just sent someone with cash to pick up the painting for him, so one could not say for sure who the owner was or what he did. And then, Lenin had a story about when he was invited to give an exhibition in a neighboring town: some local guys came to help him hang the canvases and, in order to give themselves more freedom of motion, each took his pistol out of his jeans before climbing the ladders.

Lenin and Oscar were quite different from one another. The former

was quiet, a teacher at DIFOCUR and the local art museum, prematurely bald, with a beard that seemed intended to cover a basic timidity. Oscar was clean-shaven, bright-eyed, back in town for a visit from his new home in Mexico City. He was having greater success in the mainstream art world than his compatriots and also seemed to be more popular around town. As Mendoza said, he was *"mas vago,"* more of a vagrant, bohemian rascal than Lenin. This was meant as a compliment—while there are undoubtedly plenty of people in Culiacán who value respectability and sobriety, I never met one of them. Indeed, the Sinaloans often seem to vie with one another for a reputation as *vagos,* even if they are hardworking, responsible citizens. On my second evening in town, Oscar and some friends took me from the café to a strip club. It seemed an odd place to bring a gringo writer as an introduction to one's hometown, but during my three weeks in Sinaloa I would visit four such clubs, some multiple times, never at my suggestion. It seemed simply to be what one did if one was a single male, at least when one had guests to entertain.

Incidentally, the strip clubs in Culiacán are the world's last bastion of classic burlesque: El Quijote, the one I visited with Oscar, featured two alternating blond women stripping down to bikinis, interspersed with a mediocre ranchera-rock band, a female impersonator, a fellow who seemed to be doing his impression of a gay Pedro Infante (the great Sinaloan movie star and singer of the 1940s), and a naughty ventriloquist. The ventriloquist sang one of El Coyote's banda hits, with his dummy making sarcastic comments between lines. To top off the experience, a short, dark man came over to our table, and Oscar introduced him as *"La voz gemela de Chalino Sánchez"* (the "twin voice" of the murdered corrido star Chalino Sánchez). La voz gemela had the shy, withdrawn manner of a country boy out of his territory, but Oscar assured me that, when he donned his ostrich-leather boots and pistol belt, he performed an uncanny impression of the Sinaloan idol. Unfortunately, he was not working that night, and I got the idea that most of his performances were at private parties, a coy way of saying that he mostly sang for the drug crowd.

Oscar's paintings are dark, abstract canvases, with drug- and crime-related words included here or there, and it is easy to understand why they might not appeal to the old-fashioned, countrified tastes of the sierran traffickers. Lenin's are far more accessible, straightforward portrayals of gunmen, execution victims, and a triptych of "the three animals." His favorite subject is Saint Jesús Malverde, whose likeness he has painted dozens of times and sculpted in small, folkloric dolls. Variously

known as El Bandido Generoso (the Generous Bandit), El Ángel de los Pobres (the Angel of the Poor), or El Narcosantón (the Big Drug Saint), Malverde does not appear in the official Roman Catholic canon, but in Sinaloa he is the cowboy-garbed patron of the poor, the oppressed, and most famously, the traficantes. He should also, without question, be patron saint of the modern corrido: there are at least three cassettes of corridos dedicated to his life and miracles, along with songs by hit groups like Los Tucanes and Banda El Recodo, and his chapel resounds with norteño and banda music from dawn to dark and often late into the night.

Malverde's chapel is located out by the railway yards, a large glass-block structure about the height of a two-story house, surrounding an inner sanctum where the saint's bust sits alongside statues of Saint Judas Thaddeus and the Virgin of Guadalupe. As in saints' shrines through-out the Catholic world, the walls are covered with plaques commemo-rating miraculous healings and other favors: rich catches of fish, or—a specialty in this case—releases from prison and the success of discreetly unspecified business ventures. Many of the grateful donors have names that are familiar to any reader of the Mexican nota roja—Quintero, Gal-lardo, Felix, or Carrillo—but these are not especially rare names in Sinaloa and so prove nothing, any more than the initials R. C. Q. carved into a stone tablet, which might or might not represent a substantial donation from Rafael Caro Quintero himself. The behavior of the visit-ing faithful, however, has little in common with ordinary pilgrim prac-tice: beer and whiskey bottles are respectfully placed alongside the votive candles, and Malverde's followers like to join the saint in a drink and buy him a serenade from the norteño trio stationed at the entrance of the inner chapel. His hymns include "Contrabando y Traición," "Pacas de a Kilo" (One-Kilo Packets) and an obvious favorite, "Corrido a Jesús Malverde":

> Voy a cantar un corrido de una historia verdadera,
> De un bandido generoso que robaba dondequiera.
> Jesús Malverde era un hombre que a los pobres ayudaba,
> Por eso lo defendían cuando la ley lo buscaba.

> (I am going to sing a corrido of a true story,
> Of a generous bandit who robbed wherever he went.
> Jesús Malverde was a man who helped the poor,
> Because of that, they protected him when the law was
> after him.)

61

Other pilgrims have brought whatever offerings they thought might please the saint—the first fruits of harvest, an impressively large shrimp preserved in alcohol, or, in one instance, a fully functional AK-47.

The small store inside the chapel has a similarly varied array of goods: not only votive candles and souvenir photographs of the altar, but also cassettes, T-shirts, and hand-painted baseball caps with images of Malverde accompanied by slogans like *"Mexicano 100%"* and pictures of the ubiquitous three animals. Then there are the many likenesses of the photogenic saint in his white and black cowboy shirt and string tie: large plaster busts, smaller plastic figurines, photos, paintings, medallions, and key chains. In some of the pictures, as in the chapel itself, he is accompanied by the Virgin of Guadalupe, and also Saint Judas Thaddeus, who has somehow become conflated in Sinaloan mythology with the Judas who betrayed Christ, and thus provides an alternate blend of sanctity and criminality.

This being Sinaloa, there are widely varying stories of who Malverde was and what he did. Unimaginative historians insist that the Sinaloan Robin Hood never existed, that he is a folk fusion of Catholic iconography and the legend of Heraclio Bernal, but his followers say that he was a popular bandit, executed in 1909 by an evil governor and left hanging from a tree as a warning to his admirers. One day a mule driver took pity on the desiccated skeleton and buried it while asking for aid in finding some lost mules. The mules turned up, and from that time on, people brought stones to lay on the generous bandit's grave and received miraculous rewards in return.

In the early 1980s, the state government announced that it would bulldoze the stone-covered mound to build the new state capitol. There were marches and protests of the faithful, and it is said that the earth-moving equipment kept breaking down and the workers suffered innumerable accidents. Finally, bowing to the combination of popular and supernatural pressures, the authorities donated a piece of barren ground alongside the railroad tracks behind the capitol building for a chapel.

The builder and self-ordained chaplain of La Capilla de Malverde is a gaunt, scruffy-looking man named Eligio González. Most of the time, he can be found sitting in front of his creation, minding a small cement souvenir stand. A grizzled figure in shabby clothes, he might easily be mistaken for a homeless vagrant until one sees him dishing out food and words of comfort to the chapel's poorer patrons. Eligio is a composer and musician, with a cassette of his corridos of Malverde available for sale. He is also a corrido protagonist: a cassette of Malverde songs by Los Cadetes de Durango opens with the "Corrido de Eligio González,"

which tells how Eligio, in his days driving an *araña*, a passenger truck, into the sierra, was shot four times by robbers:

> *Muy mal herido en el barro, Eligio se desangraba.*
> *Casi más muerto que vivo lo llevan pa' Tierra Blanca . . .*
> *Pero un milagro del cielo quiso que nada pasara.*
> *Eligio ya se alivió, y aquí no ha pasado nada.*
> *Ahora es encargado de la tumba de un valiente*
> *Que robaba pa' los pobres, de nombre Jesús Malverde.*

> (Very badly wounded in the mud, Eligio lay bleeding.
> Almost more dead than alive they carried him to Tierra
> Blanca . . .
> But a miracle from heaven wished that nothing should happen.
> Eligio recovered and nothing has happened to him.
> Now he is the caretaker of the tomb of a brave man
> Who robbed for the poor, by name Jesús Malverde.)

63

That was in 1973, Eligio explains, mumbling in a thick rural accent: "They hit me with four bullets on the twenty-third of April and—God and him first! [gesturing toward the shrine]—in eight days I was out of the hospital. So I stayed over there, taking care of that little grave, just cleaning it, clearing the trash away. Then, when the government gave us this land, I came here and dedicated myself to building the chapel, to helping people. I've given 9,959 funerals to people of scarce economic resources. I've given them coffins, and in different parts of the republic I've given away six hundred wheelchairs to people who were invalids, I've given food, prescriptions—all with the donations that people give, and a part of my earnings, because I work selling newspapers." As one might expect, there has also been some miraculous help from the saint: "I've hit the lottery twelve times—and so we keep on going forward."

Eligio gives an abbreviated version of Malverde's story, explaining that the bandit's real name was Jesús Juárez Maso, but he was called Malverde because of the green (*verde*) plants in which he used to hide himself from the *rurales*, the rural police. With the aid of the country people, he evaded capture until, like Jesus Christ, Heraclio Bernal, and Jesse James, he was betrayed by a close companion. As Los Cadetes sing in their "Mañanitas a Jesús Malverde":

> *El ayudar a los pobres siempre fue su devoción,*
> *Por eso lo recordamos con una gran emoción.*

Su compadre fue el culpable, lo traicionó y lo vendió,
Por ganarse veinte reales que el gobierno le pagó.

(Helping the poor was always his devotion,
Because of this we remember him with great emotion.
His friend was the guilty one, he betrayed him and sold him,
To earn twenty reales that the government paid.)

Eligio says that the story was actually more complicated: Malverde had been gravely wounded by his pursuers and knew that he was dying. Rather than letting his death go for naught, he asked the friend to turn him in, collect the reward, and give the money to the poor.

How the Angel of the Poor became the Big Narco Saint is obvious enough. If there was ever a class of poor people who needed a supernatural guardian, it was the drug traffickers, and Malverde had a natural affinity for those on the dark side of the law. Today, his image pops up throughout the northwestern drug world. When the police or soldiers raid marijuana and opium plantations, they regularly find chapels to Malverde and medals of the saint hung on sticks at the edge of the fields, and many a drug "mule" would not consider crossing the border without a Malverde medal hanging from his or her neck.

Eligio does not deny that the drug world has made his chapel its own, but says that the narcos only make up a small fraction of Malverde's constituency. The saint is available to anyone who needs his assistance, and people travel from all over Sinaloa and beyond to take advantage of his miraculous powers. For example, I struck up a conversation with a twenty-two-year-old woman from Guamúchil who had taken the bus to Culiacán just to light two candles at the saint's shrine before making her first trip to the United States, where she had been promised a job in a poultry-processing plant. She said that her sister had already gone there the previous year, but she was still frightened to be traveling so far and wanted to make sure that the saint was with her.

The singers know that, while such pilgrims cannot pay like the narcos, there are far more of them, and the title song of the Cadetes' *El Ángel del Pobre* cassette is the prayer of a migrant, asking the saint to take care of his wife and children while he is away, and promising to pay a visit to the chapel as soon as he returns.

And then there are the drug addicts. While in general Mexicans export drugs rather than consume them, the country has not entirely escaped the rise of crack and heroin use, especially in the major urban areas—Mexico City, Guadalajara, and Monterrey—and border towns

like Juárez and Tijuana. Culiacán has not been hit as hard, but behind the Malverde chapel, in the no-man's-land of the railroad yards, lives a small colony of junkies. There are probably only one or two dozen of them, but a few can always be found around the chapel entrance, cadging coins from the faithful. Eligio says that at first he tried to help them, but they stole anything that was not nailed down, so now he dismisses them with uncharacteristic contempt. Still, they sit on the benches in the sunlight, striking up disjointed and pointless conversations with anyone who stands still. Many are distinctive for their youth, especially a teenaged woman, angelically beautiful, who sidles up to strangers with a tiny puppy in her arms. These are the drug-world characters who will die without getting their corridos, and who apparently couldn't care less.

They do like the music, though, and join the audience that gathers whenever a special concert is given in Malverde's honor. I was only present for one such show, on my third visit to the chapel. Someone had hired a full banda to serenade the saint, and a small cluster of spectators had formed around the players. Musicians overflowed onto the street, and the noise inside was deafening. When I arrived, I was told that they had already been playing for three hours and would continue for three more. Since a banda, even the relatively small-time groups that work out of the dingy offices near the town market, charges close to two hundred American dollars per hour, this was no small offering. Clearly, someone had brought in a good harvest without being spotted by the drug squad, or a successful shipment had arrived at its destination on el otro lado. When I asked Eligio to point out the grateful sponsor, I was told that he had not appeared himself, but simply sent the banda. Apparently, these days it is considered indiscreet to be seen spending too much money, too obviously, on El Narcosantón.

Which was, to me, a bit of a disappointment. I had particularly arranged to be in Culiacán on the third of May, the anniversary of Malverde's death, having read that this was a day of major celebrations, with the street sealed off and limousines lined up to pay tribute to the guardian of the city's biggest business. As it happened, my news was long out of date. The big guys now live in other regions or are keeping a low profile, and the day was much like any other. An Austrian television team had showed up with the same purpose, and it was fun to watch them wandering around filming everything, but no crowds materialized, much less the flashy narcos I had come to observe in their native habitat. Eligio did provide a special meal for the poor in the small funeral parlor that adjoins the chapel, and sent up some homemade rockets, but that was about it.

Nonetheless, the timing of my visit did produce one interesting bit of inside information. I mentioned the Malverde anniversary to one of the men I had met at the cafés around the plaza, and he invited me to be a guest on a local radio news program, to talk about my project and the Malverde connection. After the show, one of the other radio presenters, a stout, earthy character who was always cracking jokes, told me that I had to come meet his uncle, who had some stories I would want to hear.

The following afternoon we drove out to the uncle's house, in a pleasant, middle-class neighborhood about two miles from the center. Carlos García looked to be in his seventies, old enough that he recalled the poppy beds around the cathedral. He invited me into his living room, served me a 7UP, then proceeded to tell me the story of Malverde as he knew it. It was the perfect Sinaloan tale, a heady blend of medieval myth, streetwise cynicism, wry humor, and sharp business sense:

"The old people, when I came here sixty years ago, told me that there was a boy, an orphan, no one knew his family, but he was white, good-looking, a wanderer who went around by himself in the old Culiacán of I don't know how many years ago. Going around alone, without any family, he got into drinking a lot of beer, a lot of wine, and since he had vices and no way of satisfying them, he became a crook. He would steal, and then he would go to the cantinas and buy drinks for all his friends, and he was very popular because he was the one who paid the tab. And one day it happened that, at a get-together, he boasted that he was going to steal the governor's sword.

"Now, you know how rumors can grow, and the story got to the governor. So, one day someone stole his sword, and he knew that this Malverde had said that he was going to take it. So he offered I don't know how much money as a reward, and told the police, 'Seize him and bring him to me.'

"But it seems that they couldn't catch him, because he lived in the poor neighborhoods, over there by the railway, and he had many friends where he could sleep at night, one night with one and the next with another, so they couldn't find him. He was very popular, because people said that he helped the poor—and sure, when he came to someone's house to eat he gave them some money, but his big donations were to his friends, paying the tab in the cantinas, which was the real source of Malverde's popularity. Anyway, one day he got very sick, and he died, and when they went and asked the governor for permission to bury him, instead of giving permission he ordered that the body be hung up there by the railway."

Don Carlos went on to tell how the monument was built, stone by stone, how the tomb became famous for its miracles, how the govern-

ment tried to destroy it to build the new capitol and the machinery broke—"but that was just talk"—how Eligio was wounded, recovered, and came to build the chapel and become "the one who takes care of, and exploits, the church."

Which is where Don Carlos himself entered the story. He and his wife had a store in town, and as he watched the faithful flocking to the chapel he saw a business opportunity. All these people were coming, but Eligio had nothing to sell them. Don Carlos had the solution: "I asked him to give me a photograph so I could have a bust made." Eligio agreed to do so, saying that he had one photograph belonging to an old woman who had known Malverde, but the weeks passed and nothing came of it. "He couldn't get it, and that's because in those days photography didn't exist. For the people with money there were painters who did their portraits. Finally he said, 'I can't get it, I can't find it.' And I was making a trip to Guadalajara, I was going to buy some plaster figures, and I said to the man there:

" 'Listen, can you make me a bust?'

" 'Sure, no problem. Of who? Benito Juárez, Abraham Lincoln, or who?'

" 'No, of Malverde.'

" 'Well, bring me a photo.'

" 'There isn't one.'

" 'So, give me an idea.'

"And since at that time Pedro Infante and that Jorge Negrete were popular [movie stars], I said to him, 'Look, he was a good-looking boy, white, and so that people will identify with him, make it somewhere in between Pedro Infante and Jorge Negrete.'

" 'Fine.'

"And when I came back three weeks later, he showed me the bust with the string tie, the sideburns, the mustache, and he asked me, 'What do you think of this?'

" 'Perfect, it's like a graft of Pedro Infante and Jorge Negrete, it's good. So, how much will you charge me per bust?'

" 'Well, so much.'

" 'Then make me two hundred.'

"He sends them to me, I go see Eligio and I say, 'Eligio, I've brought you the bust of Malverde. Here it is.'

" 'Ay!' he said. 'How pretty it came out!'

"So I said to him, 'Now, since people come here to see Malverde, I'll leave these with you, I'll sell them to you for so much, and you can sell them for so much.'

"In one week he sold the two hundred busts. I made a telephone call

to Guadalajara: 'Send me five hundred.' Here come the five hundred; in one month they were gone. 'Send me a thousand.' But that was all the miracles I had coming—Eligio had some busts made on his own, he cut me out of the business, and that's the end of my story."

Carlos's nephew drove me back to town, and I settled into my hotel room with a pile of cassettes. I was beginning to feel at home, to have a sense of the local scene. Now I was ready to get on the trail of the corridista who has become a modern Sinaloan legend: Chalino Sánchez.

EL VALIENTE

Chalino Sánchez

> *Me recuerda que el Chicago de aquellos años '40s,*
> *Que mataban ciudadanos con diversas metralletas.*
> *Ya en Culiacán, Sinaloa, a nadie se le respetan.*
>
> (It reminds me of Chicago back in the forties,
> When they killed citizens with various machine guns.
> Now in Culiacán, Sinaloa, they respect no one.)
> *"Ha Muerto Chalino Sánchez"*—José Alfredo Sauceda Rojo

While I had timed my trip to coincide with Malverde's saint day, my main reason for coming to Sinaloa was to pursue the legend of a more recent martyr. Rosalino "Chalino" Sánchez is the one major corrido writer of the modern age whom I would not find available for interviews. He is also the figure who set the style for the cutting edge of the corrido boom, the young Sinaloan gangstas who dominate the scene from here to Los Angeles.

The facts of Chalino's life are fairly straightforward. He was born in the rancho of Las Flechas and raised in Sanalona, a village about twenty

miles east of Culiacán. According to the American reporter Sam Quiñones, who has interviewed many of Chalino's friends and associates, his legend begins with an incident right out of the Pancho Villa saga: when he was a child, a local tough raped his sister and, at age fifteen, Chalino ran into the rapist at a party, walked up to him without saying a word, and shot him to death. With that, he had to leave town, and he moved to Los Angeles to live with an aunt. He worked various jobs, both the low-paid, semilegitimate work available to illegal immigrants and small-time border hustles, smuggling drugs and people across the line in partnership with his brother Armando. In 1984, Armando was shot and killed in Tijuana, and the story is that Chalino's first corrido was written shortly afterward to preserve his brother's memory.

It was around that time that Chalino ran afoul of the law and spent a few months in jail, and some say that this was the beginning of his new career. He wrote songs about his fellow inmates, trading his compositions to their protagonists in return for money or favors. He turned out to have a striking facility for making up lyrics, and on his release found himself in demand among the low-level traffickers and tough guys of southern and Baja California. He would write on commission, serving as a sort of musical press agent for whoever cared to come up with the cash. In this world, where literacy is by no means the rule, corridos are a performed rather than a written style, and Chalino's clients wanted not a printed lyric, but a cassette with their ballad performed by a band. He did not consider himself a singer, so he hired a local norteño outfit, Los Cuatro del Norte, to record his first batch of commercial products. Once they got into the studio, though, he found himself taking over. As his friend Pedro Rivera tells the story, "They had no idea how to sing a corrido, so he got angry and said, 'Give them to me, I'll sing them myself.' He got up and sang them the way he thought they should be sung, and that's how they were recorded for all time."

Chalino knew that he was not a good singer, but he could deliver a corrido lyric, and anyway the tapes were not intended for widespread consumption. "The second recording he did with banda, with the banda Los Guamuchileños," Pedro says. "And the engineer said to him, 'Listen, the trumpet is out of tune there, and you're out of tune there.'"

Chalino's response summed up his intentions, "'No, *loco*, it's fine like it is. I don't want to sell this, it's just so each cabrón can hear his corrido and so I've got it recorded.'"

That was how it went for the first few cassettes. Chalino would record fifteen songs, each commissioned by some local *valiente* (brave man or

tough, depending on how you care to translate), make one copy for each client, and that was that. By the third recording, his clients were ordering extra copies for their friends, and the studio owner, Ángel Parra, suggested doing a proper, professional run of three hundred cassettes. These sold easily and were followed by reorders, and Chalino found himself becoming a professional singer. It was a gradual process: he had first entered the studio in 1986 or 1987, and it would be several more years before he began drawing serious crowds, but already people were being struck by his unique style.

Chalino was nothing like other norteño stars. Indeed, one could say that his appeal was as an antistar. He was seen not as an entertainer, but as the real thing, a valiente fresh off a Sinaloan rancho. His voice was anything but pretty, a flat, nasal whine that, especially on the early recordings, tends to sound tight and forced. His own assessment of it is said to have been, "I don't sing, I bark." As it turned out, this was among his greatest assets: when people heard him, they instantly knew that he was different. You could not mistake that voice, and its very ugliness suggested that the singer had lived the life and knew what he was talking about. This was not a pop norteño band in fancy cowboy outfits singing about Camelia la Tejana. It was the true voice of the drug traffic, of the dark guys in the giant pickup trucks whose expensive clothes could not conceal their country manners.

Chalino was the right man in the right place at the right time. In 1988, Los Tigres themselves turned away from flamboyant cowboy suits and a musical path that had broadened to include soft rock and South American rhythms, and released a stripped-down crime-ballad collection called *Corridos Prohibidos* (Prohibited Corridos). A challenge to those who thought they had grown rich and detached from their roots, it showed them on the cover as a group of street guys in a police lineup, and the title boasted of the fact that their narco songs were regularly banned from radio airplay. By some reports it was their most popular album to date (since corrido albums, in particular, sell largely in bootleg versions, there is no way to establish sales) and, though they soon returned to ornate white tiger suits, it proved their ability to capture the spirit of the times. Just as rap was forcing the Anglo pop world to confront the raw sounds and stark realities of the urban streets, the corrido was stripping off its own pop trappings to become the rap of modern Mexico and the barrios on el otro lado.

Los Tigres understood the new wave, but Chalino defined it. Like Elvis Presley, Bob Dylan, Aretha Franklin, or the gangsta rappers, his style crystallized a moment after which nothing would sound quite the

same. A lot of people hated his records, attacking them as grating and amateurish, but his fan base soon reached far beyond the LA and Tijuana street crowd that had given him his start. Older corrido fans in the Sierra Madre or the northern deserts were attracted by the same thing that excited the young punks in LA: Chalino was the real thing, a fiercely accurate corridista chronicling the world around him.

In keeping with his raw sound, Chalino avoided all pop-star trappings. He appeared on his album covers in a plain white or conservatively striped cotton shirt, dark slacks, and cowboy boots or sandals. He looked straight out of the mountains, one more of the shy, fierce men drinking in the cantinas and carrying drugs across the border in suitcases, ready to do the jail time with quiet fatalism, or to kill someone over a woman or a thoughtless remark. He knew his audience and carefully preserved the mannerisms that other country-born entertainers worked hard to shed. Parra told Quiñones that Chalino would consciously accentuate the Sinaloan quirks in his speech: "For example, instead of saying 'te fuiste' [you left], he'd sing 'te fuites.' That's how it's said in the hills. He knew how to say it correctly. But he'd say it that way so that people, *campesinos*, would hear it the way they were used to."

Chalino's songs were of a piece with the rest of him. They were spare and straightforward, without the flashes of poetry of a Paulino Vargas or the clever linguistic play of other successful composers. His major innovation was to popularize what would come to be called the *corrido de amistad*, or "friendship corrido." Before Chalino, corridos were typically murder ballads: if they were commissioned, it was usually by the friends or family of the deceased. Indeed, it was often said that young valientes would get into fights just in hopes that they would get shot and become corrido heroes. From a professional composer's standpoint, this had an obvious disadvantage: even with all the violence of the Mexican drug world, there are only just so many murders, and not all of the slain will be survived by someone who wants to buy a commemorative song. The corrido de amistad provided a perfect solution: rather than telling of a desperate killing, it simply praised the bravery and character of some gangland figure, with a salute to his friends and a greeting to the folks back home. The protagonists of these songs might be genuine valientes or not; what mattered was that they had the money to buy a corrido.

Of course, while the corridos de amistad paid the bills, they were rarely memorable epics. Chalino recorded quite a few of them, and his success legitimized the style, but he also recorded plenty of murder ballads, and these are what his fans tend to remember. They are rough, simple pieces and have not been much covered by other performers,

but there was something distinctive about them. Other composers point out that Chalino had an eye for the telling detail, and a gift for capturing the interest of his audience. At times, his songs also had a directness and brutality that went beyond anything previously heard. The song that Sinaloans tended to single out for me was not actually written by Chalino, but in a world of pirate cassettes no one would know that, and it exemplifies much of his appeal. Called "El Crimen de Culiacán," it was composed by Nacho Hernández, the accordionist and leader of Los Amables del Norte, who accompanied Chalino on seven albums. It tells of two men who were tortured and murdered in Culiacán because one of them had killed the guy who stole away his girlfriend. What made it memorable was not its plot but its goriness: after shooting the men, the killers drove their car over the dead bodies, then left them on the road, a tableau described in the song's fourth verse:

> *Otro día los encontraron al amanecer el día.*
> *Tenían las tripas de fuera, y un perro se las comía.*
> *Y unos momentos después llegaba la policía.*

> (The next day they were found at dawn of day.
> Their intestines were hanging out and a dog was eating them.
> And some moments later the police arrived.)

This is not lighthearted brigandage or swashbuckling heroism: it is a callous, messy business without romance or humor. Its appeal could not have been farther from the television-friendly romanticism of mainstream ranchera, but perfectly matched the stiff, unsmiling figure one sees on Chalino's album covers, a regular guy in a tough racket. Even when he is occasionally pictured in better clothes—a matching jacket and slacks, for example—they look like something made by a cheap tailor for a village boy to wear to a dance. His one striking costume accessory is the ubiquitous pistol, worn in a leather holster or just shoved into his belt. Sometimes he adds a historical touch, standing by a horse with a rifle in his hand and cartridge belts crisscrossing his chest in the archaic style of a mountain bandit.

In the beginning, Chalino's antistar appearance was simply a reflection of his circumstances. He considered himself a writer first and a singer second, and sold his cassettes out of the trunk of his car, upgrading to a pickup as the demand increased, or distributed them to dealers at swap meets around southern California. After putting out the first few under his own RR (Rosalino Records) brand, he signed a deal with

73

Pedro Rivera's label, Cintas Acuario. His reputation was still very much a street thing, and Pedro says that they had a hell of a job getting his music played on even the most receptive of the LA radio stations:

"There's an announcer named Pablo Carrillo who sold me three slots to play three of my songs, and I would go in and change the songs. One day I didn't find him, and I left him a new record of Chalino Sánchez, 'La Flor Margarita,' and a little note: 'Pablo, put in Chalino Sánchez for El Chapo de Sinaloa.'

"When I got to my office, there was an emergency message to call him immediately. I talked with him, and he said, 'Pedro, if I play that crap on here, they'll fire me.' And he didn't play it."

Pedro even had bands turn down deals with Cintas Acuario because "you recorded that cabrón Chalino, and it would be worth more to hear a dog bark than to listen to that beggar sing."

Chalino's sound was anathema to the mainstream ranchera world, but the slow, low cars cruising the barrios soon had his tapes blaring from their windows, and his following spread like brush fire. In 1990, he played a concert at El Parral, a popular dance club in South Gate, and so many people showed up that the owner had to lock the doors to prevent an overflow.

He was still a relatively local phenomenon, though, known only in southern California, the immediately adjoining border region, and in Sinaloa. His breakthrough, in terms of wider publicity, came on January 20, 1992. That night, he was singing in a club in Coachella, California, just outside Palm Springs, when an unemployed mechanic came up to the stage to make a request, then pulled out a pistol and shot Chalino in the side. Living up to his reputation, Chalino pulled out his own gun and returned fire. By the time it was all over, the would-be assassin had been shot in the mouth with his own gun, Nacho Hernández had been shot in the thigh, and at least five other people were wounded, including a young guy who bled to death as his friends drove him to the hospital. In Sinaloa it is commonly said that the death toll was higher, but that most of the killed and wounded, being undocumented aliens with criminal connections, were spirited out of the club and over the border before the police arrived.

The shooting made the Anglo as well as the Spanish-language newspapers, and even got a spot on ABC's *World News Tonight*. Chalino's sales skyrocketed, and he finally began to get some airplay, though only for an old-fashioned, non-narco pop song, "Nieves de Enero." At his next LA appearance, El Parral was packed and had to close its doors by 6:00 P.M., some five or six hours before he was due onstage. According to

Quiñones, however, Chalino was not all that cheerful about his new notoriety. He was having intimations of mortality, and in the next few months he portioned out his gun collection among his friends and signed a contract with Musart, one of Mexico's biggest record and publishing companies, giving Musart the rights to his songs and him enough money to buy a house for his wife and children. This deal, which reportedly earned him the impressive sum of 350,000 pesos (at the time roughly $115,000), made perfect sense in the street corrido world, where songs rarely outlast their singers, but would turn out to be a disastrous financial miscalculation. The contract gave away all rights, with no royalty provision, and Chalino's family was thus robbed of any share in the millions earned after he became a legend.

Chalino's legendary status arrived more or less as expected: On May 15, four months after the Coachella shooting, he played a rare gig in Culiacán, at the Salon Bugambilias. The show was a huge success, but afterward things turned nasty. As Quiñones tells the story in his book *True Tales from Another Mexico,* Chalino drove away from the club with two of his brothers, a cousin, and several young women. They were pulled over at a traffic circle by a group of armed men in Chevrolet Suburbans, who flashed state police identification cards, took one of the brothers out of the car, then told Chalino that their *comandante* wanted to see him. Chalino at first seems to have taken the incident for an extortion attempt. He offered the gunmen money, which they refused, then persuaded them to release his brother, saying he had just met him at the show. They talked a bit more, and then Chalino agreed to go along with the men, getting into one of their cars while the other followed behind.

> A few hours later, as dawn broke on May 16, 1992, two campesinos found the body of Chalino Sánchez dumped by an irrigation canal near the highway north out of town. He was blindfolded, and his wrists had rope marks. He had been shot twice in the back of the head.

The sequel was a Mexican version of the Tupac Shakur story: Chalino's death elevated him from a singer to a legend, and the West Coast corridistas rushed out reams of verses in honor of the fallen bard. Chalino's widow told the Swiss researcher Helena Simonett that she knew of over 150 corridos dedicated to her late husband, and there were undoubtedly others that did not come to her attention. Meanwhile, "Nieves de Enero" became a radio hit, and Musart rushed out a bunch of "new" Chalino albums, reusing his vocal tracks to create banda

and mariachi versions of his songs, and faking duets with the dead Texas border idol Cornelio Reyna and the female ranchera star Mercedes Castro. Within a couple of years, the corrido scene from Culiacán to Los Angeles was flooded with imitators, all singing in approximations of his raw country tenor and pictured with pistols and rifles. A few expanded the tradition somewhat, appearing on their album covers with the more modern AK-47s or R-15s, but that was about as far as they went in diverging from his pattern.

It is unclear who killed Chalino or why. The men who "arrested" him may or may not have been real police, a distinction that, in any case, can be pretty foggy in northwestern Mexico, where it has been common for drug gunmen to be equipped with authentic police credentials and for policemen to serve as triggermen and bodyguards for gangland figures. As responsible researchers, Quiñones and Simonett simply report the reasons for Chalino's killing as obscure and indiscoverable and leave it at that.

Fortunately for his legend, virtually no one in Sinaloa has taken a similarly conservative approach. In Culiacán, I made it a practice to ask everyone I met why Chalino had been killed, and pretty much all of them were pleased to give me their version of the inside dope. The man behind the counter in a small record store explained that the killers were hired by a big-time narco whose wife had been having an affair with the singer. This narco had been behind the Coachella shooting, and after it failed he arranged the concert at Las Bugambilias through middlemen with the sole intention of having Chalino killed.

No, no, explained Oscar García. Oscar's cousin was one of Chalino's closest friends, and Chalino often visited their house, so he knew all about it: Chalino's brothers were involved in a long-running feud with another family, and had recently killed one of them. The other family retaliated by killing Chalino, just because he was a Sánchez brother. "It was that simple."

Oscar told me this story in the cafeteria of DIFOCUR, and I remarked to him that, as far as I could tell, one of the wonderful things about Sinaloa was that everyone had a story about everything drug and gang related, and one could stop any grandmother on the sidewalk and get yet another version of the "truth" about Chalino's murder. Far from being offended, Oscar just laughed and, when we found ourselves sitting with some other guys on the plaza, offhandedly asked whether anyone at the table knew why Chalino had been killed.

Absolutely, said an older man who ran some kind of business office: Chalino had written a song about a killing in Los Angeles, and the asso-

ciates of the killer had taken offense at the way the corrido made his victim out to be the hero of the incident. "You know how those people are, they will kill over anything, and when they heard he was singing here they decided to deal with him."

A round-faced, bald-headed man across the table begged to differ. Of course he had heard that story, but it was the sort of rumor that always flies around the music business. The fact is that it was a much more mundane matter. Chalino was, as everyone knows, *muy metido* (very deeply involved) in the drug world. He had been part of a deal in which some cocaine had gone missing. It had nothing to do with his musical career; it was just one of those things that happens all the time in that environment, "a matter of a few kilos."

And so it went, for as long as I stayed in Sinaloa. Those were the four basic explanations—revenge, women, music, or drugs—but everyone had a different variation. In one version, the killers were members of a norteño group whose members were nephews of Lamberto Quintero, one of whom had been killed in Coachella by a stray bullet from Chalino's gun. In another, the woman trouble was something that had happened that same evening, someone's girlfriend who had gotten a little too chummy with the singer. I even heard a story that he was killed simply for getting too big for his britches, that he had refused to play at a party given by a trafficker who had helped him in his early years, and the host took umbrage. The fascinating thing to me was not just the range of stories, but the fact that, in three weeks of asking, I only came across one person who said he did not know anything about the killing. To my surprise, that one was Pepe Cabrera.

Pepe is the only important, longtime Sinaloan corrido singer and composer who has remained on his home turf, and he serves as a link between the era of Paulino Vargas and the contemporary narco boom. Though I had been warned that he was reclusive, he turned out to be easy enough to find: I bought his latest cassette and called the phone number on the insert, and the person who answered put him on the line—the cassette had come from his own studio and record label.

Along with the phone number, the insert also provided a three-page biography, the only time I had found liner notes in a corrido release, and that should have tipped me off that Pepe was more than simply a competent writer and singer. As it turned out, when I showed up for an appointment at the offices of Discos Once Ríos, he is a master of every angle of the music business, from performing and concert production to recording, promotion, and marketing. His studio, located on the southern edge of the city, is modern and professional. The walls are

adorned with pictures of his son, Jorge Luis Cabrera, a romantic ranchera singer who is hitting it big on both sides of the border, and album covers of other artists with whom he has been associated over the years; Los Tigres, Los Baron de Apodaca, and the contemporary pop groups Los Mier and Bronco. Pepe is a small, dapper man with a neat mustache, and sported a white shirt with glistening mother-of-pearl snaps and a white cowboy hat. He ushered me into his office and sent an assistant to get me a glass of water, then proceeded to fill me in on his life.

He was born in El Manchón, a rancho outside the small town of Mocorito, in the foothills of the sierra, and raised in Guamúchil. His family were farmers, and the liner-note biography tells of his childhood in eloquently purple phrases: "His still childish hands began to know the roughness of the fields . . . and his heart fell in love with the earth that provided sustenance to him and his beloved family." In his early teens, he began to play music, first guitar and then accordion, and by 1963 he was living in Culiacán and making his living as a musician. He had some success and released a few singles, but his career remained purely local until the early 1970s, when he happened to make a recording trip to Mexicali. The recording engineer was friends with a group from San Luis Río Colorado, Los Bravos del Llano, and took Pepe and his musicians to have dinner with them. As it turned out, Los Bravos were cousins of Paulino Vargas and he had sent them a new song, "La Banda del Carro Rojo," which they were in the process of recording, but never got around to issuing. They sang it for Pepe and gave him the lyrics, and he went back to Culiacán and recorded it himself at his own studio.

Actually, Pepe says the recording was made outside the studio building: " 'La Banda del Carro Rojo' was recorded on two channels—the system I recorded it on was worth three thousand pesos, at that time it was three hundred or two hundred in dollars—and I made the recording out in the open air, because my house was just one little cheaply constructed room, which was what they gave with government aid. And I had really struggled just to get that house. There was so much poverty: I had never had ten thousand pesos of my own at one time. The most I made in those days was once when I sang for thirty-seven hours, my group and I, standing the whole time, without eating, very tired. It was a party in a club, someone had a birthday and got a bunch of friends together. We finished with them and went to another club and they were getting drunk and one would quit and another would bring us to his house. Thirty-seven hours, I almost died, and we made three thousand Mexican pesos between all of us, seven hundred and fifty pesos each. So

'La Banda del Carro Rojo' gave me everything I have. That record hit in Guadalajara, Tijuana, Durango, all over Mexico, and once I had made a name I suddenly started, from not having anything, to make ten thousand pesos a day. A movie theater gave me ten thousand pesos just to sing for forty minutes."

Of course, the song was soon covered with far greater success by Los Tigres, but it had started Pepe on his way. Having found his niche, he began to write his own corridos. He had success with a Camelia-inspired song, "Mujeres Contrabandistas" (Smuggler Women) which told of two women dressed in men's clothing who attempted to smuggle marijuana in their car tires and were killed by the police, and with the ballad of a local gunslinger, Pedro Paez, who had been shot and killed in the Culiacán airport. The latter is interesting as much for its sponsor as for its subject: Pepe recalls that it was commissioned by Paez's cousin, Lamberto Quintero.

The most famous of Pepe's compositions is "La Mafia Muere" (The Mafia Is Dying), the musical commemoration of Operation Condor, which was recorded by pretty much everyone in the corrido field—off the top of his head, he mentions Los Tigres, Ramón Ayala, Banda La Costeña, and Los Cadetes de Linares. Operation Condor was a massive military operation, involving ten thousand soldiers and carried out by the Mexican administration of Luis Echeverría with the assistance of the DEA. For two years, from 1977 through 1978, the government conducted massive aerial sprayings and burnings of marijuana and opium fields, as well as staging commando-style raids on secluded ranchos. The sierra turned into a war zone, and thousands of small farmers—whether or not they had been involved in drug cultivation—were forced to flee with their families to Culiacán and the other lowland towns, or to emigrate to the United States. In Culiacán, small-time traffickers were blown away in roadside gun battles, while the big guys consolidated their power and moved to safer regions, principally Guadalajara. Cabrera's song stands as the local testament to this era, lamenting both the bloodshed and the exodus of the wealthy figures who had pumped so much into the economy:

> Culiacán, capital Sinaloense, convirtiéndose en el mismo infierno,
> Fue testigo de tanta masacre, cuantos hombres valientes han muerto . . .
>
> Se acabaron familias enteras, cientos de hombres la vida perdieron,
> Es muy triste de verás la historia, otros tantos desaparecieron.
> No se sabe si existen con vida o tal vez en la quema murieron.

Tierra Blanca se encuentra muy triste, ya sus calles están desoladas,
No transitan los carros del año ni se escucha el rugir de metrallas.
Las mansiones que fueron de reyes hoy se encuentran muy
* abandonadas.*

(Culiacán, Sinaloan capital, is converting itself into a very hell,
It was witness to so many massacres, how many brave men have
 died . . .

Entire families were wiped out, hundreds of men lost their lives,
It is truly a sad story, many others disappeared,
No one knows if they are still alive or if they died in the
 burning.

Tierra Blanca is very sad, now its streets are deserted,
The "cars of the year" don't drive by, nor does one hear
 machine-gun fire.
What were once the mansions of kings are now all abandoned.)

Over the years, Pepe has written some sixty corridos, the vast major-
ity about local gun battles of one kind or another. They are commis-
sioned by friends or family of the slain, or Pepe will simply seize on a
good story out of the newspapers. He is quick to assure me that he
writes nothing from personal experience: "I just sell music, I don't know
anything about drugs, although I'm in a city that is very famous for
drugs. But you must notice that there are good people as well here, and
we performers have nothing to do with the people in that business. We
sell music, happiness; other people make the stories."

I take this statement with several grains of salt, as the idea of being a
major corridista in Culiacán and not knowing any narcos is patently
ridiculous. There is nothing to be gained from arguing the point,
though, and we go on to talk of Chalino's life and music. Pepe sees a
clear connection between his own style and Chalino's. Like Chalino, he
grew up a poor kid in the foothills of the sierra, and his success was sim-
ilarly aided by his unschooled vocal technique. When I diplomatically
attempt to raise the issue of the "strange" voices of many Sinaloan stars,
he laughs: "My voice is one of those 'strange voices,' as I'm the first to
admit. To tell the truth, between Chalino and me, if you say he was bad,
I'm more bad. But I've made a lot of cassettes and the people care about
me. I'm not the god of the moment, but at one time I had a very high
standing, and the people have kept caring about me. With a bad voice,

it isn't the voice of Pedro Infante or of Jorge Negrete. These days, those voices aren't the ones that are hitting: now the style is to have a very hoarse voice, that's what pleases the public."

Pepe knew Chalino, as he writes in the first lines of his own posthumous tribute:

> *Para cantar estos versos voy a quitarme el sombrero,*
> *Para contar la tragedia de un amigo y compañero.*
> *Chalino Sánchez ha muerto, que Dios lo tenga en el cielo,*

> (To sing these verses I will take off my hat,
> To recount the tragedy of a friend and companion.
> Chalino Sánchez has died, may God have him in heaven.)

The two met in the late 1980s. Pepe had retired from performing to become a successful promoter, presenting all of Los Tigres' shows from Tijuana down to Guadalajara, as well as concerts by other top ranchera groups. One day, a policeman who worked for him doing security brought a young friend to the studio. "It was Chalino, and he had a corrido which he had written for me. He said, 'Listen, Señor Cabrera, I'm a singer and I have a corrido that I wrote about you. I'd like you to listen to it, and maybe you'll give me a chance to record.' "

Pepe liked Chalino and his songs, but says that there were things about the young man that made him want to keep his distance. "He came to see me many times, he wanted me to manage him, to work with him. And I liked him, but then he left town. At that time he had some trouble here: he was a gunman, a tough guy. He was a singer, but a very, very different sort of man from me. I'm a humble man, I do my work, and he was very tough, he didn't let anyone yell at him. Just look at his records: his guns, his pistols. He always carried a pistol and would have one or two guys with him, he was a guy who didn't let anyone put anything over on him. And he had to clear out of here, I heard he got in some kind of trouble, he was involved in a shooting with somebody, and two or three years went by that he didn't come here. By then he had some recordings, and he wanted me to represent him artistically and work with him at dances. I worked with him only once, in the bullring here in Culiacán: I used to hire the ring for my dances, and I put him on there. And he always came to see me here, to say hello, every time he came he brought me a poster, a record."

Pepe says that Chalino's personal toughness was one of the things that made his songs special. "He would always tell it like it was: if he had

to pick a fight with somebody in a corrido, he would say it straight out. He wasn't scared of death, he didn't know fear. But me, I do get scared. I'm a singer and a composer, I'm not a journalist, I'm not going to publish things which I shouldn't publish. Because as I see it, there are certain limits for a corrido: things which could get me in trouble, or get the person I am writing about in trouble, I don't say them. But Chalino got into a very heavy trip, he was very direct.

"I have an anecdote about him, which someone told me at an event where I was singing, over there in the United States. The person who told me, he was also one of those tough guys—in Sinaloa there are a lot of people like that, tough, men of arms, men who don't let anyone make suckers out of them. Not all, the majority of us are quiet, but there is a high percentage who don't allow anything. OK, so anyway, this person told me that one day he met Señor Chalino Sánchez in a restaurant in Los Angeles. A *compadre* of his was singing with a mariachi, and he introduced them: 'Look here, compadre, this is Chalino Sánchez, he's a composer.'

"He said to Chalino, 'Pleased to meet you, señor.' And the compadre who was a friend of Chalino's said to him, 'Compadre, Chalino can write you a corrido if you want.'

" 'Well, that's fine,' he told him. 'Maybe sometime he'll write one for me.' "

Pepe assumes a menacing posture and imitates Chalino's rasping response: " 'If you want—and if you don't want, I don't give a fuck, I'll write you one anyway!'

"And both of them armed, Chalino and the other señor, about to get in a fight, to start throwing punches or maybe to shoot each other, over a trifle. So that shows you, the man had a lot of guts, he didn't let anything by him, and he was very famous for that."

Pepe was not at the Salon Bugambilias the night Chalino was shot, but he heard about the killing the next morning and immediately set to work on a corrido:

> En la glorieta Cuauhtémoc el camino le cerraron,
> Varios hombres bien armados de su carro lo bajaron,
> Y en el rancho La Presita amaneció acribillado.

> (At the Cuauhtémoc traffic circle they blocked his way,
> Some heavily armed men took him from his car,
> And in the La Presita rancho the dawn found him riddled
> with bullets.)

"I was in Los Angeles, and he had hardly been dead nine days and I premiered his corrido, and the place was packed. I did a video for the television, the video sold like crazy, my cassette sold all over the place, because it had the corrido of Chalino."

> *Ha muerto Chalino Sánchez, en la historia va a quedar,*
> *Sus familiares y amigos, y público en general.*
> *El ídolo sinaloense ya no volverá a cantar.*

(Chalino Sánchez is dead, he will live in history,
His relatives and friends, and the general public.
The Sinaloan idol will not sing again.)

"Chalino was an idol, his music was listened to by every kind of person. In Los Angeles, it was crazy. Lots of people told me that they had been *cholos* [urban street guys] before, and now they were all dressed up like Chalino Sánchez: a cowboy hat like Chalino, and trying to get into Chalino's whole trip. Many of them, very many. And lots of singers have come out who try to sing like him: I have friends who make their living singing like Chalino. It gives me great pleasure, because Chalino, even after his death, still keeps on giving life to young people who sing with his voice, and the people keep on caring for him. The troubles that he had in his personal life, poor guy, what a pity, really it's an irreparable loss, it hurts me that he went so young, thirty-two years old."

Sitting behind his desk, Pepe sings me the final verse of his ballad:

> *Adiós al rancho Las Flechas, tierra que lo vio nacer,*
> *Adiós mi esposa y mis hijos, no me volverán a ver,*
> *Adiós Amables del Norte, me tocó la de perder.*

(Good-bye to the Las Flechas rancho, the land that saw
his birth,
Good-bye to my wife and my children, they will not see
me again,
Good-bye Amables del Norte, my fate was to lose.)

"Because—since he was very tough, he never let anyone put anything over on him, poor guy—because of that he lost everything."

83

CHALINITOS

El As de la Sierra

Qué tal mis amigos, me estoy presentando,
Vengo de la sierra, y ahí de Mazatlán.
Le canto a mi gente, le canto a mis pueblos,
Del As de la Sierra les voy a contar.

(How are you, my friends, I am presenting myself,
I come from the sierra, and there by Mazatlán.
I sing to my people, I sing to my villages,
I am going to tell you of El As de la Sierra.)
 —*"El As de la Sierra," by El As de la Sierra*

Chalino has been dead for almost a decade, but his voice is heard from Sinaloa to Los Angeles. At least, it sounds like his voice. In the West Coast drug belt, the 1990s became the decade of the *chalinitos*, the little Chalinos, hundreds of young men trying to sing, dress, move, and live like their idol. The audience demand was there, and many became popular recording artists. In ten minutes, a record store owner in Culiacán showed me cassettes and CDs of twenty-five different chalinitos, from the obviously named Chalinillo to Chalino's friend Saúl Viera, El Gavilancillo (the Little Hawk), who was assassinated in 1997, and on and on.

Some of the most popular chalinitos are LA kids who grew up with rap music but have gone back to their parents' roots: the music that once seemed a badge of poverty and backwardness now represents the cutting edge of drug-fueled cool. Many, though, are Sinaloan country boys like Chalino himself. In the sierra, as in the ghettos of the United States, music has become an alternative way out of rural poverty, a means to move to LA and buy a fancy car, meet women that look like they stepped off the television screen, and get a taste of the good life. LA is the dream: as soon as a singer hits in Sinaloa, he moves north to the money and the big record companies. The only major contemporary stars who have remained in the state are Miguel y Miguel, a guitar duo who have tended to avoid narcocorridos but still draw a big drug audience with their pure hill-country style, and El As de la Sierra (the Ace of the Mountain Range).

I first saw El As in Mazatlán. I had just arrived, and he was playing in La Herradura (The Horseshoe), a dance hall in the touristic Zona Dorada (Golden Zone). Nearly everyone walking through the Zona is a foreigner or a wealthy urbanite on vacation (with the exception of hotel and restaurant help), but La Herradura might as well have been on another planet. Except for me, the audience was *mexicano cien por ciento*. The concert was not mentioned in the English-language news sheet, nor was the tourist office aware of it, but the whitewashed walls on the way into town had been painted in meter-high letters with ads for the show.

The early arrivals, sitting and drinking at the tables that filled the center of the room, did not look like they came from either the beach resort or the port. They had the lean look of the mountains, and their boots and cowboy hats had seen plenty of use. The club clearly knew its audience, as the large-screen television was showing not music videos but bull riding, and some of the men were commenting critically on the riders' technique. Most looked to be under thirty, and a few of the more fashion-conscious were wearing the same *crema de seda* (cream of silk) shirts that one sees in LA—shiny Versace knockoffs adorned with marijuana leaves or the Virgin of Guadalupe—and boots and hatbands of exotic leathers. In Sinaloa, though, the fancy cowboy look is more ambiguous than in urban California: this close to home, it can stamp one as hick rather than hip, so some of the later, cooler arrivals were wearing loose cargo pants, backward baseball caps, mirror sunglasses, and a lot of heavy gold jewelry. Almost all the early arrivals were men, but by eleven, women were streaming in as well, all in impressively high heels and astonishingly short dresses or paint-thin pants.

El As took the stage shortly after midnight, heralded by a cloud of smoke and a recorded voice booming out the titles of his hits. He wore

a bright green suit adorned with Mexican flags, and sang nothing but narcocorridos, his harsh voice supported by the pumping rhythm of an accordion combo. The dance floor was so packed that the couples were hardly moving, but no one seemed to be paying much attention to the evening's star: there was virtually no applause or yelling, nor did the dancers bother to look up at the stage. Which, I was to learn, is pretty much the Mexican dance-hall style. Customers show their appreciation by getting out on the floor, and no one short of Los Tigres or Los Tucanes is given much more acknowledgment than that—although customers will pay a high ticket price for the privilege of treating their favorite artists in this apparently cavalier manner.

I had been told that El As came from the Mazatlán region, but by the time I got to Culiacán I had learned enough not to trust such reports. Inspired by the Pepe Cabrera experience, I bought one of his albums, *El Helicóptero Negro y Mis Corridos* (The Black Helicopter and My Corridos), with bright lettering across the front declaring him "El #1 de Sinaloa," and called the phone number on the back. Whoever answered was unwilling to give me a number for El As, but did put me in touch with José Alfredo Sauceda, the album's artistic director and the composer of five of its songs, among them a Chalino tribute, "Ha Muerto Chalino Sánchez" (Chalino Sánchez Has Died). José Alfredo turned out to live in Los Mochis, and when I called him, he gave me another number, also in Mochis, to contact El As, then invited me to come by his office the following week.

Mochis is a dry, unimpressive town, without any of the flair of Culiacán, but I was lucky enough to end up as a guest of Ricardo Corral, the painter whose work had so impressed me at the Mazatlán exhibit. With Ricardo as my guide, I managed to work out the intricacies of the local bus system, and made my way to the quiet residential neighborhood where José Alfredo shares an office with an insurance company. Aside from a small rack of cassettes, there was little about either the man or the room to suggest a corridista. Unlike the other composers I had met, for whom music was a way out of farm labor or petty crime, José Alfredo is college educated and has the neatly cut hair, conservative clothes, and polished manner of a successful small businessman. While he makes much of his living as a composer of narcocorridos, he says that he does not really like them, that he prefers the more socially relevant ballads of the Revolution or of political figures like the 1970s guerrilla leader Lucio Cabañas. However, one must make a living: "Unfortunately, the forbidden is what people buy. If one prohibits marijuana or cocaine or opium, people tend to search out the unknown, the forbidden, the

strong emotions. And the same thing happens to us with the corrido. I myself repudiate my own corridos, but nonetheless, well, that's what sells."

Which is to say, José Alfredo's appearance is not deceptive. He is first and foremost a businessman, and he runs his little Joalsaro record label (the name combines the first letters of José Alfredo Sauceda Rojo) with studied efficiency. His catalogue is a well-balanced sampler of the current Sinaloan trends: hardcore, Chalino-style norteño by Los Grandes de Sinaloa and Los Angeles del Norte, brass band music by Banda Felino, Miguel y Miguel–style guitar and vocal duets by Los Maleantes de la Presa, and a preteen banda singer known as El Zurdito (the Little Left-hander). (Such child singers are perhaps the oddest trend in West Coast ranchera. The apogee of child corridista weirdness is Lolita Capilla, "La Bronca de Sonora," a little girl who is shown on her cassette covers wearing a white, frilly confirmation dress and holding an assault rifle.)

Sinaloa is particularly rich in small labels like Joalsaro. By Pepe Cabrera's count there are fourteen in the state, and their success is at least in part due to the flood of chalinitos. Since these singers' appeal remains largely confined to the West Coast, and they all sound more or less alike, none has been able to rack up the sort of sales that would attract a major international label, but the better ones can bring in more than enough to support a small, local supplier. José Alfredo adds that the Sinaloan labels have also profited from a more surprising source: the radio ban on narcocorridos. This prohibition has been a fact of life in northwestern Mexico since the 1980s. Self-appointed guardians of decency have attacked the corrido craze with the same fervor their northern neighbors direct at gangsta rap, and in 1987 the governor of Sinaloa made a formal call to "suppress the exaltation of violence" in radio programming. There have been similar calls in Sonora, Chihuahua, and Baja California, and though I have found no evidence of an outright legislative ban, no narcocorridos are heard on the air in Mexico's main drug states.

For the corridistas, this has been both a curse and a blessing. Los Tigres capitalized on the controversy with their *Corridos Prohibidos* concept, but on the whole the ban has made it difficult for the major labels and top groups, who rely on radio for much of their promotion, to command their usual share of the market. Meanwhile, it has leveled the playing field for local outfits like Once Ríos and Joalsaro. In Monterrey or Mexico City it is virtually impossible for a recording to be a hit without a major label behind it. In Sinaloa and Sonora, by contrast, all the

money in the world will not get a narcocorrido on the radio playlists, so news of new songs is spread by the fans, and by play in local record stores and bars. "The corrido goes from mouth to mouth, we don't need more than that," José Alfredo says. "These songs are prohibited, the radio doesn't play us, so people go and buy the cassette. They say, 'If it's prohibited then they must be good.' "

Thus, while the locally recorded chalinitos may never sell much outside the region, on their home turf they can outsell the international stars. José Alfredo adds that the small labels do use the radio to some extent, but largely as a way of introducing a new artist. Chalino himself got his only mainstream radio play with romantic songs, rather than his trademark corridos, and when José Alfredo has a new chalinito he will record both a corrido cassette and one of *canciones*—regular, non-narco songs. "I'll get the cassette of, say, Los Grandes de Sinaloa [his latest chalinito group] singing canciones on the radio, and people hear them and like their style, and afterward the word gets around that they also have a cassette of just corridos, so people buy the corrido one as well. Or the record stores help us out: someone comes and says, 'Listen, I heard Chalino Sánchez doing "Humilde Serenata" on the radio, and I had never heard him do that one.'

"The guy at the record store says, 'Ah, permit me, here it is,' and he puts our cassette on.

"They listen to it and say, 'Yes, that's the one.'

" 'But, you know, it isn't Chalino Sánchez—it's Los Grandes de Sinaloa.'

"And people buy it. Then if he says to them, 'I have this one with "Humilde Serenata," but I also have this other one of theirs which is all corridos':

" 'Ah! Let me have both of them.' So that's how this stuff sells."

With its dependence on word of mouth, this is necessarily a local business. José Alfredo says that his cassettes sell on the coast from Mazatlán up to Hermosillo, Sonora, and in the small towns of the sierra, but that is about it. That, he explains, is why El As de la Sierra is on Titan Records rather than Joalsaro. Titan is based in the nearby town of Guamúchil, but also has an office in Los Angeles, and José Alfredo made a deal with them as soon as he saw El As's potential.

While the extent of El As's success has been exceptional for the Sinaloan scene, his story is fairly typical. José Alfredo says that he was alerted to the singer's work by a friend, Humberto Quintero Valle, who leads a local norteño band: "Humberto kept coming to me and insisting, saying to me, '*Licenciado* [a term of respect for anyone with a uni-

versity degree], I have someone who sings very well, exactly like Chalino Sánchez.'

"Every time he said that, I said to him, 'Humberto, imitations don't interest me, they don't interest me at all.' But he was so insistent that one day I said to him, 'You know what? Make an appointment with him to come by the place where you are playing, at eight in the evening, so I can go hear him.'

"At that time, El As de la Sierra was working right around the corner from the place where they were playing. He worked in an import company—why not say it, if he says it himself—lifting and getting down boxes as a hauler and porter, and cleaning up the office. Why? Because the owner of the business is from the same town as El As de la Sierra, so he brought him from there and gave him work so he would be able to eat, you understand?

"So anyway, I go to the bar at eight on the dot; Humberto saw me and said, 'I'll be right back, I'll go tell him.'

89

"And off he went, it was just around the corner, and brought the boy back with him. That was when I first met El As de la Sierra, five years ago. I saw him, and: 'What's up, *muchacho,* how are you doing?'

" 'Fine.'

"I introduced myself, and then said to him, 'You know what? I'm going to ask you to show me that you can sing like Chalino Sánchez, sure, but sing me a song that Chalino Sánchez never sang. Then maybe I'll be inspired to record you.'

"He said to me, 'Sure, no problem,' and he went over, the boys agreed on what they were going to do with him—he found the key and everything right off, because he's a natural—and he sings 'Los Barandales del Puente,' which Chalino Sánchez had never sung, and he sings it in his style and I was amazed. He sang 'La Cruz de Palo,' another that Chalino Sánchez had never sung. *¡Ai caray!* The people, the customers who were there having a drink, they all began to turn to where that boy was singing, just twenty-two years old. He sang another which Chalino Sánchez had never done, and I gave him a sign that it was enough. But the people began to crowd around him and to ask him for Chalino's most popular songs, like 'Las Nieves de Enero.' So then El As—who was not yet El As—turned around and stood there looking at me, and I gave him a sign to go ahead and he sang 'Las Nieves de Enero,' 'Nocturna Rosario,' and 'Alma Enamorada.' No, *hombre,* it was something incredible, the way the people were applauding. And I said to myself, 'This is it.' "

José Alfredo made a date to meet the young singer the following

morning at a restaurant in the center of town. There, the future Ace unfolded his story: "He said to me, 'Look, I suffered a lot, ever since I was a child in my pueblo.' He is from an area of Mazatlán, I don't remember exactly, but an area up there in the sierra, and he was working at what people work at there, who are trying to find a way to get by—why not say it; I don't think it will do him any harm—he was planting and harvesting the stuff that—I never mention the words in my corridos, I never mention the word 'marijuana,' I always call it *la hierba mala*'—but anyway, that and other things are what they grow in the sierra. The coca is brought in from Colombia; grass and poppies are what spring up in these parts. So he was into that, but he suffered a great deal. The *federales,* the soldiers who watch over that area and who are responsible for seeing that it doesn't sink deeper into this vice business, they gave people a lot of beatings, a lot of setbacks, they burned the hierba mala, sprayed the poppies and all of that. All in all, with those kinds of problems, he decided it would be better to come down from the sierra and he came here to work as a porter. I admire him very much, because he preferred to earn the minimum wage, because he already had his wife and two little children, a girl and a boy, so he said, 'This is no kind of life. Better to go to work and eat whatever we can eat.' And that's how I met him, like that, in his humble way."

José Alfredo offered El As a five-year contract, and the matter was quickly settled. Then they got to the question of an artistic name: "I said to him, 'So, what would you like to be called?'

" 'Well look, my name is José Manuel Camargo, but I would like to be José Heredia'—after a grandfather or an uncle, he told me something like that—'but I want my nickname to say something about the sierra, and I want to get to be number one. . . .'

" 'Okay, if you want to be number one, the number one in the deck is the ace. Why not, from here on in, what do you think of being El As de la Sierra?'

" 'I like that.' And that was how El As de la Sierra was born."

José Alfredo pulled some songs together, El As picked the ones that suited him, they made the first recording, José Alfredo took it to his friends at Titan, and El As was on his way. Today, El As is by far the most popular of the Sinaloan chalinitos. He has broken into the international market, selling out clubs as far away as Chicago, and even the hardcore LA gangsta crowd tends to accept him as Chalino's truest heir. He is also the man who has taken the corrido de amistad to its ultimate conclusion—where Chalino proved that one could succeed with corridos that were simply friendly salutes, without any gunfire or mayhem, El

As is the only composer I know who has written such a salute to himself: the *Helicóptero Negro* cassette includes a self-penned corrido titled "El As de la Sierra."

I wanted to get El As's story direct from the source, but it took several tries before I managed to reach him. When I finally spoke to him on the phone, it was clear from our first words that this was not going to be as easy a process as interviewing Pepe or José Alfredo. First of all, he sounded suspicious: Who was I? How had I got his number? What exactly did I want? Then there was the problem of when and where we would meet. He was a very busy man, he had to go to Guamúchil, he was traveling a lot, it was not clear when we could get together, I should call in a couple of days. When I called back, he said he could meet me the following day, but I could not come to him, he would come wherever I was staying. I gave him Ricardo's address and said I would call in the morning to confirm. He was out when I called back, but, a bit to my surprise, he shortly returned my call and said he would come to Ricardo's at two in the afternoon.

It was three o'clock, and Ricardo and two of his older relatives were trading bets as to whether El As would show, when a big SUV with smoked-glass windows pulled up outside. I went to the door and, after maybe half a minute, two men got out of the car. Neither was El As, both were pretty big, and they were clearly nonplussed by the modesty of the surroundings. "Who lives here? What does he do? Where are the television cameras?" I explained that there were no television cameras, that I was a writer, writing a book on corridos, that I had talked with Paulino Vargas, with Pepe Cabrera, with José Alfredo, that I was a great admirer of El As.

"You don't have any kind of camera? Do you have some proof of who you are and what you're doing?"

It was a new question for me. Everyone in Mexico, even officials at the big TV networks, had simply accepted my story at face value. Luckily I had an article from *El Noroeste,* the Mazatlán newspaper, which had my photo alongside a shot of Los Tigres and a full interview about my project. One of the toughs looked it over, giving little sign of comprehension but at least recognizing the photos. Apparently that was enough to establish a first level of credibility, since he then asked Ricardo if he could take a look around the house. Since the house consisted of only five rooms, this was quickly done, and he rejoined me at the front door and pulled a walkie-talkie from his belt. He murmured something into it, and, after another wait, the car's back door opened and another man came out, followed by El As.

If I had not already seen him onstage, I would have been hard put to pick El As as the leader of this group. He was a slight and rather unprepossessing figure, the smallest, shyest, and least at ease of the four visitors. He was also the one wearing the least gold jewelry. We sat in Ricardo's front room, El As beside me on the couch and the other three facing us. Ricardo asked if they wanted anything to drink, and one of the bodyguards said he would have a beer. El As requested a glass of water, and the others just shook their heads, without taking their eyes off me.

El As was clearly unused to being interviewed, especially by a foreigner. At first he was unsure whether he should let me record the interview, and even after he agreed, his answers were short, halting, and punctuated by nervous laughter. After a while, though, he began to relax and seemed to relish the opportunity to express his views. As I listened, I found it easy to imagine him as he was a few years ago, a humble laborer hoping for a stroke of good fortune, but he also had a certain calmness and poise, the air of a man who has become used to holding an audience. (Furthermore, he says that, with all due respect to José Alfredo, it was he who came up with his alias.)

El As says that music came naturally to him: "Ever since I was a kid, I sang; the teachers used to bring me out to sing at school. That's how it is. For me, it started as a game. It was my dream to sing, to see myself on the front of a cassette, to hear my music, but I was a person of humble means, I didn't have enough to pay for a recording."

In fact, his early life was just as he describes it in his corrido:

Rancho del Cañón, donde yo he nacido,
Fuenquillo San Marcos, allí me crié yo,
Anduve en la sierra, en aquellos barrancos,
Buscando futuro que nunca llegó.

(Rancho del Cañon, where I was born,
Fuenquillo San Marcos, that is where I grew up,
I wandered the sierra, in those ravines,
In search of a future which never arrived.)

The first time he heard Chalino, he knew that he had found a style that suited him: "It was something new, very different from what other people were singing. It was a personal style, which started with him, and my style was born out of that. I never tried to imitate him, and I still don't, but yes, they are very similar, his style and mine—but now it is a personal style of El As de la Sierra. That's how it is."

In the sierra there was no living to be made as a singer, but El As says that once he met José Alfredo and started recording, success came quickly: "I think that the way the person sees himself, the performer, has a lot to do with it. That is, the way he treats people when he gets up onstage. I feel that everyone likes me, I don't know why it is. Because this is a very difficult thing, to accomplish what I've accomplished, and I can say that really I never had to struggle at all. The people have accepted me, and without the radio, which hasn't played us. All the stations in Mexico and the United States ask the same question: how can this be selling without any help from radio? Well, because people like it. Above all, what I record are corridos of the drug traffic, *corridos bravos*, to put it that way, and that's the style right now, it's what people are asking for.

"I think that I know the taste of the people from the sierra, and up to now it hasn't failed us. Because everybody is connected to the sierra. Here in Mochis, if there are one thousand inhabitants—to put it that way, it's an example—eight hundred are people who came down from the sierra, and I think that all over Mexico it's the same. Now, there is also a public that can't seem to appreciate my music, I think that there is a group of people in the cities who are called 'high society' who don't buy it. My public is the people who live on the edges of the cities, but in the cities as well there are a lot of people of the ranchos, to put it that way, so the majority of the people are my public."

El As has nine albums on the market, but he says that only twelve or fifteen of the songs he has recorded are his own compositions. To him, it makes little difference whether a song was written by another writer as long as it is truthful and feels right to him. "I think that when a corrido is real, you can feel that. When it is fictitious it also can give a feeling, but it isn't the same. Me, everything that I compose is taken completely from real life. Because of that, I sing with enthusiasm, because I know that I am singing about something that really happened. A fictitious corrido, I don't feel the same way singing it, because I don't know whether it happened or not."

As for his choice of themes, he is simply following the tastes of his customers. "This singing thing is a job, like being a journalist, you might say. Someone pays me to make a corrido and I do it. Why not? To me, it's no crime, because it's my job. So if a drug trafficker comes to me, wants me to compose a corrido for him, I do it with pleasure. Sure, I always try to protect him, I say to him, 'Give me a nickname to use,' but a lot of them don't want that:

" 'I want my own name!'

" 'Oh, fine, it's your problem. I'll do it with your name.' "

El As laughs as he imitates the braggadocio of his customers. It is an odd business, this lust to be immortalized in song, and I am reminded of a story José Alfredo told me: A law-abiding businessman from Los Mochis, the owner of a printing shop, sent over an assistant to commission a narcocorrido saying that he was a powerful traficante and had fought a great battle in which all of his employees died (he provided a list of names) and he was the only survivor. Now the song is a local hit, the printer's name has become notorious, and José Alfredo says, "If I told them that he's just the owner of a printing shop, nobody would believe me."

El As found this very funny, but added that it is no longer necessary for a corrido to be about desperate characters, or full of gun battles: "You can write a corrido for a mason, a journalist, for whoever you want. Whoever asks for a corrido, I write him one; he doesn't have to have killed someone or to be a drug trafficker. To make a corrido, all I need is when you were born, the names of your parents, what your work is, or what you do with yourself, where you're from, the name of your town—and with that the corrido is done, just as easy as that. That is, you don't necessarily have to go around running trailers stuffed with *mota* [marijuana]."

By now, the atmosphere has thawed considerably, and El As chuckles as he says that last line. Even the bodyguards are smiling and looking more relaxed. I do not have much more to ask, but am interested to know where El As sees himself headed, how far he thinks his career can go. "Wherever the people bring me," he responds with elegant diplomacy and another laugh. "We are where we are now because the people have brought us here. I don't like to say that I will get to a certain place; I go on living in the moment. That's how it is. But yes, I am curious to know how far the corrido will take me, because it has taken me a very long way, and we are doing well, thank God."

El As nods his head with confident finality. Then he pauses, and his optimism acquires an edge: "My career is something very nice, very pretty, but it is also very dangerous. It is not just a matter of getting up there and singing. My public is a public—how should I put this—a public of drug traffickers. Not all of them, there are people who just dream of seeing El As de la Sierra, of knowing him, but in my public there will always be businesspeople, as I call them. So, for me, it is not just a matter of getting up onstage, it is dangerous. This thing of composing corridos—I could compose a corrido to you and you have an enemy who doesn't like it and who could make problems for me. That is, this isn't a game, it's something delicate. I have to bring men with me to watch

out for me, I can't be without them. That's how it is, these are delicate matters."

And that's that. El As shakes my hand and leads his troop outside. As he gets into his car, I cannot help thinking of the last verse of his auto-biographical corrido:

> Conozco de todo, lo bueno y lo malo,
> Gente con dinero y humilde también.
> Para mí es la misma, yo vivo la vida,
> Al fin, cuando muera, nada llevaré.

> (I know all kinds, the good and the bad,
> People with money and humble ones as well.
> To me it is the same, I live my life,
> At the end, when I die, I will take nothing with me.)

El As opens his window to give me a parting smile and a wave. Then the smoked glass rolls up, hiding him from view, and the car moves slowly off down the street.

95

BADIRAGUATO

Este pueblo tiene fama por todo mi Sinaloa,
Porque nos echan la culpa que aquí sembramos la goma.
Solo les quiero aclarar que aquí sembramos de todo,
Y si se enojan por eso, pues que se enojen, ni modo.

(This town has a reputation throughout my Sinaloa,
Because people cast blame on us that we grow opium here.
I just want to make it clear to them that we grow everything
 here,
And if they get angry at that, well, let them get angry, that's
 life.)
—*"El Corrido de Badiraguato," by Los Hermanos Esparragoza*

By now I had pretty much got what I needed on the Sinaloan scene, but I had one more visit to make. José Alfredo had told me of a friend with a record company in the hill town of Badiraguato, who had been kidnapped by some narcos and locked in a room until he had composed a corrido of their deeds. This struck me as excellent local color, especially as Badiraguato had already been mentioned to me as *la mera mata*, the real deal, birthplace of generations of drug lords. I said as much to José Alfredo, he made a phone call to the friend, Antonio Uriarte, and Antonio said I was welcome to come see him on Friday around five o'clock.

A city bus took me out of Los Mochis to within a block of the high-way. Walking past a truck stop, I was called over by one of the attendants, who asked me to play a song. I played a short blues for him, and by the end there was a group of five or six men standing around, laughing at the novelty of a hitchhiking gringo guitarist. "Where are you from?" one asked.

"Boston."

"Boston, Texas?"

"No!" his friend broke in. "That's Austin. Boston is in Massachusetts, isn't it?"

"Yes."

"Where are you going?"

"Badiraguato."

It was like something out of a movie: Smiles froze on faces. One guy's eyes actually narrowed into slits. The party was over. No one asked me why I was going there: no one had anything more to say.

The rides came easily until south of Guamúchil, where I got stuck for about an hour. Finally a bus pulled over, and I thought what the hell and climbed aboard. As it turned out, the driver had picked me up as a hitchhiker, not a passenger, and he declined to take my fare. One more thing to like about Sinaloa. He dropped me off at Pericos, where a side road heads east toward the Sierra de Badiraguato. By now it was around 3:00, and I ate lunch in the restaurant that doubled as a bus station: two plates of greasy, smoky tacos of lamb, tongue, and chicken, washed down with grapefruit soda. During the forty minutes I spent there, not one car headed past toward the mountains, so I got on the bus that was waiting and paid my passage like everyone else.

The road wove and twisted as it climbed into the foothills, the bus swaying at every turn, but on this side of the sierra the countryside did not have the dramatic jaggedness of Parral. It was dusty and yellow, small rises and rocky mounds covered with dry scrub. Hardly anyone got off along the way. A lot of the passengers were probably going on beyond the main town, to the mountain ranchos higher up. The couple behind me was exchanging local gossip:

"Which curve was it, exactly, where the body was found last week?"

"Oh, yes, it was right up ahead. He was the brother-in-law of María Luisa's daughter, you know the one. . . ."

The town of Badiraguato lay in a valley, with tree-covered peaks rising beyond it to the east. It was pretty enough, but sleepy and nonde-script, one more of a thousand small Mexican pueblos. There was a town cultural organization with an office on the main square, so I wan-

dered in and looked at exhibits on the history of Badiraguato, sepia photographs of long-dead *hacendados* and the faded uniform of a Revolutionary hero who was born here. From a pay phone on the square, I tried to call Antonio, but his wife said that he was out of town and would not be back for at least another hour. As I hung up, two girls came over, both in their early teens. Carmen was chunky and voluble, Lili slim and quieter. Both were curious. "What the fuck are you doing in Badiraguato?"

So I told them the story, and they plied me with questions. Was I married? Did I have a girlfriend? Where was I staying tonight? Did I want to come have dinner with Carmen and her grandmother? It would only be simple fare, but I was welcome. Did I like the Sinaloan girls?

Of course, the Sinaloan girls are the most beautiful in Mexico, everyone knows that.

Did I know the rhyme? They recited in unison: *"Mucha nalga, poca chichi: Culichi; mucha chichi, poca nalga: Chilanga."* (Lots of ass, little tits: Culiacán; lots of tits, little ass: Mexico City.) "Do you think it's true?" Carmen asked, displaying herself as living proof. "It really is, you know. I mean, I've never been in the DF, but I've seen them on television—what a bunch of ugly, big-titted fatties!"

They knew who Antonio was: the one with the new house on the hill and the big car. Drug guys? "Oh, yeah, fuck, they're everywhere. You see those guys driving by over there? Oh, fuck, and up in the mountains, on the ranchos . . . Up there it's wild! I mean, maybe you think I have a bad mouth, but fuck, up in the mountains even the grandmothers, they think I talk like a little angel."

The girls took me down a narrow side street to a small store with a few chairs and tables set out on a dirt patio. Carmen and I sat outside with a boy she knew while Lili went in and bought us Cokes. We drank them, chatting in the shade, then walked up the hill to Carmen's grandmother's house, an L-shaped stone building set back from the road and surrounded by fruit trees, about a block above the regional prison. The grandmother could be seen working at her sewing machine in a front room, but she did not turn her head as we passed, and Carmen did not greet her. We stowed my pack and guitar, then walked back to the square, where I called Antonio. This time he was home, and he drove down and picked me up. Carmen told him how to find her place after we were finished with the interview.

Antonio's house was on the ridge where the road makes its dip into central Badiraguato. It stood by itself, a new building surrounded by a balcony with a striking view of the town and the mountains beyond.

Antonio proudly explained that he had spent the last eight years build-
ing it with his own hands and a couple of assistants, and said that he
was still planning some additions. Inside, we walked through a living
room full of imitation Louis XIV furniture, past a modern kitchen
where he introduced me to his slim, pretty wife, then settled down in his
office.

At thirty-one, Antonio is younger than most of the composers I had
met. He is a self-made man who started writing in his teens and already
has some two hundred recorded songs to his credit, including several
on discs by internationally popular artists like Grupo Exterminador and
Raúl Hernández (the "Lone Tiger," who recently embarked on a solo
career after almost thirty years with Los Tigres del Norte). Antonio's
own company, Uriarte Records, is a local outfit, but he has good outside
connections: he uses Pepe Cabrera's studio in Culiacán and has a dis-
tribution deal with Pedro Rivera's Cintas Acuario in Los Angeles. Uri-
arte's operation is still new and small—a standard first run for him is
one thousand cassettes, or two thousand for his top artists—but it is
growing and boasts a range of performers similar to Joalsaro's: a chalin-
ito, a norteño group, a banda, a preteen sensation.

What sets Antonio's catalogue apart is his focus on the guitar-driven
style that has been hitting for the reigning north Sinaloan stars, Miguel
y Miguel. This is one of the most curious twists of the recent ranchera
scene: the Miguels sing in a traditional, even archaic style, backed only
by their own rhythmically sharp acoustic guitar work and a bass—they
sound very much like a country-bluegrass brother duet—but they have
been outselling all but the most popular banda and norteño groups in
northern Mexico. They sing many corridos, but few with narco themes,
preferring old-fashioned stories of love, jealousy, rural gunfights, and
the Revolution. And yet, because this sort of spare, stripped-down sound
has always been what was played by amateurs up in the mountains, they
are hailed as the realest of the real, the true sound of the sierra.

Antonio has his straightforward Miguel y Miguel clones, a duo called
Sierra Llanera that includes the most spectacular guitarist I have heard
in the genre, but he has also been attempting quirky variations on the
style: Los Renegados de Badiraguato blend two acoustic guitars with a
banda horn section, and his most popular group, El Canelo de Sinaloa
y los Dos del Sitio, is a trio of two guitars and tuba. The tuba takes most
of the lead chores, making for one of the most bizarre and unmistakably
Sinaloan sounds on record, and the group has put Uriarte Records on
the map, selling like crazy throughout the sierra and north to LA.

I assume that, being based in Badiraguato, Antonio must be writing

a lot of commissioned corridos for local characters, and indeed that is a fair part of his business: "They give me a list, telling me the name of their rancho, what they do for a living—if they want me to mention what they do for a living—just stuff like that. They say 'Put it in there that I like women a lot,' that he's had three, four women, and that kind of thing. So I take down the most important information and then, based on the list, one goes and writes the verses and it's done. Some want their name to be used, some not—they give me some code, because sometimes if a corrido comes out saying that they have two, three women, and he has a wife at home, when he gets back she'll be after him with a broomstick."

Of course, angry wives are not the only people a corrido hero, or composer, needs to worry about. Like El As, Antonio says that corrido writing can be a risky business, and as the owner of his own company, he must be particularly careful. As a result, he says, more and more of his corridos are now fictitious: "I like to write tough corridos—when a corrido comes out that's pretty and really high-energy, that gets people in the mood to drink and enjoy themselves, makes them happy, it inspires me to write corridos like that—but I have to know that I won't be bothering anyone, you understand? So I don't mention any names of anyone or anything.

"At this point, one can't record a corrido of—to put it like this—a person who is a *contrabandista*, because maybe he doesn't approve or it might make problems for someone, and it's better to avoid problems. So one writes a corrido that could be about anybody. For example, I composed a corrido called 'El Chacal de Chacales' (The Jackal of Jackals). That corrido isn't about anyone: it says, 'I am the jackal of jackals,' and it talks about how he is brave, that he can do anything, anything at all. That corrido could fit anybody, and now lots of people say, 'That corrido fits me perfectly. It's mine.' So that inspires people and they like it, and it doesn't compromise anyone."

Antonio has written dozens of these corridos, macho tales of heroism that can be appropriated by whoever cares to claim the leading role. For instance, there is "Rumbo de Badiraguato" (Toward Badiraguato), which he has cut with both Sierra Llanera and the Renegados. It is the nostalgically boastful song of a local guy who has ended up on the wrong side of the law:

> Tierra de Badiraguato, sueño con volver contigo,
> Hoy me encuentro prisionero, tú ya sabes los motivos,
> Lo que son bastantes años los que estar en el presidio.

La muerte a mi no me asusta, tampoco estar encerrado,
La prisión es para los hombres, yo soy un gallo jugado,
Si ésta me tocó perder, también muchas he ganado.

(Land of Badiraguato, I dream of returning to you,
Today I find myself a prisoner, you already know the reasons,
It is plenty of years that one is to be in prison.

Death does not frighten me, nor being locked up,
Prison is for men, and I am a tested fighting cock,
If I happened to lose this one, I have won plenty.)

Considering how many local characters seem to end up spending time in jail, and how many friends and relatives sympathize with their situation, Antonio's market is obvious. Along with the literal prisoners, there are all the Badiraguatenses who have had to leave their ranchos and emigrate to el otro lado. While not behind bars, they are still stuck in a strange and foreign place, easy prey to homesickness, and tighter immigration restrictions mean that it is getting harder and harder for those without papers to cross back for visits. Antonio says that his songs are selling very well in southern California: "A lot of people from here in the sierra leave for Los Angeles, so they listen to the corridos we are writing here and it makes them feel as if they were here in Badiraguato. They like the corridos because of that as well, because it takes them back home."

I am interested in all of this, but am itching to ask Antonio about his kidnapping. José Alfredo had said that the composition he wrote under duress was "De Cerro a Cerro," the lead song on the second Canelo cassette, and, with as much delicacy as possible, I ask if the tale is true. Antonio seems a bit surprised at the question, then dismisses it with a short laugh. "No, it wasn't like that," he says, waving the idea aside in a way that leaves me only partially convinced. "That is, it was friendly, they didn't force me. It was completely voluntary. He told me that he wanted a corrido, asked if I could compose one for him, and yes, I composed it, it took about an hour, I did it just that quickly. But it doesn't mention any names or anything. It's pretty, have you heard it?"

As it happens, I have not, and he puts it on. The instrumental mix is unique and curiously attractive, the guitars playing a steady rhythm while the tuba skips around them like a light-footed hippopotamus. Then El Canelo comes in, his voice rasping with the nasal intonation of the Sinaloan hills:

Hoy cruzo de cerro en cerro, sin importarme el peligro,
Esto lo traigo en la sangre porque soy de los malditos,
Ahí paso por el aire al rancho de Batopito.

(Today I cross from hill to hill, not bothering about the danger,
I have this in my blood, because I am one of the damned ones,
I travel through the air to the rancho de Batopito.)

The instruments play a short break, the tuba doubling the lead gui-
tar in a fast and precise unison passage, then the lyric continues:

Desde que tenía doce años a la vida le buscaba,
Unos me daban la mano y otros a mí me ignoraban,
Ahora les tiemblan las corvas, porque no perdono nada.

(Ever since I was twelve years old I made my way in life,
Some gave me a hand, and others ignored me,
Now their knees are trembling, because I forgive nothing.)

Even if the song did not arise from a kidnapping, with themes like
this it is natural to ask Antonio how his work has been shaped by living
in what is considered the most notorious town in the most notorious
state in Mexico. And, when I ask, I suppose it is just as natural for him
to defend the reputation of his home pueblo: "Yes, there are problems
here. But there are problems everywhere, right? Wherever you go, you
can find violence, smuggling, everything is everywhere, so how could we
say that these things don't happen here, if they happen everywhere? But
Badiraguato isn't like its reputation—or rather, Badiraguato has that
reputation because the people come from here, but they are sometimes
living in Chihuahua, or very far away. They get involved in violence or
other problems, and in the newspaper it says, 'Badiraguato, Badira-
guato,' so everything is brought home to us. We get the reputation, but
really, here in Badiraguato it's calm.

"I've lived here for a long time, and I've never had any problems, not
at all, ever. I'm comfortable, at ease, otherwise I would have gone some-
where else. Because I like to always keep my mind clear. I don't like to
have to go around thinking about other things, because I want to be
composing. I feel good when I'm alone, away from everything, from all
the crowds, when I can be fully centered on what I am doing. Some-
times I go off with my notebook and I sit out somewhere and look at the
hills, I relax, and I get to writing corridos. It's wonderful how it focuses

my attention to be out looking at nature—that gives me a lot of the foundation for my writing. It's a nice feeling, very satisfying."

The last bus had left at 5:00, but Antonio offered to give me a lift down to Pericos and I decided to accept. We swung by Carmen's house and she came out in a new costume of short shorts and a tank top. She seemed rather disappointed, but gave me my pack and guitar, and we drove down to the crossroads. There was at most another hour of daylight, but I was only half an hour from Culiacán, so I was relaxed and pleased with the day's events. After about twenty minutes, a pickup came down the road from Badiraguato, paused at the crossroads, then pulled out into the main road, and the three guys sitting in the back waved for me to jump in. The taxi driver who works the Badiraguato-Pericos line had told them they should give me a lift.

My new companions were rural schoolteachers, or, as they put it, *"pobresores"* (poorfessors), taking weekend leave in Culiacán from their one-room schoolhouses in the ranchos above Badiraguato, or, as they called it, "Marijuanato." They were working their way through a couple of cases of beer, and I was happy to join them, then plied them with questions about life in the mountains. Unlike Antonio, they were more than willing to talk about the drug scene: "Oh yeah, it's everywhere," the thinnest, most talkative guy told me. "When you first go up there, in the first few days, the local men come around and invite you to a party, get you drunk, give you marijuana, cocaine. The marijuana is incredible, nothing like what you get in the city: I took two or three tokes, and I was on the floor. But you have to join in, you know? Everybody thinks, because you're a schoolteacher, that maybe you're a faggot, so they're trying to test you out. Then, after that, you're okay, they don't bother you."

His name was Juan Carlos, and he told me that I should come up and visit him sometime during the week. He said that it wasn't really as dangerous as people say, that you just had to know where not to go, which ranchos were full of troublemakers. Only one thing: "If anyone offers you cocaine or mota you take it, because when they see that you're a gringo they may suspect you're from the DEA or the CIA, and if you refuse to take a snort then it's like a test, 'cause they know the agents aren't allowed to do drugs."

Somehow we all ended up at yet another strip club, La Jacaranda, somewhere over in a run-down part of the city. I was tired, but there was no escape: Juan Carlos had invited me to stay at his house, I had

accepted, and the pobresores had to unwind and blow off some steam before going home. Juan Carlos knew the club's manager, so I stowed my pack and guitar in the office and hunkered down for another long evening of women peeling down to bikinis over bad disco music, subpar ranchera singers and, this time, not even a ventriloquist to perk things up. The one interesting aspect of the situation was watching the men along the ramp, as they watched the ladies but kept running their hands over one another. Oscar, the painter, had pointed this out to me at El Quijote: a lot of the macho men seem to let out another side of their personality when there is enough alcohol, sex in the air, and no "decent" women around. One of the pobresores even had a go at me until Juan Carlos told him to lay off.

I lost track of time, but it must have been around midnight when we finally left. By now it was just me and Juan Carlos. He hailed a cab and instructed the driver to crawl slowly down a nearby block until he spotted a fellow lounging by a taco stand, then waved the guy over and bought a twist of clear plastic containing a single hit of cocaine. He did not ask whether I wanted any, just took his sniff and directed the taxi to a discotheque down by the river. I think we went to another bar afterward, but I was so groggy by then that I cannot say for sure. I have no idea what time it was when we finally ended up at his house. He lived in a nice little two-story duplex in a modern neighborhood, and his wife met us at the door and welcomed me warmly, despite our condition and the lateness of the hour. She moved the kids onto the couch and showed me to their bedroom, and I collapsed into a heavy and dreamless sleep.

The next day, I figured that Juan Carlos and his family needed their weekend to themselves, so I checked back into a hotel in the center of town. Once I was settled, I decided to listen to the Canelo tape again, but found that my tape recorder was missing. Someone could have taken it from my pack in the strip club office, or even at the disco. Me, though, I suspect Carmen.

NEW GENERATION

Mario Quintero y Los Tucanes de Tijuana

No solo de traficante se puede ganar dinero,
Mi respeto a los que son, pero yo tengo otro empleo,
Y tengo amistades grandes, y traigo mi carro nuevo.

(Not only as a trafficker can one make money,
My respects to those who are, but I have other employment,
And I have important friends and drive a new car.)
—"No Solo de Traficante," by Mario Quintero Lara

Saturday was a good night to be in Culiacán, as the Carta Blanca base-ball stadium had a seven-act ranchera show featuring the return of Sinaloa's hottest young band. Los Tucanes de Tijuana were headlining a bill that included Julio Preciado, onetime lead vocalist for Banda El Recodo, and his new banda; Priscila y sus Balas de Plata, the new teen queen of norteño pop; two lesser bandas; a norteño conjunto; and a Miguel y Miguel–style guitar duo.

Los Tucanes, a quartet of telegenic twenty-somethings who have been racking up hits since the mid-1990s, are the most criticized band in mod-ern ranchera. While Chalino was *el mero mero*, the hardest-bitten corrido

singer of them all, it is the poppier Tucanes who have drawn the mass of fire from antidrug polemicists and guardians of public morality on both sides of the border. One reason is simply their popularity among young listeners: like Eminem in the rap field, they are not the most extreme group but are the most worrisome to middle-class parents, and their high sales—second only to Los Tigres in many markets—make them a headline-grabbing target. Then, there was an interview in the respected *Proceso* magazine with an informant from Tijuana's Arellano Felix drug cartel, the most violent in Mexico, in which he said that Los Tucanes had started out as protégés of Ramon Arellano Felix, who bought them stage outfits and had them write songs about the cartel's killings.

What cemented Los Tucanes' bad reputation, and provided juicy quotes to horrify respectable newspaper readers, was that their songs departed from previous narcocorrido tradition by celebrating not only drug smuggling but the drugs themselves. When they first hit with "Mis Tres Animales" (My Three Animals) in 1996, they created a colorful new iconography of narcotics and made a lot of people nostalgic for the more innocent days of Los Tigres. The song is a cleverly coded celebration of the trafficking lifestyle, based on slang terms that were already common on the street but were unfamiliar to less drug-savvy listeners. It begins with a montage of farmyard noises, then the accordion starts up, accompanying a deceptively childlike lyric:

> *Vivo de tres animales que quiero como a mi vida,*
> *Con ellos gano dinero y ni les compro comida,*
> *Son animales muy finos, mi perico, mi gallo y mi chiva.*

> (I live off three animals which I love like my life,
> I earn money with them, and I don't even have to
> buy them food,
> They are very fine animals, my parakeet, my rooster,
> and my goat.)

The singer goes on to say that in California, Nevada, Texas, Arizona, and even Chicago he has people who sell his animals "more than McDonald's sells hamburgers." He once was poor, he explains, a burro driver, but now he is a great man because the *güeros* (white folks) crave his "pets." He has lots of money to spend on his friends and to attract women, and the government cannot catch up with him. Of course, his life is also filled with danger, so the song ends with what, in Los Tucanes' world, passes for a moral warning:

Dicen que mis animales van a acabar con la gente,
Pero no es obligación que se les pongan enfrente.
Mis animales son bravos, si no saben torear, pues no le entren.

(It is said that my animals are going to destroy people,
But no one is being forced to get involved with them.
My animals are fierce; if people don't know how to fight
 bulls, they shouldn't try.)

Mario Quintero, Los Tucanes' songwriter, musical director, bajo sexto player, and lead singer is painstakingly serious as he defends the harmlessness of his most famous composition. A thoughtful young man, who would look baby-faced were it not for his bushy, black mustache and piercing, dark eyes, he says that the song's double meanings are a way of protecting young listeners: kids will not get the coded references and can just enjoy it as a fun little ditty about animals. "I never say 'drugs' or 'mafia' or anything. That's so people can understand it in their own way, each according to his taste. I do my best to protect the children, who really don't know what it's about—when they grow up, then they can understand it differently, but I don't want to have a negative influence on anyone's thinking."

Mario seems sincere, but it is a bit hard to buy this explanation and harder still to apply it to some of his other compositions. Take "La Piñata," a 1997 hit that tells of a party featuring a piñata that, in place of candy, had "something more expensive, nothing but little bags full of the fierce animals," and was followed by a cake that, instead of being made with flour, was a "Colombian cake," handed round in servings of five or six grams. "And if you want to make piñatas," the song ends, "I have the little bags right here." Another song on the same CD, "La Mesa Servida," explains that whenever the singer arrives at a dance his table is already set with beer, wine, and women, "and a little paper packet in the corner—to listen to corridos, these are my vitamins."

"La Piñata" was cited all over the place as an example of the depths to which the corrido had sunk. It was also widely imitated: Antonio Uriarte, for example, has a song called "Pastel Colombiano" (Colombian Cake), a barefaced rewrite of the Tucanes hit. These songs reflect a new trend not only in drug corridos but in drug use. As Mexico has become the main transshipment point for Colombian cocaine, the pricey white powder has taken on something of the same mystique it had in 1980s disco culture north of the border. Much of its appeal comes from the fact that it is foreign and expensive. Unlike marijuana, which has always

107

been around and is considered something for peasants, hippies, and bored soldiers, and opiates, which were once an upper-class vice but now are the mind-deadening narcotics of scruffy urban riffraff, cocaine fits with a lifestyle of greenbacks, crema de seda shirts, *carros del año*, imported whiskey, and beauty queens. (Crack, the less chic form of coca, is becoming more common among poor kids in the larger border towns, but as far as corridos go, I have never found a mention outside the LA gangsta scene.)

Coy references to cocaine use began sliding into norteño in the mid-1990s (the first example I know is in Los Tigres' 1994 hit, "Los Dos Plebes"), and it soon became a corrido cliché to include a line where someone offers someone else "something to keep you awake," or makes a little trip to the men's room "so as not to get tired." In a distinctively Mexican fusion of narco chic and old-time machismo, cocaine has been hailed as the drug that counteracts alcohol, allowing its users to keep drinking all night long without becoming sleepy or befuddled. Los Tucanes, though, were the first major group to go beyond such fleeting references and devote whole songs to cocaine parties. "La Piñata" was a great favorite in some circles, and on their next corrido album, titled *Los Más Buscados* (Most Wanted), Mario further expanded his repertoire to include marijuana songs. In one number, "El Pelo de Ángel" (Angel Hair, the top grade of Mexican marijuana), he mounts an uncharacteristically didactic defense of smoking:

> *Han dicho grandes doctores que estas plantitas no dañan,*
> *Que te relajan los nervios y tus tensiones se acaban,*
> *También provocan apetito a la gente desganada.*

> (Great doctors have said that these little plants do not
> cause harm,
> That they relax your nerves and eliminate tension,
> Also, they provoke an appetite in people who do not
> want to eat.)

More usually, though, what distinguishes Mario's writing is its lightness and humor. Another marijuana song, "El Paro" (The Break), is the monologue of a guy taking a break from work to smoke some dope (which—presumably to protect the children—he refers to as "Martin") with his friends, and is full of lines like:

> *La policía la quema, también nosotros podemos;*
> *Si ellos queman toneladas, nostoros quemamos leños.*

La culpa no es de nosotros que exista la hierba buena,
Porque aquí la combatimos, en cuanto llega se quema.

(The police burn it up, we can do the same;
If they burn tons, we burn joints.
It is not our fault that grass exists,
Because we are combating it here; as soon as it arrives
 it gets burned.)

When one puts these lyrics alongside Mario's cozy rhymes about drug lords and Los Tucanes' purported Arellano Felix connection, it is easy to see why the band's work is often treated as a Mexican equivalent of gangsta rap. The comparison does not extend very far, though. While the LA-based chalinitos cultivate a street-smart, gun-toting, tough-guy image, Los Tucanes dress in brightly colored, Tigres-style cowboy outfits, with no guns in sight, and have created a successful double life for themselves: their albums are released in pairs, one of corridos and one of love songs and dance numbers. The corrido releases have drawn more attention from the serious press, but the "clean" albums are what get covered in the teen-beat fan magazines and played on radio and television. Chart listings show the corrido sets selling somewhat fewer copies than their twins (though this balance may be redressed in the pirate cassette world), and, aside from "Mis Tres Animales," the group's biggest hits have been love ballads like "Amor Platónico" (Platonic Love) and merengue-flavored dance-club workouts like "El Tucanazo" and the fabulously popular "La Chona." Because of this, I often ran across ranchera fans who did not even think of Los Tucanes as a corrido group. The band is sort of a norteño-pop Jekyll and Hyde: even as congressmen are using their songs as exhibit A for banning corridos from the airwaves, I passed a PRI-sponsored billboard outside Torreón which boasted the endorsement "Los Tucanes de Tijuana con Paco Davila Gobernador" (Los Tucanes de Tijuana support Governor Paco Davila).

Indeed, if one could ignore all the drug lyrics, Los Tucanes could lay claim to being moralists and patriots. *Los Más Buscados* includes one of the only corridos I have found about the AIDS crisis, and it manages the neat trick of warning young Mexicans about the disease without suggesting that a plague so clearly connected with immorality could be contracted in Mexico. Called "El Error del Graduado" (The Graduate's Mistake), the song tells of a young man, recently graduated from college, who is sent by his family to a business meeting in New York, where he meets a girl at a party and is infected with the fatal virus.

Mario seems genuinely horrified that anyone would put him in the

same class with the gangsta rappers, or even with mainstream Mexican rockers. "There are songs in rap, or in rock music, which are much nastier than mine," he says. "But really much, much more. I don't use bad words in my corridos, because I don't like them, but I've heard lyrics by groups like Maná, Control Machete, Molotov, from all the rockers—I understand that everyone works in his own way, but their stuff is much stronger. The corridos are cleaner."

Offstage, Los Tucanes are pleasant, well-spoken young men, polite and respectful to those around them. While their fans may imagine their lives as one long party, they are dedicated professionals who spend most of their time on tour eating salads and avoiding anything that could interfere with their work. "We take good care of ourselves," Mario says. "The only vice we have is women, and I think that's a very good vice. Yes, we enjoy having a beer and a drink, but we try to take care of ourselves so as not to cheat the public. Because we are always working. If we're drunk, that's no good, and besides we don't have the time. We always drink water, all kinds of juices. . . ."

I first met Los Tucanes in Mexico City. I had expected to have some difficulty getting access to such a popular band, but being a gringo writer turned out to be a magic charm, and I caught up with them backstage at a television special celebrating the end of a two-week educational fair sponsored by Televisa, Mexico's main network. They were the featured band, headlining a full-scale blowout with movie stars, comedians, and a sexy blonde singer twisting in skintight, tie-dyed bell-bottoms. (As she did her bit, one of Los Tucanes' crew informed me that she was a Sinaloan beauty queen with high-level drug-lord sponsorship.) She was accompanied by four bare-chested male dancers, all flamboyantly gay, and Los Tucanes spent the rest of the evening doing imitations of the way one had sidled up to Mario and said, *"Hola, compa"* (Hi, buddy).

On TV, Los Tucanes mimed along to their dance hits, with Joel Higuera, the group's accordionist and comedian, spending a few wonderfully ridiculous minutes trying to teach the host how to do the gawky, flapping dance he has invented to go with "El Tucanazo." The stagehands, who had pretty much ignored the other acts, were watching, and a couple even danced a few steps of *quebradita,* the hot new ranchera dance style. Later, as we got into the van to head back to Los Tucanes' hotel (one of Mexico City's most expensive, where the dining room was being kept open after hours just to provide us with dinner), the parking attendant asked all the band members to autograph the back of his orange jumpsuit.

A few nights later, I was with the band again, this time for a concert in Temixco, a suburb of Cuernavaca. They were headlining a multiact bill at an outdoor fairgrounds and drew over seven thousand paying customers. This looked to me like a pretty fair bunch of people, but their manager took me aside to apologize and urged me to come see them again when they had a decent crowd. The band, meanwhile, showed no sign of disappointment. They played for two and a half hours, working on a portable stage that included palm trees, inflatable toucans, a moon and stars, Roman candles, and massive screens on either side showing close-ups of the show blended with clips from the group's music videos.

At the Culiacán show, there was no reason to apologize for the turnout: Los Tucanes broke the previous record for the baseball stadium, bringing in a crowd reported as between twenty-two and thirty thousand. Their manager told me that they had just done a Tijuana show in front of sixty-five thousand but this was still quite respectable. They were using a different stage (they have three), and it included not only the usual lights, video screens, and toucans, but also a mortar to launch rockets that exploded above the field at key moments. At Mexican outdoor concerts, it is usual for each group to have its own stage, which means there is no wait between acts. As each group ends its set, another starts up on the other side of the field, and the crowd surges across to the new site. The only problem with this arrangement is that if one wants to be up close to the headliners one has to stake out a position at their stage and thus miss whoever is playing before them. In this case, Julio Preciado had only about half the fans watching his set. The others were already jockeying for positions to see Los Tucanes.

Los Tucanes presented their usual fast-paced mix of corridos, love songs, and dance numbers. While bass and drums kept a steady pulse, Joel sang harmony, punctuated the vocals with little bursts of accordion, and entertained the audience with his mugging and dancing. (His instrumental work is effective but hardly virtuosic, and he jokes, "I dance because I don't know how to play.") Meanwhile, Mario held down a solid rhythm on the bajo sexto and sang lead in his clear, sharp Sinaloan tenor. Though less showy than Joel, he is an engaging frontman with a sprightly, good-natured approach on the dance numbers, a rather moony style on love songs, and a hard-edged humor for the corridos.

"When it's time to perform a corrido, you have to act it out," he says. "You have to make people believe in what you're saying. This is very important, because there are groups that record corridos just to record: they say, 'If Los Tucanes . . . if Los Tigres . . . ,' and they record a corrido

and do it like a romantic song. They don't give it the feel it should have. A corrido should be fierce, interpreted strongly—just as you have to give a romantic song a certain sentiment, you have to give a corrido its own feel."

In Culiacán, it is the corridos that get the loudest cheers: "Mis Tres Animales" has the crowd yelling as soon as the animal sounds come over the speakers. This sort of recorded introduction is now a staple of the narcocorrido genre: Los Tigres started the trend when they used farm noises to open "Pacas de a Kilo," and any sound effects that are used to introduce songs on record are also broadcast at live concerts. Later in the show, we get Joel miming the part of a pilot and Mario his passenger as their recorded voices boom out over the sound of an airplane engine:

"I want you to land immediately!"

"But we can't, sir, it's very dangerous."

"Do as I tell you!"

"All right. Here we go."

"Be careful. Don't be scared. Careful! Aaaaaahhh. . . ."

There is the sound of a crash, and Los Tucanes swing into the ballad of Hector Luis "El Güero" (Whitey) Palma, who was captured by the Mexican army at his Guadalajara mansion in 1995, after surviving the crash of his Learjet the previous day. (Also arrested were over thirty policemen who had been acting as El Güero's bodyguards.) The song refers to Palma as "a respectable gentleman," and ends with a typical warning to the drug lord's enemies:

> No estén tranquilos señores, que el cuento aquí no se acaba.
> Las órdenes son las mismas, siguen al pie de la raya.
> Hagan ya su testamento, puede explotarles la almohada.

> (Don't rest easy, gentlemen, the story does not end here.
> The orders are the same, keep toeing the line.
> Make your will, your pillow might explode.)

The listeners, by and large, do not look like drug guys, or at least not very successful ones. The big shots are in Guadalajara or up on the border, and in any case would be unlikely to spend their evening standing around a packed-earth baseball field. Most of the fans are young, boys and girls on dates or clumps of guys together. Some are in the latest fashions, others clearly have come down from the ranchos just for this concert. To these folks, Los Tucanes are more than stars: they are sym-

bols of local kids who have caught the brass ring of success. The drug connections are almost irrelevant. What matters are the fancy clothes, the immaculate, swanky tour bus, the fireworks and video screens, and the girls who stand in a long line at the side of the stage waiting their turn to run up, three at a time, and plant kisses on the cheeks of their idols.

Mario has been a professional performer for almost half of his twenty-eight years, but his impressive control and self-confidence are blended with the old-fashioned reserve of someone raised back in the country. Los Tucanes come from the same small rancho near Mocorito where Pepe Cabrera was born, and simply getting to Tijuana—a place Mario describes as "paradise" compared to his birthplace—was an accomplishment. At the time, Mario was only twelve, and his partners a year or two older. "Each of us arrived on his own, even though we're cousins," he explains. "And we all had the same dream of playing music."

It is a dream shared by many country kids, but Los Tucanes had good connections. Their uncles had headed north ahead of them and formed Los Incomparables de Tijuana, the most popular group in the West Coast border state of Baja California. Los Incomparables took their young relatives under their wing, buying them instruments and giving them opportunities to show off their stuff: "When they would take a rest at the parties, we would fill the fifteen-, twenty-minute intermissions. That was how we got started, playing at weddings, *quinceaños* [more usually called *quinceañeras*, these are fifteenth-birthday parties, a important rite of passage for Mexican girls], baptisms, store openings. They always had faith in us and helped us out with everything."

The quartet started playing professionally in 1987, when Mario was fresh out of school and still not old enough to enter clubs as a customer. "We played in a cantina called Raza's Club. I was sixteen and you had to be over eighteen to get in, but they let me in because I had a mustache, I let my beard grow and all that. As soon as we finished playing in the bar, Joel would take me home because I couldn't hang out there. Plus, I was working in a factory and had to be there at seven in the morning— we made files, for smoothing all kinds of things. So I would leave the bar at three and be at work by seven. Each of us had different jobs, we did all sorts of things, thank God we never lacked work. But it was hard, and we kept struggling to make something of ourselves, until finally we decided we would all give up our jobs and dedicate ourselves one hundred percent to the group."

While Los Tucanes' success owes much to the help of their uncles, to

their work ethic, and to their upbeat, highly produced live shows and music videos, their strongest card is Mario's songwriting. They are the only major group in the history of norteño to rely exclusively on the work of a single composer. In some ways, this is a handicap: unlike Los Tigres, they cannot switch writers when they need a new sound, and some old hands think that their career has already passed its peak. Still, the variety and freshness of Mario's songs, from clever corridos to catchy dance hits, have made them the most influential young group in the field.

Mario has no worries that he will burn out, least of all as a corrido composer. He says that there are simply too many good stories around: "We live in Tijuana, and Tijuana is a clash of cultures; people come there from every part of the world, and each comes with a story. These people approach those of us who have groups that sing corridos, and they tell us stories, they write us letters—including people who are in jail, they write me letters about their lives. So I look for the most interesting story, something that I think is similar to someone else's story, so they will be interested, so they can identify with it. Then I develop it and put in my own fifty percent that I think will help it work—but that is just as real, because I have seen how people act."

Mario started writing as soon as he got into music, and corridos were his first strength. At sixteen, he provided Los Incomparables with "Clave Privada," which went on to be a big hit for Banda El Recodo. It is the lilting, waltz-time boast of a self-made drug lord who drives around Tijuana in his Cheyenne del año with two men in the back, each holding two *cuernos de chivo* ("goat's horns," or AK-47s, so called because of their curved forward grip), and two cars of bodyguards alongside, and who sends drugs to the United States, where "they buy a hundred kilos of powder as if they were buying flowers." All in all, the usual narco fare, but it is still a polished piece of work for a sixteen-year-old. Mario says he was influenced by the best of the previous generation of corrido masters—Paulino Vargas, Reynaldo Martínez, Julián Garza—but his biggest influence was his uncle Mariano Quintero, one of Los Incomparables:

"I began looking at what he wrote and absorbing the way corridos are made, and I wrote some verses and showed them to him, and he corrected me. He explained, 'This needs to be this way, this should go here, and that doesn't fit.' Because, since we were born in the sierra, I used words like '*pos*,' instead of '*pues*,' and got the themes all tangled up. I didn't give them a beginning and an end, I had them backward, I would say the same thing over again and it was very repetitive. And he always told me, 'A corrido has to have a beginning and an end, it has to be two verses and a chorus, another two verses and a chorus, and at most it

should have seven verses, because it has to be at most three and a half minutes long [for radio play].' And, more than anything, he taught me how to put together rhymes. So I got all of that from my uncle Mariano."

"Clave Privada" showed all of this solid technical schooling, and also a personal touch that would be typical of Mario's corridos: alongside the boasting about guns, cars, and women, the traficante cites his humble roots. "For a long time I was poor and many people humiliated me," he sings in the second verse, before saying that now they all respect him and call him boss. This is a sentiment that resonates strongly both with the corrido-buying public and with the performers themselves. Despite Los Tucanes' fancy trappings, Mario has not forgotten his childhood of rural poverty. His songs about drug dealers are accurate and sympathetic, in part because he spent his youth around kids who are now in the trade and he understands exactly how they came to be there. "We grew up in the country life: horses, cows, growing corn and beans to eat—not a corrido, eh? There in the sierra there's no future, you're just like Indians. Thank God we had the opportunity to leave and to get to know cities, but there we didn't know anything about cities. We always ate everything we grew. So, in the sierra you have to do something to get ahead. You can't do it in school, because there isn't one. When we were born there wasn't even electricity or anything, you got water from wells or from the stream."

Again and again, Mario's protagonists stress their humble past and the poverty that inspired them to skirt the law. "The money I have was not inherited," declares a character nicknamed La Ley 57 (Law 57), and another says, "Today I have what I want, although the government pursues me / That doesn't worry me—being poor is what scares me." "El Cartel de a Kilo" (The One-Kilo Cartel) celebrates a proudly small-time dealer, someone who sells single kilos to individual clients rather than shipping tons across the border. While plenty of people say that what he is doing is wrong, and that the money he earns is soiled, the dealer's response is that, "Even if money is dirty, it will take away hunger. . . . Poverty is not pretty even in the movies."

This is the philosophy that underlies the paeans to high-powered narcos. When Mario argues that his corridos have a "positive message," that they are warning people about the drug trade, "so that they can protect themselves and so that they will know about all of the bad things that surround them," he sounds more than a little disingenuous. Whatever he may claim, his songs do celebrate the bravery and flashy lifestyle of the traffickers, obviously and with relish, and when he relaxes he can be quite open about his admiration for his successful compatriots. He points out that he has seen another side of their characters: "Most of the

people who dedicate themselves to this kind of business are people from the small towns, from the ranchos, from the sierra, right? Sinaloans, and we're Sinaloans, so, well, we feel like we're part of this as well. And what's more, we admire that portion of the traffickers who are sensitive people: there are Catholic traffickers who build churches, who build primary schools, bring lighting to the ranchos. They don't just spend the money on themselves.

"We Sinaloans are very hardworking, we have a mentality that is very positive, always forward, forward, a mentality that is very noble, with a lot of patience, and we each do well in our field. I see that the majority of the mafiosos are Sinaloans, and, well, those are people who are brave and strong, aren't they? And I think of myself that way. We are Sinaloans, and we are brave too, but our talent is musical rather than for those sorts of bad things. That's what I think. I'm not in favor or opposed to the drug traffic—I'm a minstrel of music."

It is a theme he echoes in his autobiographical corrido, "No Solo de Traficante" (Not Only as a Trafficker). Writing in the first person, he explains that he, for one, has made his fortune without turning to the drug trade. "Everyone does what suits him," he sings. "I listen to narcocorridos and I don't sell hierba mala." He tells me that the song was written specifically in answer to the bad press he was getting: "I received a lot of criticism, saying that I was praising [drugs and criminals] in my lyrics," he explains. "The journalists said that I was making people get into the drug traffic. And I said, 'No, that's not true.' Because for me, when I was in the rancho in the sierra, I listened to 'Camelia la Tejana' and I didn't want to be like Camelia, a traficante. I wanted to be like Los Tigres, to sing corridos. So I said, 'Not only as a trafficker can one make money,' because we have many friends who are entrepreneurs, they have businesses and their carro del año, their family is well taken care of, as God wills, they are rich, they live very well. So it was to make people see that it's not true, that it's not just as a trafficker that one can make money. And also, it's part of our own lives, because thank God we are doing very well, we are enjoying our lives, satisfied with what we have accomplished, and we didn't dedicate ourselves to drugs." As he sings:

> Hay que empezar desde abajo pa' disfrutar lo logrado,
> Yo le doy gracias a Dios porque siempre me ha ayudado,
> Aquel negocio pequeño ha crecido demasiado.

(You have to begin at the bottom to enjoy what you have
 achieved,

I give thanks to God, because he has always helped me,
This little business has grown so much.)

Yet, even as he exults in his own crime-free success story, Mario does not forget the powerful fans who have made other choices. He concludes the song with a salute to those who have achieved their fortune by more dangerous means:

Si me escucha algún mafioso, yo le mando un gran saludo,
Porque esos sí gastan lana y nos han fortalecido.
Si no hay dinero en el pueblo, hay bastante mas peligro.

(If any mafioso hears me, I send him a big hello,
Because those guys spend dough and have made us strong.
If there is no money in *el pueblo*,* there is a lot more danger.)

Since he wrote the song in response to his press coverage, Mario is a bit irritated that none of the writers who have interviewed him ever ask about it. To him, this is typical of a hypocrisy that underlies the whole anticorrido backlash. "The reporters always say to me, 'Why do you write corridos about El Güero Palma, about Chapo Guzmán, about Caro Quintero, when they are the ones who are poisoning the world?' Well, I read the newspapers and I see that these are people who are monopolizing the attention of the press, so I see it as a business as well. I'm not going to make a corrido about some cousin of mine whom no one knows. Better to make one about Chapo Guzmán, who has monopolized the newspapers and the media, and whom everyone is talking about. And especially when these are people like I mentioned a little while ago, people who help the poor, who protect the humble folk from the ranchos."

Mario adds that, in any case, the bad press has probably helped Los Tucanes more than it has hurt them: "The people who have talked about us, who have thrown dirt at us, who have criticized us, they have opened doors for us, they have given us many important interviews. So I look at it from the positive side. And I've always said that we aren't doing anything harmful. We are an effect of the drug traffic, not a cause. If we were to stop singing corridos, there would still be people

* In general, I have translated *el pueblo* either as "the village" or "the people," depending on the context. In Spanish, though, it can be both simultaneously, as it is here.

doing what they do. I say, 'If by getting rid of corridos you can get rid of drugs, go to it! We'll retire.' We have nothing to do with all of this, we just put it to music."

Anyway, how many of the ink-stained wretches who criticize Los Tucanes would give anything to be up onstage right now, the focus of tens of thousands of adoring eyes, urged on by screaming hordes of happily undulating female fans, and earning a fortune? No wonder Mario finds it easy to shrug off his detractors, or that he willingly spends his energy in an endless whirl of interviews, publicity events, and multi-hour concerts.

"One has to keep going forward, doing new things," he says cheerfully. "And for me, all of this isn't difficult, because it's what I always wanted to do. I love it and it's not work to me. It's my dream come true, and I do it with all my heart."

According to the next day's newspapers, Los Tucanes' concert lasted four hours, but I was exhausted and left somewhere into hour three. As I was walking back along the river that divides central Culiacán from Tierra Blanca, a police car pulled over with two cops in it. They demanded my identification and asked what I was doing, where I was coming from, and where I was staying. Then, changing their tone, they said to jump in and they would give me a ride to my hotel. I settled in between them, trying not to jostle their submachine guns, and as we drove, one of the cops passed me a notebook full of his song lyrics. "I have plenty of songs much better than Los Tucanes'," he told me. "It's just that I don't have their connections." None of the songs were corridos, so I did not pursue the subject.

SECTION 3

El Otro Lado

THE CLOWN PRINCE

Francisco Quintero

It was time to get a glance at the corrido world on el otro lado, which meant a change of lifestyle: when in Gringolandia, do as the gringos do. I flew into Los Angeles and rented a car at the airport, ate a good meal of barbecue, greens, and sweet potato pie, then called Francisco Quintero. I had decided that Francisco would be the perfect Hollywood corridista. Although he made his reputation as a writer for Los Tigres, his main work these days is with Grupo Exterminador, the most ridiculously flashy and theatrical narco band in the business.

A young quintet from Guanajuato, Exterminador can be considered

a logical extension of Los Tucanes: like Los Tucanes, they are clean-cut, handsome young guys who play both perky dance numbers and tough narcocorridos, but in Exterminador's case the corridos are often played for laughs, and it would be hard to take them for serious chroniclers of the drug world. Not that they suffer from a shortage of drug references: their first hit album was titled *Me Gusta Ponerle al Polvo* (I Like to Do Powder). It is just that they are so over the top. Their lead singer has a gravelly voice that sounds like something out of a cheap gangster movie, and the songs Francisco has written for them often sound like parodies of more famous narco hits: where Los Tigres sang "Pacas de a Kilo" (One-Kilo Packets), Exterminador sings "Narices de a Gramo" (One-Gram Nostrils). Their singles tend to include little introductory playlets, in which they act out the confrontation between a narco and a cop or the flummoxing of a border patrolman by a clever trafficker, before the accordion revs up and they sail into the corrido. At their best, they come off as a norteño equivalent of the Coasters, the court jesters of early rock 'n' roll.

Exterminador's theatricality has brought them a unique audience: the hardcore narco crowd considers them entertaining clowns, while youngsters who are turned off by the harder-edged groups can enjoy their comic-book version of the crime world. The one time I had seen them live, they were performing in the Rodeo Americano, Mexico City's attempt at a New York–style "urban cowboy" hangout. There was a mechanical bull to the left of the bar, and a man selling cowboy hats to the city kids as they came in the door. Exterminador hit the stage amid fireworks and smoke bombs, wearing long leather coats out of a spaghetti western, and heralded at frequent intervals by a booming voice echoing "GRUPO EXTERMINADOR-DOR-DOR-DOR-DOR," over a barrage of machine-gun fire. The girls screamed, the musicians strutted, and when the concert was over we all filed into an adjoining hall to sit on metal bleachers and watch a midnight rodeo, complete with bucking horses, relay races, and steer roping.

The kids cheering in the nightclub bleachers were typical of the audience for Exterminador's narco lite, though it would be wrong to suggest that the group is limited to this scene. Thanks to Francisco's compositions, Exterminador has become one of the biggest-selling bands in norteño, beating Los Tucanes in some markets. Their most famous song is his comic masterpiece, "Las Monjitas" (The Little Nuns). This is the saga of "two very cute *muchachas*" from Durango who disguise themselves as nuns and head for the border with a van full of cocaine, which they have disguised as powdered milk for an orphanage in Phoenix. They make it past most of the roadblocks, but finally are

stopped by a commander of federales in Nogales who is insufficiently religious. He gives orders to search them, but first asks the "sisters" their names: *"Me llamo Sor Juana"* (I am named Sister Juana), says one. Then her partner, stripping off her habit, yells, *"¡Me llamo Sor Presa!"* (I am named Surprise!), and they whip out machine guns, massacre the policemen, and go merrily on their way.

Francisco was my first Stateside corridista, and I had wondered whether it would be harder to get an interview with him than with people in Mexico. After all, LA is famed for its fast-paced showbiz mentality, and it also seemed possible that a Mexican narco composer would be more suspicious on this side of the border. As it turned out, I need not have worried. Francisco responded to my call with the welcome I was used to: "Come on over tomorrow, if that's convenient," he said, and suggested I meet him at the Durango Restaurant in La Puente, a small suburb that has been engulfed in LA's expansive sprawl. The next afternoon I drove east toward the snowcapped peaks of the San Bernardino Mountains and found the Durango nestled in a rather run-down shopping mall that looked like every other run-down shopping mall in southern California. It is a mission-style building, owned by Francisco's sister, and incidentally something of a corrido landmark: Francisco made it the setting for "También las Mujeres Pueden" (Women Can Do It Too), a hit for Los Tigres:

> *En el Restaurant Durango, de La Puente, California,*
> *Tres muchachas esperaban, procedentes de Colombia.*
> *Ahí quedaron de verse con las dos de Sinaloa.*

> (In the Durango Restaurant in La Puente, California,
> Three girls were waiting who came from Colombia.
> They had a date to meet there with the two from Sinaloa.)

The song is Francisco's bow to feminism, telling of five women who meet up in the restaurant for a drug deal and get into a gun battle. Of course, the Colombians die and the Sinaloans head back to Sinaloa. "Women can do it too," the corrido concludes. "They die like men, and there can be no doubt about that."

Francisco is a stocky, rumpled-looking man with a thin mustache and the pointy, oversized canine teeth that have given him his performing alias, El Vampiro (the Vampire). He wears his shirts open to the navel to show his gold chains, his wrists and fingers have plenty more gold, and he balances these disco-king accoutrements with a fringed leather jacket and a white cowboy hat. He greets me as I enter, and gestures me

to a booth near the front windows, then sits across from me, carefully placing his hat on the seat beside him.

"So, was there really a shoot-out here?" I ask him, after settling into my seat and ordering up a large plate of *chiles rellenos*.

"No, no," he says, shaking his head and smiling. "Everything I write is fictitious. I don't rub elbows with those kinds of people, because rubbing elbows with those people is dangerous. I know some of them because I'm a musician—not a famous musician, but a musician in the nightclubs, which is where one sees the worst things. That's my school, the school of life. But I don't like drugs, and I have nothing to do with those things.

"There are others, for example Chalino, who composed corridos for people who were involved in dirty business, with drugs. They would give him money or whatever, presents. But I don't do that. My corridos don't harm anybody, because they're about characters who don't exist. And I live peacefully with everyone. No one speaks ill of me, I have made myself a respected figure. We are not gold coins that please everybody, but I always wear my hat pushed back on my head [i.e., not concealing his face], and things have not gone badly for me. I was born naked and now I wear shoes, I go around in good clothes, so what more can I ask of life?"

Francisco was born some fifty years ago in El Salto, Durango, the *tierra* of Paulino Vargas. His father and grandfather were both accordionists, and he followed in their footsteps, becoming a professional musician when he was eighteen. He started out in Durango, then moved up to Tijuana, and a year later to the United States. That was in 1969, and he spent the next twenty-five years playing in small nightclubs and at weekend dances, meanwhile supporting himself with a day job as a construction worker: "I worked making blocks, bricks, cement. I did many things, but I was always listening to the radio, and there was a time when banda was very hot all over the place, tecnobanda and everything, and they were playing lots of songs that had no point and corridos with no point. So I said, 'I can compose better than those guys who are working around here,' and I set myself to thinking.

"I have a little bit of talent and vision, which makes it easy for me to compose. I like to listen to people, how they talk and the things they say. When I hear something curious, a curious saying, I always seize on it, I write it down, and then I put it in the songs and it works very well. In that way, one day I wrote that corrido, 'Los Dos Plebes' [The Two Plebes, or Guys] and when people began to hear it, I began to sell a lot of cassettes—that is, for me to sell five thousand cassettes was a lot—but without promotion or anything, without a record company. Then, other

people began recording it, different groups, and Los Tigres del Norte did it and that was the *home run.*"

"Los Dos Plebes" is the most uneventful of corridos: two guys meet in a cantina, have a conversation over a drink and a bit of cocaine, then go their separate ways. Francisco says that the reason it hit was the language his characters used: "I listened a lot to people from Sinaloa, who said *'plebe'* for everything, that's the people's word, and they also call the important people *'plebe,'* like, 'There the *plebe* are, drinking.' So I said, 'That word has something.' That's the curious thing, that in a corrido there will be one or two words that make it attractive to people. It's not the whole corrido—of course, it all has to be good, but what always catches people's attention, what hits them, is that one word. And that corrido had a lot of words that no one had put in a corrido. Check it out: *'compa'* [buddy], that's a very common word: *'Qué pasó, compa,' 'Hey, compita,'* okay?" Francisco pauses, and starts humming the melody to himself, searching for another example. "The *'troconas del año,'* no one had used that before. The words were already there, for years, years, years, but no one had seized on them."

It was more than simply those few words. Francisco captured a whole style of speech and, while some of it is slangy and of fairly recent coinage, it is not a secret argot of the drug world. It is the common language of the Sierra Madre, mixing the rough style of backcountry farmers and cattle thieves with the elaborate locutions of an earlier, more courtly age: "There in the rancho, I used to hear my father when he introduced people, and it is a very different way of talking. Here, when you introduce someone, it's just: 'This is a friend.' 'Ah, pleased to meet you, my name is so-and-so.' And that's it.

"But there in the rancho it's very different: 'Look here, I would like to present my friend.'

" 'Ah, my name is Pascual Quintero and there in the so-and-so rancho you have your poor house. I am there to serve you at noon or at midnight, at the hour that . . .' It is all very long, and I put all of that in the corrido, and I think that people liked that, the way it goes:

> *Cuando vaya pa' Durango, oiga amigo sinaloense,*
> *Ahí tiene su pobre casa, por si algún día se le ofrece.*
> *Si en algo puedo servirle, pues no lo piense dos veces.*

> (When you go through Durango, listen, my Sinaloan friend,
> There you have your poor house, in case someday you care
> for it,
> If I can serve you in anything, well, don't think twice about it.)

"I think that all of that is what made the corrido become such a big thing, that it showed a friendly bond, not something conceited. There are some corridos that talk about very conceited characters, that say, 'I love all the women,' 'I carry a pistol,' 'I give my life for my friend,' 'I give cash to. . . .' Fine, but I don't write that class of corridos."

Francisco pauses a moment, and I seize the opportunity to tell him a story. When I was hitching down toward Durango, I was talking with one of the drivers and telling him about my project, and he told me that he knew one of the "Two Plebes," that the Durangan came from his home rancho. I was struck by the claim, because the corrido is so completely uneventful, and the characters so generic, that it would never have occurred to me that it might be about anyone in particular. And yet, just because the characters are so faceless, it is easy for anyone to appropriate them.

Francisco laughs and nods his head. "Yes, when I did that corrido, many people made themselves into the characters. Lots of *chavales* [guys] riding around in their trucks thought that they were the two plebes and lots of people said, 'I know them.' But that's what people are like. And I felt very good about it, because it was something that I had done. Although I'm an ordinary person, without education, who almost doesn't know how to read or write, I have managed to do some very nice things."

Francisco talks with pleasure of his record albums, which have been moderately popular on the local scene, and of the direct-to-video movies based on his corridos. He is particularly pleased to have starred in a couple of these, especially *El Agente Borrego* (Agent Ram), in which he plays an antinarcotics agent: "In real life, I always wanted to be a government agent," he says, rather to my surprise. "I never could, because my schooling didn't amount to much—in Mexico it would have been easy to be one, but I grew up here, and here one can't—but I've always been a man who likes justice, so I wanted to be that, and in the movie I had the opportunity. I played the leading role and killed various people, there were a lot of deaths, I was against drugs and corruption, and it was a very, very nice film."

There is an engaging oddity to Francisco, the disco cowboy who writes cheery drug songs while dreaming of being a cop. It is this off-kilter sensibility that makes for his most distinctive work. While he has provided Los Tigres with "Adiós Amigo," a quiet song about a man visiting his friend in prison, and the antidrug corrido, "Las Novias del Traficante" (The Trafficker's Girlfriends), it is his comic songs for Grupo Exterminador that set him apart. In a way, a number like "Las Monjitas"

is in the same tradition as "Contrabando y Traición": it makes no pretense of hard-bitten realism, but is infectiously entertaining. Francisco's best work has the broad humor of the Terence Hill–Bud Spencer spaghetti westerns, the gaudy Mexican shoot-'em-ups of El Piporro, and the goofily off-color Austin Powers movies. They are corrido cartoons, and Francisco says that "Las Monjitas" actually grew out of a naughty joke: "I'm always thinking, because I need to come up with things that are different, and I took 'Las Monjitas' from a joke about a prisoner who escaped from a prison. He was a criminal and the law was hot on his trail, and he didn't know where to hide and he went into a convent full of nuns. He asked the nuns to hide him, and they dressed him as a nun. So, the law arrived looking for the prisoner and they told the mother superior, they said, 'Let's see, bring them here, line up the nuns so we can see them.' And they ended up bringing all the little nuns, they lined them up, and they told all of them to lift up their clothing, and they all lifted up their clothing and when they got to the prisoner, he lifted up his clothing and, *'Surprise!'* And that's where I got that. I heard it in English, but I put it in Spanish—that is, when she lifted up her petticoat, *'Me llamo ¡Sor Presa!'* "

127

Francisco says that he spent two full weeks working on "Las Monjitas," and that other songs have taken still longer: "God gave me a talent, and I have made good use of it, and I don't write a corrido in an hour. All the composers boast that they write a corrido in a half hour, but not me. I'm very demanding. Some songs I write in a day, others I write in two, three days, but I have taken a month to write one. Why? Because it is very, very carefully worked out. I'm the number one critic of my corridos, and if they aren't good, it doesn't matter that they are mine, they are not good."

I am a bit surprised at this, since I think of Exterminador's work as relatively lightweight, but there is no denying that Francisco's comic corridos are expertly put together. They have the polished appeal of a summer blockbuster, complete with bimbos, car chases, and special effects, and are aimed at a different audience than the songs of a Chalino. Francisco is the first to agree: "What Exterminador does, it's pure theater, to sell, it's a business, not because they are involved in anything to do with drugs. It's like a movie. And me, I like action movies. If I go to the theater and don't see an action movie, I fall asleep, and in a corrido it's the same. A corrido, if it's full of action, and if it doesn't sound stupid, if the words are catchy, I enjoy hearing it."

Francisco tells me about a follow-up he has written for "Las Monjitas," a corrido called "El Curita" (The Little Priest): "I thought of the

story because you see that there are lots of priests who have raped women, children, so it's said. So I put in this corrido that he had got the better of more than four husbands, with their wives, and then the order came from the Vatican and he was defrocked. He went off to Sacramento and, since he didn't know how to do any other work, he began to push drugs, and he turned out to be very good at that. So, I wrote that now instead of blessing with holy water, he blesses with bullets, and that once he had a run-in with policemen in Tijuana, and he took off running, with his petticoats flying up. One has to find something different: just picture the little priest running, with his petticoats flying—that's what people see in their minds when they hear the corrido."

It is not exactly the heroic corrido of old, but Francisco is amusing himself and his listeners. He mentions two other recent songs, the first about a smuggler whose girlfriend was very thin—"she didn't have anything here or here either," he explains, with appropriate gestures—so he outfitted her with false buttocks, filled them with drugs, "and when she crossed the border, the immigration guys were so busy drooling over her, they didn't say anything to her." The second, "El Perro Traficante" (The Smuggling Dog) is about a trafficker who sends his dog across the border at San Ysidro every night, carrying two kilos of cocaine, until one day the dog gets in a fight with a police dog and is sent off to the pound. The song's hook comes in the final verse, where he writes, "No point in questioning him, the dog won't sing / If they want to understand him, they'll have to learn to bark."

Francisco occasionally sounds as if he would like to be known for more serious material—he mentions a corrido he wrote in response to California's anti-immigrant Proposition 187—but he is pragmatic: "The market is like that. To put it this way, speaking as we speak, if over here you are selling tacos that are very tasty, very good, and if over there is another little restaurant selling pure rotten tacos of shit, and the people go there, you have to give them those kind of tacos, because that's what they want."

Francisco adds that, in his own work, he has managed to rise above this level. He is proud that he has not stooped to the foul language now being used by some local corridistas, or to writing corridos de amistad for the drug lords. Still, in the next sentence he will boast of having been the first person to market an album under the now-popular LA rubric of "corridos perrones" (badass corridos). He may dream of being a federal agent and decry the damage wrought by drugs, but if this is the time of the narcocorrido, he intends to make the best of it: "The business of killing, of death, that has always existed, ever since the first men

were in the world, but in those times they killed with a bone, like Cain with the other guy—who was it? There are different eras, to put it like that. In one era they talked of brave people, of revolutionary people. And then they spoke of drinking, because that was all there was. And now drugs came along. So, depending on the era, you write about what people are talking about. And you try to write something different, so you won't seem like all the others. Because there is one thing I can say: around here, they are all trying to follow me, they are all monitoring me.

"You know, yesterday I came from Tijuana, and I heard that in Mexico a politician said a phrase, he said, 'If the dogs are barking, it's a sign that I am arriving.' They had criticized him a lot, because they are in the middle of the elections, and he was saying that all the politicians are talking about him, only he put it, 'the dogs are barking.' So I'm putting that in a song, and I was just working on it as I drove, I was writing in the truck. I don't yet know how it will go, but maybe I could write it for myself, as if I were referring to the other artists. Because right now a lot of people are talking about me, and there are artists who don't like me for whatever reason, out of envy. So I could say, 'If the dogs are barking, it's a sign that I am arriving.' "

GANGSTA CORRIDO DYNASTY

The Rivera Family

The visit to Francisco had been fun, but I soon realized that I had been
wrong to pick him as the perfect LA corridista: his songs may be full of
Hollywood flair, but Mexican LA is a long way from Hollywood. At least
as far as corridos go, this is a world of young street toughs singing about
their drug-dealing, gun-slinging pals; Chalino country with an overlay of
gangsta rap. The voice jumps off the radio: *"¡Aquí suena la Qué Buena!
¡La mamá de los corridos!"* A whole station, call letters KBUE for *"qué
buena,"* or "how great," calling itself "the mama of the corridos," plays
nothing but Los Tigres, Los Tucanes, Los Originales de San Juan,
Grupo Exterminador, Luis y Julián, and the whole swarm of young,

homegrown LA favorites, the urban gangstas of the narco boom. No station in Mexico has ever concentrated this heavily on the style, even in the states where it is permitted. And here, not only is it permitted, but La Qué Buena is one of LA's three top Spanish-language stations, and one of the top six overall. The week I arrived, it was running constant spots for a *"gira de las escuelas,"* or school tour. The *gira* was being promoted as a contest: whichever high school got the most signatures would win a free concert featuring Lupillo Rivera, Las Voces del Rancho, and El Chalinillo, three of the most down and dirty narco acts.

The Riveras are the first family of the LA corrido world. Pedro Rivera, the family patriarch, made his fortune as Chalino's producer, and his Cintas Acuario label has remained on the cutting edge of the local scene. When I had last been in town, in the summer of 1998, Pedro's son Lupillo was not yet a star, but he was already writing songs for many of the artists on Cintas Acuario and its sister label, Kimo's CDs. Now I heard him over and over, day after day, along with his sister Jenni and, somewhat more rarely, his father or his brother Juan. The Riveras have combined musical talent with a gift for marketing and promotion. I had first become aware of them through a series of CDs they issued under the title *Puros Corridos Perrones* (Nothing but Badass Corridos), with subtitles like *Para Raza Pelotera* (For Ballin' Dudes) or *Somos Cocodrilos . . . ¡Y Qué!* (We're Crocodiles/Cokeheads . . . Want to Make Something of It!). The album covers show drug transactions, with cowboy-hatted young men exchanging black briefcases while their bodyguards cover them with the latest weaponry. The analogy to the LA rap scene is unmistakable: Stetsons and pointy-toed boots are substituted for baseball caps and sneakers, but only to evoke the same atmosphere of big money and gangsta cool.

The music of the young LA corridistas mirrors this blend of old and new, country and city. Lupillo's latest hit is a remake of a Mexican folk standard, "Veinte Mujeres" (Twenty Women), a Spanish-language cousin to "St. James Infirmary" and "Streets of Laredo," but it opens gangsta-style, with a newscaster's voice saying, "We interrupt this program to inform you of a tragic news item: the well-known singer-composer Lupillo Rivera has received multiple bullet wounds and is in critical condition." Then the bajo sexto strikes up a waltz and Lupillo drunkenly shouts, "Carry me to the cemetery with this song playing!" As the accordion joins in, he sings of all the friends and musicians he wants to have follow his coffin, including twenty beautiful women, his true and not-so-true loves: "Some are crying from sorrow, others a sincere pain / And others, if I'm not mistaken, are crying for money."

LA is the new corrido frontier. The region has the largest concen-

tration of Mexicans outside the DF (some three million in LA County, making up between a quarter and a third of the total population), and its economic power makes it the center of the modern norteño music business. The major record labels have their offices here, the hardcore Sinaloan singers have mostly moved to the area, songwriters have come in search of publishing deals, and norteño and banda cassettes blast from car windows all over Lynwood, South Gate, Long Beach, and dozens of other neighborhoods and satellite towns. Driving down Pacific Boulevard, there is nothing but the street sign to suggest that English has ever been spoken here. All the businesses are run in Spanish, and there are record stores every couple of blocks. The radio is constantly promoting upcoming concerts and club dates: my first weekend, the big show was at Pico Rivera Stadium and featured a dozen well-known corrido groups, along with a *charrería,* or Mexican rodeo.

On any weekend night, the clubs are packed. In El Parral in Lynwood, every table has a centerpiece of long-necked Pacífico beers in a metal ice bucket, and brass bands alternate onstage, pumping out polkas and waltzes, with a norteño group filling in the breaks. The customers are mostly in their twenties, the men dressed in shiny crema de seda shirts, boots made from exotic leathers, and expensive cowboy hats. The women's clothes are shorter, tighter, and lower-cut than most would dare to wear in Mexico, and many of the wearers look all too conscious of that fact: as they make their way through the crowd, they keep their arms crossed protectively over their chests, except when they reach down to tug at the hems of their miniskirts.

The conversations are mostly in Spanish, but it is not unusual to pass a table speaking unaccented English. People outside the scene, Chicanos included, tend to stereotype the corrido and banda listeners as recent immigrants, but in fact the audience has plenty of kids who grew up in California, listening to rock and rap. Many of them still listen to Anglo pop, maybe mixed with a little *rock en español,* and when they go to other clubs they will wear the latest brand-name sneakers and warm-up jackets, or whatever is currently hip. They are the same kids whose older relatives wore zoot suits or drove low-rider cars, but for the first time the hardcore street style of Mexican LA is coming from the old country rather than adapting black ghetto archetypes.

The reason, pretty much everyone agrees, is Chalino. Before he hit, most LA-bred Mexicans thought of norteño and banda as old folks' stuff. As Lupillo—a native Angeleno who speaks to me in English, without a trace of Mexican inflection—recalls, "When I was in high school, I was the only one that was actually listening to this music and playing it

loud like you would play rap music or whatever, and people'd make fun of me. They would laugh at me and say, 'What is that, clown music?' You know how la banda sounds kind of like circus music? That's what they used to call it. My girlfriend back then—which is my wife now—she used to be embarrassed, 'cause I was the only guy doing that. Everybody else was listening to hip-hop and rap and all that other good stuff."

The young Riveras grew up in a poor, tough barrio in West Long Beach. "People were getting killed every two or three hours, man," Lupillo recalls. "Not every day: every two or three hours somebody'd end up shot." The local tough guys, the cholos, drove around in low-slung cars, playing mix tapes of R & B oldies. The only Mexican music they would listen to was Ramón Ayala, a traditional-sounding accordion virtuoso from the Texas border region, whose records penetrated the urban gang world in a way that the music of more polished groups like Los Tigres never did. The cholos had never been interested in the Sinaloan sound. They considered it music for ignorant hicks.

What made Chalino different was his outlaw charisma. He had been selling his tapes at swap meets for years, largely to immigrants, but Lupillo recalls that he caught the imagination of the LA street guys when they heard about his shoot-out in Coachella: "All the young people were like, 'Oh my God!' And like the next day, all these gang-bangers, these cholos who'd been listening to oldies and all that, they started listening to Chalino. It was something new for me, because I'd always thought, 'They'll never listen to this guy.' Then, after he passed away, that's when it really blew up, all around—in Mexico, Chicago, in Atlanta—it was like a craze."

When that explosion came, the Riveras were at ground zero. Cintas Acuario had released all of Chalino's early albums, and with his success it became the most important corrido-driven company in the business. It has continued to grow, signing new artists and adding the Kimo's label, as well as sponsoring its own record store, La Música del Pueblo, on the busiest stretch of Pacific Boulevard. The sign above the store advertises *"Los Corridos Más Perrones"* in large, bright letters.

I had heard that the Riveras were suspicious of outsiders, but they proved eminently accessible. I just called the phone number on the back of their CDs, and Pedro told me that he, Lupillo, and Jenni would all be in the office the next day and I was welcome to come and talk with them. As they later explained, it had taken them a while to get used to the idea that people who came by claiming to be writers and reporters were not undercover cops or DEA agents, but by now they knew that there were a few Anglos out there who were genuinely interested in their music.

133

Cintas Acuario is on a quiet residential block in north Long Beach. It consists of two buildings across the street from each other, and once I had figured out which one was the headquarters (oddly, it was the one that did not have a sign outside) I made my way though an anteroom full of T-shirted, baseball-hatted teenagers into the main office. Pedro was behind a desk on the left, with Jenni at his back handling phone orders, and a couple of employees were doing paperwork on the other side of the room. Pedro is slim and soft-spoken, with a thin mustache and a somewhat melancholy look in his eyes. Raised in a small town in the central western state of Jalisco, he still speaks Spanish far better than English, and he has retained the diffident politeness of rural Mexico, though now combined with the confidence of a self-made entrepreneur. He explains that he has an appointment with a local radio station in an hour, but that until then he is at my service.

While Cintas Acuario is known for its young gangstas, Pedro himself may be the most traditional corridista on the contemporary ranchera scene. His recordings are a big-city survival of the corrido's roots as a singing newspaper: he has done songs about César Chávez, Panama's President Noriega, the Gulf War, the LA riots, the Zapatista rebellion, and the leftist Mexican presidential candidate Cuauhtémoc Cárdenas, as well as memorial tributes to Chalino and the Tejana pop singer Selena. His latest CD was titled *Corridos de Hierba* and concentrated on narco themes, but its final two songs were the corrido of Brian Barker, a North Carolina deputy sheriff who had shot himself and blamed the shooting on Latinos, and a defense of Bill Clinton.

Considering the other Cintas Acuario releases, I was surprised that Pedro had stayed so true to the tradition, but as I talked with him it became clear that his artistic choices are driven not by conservatism but by commercial savvy. Based in LA, with his own record company and powerful friends at the radio stations, he is one of the few present-day corridistas who can have a song written, burned onto a CD, and on the air quickly enough to be relevant. As he explained it to me, this was the original source of his popularity, and the indirect reason for the success of his label.

That success did not come overnight. Pedro first came to the United States in 1966, then returned with his family in 1968, settling in Culver City. He got a day job in a factory and sang occasionally at local competitions. Ángel González was the usual judge, and Pedro gratefully recalls how Ángel would ring the bell signaling an encore for him: "There were times when he rang it three times in one song." After a few years, Pedro quit his factory job and began going around nightclubs with a camera,

taking pictures of drunken customers who wanted to show off their pretty dates. Sometimes, as a novelty, the MC would get him up to sing a couple of songs, and gradually he developed a small local reputation. Encouraged by this, he put together nine hundred dollars to make his first 45 rpm single, which he says went nowhere, "but at least it started me on my way." In 1984, when the Olympics came to town, he bought a shipment of fifteen thousand slightly defective Olympic buttons for forty dollars, and the whole family went to sell them outside the games, making enough to record two cassettes backed by a mariachi band. Both were small-time productions with plain black-and-white covers, and he sold them for two or three dollars apiece, but they were one more step. Then he was approached by a man he knew from his night-club photography, who led a band called Los Bribones de Durango. Genaro Rodríguez was friends with Paulino Vargas, and the Bribones had recorded a full album of Paulino's songs, but when Paulino had tried to get them a contract with Peerless they were rejected. Now Rodríguez came to Pedro with the suggestion that he would hand over all the rights to the tape if Pedro would produce a record of it.

"I didn't even know what 'produce' meant, but anyway he gave me the tape, he gave me photographs, and I went off to ask how one would make an LP. And everything was hard, because no one wanted to tell me anything, not even where I could make one. Anyway, however I man-aged it, I made that first record of him, and that was Cintas Acuario number one." Once he had the basics down, Pedro began producing records for other local groups, and within a few years was having some success with a norteño outfit, Los Rayantes del Valle, and the ranchera singer Graciela Beltrán, who had the label's first real hit with the cor-rido "La Pochita de Sinaloa" (The Mexican American Girl from Sinaloa).

Pedro's own singing career had remained on the back burner, but at a Christmas Eve party in 1989 the family happened to be watching the news and saw that Noriega had been captured by US troops. Jenni, then nineteen, suggested that the story of the drug-trafficking president would make a perfect corrido theme, and Pedro wrote the song and had it on sale by January 5. It was the first time he had tried to write a corrido, and it was, by his standards, a huge hit. "The other singers around here, in Los Angeles, they were all out of joint, because they didn't even know who Pedro Rivera was, or where he came from, or any-thing."

Pedro's cassette *La Derrota de Noriega* (Noriega's Fall) was decorated with newspaper clippings, and the other songs included corridos of the

recent amnesty for illegal aliens, the murder of the DEA agent Enrique Camarena and his pilot, Alfredo Zavala, and even a corrido tribute to Alcoholics Anonymous. This sort of material was rare on the LA scene, and it soon attracted the attention of the only local performer who had staked his career on the corrido genre. After years of selling at swap meets, Chalino was ready to be on a real record label, and Pedro's seemed the most probable taker. As Pedro tells the story, they finally ran into each other at Prajin Discounts, one of the few stores that sold their kind of music.

"He said to me, 'Listen, *loco*, I want to record with you.'

"I said, 'OK, let's record.' "

They made the deal then and there, but it fell apart over Pedro's choice of backing group. He had picked Los Rayantes del Valle, who had a Tigres-style accordion-and-saxophone lineup, and it turned out that Chalino detested saxophones. "He said that to me: 'Neither Los Tigres del Norte, nor any other musician who plays with that crooked whistle is going to record with me, never in my life.' So we disagreed, but he still had the itch and he kept asking me."

A few months later, Pedro offered Chalino a deal: Cintas Acuario would record the album, but first Chalino had to sell him the rights to fifteen earlier hits as security. "In the final accounting, he gave me thirteen, at one hundred dollars for each corrido, already recorded and everything—good business considering the figure he is today, but at that time none of us were anything. As they say, no one knows in the moment what things are worth. For example, another time Chalino arrived at my office, a little office that I have there in my house, and he threw a *master* in front of me, and said like this:

" '*Mi loco*, I'm making you a present of that; I couldn't sell even one hundred cassettes, it isn't worth shit, the musicians are really feeble.'

"He threw it down there, and from that cassette we have made money to die for." It was Chalino's first recording, which Pedro now sells as *Chalino Sánchez al Estilo Norteño* (Chalino Sánchez in Norteño Style). As with generations of working-class musicians, from bluesmen to hillbilly singers and R & B stars, Chalino was thinking about a quick buck, and neither he nor anyone around him ever dreamed that his records would be selling more copies ten years later than they had on their release. Pedro recalls yet another occasion when Chalino needed some cash and offered to sell Lupillo his entire catalogue, including song rights and recorded masters, for $5,000. A few years later, Musart would pay $115,000 for essentially the same deal, but at the time Lupillo did not have the money handy, and in any case it seemed like a risky propo-

sition. Looking back, the Riveras laugh ruefully about the millions of dollars that got away, but they did record plenty of Chalino's material and were able to build on his success to create a thriving stable of LA artists.

Corridos have always been Cintas Acuario's specialty, and Pedro says that there are clear reasons why the style caught on so strongly: "Here in the United States, we are the neediest people, we are the most—how should I say it?—not to put us down or anything, but we are the people who have most problems in our country. If we are here, it's because we needed to leave our own country, because we couldn't support our- selves, or some people are here because they killed so-and-so, other peo- ple because they robbed. . . . That is, the better people, the people who are not in need, have never left their country. So, the corrido comes out of that. In Mexico, the corrido is criticized all the time, because the bet- ter people stayed back there. But those of us who are needy, and who really are of the *pueblo,* we leave our country looking for a way to better ourselves or to hide from something. So the corrido is well accepted here—whether the singer has a pretty voice or an ugly one, what inter- ests people is the corrido's content."

Nonetheless, the style took a while to find its market. Pedro has infi- nite stories of rejection by radio programmers, who could not see the profit in playing unknown songs by unknown singers on an unknown label. "*Entramos a huevito* [we forced our way in by the balls], as the say- ing goes," he recalls, laughing. Cintas Acuario's recordings caught on at the street level first, and deejays only began answering his phone calls after sales grew big enough, and requests frequent enough, that they could no longer ignore him. Graciela Beltrán's success gave him a toe- hold, but he still had to struggle to get Chalino's rough voice on the air. After Chalino hit, though, Pedro became known as the most consis- tently successful talent scout on the local scene.

Meanwhile, he continued to record his own work, though at fifty-four he is old enough to be the father of most of his current artists and his work falls outside the normal contemporary spectrum: he is neither a garishly raw singer, à la Chalino, nor a rich, virtuoso stylist like the main- stream ranchera idols, neither the toughest of the tough nor the clever- est of the clever. Instead, he keeps covering the news, winning airplay through timeliness. In a sense, his songs are novelty numbers: they sell well in their moment, but no one expects them to be around for more than a few months, and he makes no effort to reissue them or keep them in stock. As he talked about his work, I found myself recalling the news- paperman's credo laid down by A. J. Liebling: "I can write better than

anyone who can write faster than me, and faster than anyone who can write better." When he talks about his corrido of the assassination of Colosio, he says, "That happened at five in the afternoon, and by six I had finished the corrido. We recorded it the same night, and the next day, at one in the afternoon, it was already on the radio, and people went nuts."

His corrido of the Gulf War was even more timely. As he tells it, he was listening to all the back-and-forth between President Bush and Saddam Hussein, and wrote the corrido in anticipation of the war. Guided by a combination of Bush's threats and pure luck, he guessed the day and hour when the war would begin, and had the tape ready before the first bomb was dropped. Likewise, he recalls that his corrido of the LA riots was on the radio by the second day of rioting, and played alongside the news reports.

Considering the speed with which he gets them out, Pedro's corridos are surprisingly well constructed. He has no artistic pretensions and regularly says that he wrote a song out of simple economic imperatives, but he is also genuinely engaged with the issues. He may not have much formal education, but he is a thoughtful man and his interests range beyond the outlaw camaraderie that drove Chalino's work. "For me, personally, I have always enjoyed political stuff," he says, when asked directly about his motivations. "And I always liked to write lyrics and make up verses for the people who have always stood with the *pueblo*."

This strain of populism has always been common to the corrido scene, but these days it tends to be filtered through the self-censoring process of the larger record labels, who have no interest in antagonizing the powers that be. Pedro has the advantage of being his own company and having to please no one but the buying public, and his lyrics show the effects of that freedom. His "El Comandante Marcos," for example, rather than simply telling the tale of the Zapatista rebellion, is an adulatory homage, ending with the wish that Marcos should become president, since he would be a good governor, "and I am almost sure that he would save the nation." His corrido of the riots that followed the Rodney King verdict, "Violencia en Los Angeles," has an unusual mix of solidarity with African Americans—something not by any means to be taken for granted in LA's Latino communities—and a sympathetic, street-smart attitude that sets him apart from anyone in the mainstream media. He writes of the destruction with the honesty and humor of a working-class Mexican watching the rich folks' city burn, directing his moral judgments not at the rioters, but at the powerful figures who make the laws and then abuse them, "killing minorities without considering the consequences." He does not quite applaud the looters, but he

recognizes them as friends and neighbors, and his lyric suggests a certain pleasure in watching the poor folks getting a crack at wealthy businesses:

> *Caras de todos colores se miraban en acción,*
> *Saqueando a los comerciantes, visto fue en televisión.*

(Faces of all colors were seen in action,
Sacking the storekeepers, it was seen on television.)

He starts the song off by shouting, "I saw you on television, buddy, throwing that stuff in the car. Now, hide yourself!"

The corrido of Brian Barker makes its point even more explicitly. Written for Pedro by a songwriter named Adalberto Robles, it devotes three verses to conveying the bare facts of the case—Barker's shooting and his testimony that he had been attacked by two Latino men—and the other three to an antiracist polemic:

> *El mundo no tiene dueño, podemos ir dondequiera.*
> *Cuando Dios hizo la gente, no hizo pura gente güera.*
> *Hizo de todos colores, tampoco escogió banderas . . .*

> *¿Como la ven con los güeros, con su discriminación*
> *Para la gente latina que enriquecen la nación?*
> *Si no fueran por nosotros, no trajeran ni calzón.*

> *De todos estos racistas ya con ésta me despido,*
> *Pero nunca hay que olvidar un dicho muy conocido:*
> *Que con la barra que mides, con ella serás medido.*

(The world does not have an owner, we can go wherever
 we want.
When God made people, he did not just make white people.
He made them of all colors, nor did he choose flags. . . .

What do you think of those whites, with their discrimination
Toward the Latino people who enrich the nation?
If it were not for us, they would not even have underwear.

To all those racists, with this I say farewell,
But one must never forget a very well known saying:
That you will be measured with your own measuring stick.)

Unlike Pedro's earlier topical corridos, the Barker song is tossed in at the end of an album, almost as an afterthought. As he explains, the older songs were written and rushed into production out of necessity, and now he is in a different situation: "I was always on top of whatever was happening, from an anxiety to get ahead, an anxiety to earn a peso. But now everything has grown, everything has changed completely. I did that because of the restlessness I felt inside me, and now I don't do it for the simple reason that now I don't even have time to think."

Instead, he presides over a small empire of narcocorridistas, putting out songs that are notable for their lack of social consciousness, their willingness to push the limits of acceptability and baldly cash in on the most violent and nasty aspects of the drug trade. After Chalino's success, this was a logical direction, though Cintas Acuario has not concentrated on obvious chalinitos: as Pedro says, "I already had the real Chalino, and I am more than satisfied with that." Still, one has to wonder how he reconciles his current product with his political interests. His answer is typical: this is what people are looking for, and he understands them and can provide them with what they want. He is blatantly commercial, but proud that he is serving the people's tastes rather than shoving slick, prefabricated pap down their throats.

"We do narcocorridos because we know, we try to know, we think we know the feelings of the people who are involved in that, or of the people who would have liked to do something and never could. When one does a good corrido, everybody wants to be the character, and they buy it. That's one of the errors of the record industry, that they want to make people listen to what they think is good, what they think should be a hit. The record executives with the transnational labels say, 'Why should I take the trouble to record that corrido, if that corrido is for hicks?' And they are very much mistaken, because that is exactly it: the Mexican people, all of us are hicks. If people think they are very high-class and everything, then they do their sophisticated things and nobody likes them. All the producers from the transnational labels get bent out of joint, because their idea is to make people listen to what they think is good, to show the hicks what they should be playing and what they should be singing, and they are mistaken. They are one hundred percent mistaken, because one can't show the people what they have to buy, the people buy what they feel.

"In the industry we are in, nobody—not you, nor any producer, nor a million dollars—knows what will be a hit. That is the most beautiful thing in this life, because we can make a mountain of errors and from one single error, from one lucky twist that we give something, we can cure five hundred errors. Because this is something no one can predict."

If proof were needed that the corrido market is odd and unpredictable, one need look no further than Pedro's children. Today, Juan is not in the office, but Lupillo and Jenni are working, pulling together like any immigrant family trying to build a business. Not that either of them seems like the stereotype of the hardworking, goody-goody kid who might keep a grocery store. Both are casually cool-looking: Lupillo has a shaved head and pencil-thin mustache and is dressed in cargo pants and a Nike T-shirt. Jenni has long, reddish-brown hair and is dressed in a dark blue, low-cut blouse. Both are clearly LA-raised, their English full of hip street inflections, and they freely agree that, were they not Pedro Rivera's kids, they might never have gotten into corridos at all. In fact, they say that they probably would not even speak Spanish fluently if Pedro had not "got after us with a two-by-four if we spoke English at home." Jenni, in particular, says that she always listened to Anglo pop music until she started working around the record company and had to learn about the ranchera scene for business reasons.

Even after committing to Mexican music, they have not gone in for the countrified appeal of groups like Las Voces del Rancho, two LA kids who grew up on rap and hip-hop, but now are photographed in cowboy hats, surrounded by bales of hay. Lupillo has worn a cowboy hat for most photo shoots, but his current image springs more from Mafia movies than corrido archetypes: his new album cover shows him in a tailored suit, with sunglasses and a cigar, and his trademark gimmick is to sound and act drunk, hiccuping between verses of his songs.

As for Jenni, she does not need a gimmick to set herself apart from the rest of the corrido crowd: it is enough simply to be female. There are plenty of women singing romantic rancheras, but she is the only one regularly getting radio hits with narcocorridos, and is thus the "First Lady of the Corrido" almost by default. On first meeting, she seems a strange choice for a hard-bitten narco star: she has a warm, sunny smile, and her little daughter is running around the office, being pampered by the grown-ups. Jenni is funny and fun, and when I ask her age she smiles broadly and says "I'm thirty, but I look twenty." (There is nothing to do but answer, "No, you look eighteen.") Still, she is adept at her chosen role: her nasal, rural-sounding voice is ideal for a female Chalino, and she relishes the tough-gal persona she has created. While her most recent hit was a version of the classic north Mexican murder ballad "Rosita Alvírez," she is best known for her self-penned theme song, "La Chacalosa," a title that translates as "the jackal-like woman," or the wild, bad broad.

When Jenni talks about her narcocorrido career, she makes it sound almost like a feminist statement: "I wrote my first corrido in '94," she

says, "because I knew it would catch attention. All the men were doing it, and girls are bad girls too, you know. Not only do they like to listen to the music, but there are women drug dealers. So I figured we were being left aside.

"It's real hard as a female to enter the market right now. In the first place, a lot of us sing the same, the tone of our voice and everything sounds the same, and everybody's singing love songs, 'lovey dovey this,' and 'you did that to me,' and whatever. So I just wanted to do something superdifferent. I mean, if you sing nice ballads like Mariah Carey and Celine Dion, you're just another artist out there, but you sing about how you are a drug dealer and how you can kill somebody if he'll mess with you, people are like, 'Oh, she's very different.' So I wrote this corrido, 'La Chacalosa,' and it said:

> Me buscan por chacalosa, soy hija de un traficante,
> Conozco bien las movidas, me creí entre la mafia grande.
> De la mejor mercancía, me enseñó a vender mi padre.'

> (I am wanted for being chacalosa, I am a trafficker's daughter,
> I know all the moves, I grew up around the top mafia.
> My father taught me how to sell the best merchandise.)

"It says that when I was fifteen I didn't get a *quinceañera*, instead they gave me a cell phone and a pager, and a business that would give me lots of money. And then it talks about a lot of different things: that they showed me how to use guns, and I have my plantations in Jalisco and my drug lab in Sonora, and I have people that distribute it for me and I never touch a thing—the men do everything for me, I just make the money."

Jenni has even invented a style of dress to go with her narco image, fusing Latina party wear with the exotic-leather chic of the male traffickers: the *La Chacalosa* album cover shows her in what looks to be a black-velvet-and-crocodile bustier. Like Jorge Hernández or Mario Quintero, she stresses the importance of acting a corrido role, of performing as if she were in a movie: "I've seen a lot of girls that try to sing this stuff, and it just doesn't match with them. But like, I have this other corrido where the drug dealer is a female and she has her head full of braids like the black girls, and supposedly she crosses the border with the stash in her braids. So I had my hair braided for every time I would perform, like I was the girl. You have to have a certain tough image when you're onstage that people really believe in."

Jenni's daughter picks this moment to come over, saying "Mommy" in a tiny voice, and Jenni gives her a treat and sends her on her way. It seems like a good cue to ask whether Jenni and Lupillo aren't a bit concerned about the effect their music is having on young people. After all, while Paulino Vargas or the Sinaloans can argue that the drug problem is over on el otro lado, the Riveras do not have the same buffer zone. The barrios around them are home to addicts as well as traffickers, schoolmates have become junkies and crackheads, and there is no way to pretend that it is not a real, serious problem.

Jenni responds with a drawn-out, "Yeah . . . um . . . well, a lot of people ask us that. But we've always defended our point of view by the fact that we've never used drugs, we've never sold drugs, we've really never done anything that illegal—besides getting a bunch of traffic tickets, 'cause we all like to speed. And I think that's 'cause that's how our parents raised us. What we sing is not, like, the most positive thing in the world, and we realize that. But I'm only writing corridos and performing, and so is Lupillo, 'cause we're trying to make a living. We grew up around this. We didn't grow up in rich neighborhoods, we grew up in the ghetto. And we never became drug dealers, nothing happened to us, we never were influenced by anything. So I'm like, 'You take care of your kids and let me sing what I gotta sing.' "

But take the school tour, for example. Even granting for a moment that they are just poor kids trying to get by, do the Riveras really expect the schools to welcome them with open arms? I can't help laughing as I ask the question, and Lupillo and Jenni join in, but we are amused by different things. I am struck by the absurdity of the question, but they are laughing at the irony of their situation: if they were gangsta rappers, the school tour would not stand a chance, but Mexican culture has been so marginalized that no one in a position of responsibility has the faintest idea of what the corridistas are doing. "If the principals knew what we were gonna go and sing, it would be a different thing," Jenni says. "But they really don't know. Remember when we went to Lakewood High? They just thought we were folkloric singers or something like that."

The fact is, both Lupillo and Jenni would be quite happy to be mainstream ranchera artists, and Jenni actually did two romantic albums before creating her Chacalosa persona. Like their father, they have taken to corridos because that is a niche they can fill: "We're trying to make it out there in the world," Lupillo says, echoing his sister's earlier theme. "Right now I'm hitting pretty strong here in LA, in Mexico, everywhere, with corridos. Now I want to start doing half corridos and half songs, and then pretty soon it's just gonna be songs—but see, I

already got into it. People that are barely starting, they need to get into the hard-core stuff so people will notice them. 'Cause that's what people want. I mean, I would love to sing love songs that would attract young women or the fellas to say 'I love you.' But the world right now, it's not *even* like that. These days, man, you can't go serenade a woman with something like, '*Por ningún motivo me viene . . .*' [Lupillo sings the line "I come for no special reason" in a classically romantic ranchera style]. But you go over there and sing, '*Un día veintiocho de enero . . .*' ["On the twenty-eighth of January," a typical corrido beginning]—the woman's yours, man. You're gonna take her home with you."

"They like the bad stuff," Jenni agrees cheerfully. "It gives people an adrenaline rush, they get hyped up and it makes them happy. It makes them feel tough and it makes them feel, like, really, really Mexican. And I think we all like to feel that."

That pride, the feeling that you can be hip, streetwise, and smooth, but also "really, really Mexican" is a major ingredient in the California corrido scene. Lupillo describes the LA corridistas as a Mexican counterpart of the West Coast rappers who swept the United States in the 1990s, name-checking N.W.A., Dr. Dre, and Ice Cube. "The corrido guys are doing the same thing," he says. "It's just that it's in Spanish."

So, one might ask, why is Cintas Acuario issuing corridos rather than recording the new wave of Chicano rappers or the edgy young rock en español bands? Once again, it all comes down to business. While Spanish rap and rock have received more press coverage, they are not even in the same league as corridos when it comes to sales and radio play, and the Riveras pretty much dismiss them: "The people that buy music, if they're gonna listen to Spanish music they're gonna listen to the real thing," Jenni says. "I mean, Spanish rap is modern, but it's not real. So, they like to listen to norteño, to la banda, anything that has the original sound to it. The authentic stuff. That's how I think the public is right now."

After all, the whole point of the corrido is that it is the voice of the poor and disenfranchised, and the tough, raw, and wild. The trick that Chalino turned, and passed on to the new LA generation, was to make the style connect with city kids, giving them a way to assert their Mexican pride while claiming LA as their home and their turf. The Riveras' songs—Lupillo's in particular—have nothing to do with the Sinaloan hills. They are about the world he knows, the norteño accordion framing a language and attitude formed by the LA streets and an urban gangster tradition that stretches from Al Capone to Snoop Dogg. Like many gangsta rappers, he is a fanatical collector of Mafia movies ("*Scarface,* man, I've watched that over a hundred times and I don't get tired

of it."), and sometimes reworks favorite scenes and lines for his songs. His Spanish is shot through with bilingual slang, and one of his points of pride is having added a new word to the language, translating "baller" (in LA street use, a high-powered hustler, moneymaker, dealer) into *"pelotero"* in a song of the same name:

> *Un pelotero señores, tira bolas en el parque.*
> *Yo también soy pelotero, pero soy de un otra clase.*
> *Si no me entienden amigos, permítenme explicarles:*
>
> *Las bolitas que yo tiro son de puro polvo blanco,*
> *Es vitamina muy buena para andar buen atizado,*
> *Y el toque de mariguana sirve para relajarlos.*
>
> (A baller, gentlemen, throws balls in the park.
> I am also a baller, but of another sort.
> If you do not understand me, friends, allow me to explain:
>
> The little balls I throw are of pure white powder,
> It is a very good vitamin to get you stirred up,
> And a toke of marijuana will serve to relax you.)

The next two verses explain that he also pitches rocks of crystal (as in crystal methamphetamine), and little black rocks (a variety of crack). Then the song winds up:

> *Ya se le explique señores lo que es un gran pelotero,*
> *Y cada jonrón que pego es cada kilo que vendo,*
> *Pa' llegar a grandes ligas, vengan conmigo primero.*
>
> (So now it is explained, gentlemen, what a great baller is,
> And each home run I hit is each kilo I sell,
> To get to the big leagues, come to me first.)

"El Pelotero" shows an obvious debt to Mario Quintero's work, but neither Mario nor any other Mexico-raised corridista would be likely to have even heard of a baller. The Angeleno singers live in world that bears no resemblance to the heartland of ranchera, and their songs reflect that fact. While Lupillo's records have become top sellers in urban areas from LA to Houston and Chicago, many of his songs would just be confusing to the homefolks south of the border, and frankly he remains something of an anomaly even in LA.

"Oh yeah, most of the singers listen to my stuff and they just think, like, 'What's up with this guy?' " Lupillo says, laughing as usual.

"What it is is that we were born here, yet we still consider ourselves like one hundred percent Mexican," Jenni says. "But we listen to rap and to everything else that the English market is doing, like hip-hop and R & B. And I don't know, we just have this real big imagination. All of us. We're all weird and we're crazy, and we've got stuff that other people don't have. We imagine things, like 'Oh, what if we would do what they're doing in English, but we're doing it in Spanish, our way,' and that's what catches people's attention."

The audience that flocks to hear the LA singers can challenge any stereotypes about norteño fans. It includes people like Andrés Elenes, who runs a state-of-the-art Chalino and narcocorrido Web site off the server at MIT, where he is a graduate student. Or a Stanford Medical School student who is a friend of the Riveras and appears, AK-47 in hand, on one of the *Corridos Perrones* album covers.

"We call them edjumacated people," Jenni says. "Edjumacated people that are going to universities and they've got a career going on, and still you see them during the week and the weekends in the nightclubs. And it didn't used to be like that. Back in the eighties we used to sell CDs at the swap meets, and who would you sell? You would sell Vicente [Fernández], you would sell Los Bukis, all that romantic stuff, and it was more for the older people. Now you go to these clubs and they're educated people that drive real nice cars and they're going to school to be lawyers and nurses. There's people that wear business suits during the week and on the weekends they've got their crema de seda shirts, jeans, and a *tejana* [cowboy hat] on."

Lupillo has been smiling and nodding, and now he jumps in with a new idea: "That's a good-ass business to set up right now, is a shirt company like that—you'll get bank. But I guess the thing is, it's a whole new craze. It's like when Elvis came out, everybody was all crazy about the rock 'n' roll era and shit, and before that, that was not the way it was. It just switched over, and that's what's happened with the corridos. The corridos is taking over."

As I drive back toward central LA, flipping around the radio dial, I tend to think that Lupillo is right. Most Latino journalists and music-business spokespeople would disagree, but I am reminded of all the experts who spent over a decade dismissing rap as a passing fad. The corridos may not be pretty, but they match rap's rootsy, uncompromising power, and in LA, at least, they are definitely what is happening. It may drive a lot of people crazy, but Lupillo, for one, is crowing:

"I've got another idea now that's gonna come out, letting everybody from the music industry know that the corrido is taking over. I'm gonna use a Cuban's voice, saying where he doesn't want to listen to salsa and merengue. He's saying 'Take that shit off!'—he wants to listen to a corrido."

CAGE OF GOLD

Enrique Franco

No me critiquen porque vivo al otro lado,
No soy un desarraigado, vine por necesidad.
Ya muchos años que me vine de mojado,
Mis costumbres no han cambiado, ni mi nacionalidad.

(Do not criticize me because I live on the other side,
I am not a rootless one,* I came out of necessity.
It was many years ago that I came across illegally,
My customs have not changed, nor my nationality.)
—*"El Otro México," by Enrique Franco*

"Escúchame hijo: ¿te gustaría que regresáramos a vivir a
México?" (Listen, son: Would you like for us to go back to
live in Mexico?)
("Whatcha talkin' about, Dad? I don't want to go back to
Mexico. No way, Dad.")
—*dialogue on Los Tigres del Norte's recording of*
"Jaula de Oro"

By now, I was getting a bit tired of narcocorridos and I needed a break.
It was not a moral issue; I tend to agree with the corridistas that, while
their songs are not "the most positive thing in the world," they are not
a significant cause of drug use and trafficking. The United States' drug
policy is so riddled with hypocrisy, so casually racist and oblivious to real-
ity, that it is worthy of no respect. In a country that exalts wealth and

* "Los desarraigados," the uprooted, was the title of two popular Mexican films and refers
to the wandering workers, at home neither in Mexico nor in the United States.

celebrity while providing ever fewer chances for poor kids to get ahead, and that directs far more of its antidrug funding to flashy military hardware than to treatment centers, it is delusional at best to blame pop music for the fact that many barrio youngsters want to become big-spending, gun-wielding narcos.

I was not troubled by the corrido's themes, just bored by their repetition. Over and over, song after song, the litany was becoming tiresome: big new cars, beautiful women, powerful friends, the hottest guns, the finest cocaine, another brave man shot, another friend avenged, another shipment snuck past the stupid gringos. The Riveras are bright and resourceful, as is Mario Quintero, as was Chalino, but where does the genre go from here? Pedro Rivera's topical songs are more a sideline than a direction, and everyone else just seems to be in competition for who can go furthest: Paulino and Chalino wrote of traffickers, but not of drugs; Francisco Quintero hinted at cocaine use; Mario made it explicit; and now the young LA singers are upping the ante as fast as they can. Lupillo says he and his brother just wrote a song that gives instructions on how to cook cocaine into crack. (He says they got the information out of library books.) At one level, I was fascinated by all the changes the corridistas can ring on the same small set of clichés, but at another I was desperate for something different.

Fortunately, the next two interviews were to be with another kind of composer. Neither Enrique Franco nor Jesse Armenta writes much about drug themes, but they have become two of the most respected corridistas in the genre. This is largely thanks to Los Tigres del Norte, and the composers have returned the favor in kind: Los Tigres' longevity and unique standing in the ranchera world is largely due to the work of these two men.

Enrique Franco was the first corridista I ever interviewed, back in 1998, for an article in the *Boston Globe*. I had got his phone number after hearing *Corridos de los Buenos, los Malos, y los Feos* (Corridos of the Good, the Bad, and the Ugly), a superb album by a young norteño band named La Tradición del Norte, which consisted entirely of his corridos. Not one of the songs was about drug trafficking: indeed, what first attracted my attention was a corrido of Rigoberta Menchú, the Guatemalan human rights activist and Nobel Peace Prize winner. At that time, I was just beginning my research into the modern corrido, and it was only while talking to Enrique by telephone from his home in San Jose, California, that I began to realize his importance. In the 1980s, he had produced and provided key songs for the records that transformed Los Tigres from hot young action-corrido stars into the most mature,

thoughtful band in ranchera music, and he thus deserves much of the credit for their enduring stature, and for the evolution of contemporary norteño.

Now I found that Enrique had left San Jose, broken with La Tradición, and returned to his original home in Tijuana. I called him and made an appointment for Thursday afternoon, then drove down Route 5 to San Ysidro in a blinding rainstorm and checked into a cheap motel within walking distance of the border.

As it happened, it was the night of the Grammys, and I lay on the sagging bed and watched the recording industry parade its new fascination with "Latin" music. There was Jennifer Lopez in her fabulous dress (every Latino, but hardly any Anglo, knows that Lopez does not speak Spanish), and Marc Anthony, Ricky Martin, and Christina Aguilera singing their English-language hits. The award presenters included Lopez, Aguilera, Jimmy Smits, Gloria Estefan, Ruben Blades, and Andy Garcia, a fair sampling of important Latinos in the entertainment business. Although Mexicans and Mexican-Americans make up more than half of the Latino population of the United States, and Mexican artists account for almost two-thirds of Latin record sales, not one of these eight artists has Mexican roots. (Blades is Panamanian, Aguilera's father is Ecuadoran, Estefan and Garcia come from Cuban exile families, and the other four are Puerto Rican or of Puerto Rican descent.)

Clearly, if the Riveras are right about the direction of the contemporary scene, the television executives have not got the news. One does not even have to be a corrido fan to feel that Mexicans are getting a raw deal from the US entertainment media. When Lupillo talks about starting off his next song with a Cuban voice rejecting salsa for norteño, he expresses an irritation that is shared by Mexican Americans of all tastes and classes. Even in Los Angeles, where Mexicans, Guatemalans, and Salvadorans (all of whom tend to listen to Mexican music) are the overwhelming majority of the Latino population, it is common to find commentators writing as if "Latin" music were all salsa and merengue, or possibly rock en español. Though the most cursory survey of radio programming shows that Mexican music is far and away the most popular Latin style in town, and there tend to be at least a dozen major norteño and banda artists performing on any given weekend, the Latin music listings in the *LA Weekly* included thirty events the first week I was there, of which the only Mexican one was a mariachi band playing in a downtown restaurant. Ten thousand people packed Pico Rivera Stadium that weekend for a ranchera show that was not covered in any paper, while several papers mentioned much smaller gigs by Caribbean groups, and

everyone I spoke to regarded this as normal. All in all, anyone whose information is drawn from the local entertainment pages could be forgiven for concluding that LA's Latino immigrants are mostly from Cuba, Puerto Rico, and the Dominican Republic.

California, once a part of Mexico and becoming re-Mexicanized at an impressive clip, seems to be full of Anglos in denial. Some are shouting for immigration restrictions, cutting off aid to immigrant families, and trashing bilingual education. Others are celebrating multiculturalism, but now use "Latin" as they once used "Spanish," as a way of separating the romantic stereotypes they like from the ordinary, poor population growing all around them. "Latin music" is getting floods of press, but I doubt that 1 percent of non-Spanish-speaking Californians have ever heard of Los Tigres del Norte. This despite the fact that, for the last twenty years, Los Tigres have been the most eloquent musical chroniclers of immigrant America.

I got a sense of the irritation this causes when, during plans for a proposed record project, Los Tigres invited me to a meeting with Guillermo Santiso, president of Fonovisa, the biggest label in "regional Mexican" music (the Stateside synonym for ranchera). Discussing which Tigres songs might be included on a career retrospective aimed at the Anglo market, Santiso immediately suggested Enrique's "Los Hijos de Hernández." This song was never a big hit, but it was obvious why he chose it. Sung in the first person, it tells of a naturalized immigrant's experience at the US border: an immigration officer is going through his documents, and murmurs sulkily, "With all these immigrants, a lot of North Americans can't even find work." Furiously, the singer agrees that, yes indeed, Latin Americans have taken lots of jobs away from Americans. His own American-born sons, for example, entered the armed services:

> Ahí nadie se fijaba que Hernández ellos firmaban,
> Eran carne de cañón.
> Quizá mis hijos tomaron el lugar que no llenaron
> Los hijos de algún sajón.
> Si en la nómina de pago encuentras con desagrado
> Mi apellido en español,
> Lo verás en otra lista que a la hora de hacer revista
> Son perdidos en acción.

(There, nobody noticed that they signed their name
 Hernández,

They were cannon fodder.
Maybe my sons took the place that was not filled
By the sons of some Saxon.
If on the pay slip you find with annoyance
My Spanish surname,
You will see it on another list, that at the hour of accounting
They were lost in action.)

The immigration officer begins to cry, and says, "You can cross this border as often as you want. You are a better man than I."

Santiso is a major record company executive, but despite Fonovisa's consistently impressive sales figures, he still feels like an underdog in the US entertainment business. Watching the Grammy broadcast, I could imagine how angry he would be. At the meeting, he had blown up over Ricky Martin, comparing him to Desi Arnaz and saying "all he needs is a bunch of bananas on his head to make him the perfect Latin stereotype." In his view, the US Latin music scene is overwhelmingly dominated by Cubans, the only Latino immigrant group to be largely made up of its country's ruling elite rather than of poor, uneducated manual laborers. The Cubans look down on the Mexicans as peasants and consider their music a lot of hillbilly trash. Besides, Santiso added, "The Cubans hate Mexico because the Mexican government supported Castro, so they will never do anything to help our music or our culture."*

As an example of the effect of this dominance, he told of a meeting with advertising executives for an international long-distance phone service. They asked him to critique a campaign aimed at Latino consumers, which was not getting the response they had hoped for. He pointed out that they were using a Cuban actor talking over a salsa soundtrack, though Cubans are a very small part of the US Latin population and call home less than more recent immigrants, and for most Latinos salsa is the sound of the US cities, not of their home villages. He told the admen, "If you showed Los Tigres onstage, then Jorge going off to a pay phone and calling his mother in Mexico, every Mexican and Central American watching would immediately pick up the phone." The result of this conversation was that the next ad featured another Cuban actor, but the background music was a mariachi band playing "Cielito Lindo." It was so blatantly insulting that one could only laugh:

* Santiso went on to lead a Mexican boycott of the first Latin Grammys, saying that it was simply "a party for Sony and Emilio Estefan," the Miami record mafia.

an appeal to Mexican immigrants created by someone whose idea of Mexico was a tourist cruise or a theme restaurant.

Now, of course, drug violence is providing Anglos with yet another stereotype of Mexican life, but even this is less annoying to many Mexicans than the picture of the sleepy mariachi in his big sombrero. The violence is terrible, but at least it does not suggest that Mexicans are stupid, lazy, or incompetent. At times, given the sardonic Mexican sense of humor, it can even seem darkly funny.

Lying in my motel room; just a stroll away from Tijuana, I recalled one more of Santiso's stories: When he was just getting started in the record business, he had a new release out and happened to pass a store that had its whole window papered with copies of the album cover. He knew he had not provided them with that many albums, so he began to investigate the situation and found that a guy in Tijuana was pressing bootlegs. He asked around for someone who could help him shut the guy down, and one of Los Lobos del Norte, a norteño group made up of judicial policemen (and in no way related to the Chicano rock band), arranged a meeting with a Tijuana police official. Santiso explained the problem, and the official said that yes, he could help, for a price. That was expected, and they settled on a figure, after which the official asked for the bootlegger's address and they shook hands. "There's only one problem," he told Santiso. "You know, the whole block may go. . . ." To his dismay, Santiso realized that, where he thought he was paying to have the bootlegger's business closed up, the police officer was planning to torch it. "I said no, please, it was not so important that he should burn the place down. And he got all angry with me, because I was backing out of the deal!"

It was my first time in Tijuana, and as I sat in the restaurant of the Hotel Nelson the next day, eating *huevos a la mexicana* and waiting for Enrique to show up, I was struck by how little the town was fitting its stereotype. Maybe it is just that I love Mexico, but everyone seemed so friendly. I was looking for a wallet to replace one that had been stolen on the Mexico City metro, a souvenir of Sinaloa showing an embroidered marijuana leaf under a red AK-47, and the street salesmen were pleasant and helpful, steering me from one to the next and finally to a wholesaler in the central market. Even at that hour of the morning there were shills outside the nightclubs trying to get me to step inside and see "beautiful naked girls"—with hand motions to indicate where and how they were beautiful—"free, just look, don't cost nothing," but when I asked one

for directions to a bookstore, he turned off the mechanical charm and took five minutes to figure out which would be the best place and how to get there. I am not denying that Tijuana has earned its reputation as a center of vice, crime, and corruption, but it was so much more human and accessible than southern California, where life is lived in cars rather than street conversations.

I was in a good mood, though a bit disappointed that I would only be meeting Enrique in a café. His house had been flooded by the previous day's rainstorm, and he was not ready for guests. I would have liked a look at his home, especially once I saw him. He was dressed in slacks and a sweater, with a small, neatly trimmed beard, and looked to be about forty-five, which by my calculations must be at least ten years younger than his true age. (He did not choose to confirm this.) His manner and style suggest a youthful college professor or a popular novelist rather than a ranchera composer. We had planned to chat in the restaurant, but just as he came in, some kids started feeding the jukebox, so we were forced out in search of more tranquil surroundings. As we walked down the block, Enrique recalled that in his youth the Nelson was the main hotel in town, the place where all the bullfighters stayed. In those days, Tijuana had been only a few blocks long, ending at the jai alai stadium. Now the buildings stretch on for miles.

Enrique had only been back in Tijuana for a few months, and he seemed more familiar with the town of his youth than with the thriving new border metropolis. He had no suggestions of quieter places to talk, so we strolled until we passed a cigar store and espresso bar, a combination I had never seen in Mexico. We went in, settled back in the comfortable leather armchairs, were served two first-rate cappuccinos, and persuaded the owner to turn the music down to a level that allowed easy conversation. It was the sort of room where I could imagine the local intellectuals meeting to chat about books or politics, and Enrique seemed to fit right in. Matching his looks with the complexity and thoughtfulness of his songs, I was beginning to wonder about his background and started out by asking if he had, in fact, gone to the university. The laugh that accompanied his response was tinged with rueful irony: "Only the school of life. I have read what I could, I don't read much, not much literature, but I read about what is going on, I am interested in the problems, I read the newspapers—but I have to read the newspapers, to see if El América [a popular soccer team] won."

Enrique is an engaging conversationalist, but his humor has a bitter edge. He is not happy with either his own situation or the state of the world in general. His current work does not satisfy him, and he seems

to be caught in the classic bind of the self-educated man: bored and frustrated by a lot of the people around him, but without the credentials to enter a professional career like medicine or law. Or maybe, in his case, the dream would be a career in another style of music, to be a respected film composer in the tradition of Agustín Lara or part of the *nueva canción* movement, one of the college-educated singer-poets who, paralleling Bob Dylan and Joan Baez up north, became both intellectual beacons and popular stars throughout Latin America.

Or maybe I am reading too much into his manner on one morning, in one short interview. Maybe the main difference between him and the other corridistas is simply that, as a native of Tijuana, he grew up differently and had different influences. Certainly he had fewer roots in the ranchera tradition: "Around here, at that time, Mexican regional music, norteña, was not in fashion the way it was in other parts of the country. In Tijuana, they don't think that we are in the north, what they call '*el norte*' is the area around Monterrey or Tamaulipas. Norteña music was born there, and around here we didn't have that, we had tropical music, La Sonora Matancera, Tito Puente, that type of thing. When the mambo was big, people around here were into that. Afterward, when I moved to Mexico City, it seems incredible, but there I had more contact with regional music. And then I went to live in the United States, and there I realized what this music was really all about."

Enrique started out playing electric bass in a local pop orchestra, with a repertoire ranging from romantic songs to mambo, cumbia (a Colombian dance that has been Mexicanized into a bouncy, semitropical sound), and South American pop hits. After a while, he formed a lounge trio, with his wife singing and a pianist, and took this group to Mexico City, where he was based for about fifteen years. While there, he met Art Walker (or Arturo Caminante, as he often called himself), the Englishman who owned Fama Records in San Jose, California, and was mentor to Los Tigres. Enrique first served as Walker's translator, using the little English he had picked up during his childhood on the border. This was in 1979, and the two would get together in Monterrey to do some recording, then Walker would go back to San Jose and Enrique to Mexico City. After a couple of trips, Walker decided he could use a right-hand man on his own turf.

"He said to me, 'Come up here.' So one day I was inspired and got my family together; I told them we were going to Disneyland on vacation, and boom! I left for San Jose."

Enrique acted as middleman between Walker and the Spanish-speaking musicians, and also as a combined talent scout, producer, and

A and R man. At first he did little composing, but it was an obvious next direction: he had already written some pop songs and a few mariachi numbers, and Los Tigres shortly recorded a couple of these older pieces, "Plaza Garibaldi" (a tribute to the square in Mexico City where the mariachis meet) and "Gallo de Pelea" (a rowdy boast in which the singer compares himself to a fighting cock).

Enrique says that up to that point Walker had never really bothered with songwriters: "His system didn't involve original songs, he had all his artists cutting songs off old records. He had a warehouse full of records and all day long he was listening to them and he would say to me, 'Look, this one fits Los Humildes, this other fits Los Tigres, this fits Chavela [Ortiz, a woman accordionist who had married one of Los Tigres].' "

This practice of recording songs from other people's records was quite common, but it could also cause problems: Enrique says that a group of publishers got together and hit Walker up for a fortune in back royalties. Meanwhile, some of the Fama groups were becoming popular, and it seemed like high time they had their own material. At first, Enrique sought out other composers, posting ads in the "Want Advertiser" tabloids around San Jose. This was quite effective, but he says that it took some work to persuade Walker and his artists to use the material that came in. Most of the demos just featured the composer himself, "with some out-of-tune guitars," and after years of picking songs off commercial albums, Walker had trouble appreciating their quality. Still, after Enrique adapted and arranged them, enough made the cut that in that first year he provided Fama with over a hundred new songs.

He also produced an album that would represent a major turning point in Los Tigres' evolution from a popular norteño band into the undisputed leaders of the field. On their first eight LPs, the group's big hits had tended to be corridos of drug traffickers, gamblers, and gunfighters. They were drawing a huge audience, but also the sort of bad press that today dogs Los Tucanes. Realizing that it would be difficult, if not impossible, to build a long-term career simply by being bad boys, Los Tigres decided to try something completely different: their next album's title song was "Un Día a la Vez," a translation of the bathetic country gospel hit, "One Day at a Time."

This was more than an attempt at respectability. It was also a tacit acknowledgment of the evangelical churches that were beginning to gain ground throughout Central America and among immigrants in the United States, threatening a Roman Catholic establishment whose monopoly reached back to the colonial era. While its message—a plea that God help the singer to live his life one day at a time—was not restricted to Evangelicals, it reflected a new sensibility, and the record

sold like crazy. To my way of thinking, it is one of Los Tigres' sappiest recordings, but it unquestionably broadened their appeal and transformed their image. They followed up with another religious number, Enrique's "Padre Nuestro" (Our Father), and then the mawkish *A Ti Madrecita* (To You, Dear Mother), a whole album of songs dedicated to mothers.

Fortunately, this oversentimental strain did not last long. Instead, Los Tigres' next two albums featured Paulino Vargas's "La Tumba del Mojado" and Enrique Valencia's "Frontera Internacional," beginning a series of moving and well-written corridos exploring the experience of Mexican immigrants in the United States. This was not a new theme in norteño music. Ever since the United States acquired most of northern Mexico in the 1848 treaty of Guadalupe Hidalgo, Mexicans had been crossing the border to work, and writing songs about their experiences. The earliest surviving corrido, according to many scholars, is "El Corrido de Kansas," about a trail drive to Kansas sometime in the mid-nineteenth century, and it was followed by "El Corrido de Texas" and "El Corrido de Pennsylvania," among others. Some of these songs told only of the hardships of being away from home and loved ones, but others pioneered themes that would become common in the immigration corridos of the 1980s: the problems of racism and of dealing with a foreign language and culture. "El Deportado," recorded by Los Hermanos Bañuelos in Los Angeles around 1929, is the lament of a laborer who has been deported back to Mexico after coming to the United States seeking work and an escape from the upheavals of the Mexican Revolution, and most of its verses could appear unchanged in a modern corrido hit:

> *Los güeros son muy maloras, se valen de la ocasión,*
> *Y a todos los mexicanos, nos tratan sin compasión . . .*
> *Adiós paisanos queridos, ya nos van a deportar,*
> *Pero no somos bandidos, venimos a camellar.*

> (The white folks are very mean, they take advantage of the
> situation,
> And they treat all of us Mexicans without compassion . . .
> Good-bye, beloved countrymen, now they are going to
> deport us,
> But we are not bandits, we came to work.)

Not all the immigrant songs were tragic. There was also a broad strain of humor in songs like "Los Mexicanos que Hablan Inglés" (The Mexi-

157

cans Who Speak English), and "Las Güeras de Califas" (The Blondes of California), and Los Tigres had latched onto this tradition from their earliest recordings. Their interest in the theme gained new impetus in 1977, when they hit with Jesse Armenta's "Vivan los Mojados" (Long Live the Wetbacks), a song that astutely mixed ethnic pride, social commentary, and rough comedy. On the one hand, it spoke of the difficult lives of illegal immigrants, on the other it proposed a tongue-in-cheek solution: each mojado could be given a *gringuita* to marry, and could get a divorce as soon as he had his green card. The song's most memorable verses speak of what would happen to the United States if the mojados decided not to come anymore: the crops would rot, the dance halls would close, and the girls would be inconsolable.

Serious or funny, all of the mojado songs shared two things in common: they were written from an essentially Mexican perspective, looking at life in the United States as something temporary and quirky, and from the perspective of poor, migrant workers. There was no effort to speak for the ever-growing community of permanent residents north of the border, no songs about middle-class immigrants like Enrique and Los Tigres themselves, who had no plans to move back to Mexico but still felt at times like strangers in a strange land. It was this lack that made Enrique write the song that transformed his career, "Jaula de Oro" (Cage of Gold).

At first glance, "Jaula de Oro" might have seemed like just one more in the mojado tradition, but Enrique was quite consciously departing from the previous pattern: "It is not a 'mojado' song, in quotation marks," he says. "It is a serious song, and it deals with the problem of undocumented immigrants, not mojados anymore, but rather *indocumentados*. It looks at the problem as it really is, the legal situation of living in a country without having papers. At that time, I understood all about that, because I myself was undocumented. When you're undocumented, at first you don't really feel it, but as time passes, you get to feel it more and more—you don't have a driver's license, they ask for your social security card and you don't have any. . . ."

The song's protagonist is a settled immigrant who has been in the United States for ten years and has a good job. And yet, now that he can sit back and reflect on what he has built, he finds the reflection painful. His children, who were very young when they came, have forgotten Mexico and do not speak his language. They think like Americans and deny that they are Mexican "although they are of my color." His own life is a nervous journey between work and home, and he tries to spend as little time as possible in the streets for fear that he may be picked up and

deported. He has realized his dreams of economic success, and the result is unhappiness:

> ¿De qué me sirve el dinero si estoy como prisionero
> Dentro de esta gran nación?
> Cuando me acuerdo hasta lloro, que aunque la jaula sea de oro
> No deja de ser prisión.

> (What is my money good for if I am like a prisoner
> Within this great nation?
> When I remember I almost cry, that although the cage
> may be of gold
> It does not cease to be a prison.)

The song struck a chord with a lot of people on both sides of the border: it expressed the fears of the folks back home, and the trials of those in the United States. "You're not telling people anything that they don't already know," Enrique says. "But they like to hear someone say it, to hear that other people understand what they are going through, in the family. The lack of communication between parents and children in the United States is very important—I say this because I lived it, I see it—I know families where the father doesn't speak English and the son doesn't speak Spanish, I don't know how they understand one another. In this culture we have now, the fathers are no longer our children's idols. We came here [to the United States] to work, we didn't come to go to school, but our children do go to school, because they have to go. When we come here, we don't think about them, we only think of ourselves, and we make problems for them, because they will never really incorporate themselves into this culture and they become distanced from ours."

"Jaula de Oro" was successful enough to be turned into a movie, the first corrido film that was not a shoot-'em-up cowboy or gangster flick. It starred Mario Almada, the hero of *La Banda del Carro Rojo*, but this time using his lined, troubled face to convey the anguish of a father cut off from his family and country. Los Tigres played minor roles as young Mexican Americans, and the story was a parable of sticking to one's own: Almada's daughter has a blond, gringo boyfriend, who gets her pregnant and abandons her, after which she dies in a car accident. His son, meanwhile, is proud of their Mexican heritage, and in the end father and son are seen driving through the border post, back to their homeland. Though far from a masterpiece, it was a better movie than

anyone expected, and gave an alternative slant on immigrant life, even if some of the power of Enrique's theme was lost in the melodrama.

The success of "Jaula de Oro" pointed a new direction for Los Tigres, and their next few albums used Enrique's songs to establish them as the musical spokesmen of a binational generation. In 1985 came "El Otro México" (The Other Mexico), which took a still more complex look at the immigrant situation. The title was an acknowledgment that, for many immigrants, the United States has become another Mexico, a place where they live Mexican lives in a more or less Mexican society.

This is a controversial issue on both sides of the border. In the United States, Anglos insist that the immigrants should assimilate and become "regular Americans." Meanwhile, some Mexican politicians argue that the talented and ambitious people who emigrate should instead be staying home and helping to build Mexico, while others want voting rights for those citizens living on el otro lado (in 2000, something like 11 percent of Mexico's voting-age population), whom they consider a vital part of the home economy. The immigrants may feel lost and homesick up north, but they are respected as brave, worldly, and successful when they come back to their home villages, and often support the parents and cousins they have left behind. "El Otro México" is the defensive speech of a mojado who remains proudly Mexican, snapping back at those who criticize him for leaving the republic. He speaks of his home in the United States as "the other Mexico which we have constructed on this soil that was once national territory," and points out that the poor workers who sneak across the border illegally are doing more for their country than the upper-class travelers with proper papers:

> Mientras los ricos se van por el extranjero
> Para esconder su dinero y por Europa pasear,
> Los campesinos que venimos de mojados
> Casi todo se lo enviamos a los que quedan allá.

(While the rich go abroad
To hide their money and travel around Europe,
We country folk who came illegally
Send almost everything back to those who remain there
 [in Mexico].)

Enrique says that these songs were born out of his own frustrations. The first thrill of getting to a new place and beginning a new career had

worn off, and he found himself without papers, unable to drive, worry-ing all the time that people were watching him: "It was a very difficult period for me, I was so depressed that I became sick with diabetes. And then, when they passed that Simpson-Rodino law [the 1986 bill that gave amnesty to undocumented immigrants who had been resident in the United States since 1982], I didn't qualify, because I had come in with a visa—supposedly the law was for the undocumented people, so they told me that, since I had come in with a visa, I didn't qualify."

Whatever the personal costs, Enrique's frustrations were fueling the most influential period of his work. In 1987, he produced Los Tigres' *¡Gracias América . . . ! Sin Fronteras,* which won them their unique Grammy (in the category of Best Mexican/American Performance). His seven compositions on the album included "Los Hijos de Hernán-dez," along with songs exploring the theme of pan-Latin unity, a new direction that demonstrated his and the band's grasp of their wider potential. Los Tigres were gaining fans throughout Latin America, and Enrique's two title songs explicitly embraced this audience: "América" argued that the term *"americano"* should apply to everyone on the con-tinent, not just those from the United States, and "Sin Fronteras" (With-out Borders) was a song of pride for all of those "who have brown skin and speak the language of Cervantes."

Despite its Grammy win, *¡Gracias América . . . !* was actually one of Los Tigres' weaker efforts of this period. Their most memorable song of 1988, released on a record titled *Los Ídolos del Pueblo* (The Idols of the People), was Enrique's "Tres Veces Mojado" (Three Times a Wetback). This was another bow to Los Tigres' expanding audience, the corrido of a Salvadoran immigrant who has to sneak across three borders before reaching the United States, and it was made into a movie starring Jorge and Hernán Hernández. The song ended on a happy note, with the immigrant getting his status regularized through the passage of the Simpson-Rodino bill, but the movie took a bleaker view: Jorge and Hernán, as two Salvadoran brothers, find themselves facing prejudice in Mexico, treated as second-class citizens and forced off their jobs. Attempting to walk across the desert into the United States, they lose their way, and their female companion dies of thirst. Finally they crawl out to a road, and there is a moment of relief and hope, dashed as the US Border Patrol drives up to take them into custody.

Jorge would tell me that "Tres Veces Mojado" was conceived to appeal to the Salvadoran and Central American audience. He has always collaborated closely with Los Tigres' composers and says that he specifically asked Enrique for something that would reflect the aspira-

tions and lives of the Salvadoran fans who were showing up in ever greater numbers at their shows. The outreach was effective, and when Los Tigres play in cities with large Salvadoran populations, "Tres Veces Mojado" always gets one of the biggest hands of the night.

It is also one of the last immigrant corridos Enrique would write for Los Tigres. (The only later example is an oddity called "El Sueño de Bolívar," which argues that Simón Bolívar's dream of seeing all Latin America united under one flag has been realized in the United States, "where all Latinos consider one another equal, though we are from different countries.") Enrique had finally regularized his status and no longer felt the urge to chronicle the trials of his undocumented neighbors. Instead he turned to other themes. He wrote a corrido of César Chávez, and two corridos of crusaders assassinated by government or narco-connected thugs: the Tijuana newspaperman Felix Miranda, "El Gato Felix," and the Sinaloan human rights activist Norma Corona.

162

On the whole, though, Enrique was distancing himself from the corrido form. Los Tigres had returned to their old narco turf with the *Corridos Prohibidos* album, and their big corrido hits of the period were Rubén Villareal's "La Camioneta Gris" (The Gray Pickup) and its sequel, "La Bronco Negra" (The Black Bronco). To balance this trend, Enrique devoted most of his efforts to broadening their musical palette, writing comic cumbias, romantic boleros, lovelorn pop ballads, and songs in Caribbean rhythms: the old-fashioned Cuban *son montuño* and the *guajira.*

By this time, he was composing more than half the songs on each Tigres album, as well as acting as producer and musical director, but the relationship was beginning to sour. The reasons for this remain somewhat obscure: Jorge maintains that there was a clash of egos, that none of them was prepared for the extent of their success, and that Enrique, with his name on every record as producer, artistic director, and coarranger, started to think that he was more important than Los Tigres themselves. Enrique simply says that they were having disagreements and decided it was time to go their separate ways. Either way, after a 1992 live album on which he had written ten of the thirteen titles, he split from the group and they have not spoken since.

At the time, he says, he did not expect the parting to be so permanent: "I thought that after a while we would get back together, because after working so many years together we saw ourselves as more than producer and artist, it was more of a family relationship. The problem is that they managed to find other people to write songs for them, and I found no one to sing my songs—there is no one, in this type of music,

who can do them. So I dedicated myself to making commercial music, plain and simple, and that's what I've been doing. But I don't feel that I'm doing what I love, or what I want."

In his years with Los Tigres, Enrique had gotten used to being more than simply a composer. They provided a platform from which his thoughtful songs about social issues could reach millions of listeners, and his opinions were more widely heard than those of all but the most powerful politicians. Now he found that other groups had little interest in recording controversial material and could not get exposure for those songs they did record. He tried doing an album of his own, a corrido collection that included his paean to Rigoberta Menchú and "Ecología Mexicana," a critique of the pollution and defoliation around Mexico City, but it attracted little attention. In 1994, he wrote half the songs for an album by a young California group, Los Pumas de Jalisco, including a song about AIDS and a corrido satirizing the anti-immigrant rhetoric of California governor Pete Wilson. It had some regional success, but nothing earthshaking, and he next teamed up with La Tradición del Norte, a quartet of brothers from a small town outside Tijuana.

Enrique's first album with La Tradición was largely devoted to middle-of-the-road norteño pop, but included a song that in the hands of Los Tigres would have been a fine continuation of their earlier immigrant corridos. "Voy a Hacerme Ciudadano" (I Am Going to Become a Citizen) was a reaction to the recently passed Proposition 187, which denied public services to undocumented immigrants. It described Governor Wilson as incompetent and warned that this sort of abuse would have the opposite of its intended effect, that it "had woken the giant," politicizing the Latino community, and Latino voters would soon sweep their opponents out of office. Enrique clearly saw this as a new beginning, and in 1997 provided La Tradición with a full album of corridos, the masterful *Corridos de los Buenos, los Malos, y los Feos*. It combined adventurous lyrics and superb musicianship, but its artistic quality turned out to be small consolation for its meager sales, and he and the brothers have not worked together since.

There is something almost tragic in Enrique's failure to remain a force in the corrido world. Unlike other writers of his generation, who have adapted to the narco craze, he has tried to do unique and meaningful work in a genre he still believes to be the legitimate voice of the people, but without Los Tigres he can have little impact. He is not ignoring the current trends—he has written a song about a young man who is hunting the killer of his father and finds him after hearing his deeds celebrated in a corrido on the radio—but it suits neither his tastes

nor his abilities: "Most of the people who write that stuff had never written before, they are not exactly composers—not that being a composer is anything special—but in general they know what they are writing about. And I am ignorant of many terms, many things of that sort, what I wrote would sound fake. I know what I read in the newspapers, but I'm not very familiar with all of that."

Even if the style came easily to him, he considers the narcocorridos a bastardization of a noble tradition, and an advertisement for vice: "The corrido used to be a sort of homage to people of merit. To sing to an antihero, well, yes you can do that, but those kinds of corridos are not corridos, they don't speak of anything, they are lies, a fantasy. There are certain clichés, easy to pick out: 'Freeway 15 that goes to Las Vegas, there are the parties of El Señor de los Cielos'—it's always the same, the same: 'my cuerno de chivo,' 'my new SUV,' and there you have the corrido.

"Unfortunately, business is business, and selling records is a business. For a record company, whoever sells records is the good guy, the prettiest, the best singer. And the people who have connections to that kind of traffic bring in money, they are good consumers for bars, for nightclubs, for records—those people will buy ten CDs at a time, and a normal person in Mexico can't buy one. Those people want their music, and, now that we have fallen into the clutches of consumerism—to put it that way—it's the only way for them to advertise. They can't have an open publicity campaign like Pepsi-Cola, but they can do it by way of the songs. If a song by José Alfredo Jiménez made the consumer want a shot of tequila, these songs make him want something else."

Enrique has not given up: he continues to compose and produce, most recently for an all-woman band, Las Lluvias del Norte. Still, his current work is clearly not up to his own exacting standards, and his artistic problems are compounded by a more general restlessness. Though he only recently moved back to Tijuana, he already knows that it is not for him: "Here, the situation is very violent, the people are very violent, they are always getting into fights, they drive very aggressively. I won't go back to San Jose, but I have a daughter in school over there, in San Marcos [California], and you cross that line and it's another world. That is what we need to learn over here." Though he has lamented the trials of immigrant life in the United States, he also is aware of the advantages, and after twenty years Mexico no longer feels like home. He likes the order, the relative safety and lack of corruption north of the border, and he bemoans the failure of Mexican immigrants to band together and make their impact felt on the larger culture, as the Cubans have.

Basically, he is in limbo: neither Mexican nor immigrant, success nor failure. Since splitting with Los Tigres, he has been drifting, and it troubles him to be simply grinding out decent pop music while Los Tigres go on being political spokesmen. When our conversation turns to the band's more recent topical songs, in particular "El Circo," Jesse Armenta's corrido attacking ex-president Salinas, he insists that they would be doing even more powerful and effective work if he was still part of the team: "Look, I don't want to talk about anybody, but if I had written a song like 'El Circo,' I would have written a better song. Because it says nothing that you or I don't know—even a child knows what it says. But do you know the merit of that song? The merit is that it inspired Los Tigres del Norte to record it, and the record company to put it out. That was what was special about that song, because that is dangerous business here."

Enrique found the widespread acceptance of "El Circo" rather surprising, since he still recalls the threats he received after writing the far less controversial "El Gato Felix." Still, his view of Mexican politics is too sour for him to get very excited, and his final assessment is typically cynical: "In the last while, the government has let us say certain things, because it has come to realize that this calms us a little. It's 'bread and circuses.' Mexico is surreal. One never knows the truth, so I can't tell the truth because I don't know it, and who is going to tell me?"

In the 1990s, the Mexican government relaxed its long-standing censorship of opposition views, but for Enrique the new openness was a mixed blessing: "Now that one has access to more information, we find that nothing that we knew is true. Now there is a book that says that the Niños Héroes [the cadets who died defending the Military College in Mexico City during the Mexican-American War] didn't exist, that Benito Juárez [the nineteenth-century president and pillar of Mexican democracy] sold out his country, that Zapata—I don't even want to say what it said about Zapata. All in all, that our heroes didn't exist as such, that they were just stories invented by Porfirio Díaz [the nationalistic dictator who was overthrown in the Revolution], to make the business seem more folkloric, that they were nothing more than men, plain and simple, who at a certain moment did what they had to do. And maybe that's all there is to it."

Enrique's disillusionment makes him shy away even from subjects that seem tailor-made to his abilities. For instance, he has written no corridos about the Zapatista uprising in Chiapas: "I once tried to," he says. "And I wrote some pretty interesting lines. To me, it was like something from another world, to see the campesinos like that, with their ski

masks and rubber boots and wooden rifles that looked like toys. I'm saying, 'What's going on here? Where are we?' It sets your imagination ablaze. But then I began to try to document it, and since everything is manipulated, I have not been able to get the information. The story is very interesting, but since I don't know where it's coming from, who put it out—because someone had to put it out—I began feeling that it was a theatrical production, that it was arranged. But what we don't know is where that theatrical production comes from. . . .

"That's what we're like: 'What do I write about? What is the truth?' It's like with 'El Circo': I think that the moment came when the government said, 'Let's let them talk about this, and people can distract themselves with it.' Because Mexico is so surreal that they could kill Los Tigres, and twenty Tigres—or me, or you—and nothing would happen. Just like they killed forty people here in Rosarito, including children and babies, and nothing happens. Now one can talk and protest and everything, but I think they just saw that this was a way of calming the people down a little.

"You know, the problem isn't Mexico, and it isn't the Mexicans, the problem is our leaders. We have had governments that are not interested in the people, that are only interested in enriching themselves. And since the people know that, they have lost their civic responsibility and even their patriotic feelings. Mexico is in very bad shape. I have a theory I am putting into a song, which when Los Tigres start recording my songs again they will record: if the Americans had had the last three presidents that Mexico has had, they would have committed mass suicide."

Clearly, despite all the setbacks, Enrique is itching to write, and he lacks only an artist who can bring his songs to the public. He continues to believe in the power of the corrido, that the right artist with the right song at the right time can make a real difference in the world. "With a song, you can make people learn, they get an idea of what is going on, especially if they hear it from someone like Los Tigres."

But therein lies the problem. Los Tigres have moved on, and Enrique has been left on the sidelines. "It's a long time since I've seen them," he says, speaking quietly, as if he were talking as much to himself as to me. "But with the passage of time, I know that the moment is coming when we can get back together. I know that there is no one who can say what they can say. So those songs are going to stay in the inkwell for now—because to give them to just any group, that makes no sense."

11

THE POLITICAL CIRCUS

Jesse Armenta

Tijuana was a reminder. The more I traveled in Mexico, the less prepared I was for the United States. Mexico still functions on a profoundly human scale: towns are designed for people on foot, who expect to talk to other people whenever they go into a restaurant, a shop, or a bank. There are always buses going everywhere, and passersby ready to give directions. As a native of New England, which was largely settled in the days before the automobile, I find Mexico much more familiar and homelike than most of the southwestern United States. I had been struck by this before, in southern California and on visits to Texas. Still

and all, nothing had prepared me for Phoenix. "The fastest growing city in America," the boosters call it, and I have no reason to disbelieve them, but I have never seen a town so sterile and inaccessible. I rolled in on the bus and checked into the YMCA, the only affordable hotel to be found. It is located in the dead center of town, and I checked in at 7:00 in the evening, but the folks behind the desk told me that the nearest open restaurant was a Taco Bell some two miles away and the only way to get there was on foot or by taxi. I walked, and did not meet a single person along the way.

There was only one reason I was in Phoenix, and that was to talk with Jesús "Jesse" Armenta. When I first called him, he seemed somewhat suspicious, wondering why exactly I wanted an interview and who had given me his number. He thawed after I reeled off the names of the other corridistas I had spoken with, especially when I said I had gone to Basuchil to find Ángel González, and he told me I was welcome to come by his house the following afternoon. I spent the morning in the library, hiding from the 110-degree heat; Mexican friends had warned me about the Arizona desert, and it was living up to its reputation. A half hour before I was due at Jesse's, I went down to the street and tried to hail a cab. There were almost none, and those few did not stop. Finally I went into a hotel, and the desk clerk, a pleasant man from New Orleans, called a taxi and commiserated with me for the half hour it took to arrive. Apparently, taxis are not allowed to pick up fares off the street in Phoenix. The taxi companies explain that this is due to the danger to the drivers. No offense to the chamber of commerce, but if this is the fastest-growing city in the United States then there is a deep sickness afflicting the country.

But what do I know? Jesse certainly seems happy here. He welcomes me into a large, ranch-style house on a quiet block, and we settle onto the couch in his nicely furnished living room. Jesse is younger than I had expected, still in his late forties, and looks comfortably middle-class, in loafers and a blue-and-brown Hawaiian shirt. On the coffee table is a pile of magazines, recent issues of *Proceso* and other journals of the Mexican intelligentsia. "I nourish myself on all of this," he explains, adding that he is constantly shopping for books of history, thesauruses, and collections of Mexican proverbs and sayings.

Once we are comfortable, he starts right off on his life story: "I am the son of Rosario and Manuel Armenta Mijares, born in Buena Vista, Sonora, Mexico, in the northern part of the country. I began to compose when I was very small, and it was not until I came here to Phoenix, Arizona, approximately in 1966 or 1967, that I began to promote my

songs professionally. The first corrido of mine was recorded in '70 or '71. It was called 'El Contrabando de Nogales' [Smuggling in Nogales], and it talks about two traffickers who came from Sinaloa to pass drugs along Buenos Aires Street, in Nogales, Sonora, and without one knowing that the other was tricking him, he killed him to steal the merchandise, and that's how the corrido ends. It was very popular in the seventies, and then Los Tigres del Norte came along and recorded a corrido of mine called 'Vivan los Mojados' [Long Live the Wetbacks]."

That song might have set him off on a profitable career, but Jesse did not follow it up with any great energy. In the early 1980s, his royalties were shrinking with the devaluation of the Mexican peso, and he wanted a more secure trade than music. He became a real estate agent and only went back to composing toward the end of the decade, "on the insistence of my wife, Julia." He wrote some new songs, recorded a demo cassette, and began handing it around to various groups. At a festival, he gave a copy to Conjunto Primavera, a norteño band from Ojinaga, Chihuahua, and a few months later they called to say that they had recorded one of his songs, a ranchera ballad called "Me Nortie" (I Lost my Head). In 1995, the song became the title number on Primavera's new album, earning the group the first gold record in its fifteen-year career, and Jesse was back in the songwriting business. His next hit was "Que Me Recomiendas" (Recommend Me), for the norteño singer Polo Urias, which made it to the *Billboard* Latin Top Ten in the United States. And then came "El Circo" (The Circus).

"El Circo" was not Jesse's first venture into social issues. "Vivan los Mojados" had set off the wave of mojado songs, and his corrido "Dos Monedas" (Two Coins), in which an alcoholic's son freezes to death after being sent out to beg, was a big hit for Ramón Ayala, covered by dozens of other groups and adopted by Mexican chapters of Alcoholics Anonymous. Still, "El Circo" was something different. It portrayed two brothers, Carlos and Raúl, who were owners of a circus. Carlos was the lion tamer, Raúl the ringmaster, and together they took control of all the other circuses, those of the Gulf and Chihuahua, leaving only that of Sinaloa.

> Raúl se hizo millonario, dicen que por ser el mago,
> Desapareció el dinero de las manos de su hermano,
> Y dicen que está en los bancos de Suiza y por todos lados.

> (Raúl became a millionaire, they say because he was
> the magician,

The money disappeared from the hands of his brother,
And they say that it is in the banks in Switzerland and
 everywhere.)

The song goes on to say that Carlos has disappeared and Raúl is in jail, so now the people can relax "until another circus comes along, and once again the same *tranza* [hustle, or corruption]."

To anyone familiar with Mexican politics, the song's meaning was obvious. The brothers were ex-president Carlos Salinas de Gortari, who had fled the country amid allegations of theft and corruption after leaving office in 1994, and his brother Raúl, who was in jail awaiting trial on an array of charges ranging from money laundering to murder. The implication was that they had corralled much of Mexico's drug business and stashed their profits abroad. As Enrique says, this was not exactly news, but it was a shock to hear it sung about on the radio. Salinas, whatever his faults, had loosened many limitations on press freedom, a policy continued by his successor, Ernesto Zedillo, but no one in popular entertainment had taken this much advantage of the new liberties. Of course, everyone knew about the Salinas brothers' alleged misdeeds, and it was no secret that their administration had left Mexico in a state of economic crisis. Still, Carlos Salinas was the ex-president, and hence regarded as off-limits for this sort of treatment. Mexico has had its share of corrupt or dictatorial leaders, but from 1929 to 2000 (when Vicente Fox, of the PAN, or National Action Party, was elected president) all were members of the PRI, or Institutional Revolutionary Party, and, whatever their sins, they tended to be treated with respect by their successors and the media. Leadership was passed from one president to the next through a process known as *el dedazo*, or "fingering," leaving each president indebted to his predecessor for his job. While criticism of ex-presidents was not unheard-of, neither was it the common currency of popular entertainment.

Even after he had written the song, Jesse did not know if anyone would record it. Then he happened to run into Pepe Cabrera, who was paying a brief visit to Phoenix: "It had been at least ten, fifteen years since I had seen him, and it gave us such pleasure to see each other, we embraced and he said to me:

" 'Jesse, how have you been?'

" 'Fine, Pepito, fine.'

" 'Have you been working?'

" 'I just started up again.'

" 'So what do you have that's new?'

" 'Well, I have a few new things,' I told him.

"And Pepe said, 'Let's hear, sing me one of your corridos.'

" 'Okay' [Jesse begins to sing, his voice gently carrying the tune]:

> *Entre Carlos y Raúl, eran los dueños de un circo,*
> *Carlos era el domador . . .*

"He just listened to one verse, and he said [snapping his fingers]: 'Tigres. That's for Los Tigres. Don't worry about a thing, I'll take charge of getting it to them.' So he took it to Los Tigres. This all happened in December, and in January Los Tigres invited me to a family quinceañera that was being held in Mexicali. I went as a guest, and I put the cassette into Jorge's hands, with 'El Circo.' He listened to it over and over, many times, and Mr. Santiso, the president of Fonovisa, listened to it, and analyzed it word by word, and they said, 'No, this can't be. This can't be recorded.' And yes, and no. . . .

"Fine, so finally they sent it to the company in Mexico, and they hit the ceiling. They didn't want to record it, because they said, 'This will be the end of Los Tigres' career! This will be the end of Fonovisa!' or whatever. Then they opted to bring the corrido to the Department of State,* to the Department of Communication of the Mexican Republic, so that they could hear it there and give us permission to record it. They negotiated, and the State Department people listened to it, and even the president [Zedillo] himself listened, and he said, 'Record it.' So they took the song, they recorded it in San Jose, California, they arranged it all, and you know the rest."

As with "Vivan los Mojados" in the 1970s, Jesse had written the right song at the right moment. "You have to be *up to date,* as they say in English, with everything that is happening around you, in the world, especially in the area in which you are working, whether here in the United States or in Mexico, in Latin America. If something happens, some serious event, something ugly—or maybe beautiful, whatever—you can put it into a song, and if the group is there to record it and the people accept it, that makes for a big hit. In the case of 'El Circo,' I wrote it just as the country was going through a major crisis, economically, morally, socially, politically. . . . It makes me think now: with so many composers

* Jesse said *"gobernación,"* which is not exactly the Mexican parallel to the US State Department, but is the closest analogue.

in Mexico, still no one had the idea to write 'El Circo,' and, well, I thought of it, I wrote it and polished it up, and then it got into the hands of Los Tigres, and 'Boom!' "

The song's success was astonishing and was aided by the furor that followed its release. "Even when the State Department gave the green light to put the song out, in Mexico there are two very important radio networks, Radiocentro and Grupo ACIR. Radiocentro didn't want to program the song, and Grupo ACIR did program it. So when that happened, that made the song bigger, because people said, 'Why are some stations playing it, and others no?' It became a controversy, with newspapers writing about it, so the corrido kept gathering strength, gathering strength—and how great for me, and for the company! Because Los Tigres broke sales records, sold a million copies, I think in three, four months. With 'El Circo,' Los Tigres climbed to first place in the *Billboard* charts, and came out in all the Mexican press, in all the American press, in *People* magazine, in *Time* magazine. That corrido is even on the Internet."

Nobody knew that the song had been run past the government for approval, and Los Tigres were hailed as having done something well nigh revolutionary. Only a thoroughgoing cynic like Enrique would have assumed the truth, which Jesse states quite openly: that the song's wide dissemination was serving government interests rather than challenging them. Salinas had left Mexico's economy in ruins, and Zedillo was doing everything he could to distance himself from the fiasco: "It was very controversial, but at the same time the government said that it would be a good idea to put it out, so that it could serve as an escape valve for the people."

In fact, "El Circo" was not as novel as most people thought. There is a long tradition of political corridos in Mexico. It is standard practice for political campaigns to commission songs for their candidates, and some corridistas have made a regular sideline of this sort of business. Usually these songs are simple campaign ads, focusing on local issues and events, but a search through Antonio Avitia Hernández's *Corrido Histórico Mexicano*, a five-volume collection of historical corridos, turns up an earlier analogue to Jesse's song: "El Corrido Calles-Morones" attacks Plutarco Elías Calles, the president of Mexico from 1924 to 1928, strongman behind the PNR (the PRI's parent party), and organizer of the rigged election of 1929 from which the PRI's reign is typically dated. (Salinas's election was similarly suspect, marked by a "breakdown" of the computerized vote-counting system when his left-wing opponent seemed to be coming out ahead.) The song's theme of corruption in high places is disturbingly similar to that of "El Circo," and its language is even more scurrilous:

Este es el perro callista, que tanta lata nos dio,
Nos vino a quitar el sueño, y la plata se llevó.

(This is the Callista dog that was such a bother,
It came to rob us of our sleep, and took away the silver.)

Like Salinas, Calles was already out of favor and in foreign exile when this corrido was published, and both men were thus relatively fair game for critical attacks. Still, if Jesse's song was less than revolutionary, that does not mean that there was no risk involved in writing and singing it. The Salinases retained many powerful friends, and it was daring for a ranchera band to mess with politics at all. The controversy surrounding his work accounts for Jesse's initial suspiciousness on the phone, and also for the evasiveness with which he talks about his most famous composition: "When we presented the record, in Puerto Vallarta, I was mobbed by reporters, all wanting to know about me, and all asking me the same thing you are asking: 'What motivated you to write this corrido?' And, logically, I told them: 'The reporters.' " Jesse pauses, smiling. "Everything the reporters say, that was what I wrote. Then they asked whether I knew the president, and I said, 'No, I don't even know who the president is.' "

It is a jarring comment, coming from a man whose coffee table is covered with news magazines, who is obviously well up on all the intricacies of Mexican politics, and who has a reputation as the most outspoken songwriter in the norteño field. In a weird way, it reminds me of Mario Quintero's claim that "Mis Tres Animales" can be understood as just a fun song about animals. Jesse knows exactly what he is writing, but nonetheless wants to keep a safe distance from the implications of his material: "I always try, in my corridos, not to personally offend anyone. In the first place, I do not know the gentleman, and I do not know if he was a good president or if he was a bad president. I am not here to judge, neither Clinton because he had a lover, nor Salinas because they say he stole money. Those problems, let the Mexicans take care of them, the people who are inside the system. If they believe that Carlos or Raúl Salinas stole some money, fine, that's what the authorities are there for, let them mount an investigation of the affair and see that justice is done to those involved."

Despite this evasiveness, Jesse was soon delving still deeper in the muddy waters of Mexican politics. Los Tigres' next album was their masterpiece, *Jefe de Jefes,* and it included four of his songs. One, "El Prisionero" (The Prisoner) was a sort of follow-up to "El Circo," tracing the further investigations into Raúl Salinas's criminal affairs, and going into

even more controversial territory by hinting that the corruption extended to the current administration. The lyric included the lines, "It is a pity that with the finger of his best allies / The character of whom I speak expects to be sentenced," an obvious reference to the dedazo, suggesting that the Zedillo government was too closely linked to its predecessors to be able to pass fair judgment. This theme was explored more fully in another song, "El Sucesor" (The Successor), a barely veiled satire of the PRI succession that compared it to a Mafia-style family business and implied that the party had been behind the assassination of Luis Donaldo Colosio—its own original candidate for the 1994 presidential elections—for trying to institute reforms.

Though these are undoubtedly his most distinctive songs, Jesse is eager to point out that he was not spending all his time writing about politics. To a great extent, *Jefe de Jefes* was Los Tigres' proof that, having founded the genre, they remained the kings of the narcocorrido. The cover shows them wearing dark leather coats, in a black-and-white photograph taken in the ruins of Alcatraz prison, and the album was driven by drug-world ballads from Teodoro Bello, Francisco Quintero, and Paulino Vargas. Jesse was there for balance, and along with the topical songs provided one about the danger of drugs, "El Dolor de un Padre" (The Pain of a Father). He says that this was written specifically at Los Tigres' request: "When we were working on the production of *Jefe de Jefes*, Jorge Hernández asked us to do certain things; he assigned certain things to Teodoro Bello and he assigned certain things to me. We each went off to our room in the hotel, and Teodoro wrote 'Jefe de Jefes,' and that same afternoon I wrote 'El Dolor de un Padre,' and the next day we presented them and that was that."

Jesse adds that his original lyric was stronger than the version on the record. Fonovisa vetoed a recitation he had placed in the middle of the song, which not only expressed the pain of a father whose son has been lost to drugs, but went on to accuse the most powerful drug lords by name: Pablo Escobar, Juan García Ábrego, El Señor de los Cielos, and the Palma, Arellano, and Rodríguez Orihuela families, "and one or another member of the government." Jesse is disappointed that the lines were left off the record, but not overly so. He has almost infinite respect for Jorge's taste and judgment, and understands that Los Tigres have kept their position through extremely canny decisions at every stage of their career. In fact, I was surprised to find how much credit he gives them for the songs that bear his name: other writers had mentioned that Los Tigres commissioned songs from them, but Jesse describes the process as an active collaboration from start to finish:

"They chat with us regularly, whether with me or with Teodoro, with Paulino, with Enrique Valencia. Jorge will say, 'Listen, I want a theme more or less like this.' Then one comes to him with the idea, works it up, presents it, and, 'Ahh, we're going to change this, to focus it in this way, do this, and this other thing.' So the corrido gets elaborated bit by bit, it keeps cooking until it is at just the right point, the way they want it. They are very flexible, and the good thing is that we are also very flexible. We have to write the song to their taste, so that they will feel it when they sing it, so that the corrido will be a hit. That's the great thing about Los Tigres, that they are very human, they are very, very friendly as friends and, logically, as businessmen they are businessmen. And with all due respect to the other groups, Los Tigres are the ones who have helped us most, they are the best showcase one can have as an author. And, thank God, we have the privilege to be able to pick up the telephone and call them and say hello and 'How's it going?' And when they see us, they are attentive, they were just here in my house, right here exactly, all eating together, friendly, like a family, and that is the relationship one should have among artists."

Jesse adds that he does write for other groups as well and has even composed a few straightforward narcocorridos. He presents me with a new cassette by Los Norteños de Ojinaga, *Corridos Pa' Mi Pueblo, Vol. II*, which contains four of his songs, including one about El Pantera (the Panther), an associate of El Güero Palma, and "Celda de Lujo" (Luxury Cell), about a drug lord maintaining his high living standards while in prison. Although he is best known for his topical work, Jesse writes about pretty much anything that catches his attention and, as the afternoon wears on, he takes me to a small office just off the living room, which he has set up as a recording studio. It is hardly bigger than a closet, but he has all the equipment to record multitracked demos, with synthesized rhythm tracks to accompany his guitar. There are photos on the walls of groups that have recorded his work, and stacks of finished cassettes, each neatly labeled with a title and the inscription, "original song by Jesús 'Jesse' Armenta."

"I have hundreds of songs," he says. "And I don't write them thinking, 'How much money are you going to make with this song?' I write because it is born here inside me. Sunday, I went into my studio at eight-thirty in the morning, I think, and do you know what time I left that studio? It was eight-thirty, nine at night. And why? Because I was thinking about how much money I was going to make? No, I was working at what I enjoy. I wrote a corrido, once again on a social theme, about—not the stepfather who abuses his stepdaughter, no—the *señora*, wife of this man, who would like to abuse the son of this *señor*, the other way

175

around." At the moment, he seems rather captivated by such new twists on classic sex-and-betrayal themes: another recent corrido tells of a husband who comes home to find his wife in bed, not with another man, but with her female best friend.

Naturally, when a story came along that combined sex and politics, Jesse was ready, and the Norteños de Ojinaga album also includes "El Presidente," his take on the Bill Clinton–Monica Lewinsky affair. The Lewinsky story got abundant coverage in Mexico, virtually all of it favorable to Clinton. Mexicans were amused and astonished that the most powerful country in the world could be brought to a halt over a petty peccadillo, and Jesse's take is more or less typical: "I refer to the fact that many people were criticizing the president, when there is no honest politician—it doesn't matter where we go, a politican who is poor is a poor politician. So it says, 'Let he who is without sin cast the first stone.' I wrote it because I feel the effects of the economy in the United States, and I think Clinton has been one of the best presidents that we have had, definitively." He sings a snatch of the melody: *"Yo no defiendo el machismo, tampoco la corrupción, / Pero de todos los gringos, yo pienso que es el mejor."* (I do not defend machismo, nor corruption either, / But of all the gringos, I think he is the best.)

After more than three decades in the United States, it is logical that Jesse should concern himself with issues on this side of the border as well, but so far the Clinton song is unique. That is, if one does not count his corridos of immigration: the final song on the Norteños de Ojinaga release is an antiracist corrido, "La Discriminación," which takes California's Proposition 187 as a starting point for an attack on discrimination against all Mexican immigrants, legal or not:

Siempre seremos los mismos, aunque te haga ciudadano,
Aunque unos traigan permiso y otros ya estén arreglados,
Para los ojos del gringo siempre seremos mojados.

(We will always be the same, even if you become a citizen,
Even if some carry [residency] permits and others are already
 arranged [i.e. have full papers],
In the gringo's eyes we will always be wetbacks.)

Jesse's style has matured since the seriocomic twists of "Vivan los Mojados," but his sentiments have remained largely unchanged. His most eloquent immigrant song to date is "Ni Aquí Ni Allá" (Neither Here Nor There), yet another contribution to *Jefe de Jefes*. In this case, he decided to broaden his scope beyond his own community: "It has a

very good message, about what happens, not with Latinos, but rather with all immigrants—we could be speaking of those from Czechoslovakia. You see, there are times when people come here to get ahead, and the result is that they realize that the system here is hard as well, it is not easy to make it. Although this may be the land of opportunity, one has to struggle, one has to work very zealously, very hard to get ahead, and very often people don't see it like that."

With a lovely, haunting melody and some of Los Tigres' finest singing, the song may well be Jesse's masterpiece:

> *En dondequiera es lo mismo,*
> *Yo no lo entiendo y no entenderé*
> *Que mis sueños ni aquí ni allá,*
> *Nunca los realizaré.*
> *Ni aquí ni allá, ni allá ni acá,*
> *Nunca los realizaré.*

> (Wherever you go it is the same,
> I do not understand, and will never understand
> That my dreams, neither here nor there,
> I will never attain them.
> Neither here nor there, neither there nor here,
> I will never attain them.)

And yet, unlike Enrique Franco, Jesse says that the song is not his own story: "No, it was nothing personal," he says, smiling at the question. "Because, as you see, I live very much as I like. I live tranquilly, I work well, I have my cars, my house, my children in the university—thank God and Los Tigres del Norte, everything, everything is going well."

It is a surprisingly cheerful statement from a man known as the corrido world's most piercing social critic, but Jesse has put that contradiction as well into verse. As he gives me a ride back to the Y, chatting about his future plans and playing some of his recent demos on the car's cassette deck, I am reminded of the song's final lines:

> *Así pasaré la vida, hasta que llegue el final,*
> *Quitándome las espinas para alcanzar el rosal.*

> (Thus I will spend my life, until the end arrives,
> Plucking the thorns to get to the rose.)

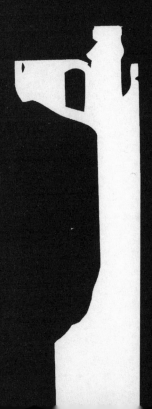

SECTION 4

NORTEÑO HEARTLAND

TRUCKER TO TROUBADOUR

Julián Garza

"Para canciones el sur, para corridos el norte"

(For songs the south, for corridos the north)
—*Reynaldo Martínez, "El Corrido de Gumaro Vázquez"*

Enrique and Jesse had provided an interesting break, and now I was ready to return to the wild and woolly world of the action corridos. My next destination was northeastern Mexico, the classic corrido country along the Rio Grande (or, as it is known in Mexico, the Río Bravo). I took a bus down to the border, then slung my guitar over my shoulder and walked through the dry desert heat out to the highway.

For anyone interested in doing corrido research, I really cannot recommend hitchhiking highly enough. Of course, one does not always get lucky: the truck driver who picked me up on the road between Chi-

huahua and Torreón was playing *Queen's Greatest Hits.* I suppose he was equally disappointed—one does not pick up a gringo with a guitar because one wants to spend the next few hours with a corrido nut. He was very decent about it, though, and after the Queen tape was over he put on Los Tucanes' *Los Más Buscados,* explaining apologetically that it was the only corrido cassette he had with him. Such is life, and I had to admire his breadth of musical interests. During the eight-hour ride, he played Sonora Dinamita, a Mexican tropical orchestra; a set of cumbias by Apache; the pop singer Carlos Vives; *The Best of Boney M;* and the most recent album by the Mexican rock band Maná, his favorite. He did not play ABBA or Yanni, but he had both. In defense of the corrido, I noted that the Tucanes tape was the only one he sang along with, and he knew every word.

I stopped off in Torreón in hopes of meeting and interviewing "Chito" Cano, but unfortunately he was out of town on business. These days, Rodrigo Ángel Cano is Torreón's most successful norteño concert promoter, but his place in history was earned during his youth as a *pistolero.* "El Corrido de Chito Cano" was one of the most popular early hits for Ramón Ayala y los Bravos del Norte, and is familiar to any ranchera fan for the immortal verse where Cano lies on the floor, a bullet in his spine, laughing and shouting, "Don't run, don't be cowards—finish killing me!" They ran, and he remains a force on the music scene, doing business from a wheelchair. At least two of the top corrido composers have written additional songs about him, Reynaldo Martínez producing "El Retorno de Chito Cano" and Julián Garza "La Leyenda de Chito Cano."

Cano's is the sort of corrido folklorists love, an old-fashioned badman ballad that starts off with the date of the shooting, tells a true story straightforwardly—albeit with appropriate heroic flourishes*—and ends with a *despedida,* the traditional balladeer's farewell. It is also the sort of corrido that continues to be played, heard, and applauded throughout northeastern Mexico. There are drug plantations, smugglers, and narcocorridos in the northeast, but they have not become an ingrained part of the culture. One reason may be economic: Monterrey is the wealthiest city in Mexico, and the money comes from industry, not drugs. In the Texas border states of Nuevo León or Tamaulipas, a young person dreaming of getting rich might be more likely to imagine a

* Lines like "Que bonitos son los hombres, no se les puede negar" (How fine real men are, one cannot deny it).

career in international business or high tech than the fast, dirty life of a smuggler.

Whatever the reason, this region has a quite different taste in corridos. Los Tucanes have never been huge here, nor have the new wave of chalinitos. Los Tigres are stars everywhere, but on radio playlists and tape decks in Tamaulipas and Nuevo León their competition is still largely drawn from the other classic groups of the 1970s. The names one sees again and again are Ramón Ayala, the accordion virtuoso who made his name in that decade and remains the most popular instrumentalist among norteño fans on both sides of the border, and all the duos that came out of Nuevo León on the heels of Los Alegres de Terán: Carlos y José, Luis y Julián, Los Invasores de Nuevo León, and a half dozen more.

The northeast's devotion to old-time songs and styles makes it an ideal area to get a grounding in the past of the corrido boom, but less fertile for a study of its present and future. The truck driver I rode with between Torreón and Saltillo would be fairly representative: he had only two recent cassettes in his cab, one by Grupo Exterminador, whose humorous take on the narcocorrido has been popular here, and the other by Los Cadetes de Linares, a classic duo that has re-formed with a new singer but continues to play an old-style repertoire. His other cassettes were all from the 1970s and 1980s, the standard northeastern stars along with Los Tigres and Los Huracanes del Norte, one of the many groups that followed Los Tigres' model. He was knowledgeable about the groups and their music, and when I explained what I was doing he began playing me favorite songs and telling stories about legendary corrido protagonists. He thought it a great pity that I had missed Chito Cano, and said I should make it my business to hunt up the families and survivors of other classic ballads. There are, for example, the Fierros, a family of pistoleros based at the La Piedra ranch, outside Matamoros, who have inspired at least a dozen corridos and two popular films, *Los Hermanos de Hierro* (The Iron Brothers) and *La Dinastía de la Muerte* (Dynasty of Death), as well as supplying more than their fair share of business for the local coroner. My driver said that the famous brothers had been wiped out, but their sister, Blanca, was still alive. "But you don't want to visit her. She drives a red pickup with a cuerno de chivo down between the seat and the door, and wears a forty-five on her hip." Like all of the corrido heroes he mentioned, the Fierros were killers but not drug guys, an important distinction in this part of the country.

If the corrido themes on the West Coast invite comparisons to

gangsta rap and Mafia movies, celebrating a world of beepers, cell phones, and the latest SUVs, along the Rio Grande/Río Bravo they still echo the gunfighter ballads of the old west, the legends of Wild Bill Hickok and Billy the Kid. This is cowboy country, and the culture is very similar on both sides of the border. According to most experts, the corrido as we now know it was born around here sometime in the mid-1800s, loping alongside the songs of the Anglophone *vaqueros* (who would spell their name "buckaroos"). An interesting monograph could be written on the reciprocal influences of the Spanish and Anglo-Irish ballad traditions, and the way this interchange gave rise to new styles in both languages. Certainly the cowboy yodel owes at least as much to Mexico as it does to Switzerland, and likewise the cowboy predilection for singing in waltz time. Cow culture crossed linguistic barriers, though Spanish was dominant in the culture's specialized lingo, providing the Anglos with lasso, bronco, canyon, mesa, chaparral, ranch, and even ten-gallon hat, a mistranslation from *galón,* or braided hatband.

The earliest corrido recordings featured singers accompanied only by their strummed guitars, and are strikingly similar to cowboy records being cut around the same time in English. There was even some direct overlap: in the late 1920s, a Texas guitarist named Valentín Martínez was recording both what would come to be called ranchera music and, in a duo with his brother Pete, cowboy yodels. The split between the two styles was not completely defined until the accordion became a norteño staple in the 1940s, and even this development ignored the national boundary: the instrument seems to have first caught on in Texas, lapping over from German and Czech-Bohemian immigrants, then moved out to blanket Tamaulipas and Nuevo León.

Like the Anglo Texans, the northern Mexicans are still wrapped up in their cowboy past. They may live in cities and earn their salaries in the chemical industry or international trade, but they like to wear boots and big hats and to go on trail rides, and they talk about Pancho Villa or General Juan Cortina (who crossed the river to recapture Brownsville in 1859, with the slogan "Death to the Americans!") the way Texans talk about Sam Houston or the heroes of the Alamo. Their corridos reflect this sense of history. While there are boatloads of cocaine unloading in Tampico and being trucked north, and a driver in Tamaulipas told me of his grandmother cultivating opium poppies in her front garden, drug culture never caught on here the way it has in Sinaloa. The difference was nowhere more clear than in the studios of Radio Ranchera, to which I paid a visit my first morning in Monterrey.

Monterrey had already surprised me, and not entirely in a good way. The city is the center of the industrial north, sitting on a flat plain with

mountain peaks visible in the distance whenever the smog clears. I first checked into a hotel near the bus station and assumed that with further searching I would find something cheaper and more "typical" down toward the center. After all, every other town in Mexico is full of little, ratty hotels near the market, where tradesmen can rent rooms (sometimes with female companionship included) while they sell their wares. Noisy, dirty, and cheap, these were my regular lodgings, and I rather liked them. I certainly liked them a hell of a lot more than the air-conditioned, characterless cubicle with a sealed window looking onto an airshaft in which I spent my first night in Monterrey. I resolved to find something more to my taste, but it simply was not to be had. Keeping up with the Joneses across the border, Monterrey has urban renewed its city center almost out of existence, creating wide, barren "public" spaces, pedestrian walking areas, and a quaintly preserved "old town," but losing a lot of what had undoubtedly been the neighborhood I was looking for. I ended up back near the bus station, in the most uncomfortable hotel of my journey. It was named the Roosevelt, which gives a good idea of its vintage, and a neon sign on the roof blazoned the message "Mexico PRImero" in the red, green, and white of the Mexican flag. The price was high, considering that the room had no hot water and the bed could have served as a topographical map of the Sierra Madre, but local color does not come free. Certainly other clients had been satisfied: the graffitti on my walls attested to the hours of pleasure spent there by couples from the provinces, and the joys of *"amor feliz."* In short, it was lousy, but all complaints faded into insignificance when balanced against the big, open window, providing a view over the neighboring houses, a wide expanse of sky, and a pleasant breeze. The window had no glass, of course, but a screen provided a line of zoological demarcation, keeping the flies out and the cockroaches in.

The bus station area, which is also the intersection point of Monterrey's two metro lines, is a vast maze of flea markets, greasy spoons, and blocks of cantinas with lines of hookers sitting outside and signs on the doors prohibiting entry to "minors, musicians, salesmen, and troublemakers." On Pino Suárez, a couple of blocks from my hotel, an electric sign announced "Música Norteña," but there was no bar visible, only a half-dozen musicians lounging on the sidewalk until the wee hours of morning, fooling around with accordions and bajo sextos while they waited for clients to come by and sweep them off to parties. The mariachis were grouped one block over, on Avenida Cuauhtémoc.

North of the bus station, the industrial area begins, blocks of factories broken only by the old Cuauhtémoc beer brewery, now converted into a museum that at the time of my visit was hosting the fourth Mon-

terrey Biennial, four floors of modernist sculpture, painting, and installations. Heading south, it is a couple of miles to the center of town, and it was on my walk there from the hotel that I passed the doorway of XEG, Radio Ranchera.

As it happened, the station had a corrido show that afternoon, and the deejay, José Jaime Zavala, invited me to come up and listen. Radio Ranchera is one of the most powerful stations in northern Mexico: a sign on the wall of the broadcast booth has a map showing radio waves fanning out over pretty much all of Mexico and half the United States, with the caption, "Be careful what you say . . . Look how far away you are heard." That afternoon, José Jaime was overseeing a series of call-in corrido duels: he would play two songs, and callers would vote for which artist they preferred. The first to get three votes won, and José would play another song by that artist followed by one from a new challenger. In most of Mexico, and certainly in California, this would have been a duel between current hits, but around Monterrey newer is not necessarily better. As I came in, the current winner was Los Cadetes de Linares's "Pescadores de Ensenada" (Fishermen of Ensenada), one of their oldest and best-loved hits. This was followed by Los Cadetes' "Pistoleros Famosos" (Famous Gunmen), another old-timer, which got two votes but was edged out by Grupo Exterminador's "Las Monjitas." Exterminador won again with "Los Dos Rivales" (The Two Rivals), surviving a challenge from Ramón Ayala's oldie, "Once Tumbas (Dinastía de la Muerte)" (Eleven Graves [Dynasty of Death]), only to be crushed three-to-one by another hit from over a decade back, Luis y Julián's "Asesino a Sueldo" (Paid Assassin). Luis y Julián held out against Los Tigres' "Contrabando y Traición," then were beaten by Los Invasores de Nuevo León, who were going up against Los Alegres de Terán when I got bored and wandered into the control booth to chat with the engineer, José Luis Silva.

I expressed my surprise that so much of the programming was songs or groups from over twenty years ago, and José Luis said that that was normal. "People like the old songs. They may not be hits, but they are hits here." I asked about Los Tucanes, and he said the only song of theirs that had much impact in Monterrey was "Mis Tres Animales." "Even Los Tigres only function with oldies. 'Jefe de Jefes' doesn't win anything here." Chalino did all right for a while, and there is no censorship of drug lyrics, but the audience prefers the classics. He added that, although corridos are stereotyped as macho music, more than half of the people calling in to vote were women.

With all the corrido groups in the area, it had been hard to choose whom to interview, but the Radio Ranchera playlist confirmed my incli-

nation to single out Julián Garza, of Luis y Julián. Of all the Monterrey crowd, he is the one who combines the greatest success as both a singer and a composer. In the musical duel I had just heard, his group had held on for three songs, winning out over Grupo Exterminador and Los Tigres, and he was also author of the Cadetes' "Pistoleros Famosos," giving him songs in four out of the seven matches. More importantly, his writing exemplifies what I was coming to think of as the northeastern sound. It is saturated in the classic cowboy style, with a traditionalism that links it to the border heritage of the nineteenth century. In fact, Julián's writing can sound so traditional that men his father's age will swear they heard 1970s-era compositions like "La Venganza de María" (Maria's Vengeance) or "Las Tres Tumbas" (The Three Graves) as children.

I tracked Julián down with the help of a local corrido researcher, Guillermo Berrones, and Guillermo made us an appointment for the following evening, then drove me to Julián's house. It is a large, new, Spanish colonial–style building in a suburb at the very edge of town, high on the Cerro de la Silla, the saddle-shaped mountain that is a symbol of Monterrey. Julián met us at the door, a massive, bearlike man, with short legs and a thick torso, dressed in shorts, sandals, and a loose, button-neck Henley shirt. "This is your house," he said with classic formality, then appended a comic apology: "I don't have the receipt just at the moment, but . . ." and gestured us inside.

Following Julián's directions, we made our way through to his office, a cluttered, comfortable room lined with bookcases. A handsome charcoal sketch of Julián hangs on one wall, alongside a three-by-two-foot, hand-colored photograph of his mother and a photo of a trail ride led by Julián, Carlos y José, and Lupe Tijerina of Los Cadetes. Julián waved us to chairs, then seated himself at his desk. The desk was cluttered with papers, with a dinosaur of an electric typewriter rising in the center. From time to time, Julián would pick up a sheet to read a lyric, first putting on a pair of little glasses that gave him the air of a comic clerk in a Sergio Leone western.

Julián is a wonderful blend of paradoxes. Like Paulino Vargas, he loves to play the ruffian, but he is both more and less believable. His size lends a certain persuasiveness to the bravado, but he is also the most well read corridista I have met, and can seem soft as a marshmallow. He is a thoughtful man, but his speech is a colorful compendium of slang and obscenities, and his faith in his own abilities is offset by a gift for comic self-deprecation.

Looking around at the books, which tend toward weighty histories of the Revolution and Mexican novels of the first half of the twentieth cen-

tury, I ask Julián if he went to college. "No, no," he says. "I am a great lover of reading, ever since I was a child, but I scarcely went up to third grade. The doctor told my father that school was bad for me—I went to the goddamn school and I got sick. I always suffered from tonsillitis, from quinsy. I think that I wasn't really very delicate, because I was a little rascal, I went up on the mountainside with the dogs, hunting rabbits and that whole scene—not hunting with guns, we didn't even know about that, but with a slingshot. But the doctor made that recommendation to my daddy. I was listening when he said, 'Don't send him to school anymore, or the cabrón will die,' and I laughed to myself and said, '*¡Chin! que a toda madre* [Fuckin' great!].' "

Julián grew up in Guadalupe, the suburb where he still lives, but he was born in the rancho of Los Ramones, near General Terán. This is the northeast's most fertile area for corridistas, if only because of the overarching influence of Los Alegres. "General Terán is a zone in which everybody plays an instrument: if a guy doesn't play accordion, he plays bajo sexto, upright bass. . . . A lot of good groups have sprung up from around there. Los Alegres de Terán, of course, are the fathers of norteña music, and so it's like in Tepito, in Mexico City: that's where the first boxers sprang up, so they keep springing up there because they want to imitate their idols. Luis Villanueva, Kid Azteca were from Tepito, and then came El Puas, and a lot of other boxers have come from that barrio, because when someone springs up who distinguishes himself in some field, then the others want to be like him, and often they end up being even better. So there in General Terán, Los Alegres de Terán were the greatest exponents of norteña music, and since all the people there are aficionados of music, well, it was normal to try to imitate them, and there are more norteño groups there than in any other region."

Julián enjoyed being around all this music, but he had no skill as an instrumentalist and his voice is nothing special, so he never thought of making a career at it until he was almost forty. He always liked to make up songs, but that was just a hobby, something he did in the bars to amuse his drinking buddies. He made his living as a truck driver, then took factory work and whatever came his way. "I always had the music itch, to compose, but I didn't think I was capable of doing it. I made up corridos as a joke: something would happen to somebody and I would immediately make him a corrido. Then a friend of mine, Juan Antonio Treviño, said to me, 'Why don't you do this seriously, since you have the talent?'

" 'No man, how the fuck could I have talent? I wouldn't be here working with my donkey, here in this shitty factory. . . .'

" 'No man, sure you have. Do it seriously.'

"And, bit by bit, the idea began to grow on me, until I said to myself,

'Maybe the bastard is right.' And I set myself to writing corridos seriously, and in one week I wrote 'Pistoleros Famosos,' 'Las Tres Tumbas,' 'Luis Aguirre,' 'El Jesús Pata de Palo,' and some others that I don't remember right now."

It is hard to believe that Julián took off quite that fast, but even allowing for some exaggeration his early output was extraordinary. His style was a model of classicism, and his songs quickly caught the ear of the region's norteño stars, then overlapped from the radio and jukeboxes into local folklore. ("Oh yeah," Julián says. "Those songs were so popular, even the damn dogs were singing them.") Many of his corridos could have been written a hundred years earlier, and even the more innovative ones harked back to his version of the good old days. "Pistoleros Famosos," for example, may have been the first example of a corrido of self-referential nostalgia (like others of Julián's compositions, it would be often imitated, but never bettered), a wistful paean to the old badmen and their songs:

189

> Por las márgenes del río, de Reynosa hasta Laredo,
> Se acabaron los bandidos, se acabaron los pateros,
> Así se están acabando a todos los pistoleros.

> (Along the edges of the river, from Reynosa to Laredo,
> The bandits are finished, the *pateros** are finished,
> Thus they are finishing off all the gunfighters.)

There followed a list of famous border pistoleros, from the Fierros on down, before the final lines summed things up:

> Desde aquí se les recuerda, cantándoles sus corridos.
> Murieron porque eran hombres, no porque fueran bandidos.

> (From here we remember them, singing their corridos.
> They died because they were men, not because they were
> bandits.)

Julián's other songs hymned the same virtues: "Las Tres Tumbas" tells of three sons who ignore their father's warning and go out partying, only to be surrounded and shot down by their rivals. "Luis Aguirre"

* *Patero* apparently derives from *pato*, or duck, and was used for people who pushed home-made rafts across the Rio Grande/Río Bravo, smuggling alcohol, immigrants, or whatever else was worth smuggling.

is a desperado who kills a lawman in a fair fight, then is himself shot by an unseen gunman; the song's high point comes in a lecture Aguirre gives his young pursuer before the shooting starts:

> *"¡Quítate de aquí, cachorro! Tienes mucho que aprender,*
> *A disparar un revólver y a que te ame una mujer.*
> *Apártate de mi vista, yo no peleo pa' perder."*

> ("Get away from here, puppy! You have a lot to learn,
> To shoot a revolver and to be loved by a woman.
> Get out of my sight, I don't fight to lose.")

This is the Wild West in all its glory, the stuff of dime novels and a thousand Saturday matinees. Julián is a western buff, and his corridos remind me irresistably of the cowboy songs I loved as a kid. I was a big fan of the Texas folksinger Cisco Houston, and when I was eight or nine I used to get some friends together to act along with his record of "The Killer," a melodramatic ballad about a shoot-out in San Antonio between the hero, Dobie Bill, and Two-Gun Blake, the "Texas killer" who has betrayed his girl. Like many corridos, it tells its tale in richly purple prose: the two gunmen meet in a bar, and Bill calls Blake a snake and a "lily-livered cur," before putting "a brace of bullets . . . true and certain through his heart."

> As he fell, his hand was grasping for that gun he got too late,
> With the notches on it showing like the vagaries of fate.
> And the man who stood there looking at the killer as he lay
> Murmured, "Now I've kept my promise, I have made that
> scoundrel pay."

It is hard to imagine anyone in modern Nashville singing a lyric like that (the last country hit in that vein that I can think of is Marty Robbins's "El Paso," from 1959, which Julián says he always wanted to translate into Spanish), but in the corrido world this sort of archaic language and unblushing romanticism, the blend of medieval balladry with nineteenth-century pioneer mythology, is still common currency. In part this is pure nostalgia, but it is also true that in some areas of Nuevo León and Tamaulipas the Wild West is not a thing of the past. When I ask Julián if he has ever actually seen the sort of shootings that he writes about, it instantly starts him on a story:

"We were entertaining at a dance, here in Vaquerías, a place to the

east of General Terán, and we were just starting the second show when we heard the shots. I thought they were firecrackers, and no, then I see the flame of the guns and right there in front of us four guys were shooting and getting killed, in the middle of the kids and the women and everybody—I don't understand how they didn't wound anybody but each other. Aside from the four of them, there were something like ten pistols fired, but there were only four killed. One was wounded, and they finished him off there, stabbing him with knives. It was very ugly, I had never been in anything like that."

"What did you do?" I ask.

Julián shouts with laughter: "Me? *Pecho a tierra, mano,* chest to ground. My brother said to me, 'Don't knock the microphone over,' and I said, 'I'll knock over the head and the speakers *y la chingada!*'* I'm not going to stand there, get killed by one of those assholes—not goddamn likely, that's fucked up.

"And one of the guys who fired comes past where I was, and handed me his gun: 'Take the gun, keep it for me.'

" 'No, cabrón, how can you give me that gun? You'll just get me messed up in this crap. What does it have to do with me? Toss it to fuck your mother, or do whatever you want with it, why give it to me?' He wanted to get rid of the evidence of the crime, so of course I didn't take it. Are you nuts? How was I going to take the gun from that cabrón? So he ran off, he went up to the mountains."

So, I ask, did Julián write a corrido about the killing? His expression becomes serious: "No, those cabrones killed each other like cowards. If they had been men, they would have gone out in the street, to the mountain, to kill each other. Those bastards killed each other with children around, that doesn't inspire me to write them a corrido."

But if they had gone outside?

"Ah, then I would have made them a corrido, of course. Let them go and kill each other like men, outdoors, among the mesquite plants y la chingada. Then, naturally, right there I would have written one." Julián is getting into the spirit of the thing, miming the action of scribbling on a notepad. Then he shrugs and dismisses the gunmen. "But the way they killed each other didn't suit me."

Julián is a ham, and his storytelling style is pure opera buffa. He acts the whole thing out, cowering as the bullets fly, blustering as he refuses

* This is a favorite, all-purpose phrase of Julián's, added for emphasis to any list. Literally, it means "and the fucked woman."

the gun, scathingly contemptuous at the bad manners of the shooters, then bursting into a rumbling laugh at the end. Not surprisingly, he has always dreamed of being an actor as well as a singer and composer. He proudly gives me a recent solo cassette on which he dramatically reads his own song lyrics, in the style of Ignacio López Tarso, a movie actor whose corrido recitations are remembered nostalgically by the older generation of Mexicans. Julián sees his cassette as a tribute to López Tarso's art, as well as to the old days when corridos were as likely to be recited as sung. "That's an inheritance from the Spaniards," he explains. "The corrido comes from the Spanish *romanza,* or whatever it's called, and back then they recited them, they read them in the streets. They weren't sung, but rather versified, declaimed." As it happens, the same was true of many cowboy ballads: in the old days, barroom recitation was at least as common as singing.

Julián adds that the new cassette is also his way of staking a claim to his compositions: like pop listeners everywhere, ranchera fans tend to be oblivious to songwriting credits, and he wanted to let them know who was really behind all those songs they knew from Los Cadetes or Carlos y José.

Watching him talk, I am sorry that none of what I am seeing has been captured on film. In the hands of a good director, Julián could have a fine career as a comic actor. Certainly, nothing would give him more pleasure. He is a movie nut and still gets excited as he recalls his first visit to a theater: "The first movie I saw, it was called *Tarzán el Indomable* (Tarzan the Unbeatable), I must have been about seven. I fell in love with the image, with film, and I always had a yearning to one day be able to to appear in one, to participate. All of my corridos, I always try to give them a title that is cinematic, like for a movie, and it wasn't long before people took notice of them, to make them into films. The first one was done without my consent—from the moment when you sign with a publisher for a corrido, you practically give them the rights, so the publisher does whatever they want. So they sold the rights to 'Las Tres Tumbas,' and I only found out about it when the movie was almost finished. They were making it there in Jalisco, and I did manage to get there before they finished, and see a little of what they were doing based on my corrido. I went to talk to the director, Alberto Mariscal is his name, and I said to him, "Well, I'd like you to give me a chance to at least appear as a bartender—whatever the fuck, something—to be in the damn movie, because it's my corrido.'

" 'I know, I know, but it's too late, I can't include you. But what are you worried about? You'll have the chance to do more things.'

"And he was right, thank God. After that one, we made *Pistoleros*

Famosos, and in that one I did play a part, and after that about twenty more. And believe me, as an actor I've turned out badly, I'm not very good, but I like that whole scene very much."

From what I have seen, Julián's film appearances capture nothing of the spark he has in person, but I suspect that the problem is less his acting than the sub-B style of corrido filmmaking. *Pistoleros Famosos* is an almost plotless shoot-'em-up, featuring the ubiquitous Almada brothers, and Julián is wasted in a brief, stiff cameo as a police chief. Me, I would like to see him in a more intelligent kind of crime movie, say as the fat, comically corrupt sheriff in a film of Paco Ignacio Taibo's wry drug-world thriller *Sueños de Frontera* (Border Dreams). I can easily imagine him drinking and sweating as he explains to Taibo's detective hero that of course only policemen get shot in the drug war, since they are the hired hands of both the government and the traffickers: "That's what the infantry's for, right? To fight the goddamn wars."

Instead, Julián's films have been uniformly awful, but he still enjoys doing them. He has even written a few screenplays, gaudy creations like *La Metralleta Infernal: El Temible Cuerno de Chivo* (The Infernal Machine Gun: The Fearsome Cuerno de Chivo). I had picked up a copy of that one and was impressed by its transcendent cheesiness. Its hero is a guy who is driven crazy by the burn scars on his face and the abuse of his ruffian brother, kidnaps the pretty girl he loves, and goes on a killing spree.

"It was a turkey," Julián cheerfully agrees, but he adds that it could have been a lot better if the director had not miscast it. He had envisioned himself as the hero, but the director cast him as the abusive brother, saying they needed someone young and handsome for the lead: "He told me, 'No, you don't fit in that damn part, we'll have an actor from Mexico City playing the good guy, you play the bad guy.' " Since the whole point of the story was that the hero was driven insane by the reactions to his ugly, burnt face, this was ridiculous. "They made him up so badly that he still looked very pretty, the little faggot—I don't remember the bastard's name. His face should have looked bad, to justify the repugnance people showed him y la chingada. And all those details were the director's mistakes."

None of this seems to bother Julián much. So what if his acting has been mediocre? He has been able to appear in lots of films anyway. It is a bit like his musical career: "I'm not a good singer, nor do I consider myself one, but I enjoy it a lot," he says. After all, he could still be driving a truck, or working a factory shift. He was just lucky enough to have a friend who pushed him to write, and then to have his songs fall into the right hands. After he brought his first compositions to Carlos y José, the duo not only recorded his work but recommended that their label, Discos Falcón in McAllen, Texas, take a chance on Julián and his

brother Luis as singers. "The people immediately liked our style, and we kept on recording, and we began to make a living from that. We left the factories where we were working, and began to live off singing, and hey, we found that it was a lot pleasanter than going out with a pick and shovel. And by now we've recorded something like eighty CDs, as they say now—before, they were called LPs, you remember?"

I had the impression that Julián was enjoying the interview as much as I was, but it was getting late, so he invited us to come back the next day for a barbecue and rehearsal. My friend Guillermo could not make it, but I accepted with alacrity. I spent the next day wandering around Monterrey, buying cassettes in the market and generally amusing myself, then caught a combination of metro, bus, and taxi out to Julián's place.

I had allowed more time than necessary, so was the first to arrive. Julián welcomed me and introduced me to his older brother, Mario, who was getting the grill going. He added that, when he first wrote "Las Tres Tumbas," he had named the three brothers Mario, Julián, and Luis, as a joke, but later changed them. Mario looks nothing like Julián: he is thin and querulous, and his brothers treat him as a gofer. Julián sent him to get us a couple of beers and sat down opposite me at a long, wooden table, under a thatched, open-sided shelter in his backyard. It was a pleasant evening, with a breeze off the mountain, and Monterrey seemed miles away. I said something to that effect, and Julián concurred. Though raised in the city, he has always set his songs in the countryside, and that is where he feels at home. "I like being outside the city. If they gave me a thousand dollars a day to live in the capital, I wouldn't go; it's completely crazy there. I'm from up here on the mountain, and I go to the city because that's my job, to sing or whatever, but not because it attracts me. What attracts me is the country, quiet places like this. And that's what inspires me most, the country dramas, of the ranchos. It's probably because I was born on a rancho. I didn't grow up there, but it has always attracted me."

Other people start drifting in by twos and threes, first the band members and finally Luis, who looks tired and down at the mouth. More beers are drunk as we wait for the meat to cook, and the musicians set up the amplifiers. After a while, someone brings out a plastic bag of cocaine and invites me down to the bathroom at the foot of the yard to partake. I say no, I never liked coke because I like to eat and sleep, and why would I do a drug that takes away my appetite and keeps me awake? "Oh no," Julián says. "You've been using that lousy stuff you get up there, cut with speed. This is very pure, it won't take away your appetite." Besides, the others point out, we will be hanging around drinking beer for hours, and this will keep me alert. When I consider

the importance of thoroughly researching my theme, no more argument is needed, so the rest of the evening is punctuated by trips to the bathroom, where we snort coke off the ends of door keys, one sniff in each nostril. It works, too. I keep drinking beer and do not get drunk in the least. Anyway, that is how it seems at the time. My notes tell a different story, becoming progressively less legible as the evening wears on.

When the sound system is in place, the rehearsal begins. Unlike most norteño performers, neither Luis nor Julián plays an instrument, so they need a four-piece backing band: accordion, bajo sexto, electric bass, and drums. They sit in a semicircle, with the drummer off to one side and Luis and Julián seated comfortably at the table, drinking and chatting between verses. The songs are new, so Luis reads the lyrics off a typed lead sheet. On the first song, the musicians suggest some changes and Julián tries to jump to another number, but they keep him in line and gradually all the parts fall into place. Julián sings the melody, and Luis works out a tenor harmony with a bit of help from the band.

By now, Julián is drinking whiskey on the rocks. This surprises me, since Mexican singers tend to be extremely careful of their voices—even the guys who sing on buses or wander the cantinas will give lectures on how one must never drink alcohol or cold liquids while singing. When I comment, Julián just laughs: "Yes, people tell me I'll hurt my voice. I say, 'What voice?' " He has a point; neither he nor Luis is a vocal giant. Still, once they get their harmonies together, their sound is unmistakable: their voices blend with an engaging looseness and the intimate, soulful feel of a country-and-western brother duet. They seem equally well-matched in their working relationship: Julián writes the songs, but the final product is a group effort. At one point, Luis calls a halt and makes Julián change a line, saying that the melody is too close to another song: "That sounds like Paulino Vargas. He puts those notes in almost all his songs."

"He's not the one that originated that sound," Julián says, sounding a bit defensive. "That's much older. Paulino went with it too, but of course corridos will sound similar to one another." He is not defending his melody, though, just his honor. As the rehearsal continues, the other musicians chip in, suggesting different harmonies and rhythms, even changing one song from a waltz to a polka. Julián goes along with all the suggestions, nodding his appreciation. "Two heads are better than one," he says, when I comment on his willingness to work as a team. "I'm not a musician, I'm a cabrón. This stuff isn't easy, so when the time comes to put something together, they help me."

The evening's main song is "Era Cabrón el Viejo" (The Old Man Was Cabrón*). It is a bit of a departure from their previous records, but one

that comes very naturally to Julián, since what makes it distinctive is the same sort of swearing and slang he favors in everyday life. Though the song is technically a narcocorrido, Julián says that it was inspired by the sight of an old man slowly riding his horse down the side of the mountain behind the house. He began thinking about the old guys, and how they had a toughness and intelligence that the young punks of today cannot match, and he invented a story:

> *Venía bajando del cerro en su cuaco cimarrón,*
> *Huyendo de aquel teniente al mando de un pelotón.*
> *Lo que no sabían los guachos es que el viejo era cabrón.*
>
> *Paulino sembraba mota en el barranco del cerro,*
> *Pero no se imaginaba que alguien le pusiera el dedo.*
> *Por eso los federales lo traían al puro pedo.*
>
> *Les preparó la embuscada a la orilla del camino,*
> *Se metió dos pericazos, también un trago de vino.*
> *Van a saber estos batos quien es el viejo Paulino.*

(He was coming down from the mountain on his wild horse,
Fleeing from that lieutenant in command of a platoon.
What the soldiers didn't know is that the old guy was a
 motherfucker.

Paulino grew dope in the ravine of the mountain,
But he never imagined that someone would squeal on him.
Because of that the federales got him by the short hairs.

He prepared an ambush for them at the edge of the road.
He took a couple of snorts of cocaine, also a swallow of wine.
Those guys are going to know who old Paulino is.)

Naturally, Paulino kills off the soldiers, then hunts down the squealer who turned him in. Julián sings the song exuberantly, savoring both the story and the obscenities. "Nowadays, I'll tell you, they're using

* *Cabrón* literally means "billy goat," and, with reference to the horns, a cuckold. As a noun, it could roughly be translated as "bastard," but in Mexico it also has a sense of strength, and that sense predominates when it is used adjectivally. Thus, while it is usually an insult to call someone *un cabrón*, to say that he is *cabrón* is typically a compliment.

lots of bad words in corridos, but less around here, here I'm going to be the first one. In our region they haven't tried that, to toss in one curse or another, but I know it can work, because people will love the idea of it. I'm even thinking of putting a sticker on the cassette or the compact disc, saying: 'This contains two corridos which are not for airplay,' or something like that, which would be an attraction to make people buy the record." (I was dubious about this plan, but Julián turned out to be right. "Era . . . el Viejo" [as it was labeled for release] would be their biggest hit to date.)

Though the dirty words are the selling point, Julián is most proud of the song's despedida, the traditional farewell. "You never heard one like that before, did you?" he asks, and repeats it in case I was not paying attention, or just because he enjoys showing off:

197

> *Habrá muchas despedidas, pero como ésta ninguna:*
> *Una, dos, tres, cuatro, cinco; cinco, cuatro, tres, dos, una.*
> *Siempre fue cabrón Paulino, desde que estuvo en la cuna.*

(There must be lots of despedidas but none like this one:
One, two, three, four, five; five, four, three, two, one.
Paulino was always a motherfucker, ever since he was in
 his cradle.)

The steaks are arriving on the table, along with piles of tortillas and a constant flow of beer. In between servings, clusters of musicians wander down to the bathroom, and the keys come out. My sense of time soon disappears, but at some point I find myself down there and Julián is standing beside me, asking a favor: during the previous day's interview, he had made a disparaging remark about the instrumental abilities of a famous norteño group, and he wants to be sure that I will not include it in my book. "No, Julián," I say, teasing him. "I'll just write about the cocaine."

"Oh, that's fine," he says, grinning. "No one cares about that. But those guys are my friends."

Back at the table, an older man in a rather worn cowboy hat comes up to talk to Julián. He is a local corridista, trying to sell the brothers some songs. He sings a few lines of the first, but it is set in Sinaloa and Julián instantly vetoes it. The next is about a shooting in Nuevo León, and Julián says to leave a cassette, explaining to me that they need another three songs to complete their next album.

So the evening continues. Julián gets more talkative, telling stories of

his early dream of being a baseball player. He played first base and batted cleanup, and he says that he could have gone pro but never really pursued it. From there we jump to Mexican history: like many people in Nuevo León, Julián still has a chip on his shoulder about Benito Juárez. Juárez was the great liberal hero of the nineteenth century, the liberator of Mexico from both Santa Anna's dictatorial rule and the European-imposed Emperor Maximilian, but apparently he is also responsible for redrawing the borders of Nuevo León and Tamaulipas, leaving the former with only a tiny corner of the profitable land along the Río Bravo. "Every city in Mexico must by law have a main street named after Juárez," Julián grumbles, "but we have nothing to thank him for in Nuevo León."

He drifts to tales of the Revolution. He seems to know every battle Pancho Villa ever fought, as well as less savory chapters from the hero's life. Once, he says, two women in Villa's camp got in a fight over a man, and one fired a shot that went right by the general's head. Enraged, Villa ordered that all the women in the camp be shot, and his bloodthirsty lieutenant, Rodolfo Fierro, carried out the order, killing ninety. Julián condemns the act and Fierro's habit of killing prisoners, but adds that he was a sincere revolutionary and a loyal follower of Villa. "I wish I had lived in that time," he sighs. "I would have either been dead or a general."

"What about 'chest to ground'?" I ask, reminding him of his cowardice during the dance hall shooting. He shrugs and laughs, not bothered in the least, and repeats the story for the benefit of his other guests. Then, reminded by Luis, he launches into yet another:

"When we began to get known in the business, my brother and I, we rented a bar here, a cantina, because, logically, in our houses we didn't have telephones, and the bar did have a telephone. So we rented this bar for two years, but all with the idea of having a telephone so people could reach us for jobs.

"One day a cabrón came from the south of the state, a place named Ejido Amaro: 'Listen, you, Julián, I've come to hire you to come and entertain at the anniversary of the *ejido*.'

" 'Yes, of course.'

"So we agreed on the price, and we went there—an almost inaccessible place, it was a struggle just to get there. There were a lot of people, and the man who had hired me was some kind of policeman, because they had improvised a police force there, armed with 30–30s. I've always been scared of those kind of people, I'm scared of them because there are some cabrones who don't reason, fucking savages. As on this occa-

sion. So we began to sing, and I see these policemen who were going around plastered, with their rifles in people's faces, clearing their way through the crowd, holding them by the barrel, all fucked up, they'd got shit-faced on mescal or who the hell knows what. And suddenly a cabrón comes up and pulls out a goddamn pistol . . . [he mimes the guy waving the gun around], and says, 'Sing me "Las Tres Tumbas," cabrón! Three times, or else you die!'

" '¡La chingada! That's fine, but put down the gun. There's no need to threaten me, cabrón.'

" 'Well, get on with it, sing "Las Tres Tumbas." Go on.'

"We sang it three times, and he put his gun away and left. But the worst of it was that as soon as he left, another cabrón came up, and said, ' "El Bayo de Cara Blanca!" Sing it for me, cabrones!'

"And the worst of it was that they didn't threaten anyone but me, they left the other cabrones alone. So there we are, singing 'El Bayo de Cara Blanca' for that bastard, and then he went away. 'This is a fucked-up mess here,' I said. 'I could get killed by one of these moronic sons of bitches.' But there we are. The style was to play a tune and then take a break, a little one-minute intermission, because there were around three thousand cabrones and only around a hundred women, no more than that. When the tune began, everybody headed over to where the women were, to dance, and because there were so few women we had to insert a parenthesis so that the guys who were dancing would let go of the broads, so that some others could grab them.

"Suddenly, two cabrones start shooting at each other in the middle of the damn dance. And the odd thing about it is that they discharged all their ammunition, they grabbed each other by the hand and took shot after shot and jump after jump—the bastards were like grasshoppers—and the only bullet that hit a target, it was a kid who was close by, watching us. He was watching the drummer, and it fucking caught him right in the chest. With all that crowd, they only hit the kid, they didn't even hit each other. So the kid fell down, and I went over, I got down off the stage there, damn it, to look after him, and nobody was paying attention to the kid.

" 'Hey, there's a kid hurt here y la chingada . . .'

"No, they didn't budge, and we quit playing, and up comes the cabrón who hired us, completely shit-faced already, and says to me, 'Listen, why aren't you playing?'

" 'There's a kid hurt here. How am I going to play?'

" 'No, leave the kid there, you have a contract with me.'

"¡Hijo de su pinche madre! So back we go to singing. I left the kid there,

199

it seems that his mother came and took him away, I don't know how the mess turned out. So finally the whole scene was over and they paid us and we got out like. . . .

"And we never went back there. Afterward, I found out that that region, there was no group who wanted to go to that place, because they already knew what would happen. But a little while later, this bastard comes into our cantina, the same cabrón, and says to me, 'Listen, Julián, I've come to hire you again. . . .'

" 'No, you know what? Go off and fuck your mother, go tame that bunch of goddamn savages of yours. Your place there, I don't even want to go over it in an airplane, cabrón.' "

By now, the bass player had begun quietly strumming a guitar, and as Julián finished the story, he started to sing an old bolero. The sweetly lilting melody was a pleasant change, and soon Julián joined in, singing harmony. The next hour was devoted to boleros, interspersed with Julián's memories of the old bolero composers and the "jewels of Mexican cinema" in which the songs first appeared. Finally, as the sky began to lighten, he sent me off in a small car crowded with musicians. They dropped me at the door of my hotel, and I stumbled up to my room and collapsed. The cocaine did not keep me awake.

I woke up around noon, jangly, without any appetite, and feeling as if my skin did not fit right. What can I say? It is not my drug. I pulled my gear together and caught a bus out to Reynosa.

FADED GLORIES

Texas and the Valley

I spent the next week knocking around the border region between Reynosa and Matamoros, with brief forays north into McAllen and Brownsville, Texas. This area is known as the Valley, running along the Rio Grande/Río Bravo, and it is the heartland of classic norteño. Not surprisingly, there were plenty of corridistas to talk with: Reynosa, for example, is home to Reynaldo Martínez, the most succesful old-time writer in the region; Juan Villareal, an accordion virtuoso who tours out to Seattle and Chicago and is now building a career writing theme songs for Tijuana gangster videos; and Beto Quintanilla, whom folks in the

Valley consider the king of the hard-core narcocorrido, a sort of Chalino of the east.

All were interesting characters, and a pleasure to meet, but what they had to say was pretty similar to what I had already heard from other corridistas. Reynaldo took me to a horse race, reminisced about his old buddy Chito Cano, and told me of narcos giving him cars in return for his songs. Juan introduced me to a neighbor who was the new super-bantamweight boxing champion of the world, and told me a bit about the movie business. Beto talked about the difficulties of being a narco singer here in the east, and his dreams of breaking into the Sinaloan market.

Beto's complaints seemed to me to be emblematic of a broader malaise in the area's corrido scene. While he has an strong cult following throughout the Valley, no one in this region would be likely to describe corridos as the wave of the future. They are appreciated as a classic form, and even claimed by many Valley dwellers as a unique regional heritage, but the hot new music in the northeast is the accordion-flavored bubble-gum pop of Selena, Límite, or Priscila y sus Balas de Plata. For straight-ahead norteño, the Valley's dominant star is Ramón Ayala, whose corrido records from the 1970s are classics and whose band, Los Bravos del Norte, once rivaled Los Tigres in popularity, but Ayala has pointedly avoided the narco trend, and corridos have become a less and less important part of his repertoire. Likewise, Juan Villareal is known in Sinaloa and Los Angeles as a major corrido composer, but when I found tapes of his group, Los Cachorros, in the Reynosa music stores, they were mostly devoted to romantic ranchera and catchy dance numbers.

I liked Reynosa, but after my travels in the west I missed the sense of being at the center of a vital, exciting musical boom. This is the terrain of the legendary Gregorio Cortez and a dozen other old-time outlaw-ballad heroes, and many experts consider it the birthplace of the corrido form, but I had the sense that people in the Valley have moved on to other things. As a result, the encounter that struck me most forcefully was my meeting with Santiago "Chago" Iracheta, the least successful of my four Valley composers.

Chago is based in Matamoros, which for some reason seems to be a less composer-friendly town than Reynosa. He has been a professional corridista for the last thirty years and also writes an entertainment column for a small local newspaper, *Reportaje*. I found him in a cramped, dingy downtown office, after following directions written on the door of a still dingier office in a building that had recently been condemned. Painfully thin, he looked like a denizen of the lower reaches of the

urban jungle, the sort of character one could imagine working at some unspecified job in the back office of a strip club. As it turns out, the strip club analogy was not far-fetched. While many of his *Reportaje* columns are about norteño musicians and composers, they are equally likely to cover the latest gossip from the seedier border nightspots and to be illustrated with pictures showing Chago with his arm around, say, the cowboy-hat-and-bikini-clad Lizeth, *"gran bailarina"* at Rhino's Bar.

Chago's columns are a reminder that, while I may think of the corrido and norteño scene as its own world, it forms part of a larger entertainment business, and few of its listeners limit themselves to one musical style. The same jukebox that has oldies by Ramón Ayala or Los Alegres de Terán will also include Elvis, the Beatles, and a lot of romantic Mexican film idols. Chago is something of a specialist—the pile of battered LPs on his file cabinets includes the most complete selection of Los Alegres' work I have ever seen, and he may well be the Valley's most serious devotee and historian of classic norteño—but he can also speak knowledgeably about all the other performers who work the bar scene in Matamoros and the surrounding smaller towns. He is also one of the founding members of the Partido Verde Ecologista, the local Green Party, and shares office space with an animal rights group.

I had not warned Chago of my arrival, but when I showed up he gestured me to a chair and said I was welcome to ask him anything I wanted. I set up my recorder on his desk, and when he talked he looked not at me, but directly into the microphone, speaking for history. He was born in 1942, and his first corrido was recorded in 1970 by Los Relámpagos del Norte. Los Relámpagos (The Lightning Bolts) was a duo made up of Ramón Ayala on accordion and the singer Cornelia Reyna, and they were the young innovators of norteño song, the most influential group since Los Alegres. Like many hot young groups, Los Relámpagos found it hard to handle their success, and they split up in 1971, Reyna taking a more mainstream pop route while Ayala became the gritty standard-bearer of the older norteño sound. Chago became one of Ayala's regular composers, producing a string of corridos about the Valley's pistoleros and valientes. He and Reynaldo Martínez pretty much divided up the notorious Fierro brothers, with Chago writing corridos of Amparo, Homero, Reynaldo, and Pedro del Fierro, as well as "Los Cuatro Hermanos" (The Four Brothers).

Chago says that he never lacked for subjects, and that he still could be writing a corrido pretty much every week without exhausting the local news. "The border, for composers, is overflowing with material with which to inspire yourself," he explains, his voice dry and nasal.

"Because, you know, these are very violent towns, they are ruled by the pistol, by the law of the strongest. And I'll tell you, for the composer this is the foundation."

Somehow, though, Chago failed to maintain his momentum. Whether it is that his work does not have the spark of Julián's or Reynaldo's, or that he has failed to keep up the necessary connections, his corridos no longer show up on hit albums and his new work is not sought by the major groups. He still makes his living in music, but on the fringes: he writes his column, he spins records for dances and parties, he has a radio show every other week with his group, Los Fronterizos de Matamoros, and he writes corridos for anyone who happens into his office with a commission. Unlike the Sinaloans, he gets few of these commissions from narcos: instead, he says that some of his most regular clients are the local political parties: "Here in Matamoros, they use corridos a lot in politics. When there's a political campaign, a lot of people already know me, and they'll say, 'Listen, Chaguito, write me a corrido for my campaign.' We agree economically, however we arrange it, and that's how we do it. For example, Homar Zamorano Ayala, who is the present municipal president of Matamoros, I composed a corrido for him to use in his political campaign—and it worked, Homar Zamorano made it to the presidency for the PRI party. Another man, Ramírez Salazar, from the PAN, I wrote a corrido for his political campaign as well."

Considering the bitter rivalry between the PRI and the PAN, this might have been problematic, but Chago says that neither party objected: "They don't mind, because they know that it's one's job—one charges for this, it's a job like any other. That is, one treats everybody the same, one gets along with all of them."

Chago rummages through his files, apologizing for the disorder since his recent move, and fishes out a photocopied sheet with "Los Nuevos Gobernantes" (The New Governors), his paean to Zamorano's administration:

> Con el nuevo y activo presidente, Matamoros tendrá que cambiar,
> Y sus calles lucirán como se debe, muy hermosa estará nuestra ciudad.
> Las colonias contarán con su drenaje, pavimento y también seguridad.
>
> Que viva y que viva Homar Zamorano, un hombre decente, muy
> buen mexicano,
> Para presidente está bien preparado, por eso a la gente va a darle
> la mano.

Téngalo presente todo el ciudadano que lo mas urgente va a solucionarlo.

(With the new and active president, Matamoros will have
to change,
And her streets will shine as they should, our city will be
very handsome.
The neighborhoods will count on having drainage, pavement,
and also security.

So long live, long live Homar Zamorano, a decent man,
a very good Mexican,
He is well equipped to be president; therefore he will give
a hand to the people.
Let every citizen be aware that he will solve the most urgent
problems.)

205

It is not great poetry, but the lyrics serve their purpose. "I base my writing on the trajectory each person has outlined, whether he is from the PRI, the PAN, or from another party, giving each what he wants, so he will be enthusiastic about the corrido. That's what it's all about, to inspire people, right? It's an advertisement: one takes responsibility for getting the lyrics recorded, and you bring him some five, ten little cassettes, and they have various political campaign vans and each van has a sound system, and that's how they promote it."

Chago apologizes again for the disorder of his office, then takes me down the street to a small music store where I can buy the most recent Fronterizos cassette (which seems to be a few years old). The cassette's cover advertises "Corrido a Don Juan N. Guerra," and a note inside thanks Guerra for his continuing patronage and for letting the band use his ranch, El Tahuachal, as a setting for the cover photo, which shows the musicians standing in a field with "the famous horse Lucerito." The corrido describes Guerra as a fine man and a patron of the races, and ends with the despedida, "*Adiós caballos famosos que corren por la pradera / Este corrido es compuesto para Don Juan N. Guerra*" (Farewell famous horses who run on the track / This corrido is composed for Don Juan N. Guerra). There is nothing in it about drugs or killings, and it was only months later that I learned that Guerra was not simply a local businessman, but "The Godfather of Matamoros," a drug world legend who for decades was the most powerful gangster in northeast Mexico and served as mentor to Juan García Ábrego and the Gulf Cartel.

As I headed out of town, I could not help reflecting that the whole visit had felt like a trip to an earlier era. Chago's situation must be pretty much what corridistas were facing in the days before the success of "Contrabando y Tración," when the corrido was widely considered to be an archaic and dying art. Even at the lowest point, there must always have been a few guys like Chago, sitting in dingy offices, waiting for whatever clients happened in the door. Now, while his counterparts on the West Coast are flying high, he is still in limbo, a small-town craftsman serving a nostalgic, aging clientele. I could not sort out all the reasons—eastern Tamaulipas continues to be a major drug-running center, and I do not see why it should be so completely outside the modern corrido scene—but the situation spoke for itself. As it turned out, it would also serve as a valuable preparation for what I found up in Texas.

The first corridos I ever heard came from Texas, and indeed the whole norteño style first came to my attention as "Tex-Mex." Like most Anglos, I was introduced to it through the work of Flaco Jiménez, heard on crossover collaborations with Doug Sahm and Ry Cooder, then on his own albums for Arhoolie Records, a California label specializing in blues and ethnic music. Arhoolie also turned me on to other Texas players, accordion virtuosos like Steve Jordan, Valerio Longoria, and Flaco's brother Santiago, and for many years I thought that these were the reigning giants of the style. It was only after I began traveling in Mexico that I learned that, in fact, they were almost unknown to the music's mass audience: Arhoolie had been able to sign them because they were too small to attract the major labels, and even in Texas they could not compete with Ayala, Los Tigres, or dozens of Mexican and California-based bands. Jiménez himself, while a superb accordion player, is utterly unknown south of the border—until his rock success, he was not a top draw even in his native San Antonio. As for the other Texas players, some have strong regional followings but only a couple have any audience outside the state, and when they venture south of the border it is only to the small towns of the Valley.*

Still, there is a long history of the corrido in Texas. Many of the most

* When I refer to the "Texas players," I am not including either Los Alegres or Ramón Ayala, who have been based in Texas for decades but continue to be considered Mexican rather than Texan. There is also a new wave of Tejano bands who frequently use accordions, but this is a pop-rock fusion style that bears little resemblance to norteño and includes few if any corridos.

famous border ballads come from north of the Rio Grande/Rio Bravo, and Arhoolie has released meticulously annotated collections of corridos recorded there in the 1920s and 1930s. Texas folklorists can talk for hours about the topical epics they have found around the state, documenting everything from minor local events to the assassinations of John F. Kennedy and Martin Luther King Jr. Joel Huerta, an assistant professor at the university in Austin, has even written a lengthy monograph on the corridos of south Texas's high-school football teams.

The Texas accordionists have also displayed a musical range and adventurousness that deserves more attention from the mainstream norteño world. Steve Jordan, in particular, seems to me to be the most consistently exciting player in the field, a wild and bizarrely innovative multi-instrumentalist whose tastes range from Mexican folk rhythms to rock and jazz. His few corrido recordings are as distinctive as the rest of his work: his masterpiece is "El Corrido de Johnny El Pachuco," a rewrite of the popular 1940s song "Juan Charrasqueado" into grungy urban street slang. Unfortunately, Jordan was not to be found: as I heard the story, he had decided that the high life was killing him, and had retreated to a house in a small border town, with no telephone and no desire to be contacted by anyone connected with the music business. It was disappointing, but I decided that I might as well respect his privacy. Anyway, if I wanted to find out what was happening in the Texas corrido world, my time could be better spent in San Antonio.

San Antonio is the center of Tejano (Texas Mexican) culture and seemed like the best place to get a reading on the current musical climate. I had been told that the man to see there was Salome Gutiérrez, so I checked into a cheap hotel near the Alamo, rented a car, and drove out to his Del Bravo record shop. Salome is a San Antonio legend: born in 1930 in D'Hanis, Texas, about fifty miles west of San Antonio, he was raised in Mexico, then moved back north of the border when he was twenty-two and became a fixture on the local music scene, working as a composer, producer, publisher, record store owner, and president of the local composers' association. Texas musicians all have stories about Salome, in which he frequently figures as a more or less charming rogue. For instance, one musician told me of an all-night recording session during which Salome got the players drunk, then had them sign a stack of blank copyright forms—that way, if they ever got a hit song later in their careers, he could fill in the necessary information and claim he owned the original rights. In another story, a producer in California told me of getting a threatening letter from Salome, claiming that a song on the producer's latest release had been copyrighted by Salome's

publishing house back in the 1960s. The documents Salome submitted seemed ironclad, until the producer noticed that they included Salome's telephone, address, and fax number. He got on the phone, and shouted, "Hey, there weren't any faxes back then!" Salome was pleasant and charming as ever: no harm in trying, and no hard feelings.

I found Salome in Del Bravo's back office, a big room filled with overflowing file cabinets, piles of cassettes and compact discs, and all the varied detritus of a busy publisher. He is a small, dark man, bursting with energy. He greeted me in broken but colorful English, then switched over to Spanish and began telling me about his childhood: "I was born with a guitar in my hands. When we left here and went to Mexico, in 1934, my parents didn't even bring any food, but they brought a Victrola to play 78s, and something like a hundred 78 records, all of corridos and songs like that. We went to live in a rancho where there was nothing for anyone to dance to, there was no radio, nothing, so you heard that Victrola or you didn't hear music. So all those songs that my father brought with him, I learned them all, I sang them, and then when we arrived in Nuevo Laredo I learned to play guitar, when I was thirteen, and I sang all those songs, and I began to compose when I was fourteen." By the late 1940s he had hooked up with the pioneering norteño duo Maya y Cantú, playing bass on their records and providing them with several songs, and he went on to compose hundreds of ranchera numbers, including the corrido classic "El Gato Negro" (The Black Cat), which still gets covered by artists from Monterrey to Sinaloa.

Since he seemed like the best available authority, I asked Salome why it was that the Mexican norteño artists are stars in Texas, but the Texans remain pretty much unknown in Mexico. He smiled broadly and assured me that, having lived on both sides of the border, and being a record producer, he could provide the true, absolute, definitive answer. First of all, he said, it was a matter of migration patterns: Mexicans come north, but Texans don't go south. "So if a group from the United States goes to Mexico, nobody goes to see them, because they don't know who they are, but a Mexican group comes here and all of us mojados know who they are and people go to see them, because it reminds them of Mexico."

There is also the problem of strong promoters on the Mexican side, who have the main Monterrey and Valley acts under contract and no interest in competition from up north. Then there is the whole question of payola and big record company connections, both unavailable to the locally based Texas bands. All in all, sure, a few of the new Tejano pop groups have had some success down south, but the more traditional-sounding ranchera players do not stand a chance.

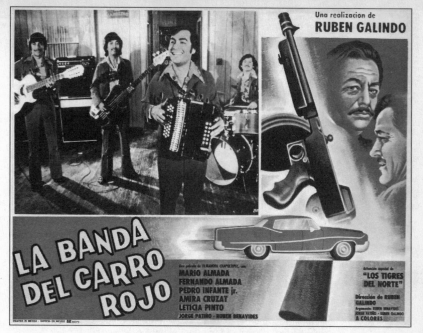

Poster for the movie of *La Banda del Carro Rojo*, showing
the young Tigres del Norte playing in a border cantina.
(Courtesy of the Arhoolie Foundation—Frontera Collection)

The irrepressible Paulino Vargas, in his living room,
demonstrates the lightning speed of his pistol draw.
(Photo: Elijah Wald)

An accordionist and bajo sexto player serenading the faithful at the mouth of the inner sanctum of the chapel of Saint Jesus Malverde. *(Photo: Elijah Wald)*

A Pepe Cabrera cassette cover, showing a notorious local corrido theme: "the Black Helicopter." *(Discos Once Rios)*

Chalino Sánchez defines the new corrido style, with his trusty pistol at his side. *(Kimo's CDs)*

El As de la Sierra in a characteristic pose, his *cuerno de chivo* at the ready. *(Titan Records)*

Poster for Los Tucanes de Tijuana's performance in Culiacán, headlined "The Dance of the Most Wanted" and featuring an array of local and national acts.

Two of the hard-singing and ever-fashionable Riveras:

Lupillo, prince of the urban gangster corrido, shows off his high-class Mafia style. *(Cintas Acuario)*

Jenni Rivera, in crocodile leather and velvet, her sexy variation on drug-trafficker chic. *(Kimo's CDs)*

Francisco Quintero, "El Vampiro," open-shirted and over-armed. *(Balboa Records)*

A rare appearance in cowboy costume by Enrique Franco, master of the socially conscious corrido. *(Musical Productions)*

Two sides of Julián Garza: the writer, at home behind his typewriter, and the performer, behind his automatic rifle as he advertises his unprintably titled new film. *(Photo: Elijah Wald)*

CORRIDOS DEL EZLN

Andrés Contreras, "the Minstrel of the Roads" and bard of the Zapatista rebellion, with one of his early cassette covers showing Subcomandante Marcos, the charismatic frontman of the EZLN, the Zapatista Army of National Liberation. *(Photo: Elijah Wald; cassette courtesy of the Arhoolie Foundation—Frontera Collection)*

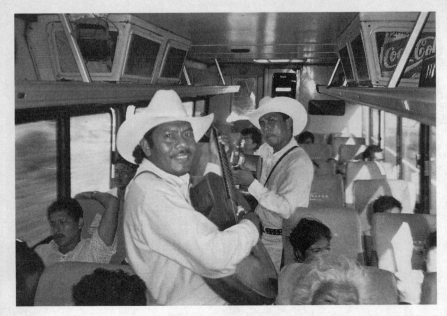

Gabriel Villanueva *(left)* and his son Lorenzo, Los Pajaritos del Sur, sing their corridos on the second-class buses outside Acapulco. *(Photo: Elijah Wald)*

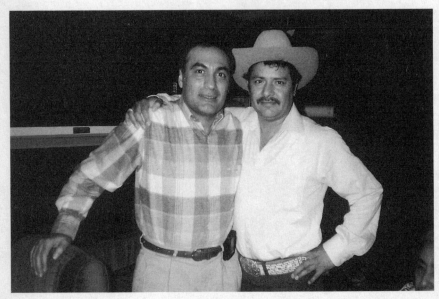

Teodoro Bello, the most popular songwriter in Mexico *(right)*, with his greatest interpreter, Jorge Hernández of Los Tigres del Norte. *(Photo courtesy of Teodoro Bello)*

Next question: what has happened to the corrido in Texas? Where once there were ballads written about everything from politics to murder to high-school football, the new records I have seen have nothing but comic cumbias, ranchera classics, and romantic songs. Once again, Salome assures me he has the definitive answer: "I have explained this to everyone, because I am a record producer and I know. I myself, I wrote many corridos. In the old days, I was one of those people that, they killed Kennedy—'El Corrido de Kennedy'—they killed so-and-so and I made the corrido. Because we were making forty-fives, and when we made forty-fives I would write the corrido today, I would record it the same night they killed so-and-so, we took the tape to the radio, people began to request it, and in a week the factory sent us the records and we could sell them to recoup our costs. Today no, there aren't any forty-fives and by the time you record ten songs to make a CD, six months have already passed and the corrido isn't news anymore, it's history. So it's been a long time since I wrote a corrido. What for?"

Salome points out that the old-fashioned, news-based corridos are not doing that well in Mexico either. Down there, though, there is drug money: "In Mexico you hear so many corridos of the mafia because the people who sell powder, the people who sell grass, they hire Paulino—Paulino is a great friend of mine, okay?—and because he writes corridos for them, they give him twenty, thirty thousand dollars for one corrido. Then this mafia boss, it's nothing to him to pay another ten thousand dollars to put it on a record; so who isn't going to record it? That's why you're hearing those corridos there. Julián Garza, same thing; Reynaldo Martínez, equally. It is all done for pay, they are in a business."

Salome says that he is different, he does not like writing for hire. Frankly, he does not strike me as someone who would turn down thirty grand for a song, but maybe there simply are not enough big traffickers wandering around San Antonio to interest a man of his stature. In any case, he says, the young Texan norteño stars (Michael Salgado, for example) are not corrido singers. It requires a special style to sing corridos, and they do not have it. Then there is all the competition from the Mexican groups, with major labels like Fonovisa and Sony putting money behind them. So no, there is no corrido scene here as far as songwriters and recordings go. Of course, plenty of people still like the older songs: Salome gives me a CD he recently produced, a studio group performing *The Greatest Corridos of the Twentieth Century* and says that he is planning a whole set of similar albums. He does not expect to sell all that many, though. He is just issuing them as a sort of budget "oldies" series, something that is easy and cheap to do and can bring in a little extra money.

That seems to be everything Salome has to say on the subject. A young woman comes in to tell him that a band has arrived for some sort of consultation, and he apologizes for not having more time, then takes his leave with old-fashioned formality, urging me to look around the store before I go. I cruise the record racks, and the selection is in keeping with our conversation: there is a fair amount of norteño, but corrido albums do not figure prominently. The big posters on the walls are of the pretty young Tejano heartthrobs and accordion pop bands—Bronco, Límite, Michael Salgado—and most local norteño buyers seem to be into this music more than the old border sounds. I am also reminded that the Spanish-speaking audience has by no means restricted its listening to Mexican or Latino styles: a lot of the posters and CD bins are devoted to collections of "low-rider" R & B oldies, and there are racks of low-rider T-shirts and doodads for cars. I pick up a couple of CDs, just to be polite, but there is not much here to excite me.

I spent two more days in San Antonio, waiting for the weekend. I wanted to check out the flea markets, which were rumored to be the area's last bastion of classic norteño. As I drove around, I kept my radio tuned to KEDA, Jalapeño Radio, which Salome had said was the best corrido station in the area. It was pretty much all norteño, though the announcers tended to speak in English, but in three days I heard only two corridos: Ruben Ramos's recording of "El Gato Negro" on both of the first two days, and a song by Beto Quintanilla on the third. The flea markets proved equally disappointing: there were bands playing at the I-37, an open-air affair out on the highway, and at the International, held in the run-down hulk of an old supermarket, but each had only a couple of dozen listeners, most in their fifties or older. They were corrido fans, requesting "La Muerta" (The Dead Woman, a corrido version of the "vanishing hitchhiker" legend) and "Los Tres Tequileros," the old bootlegger ballad that had been my original introduction to the genre, but I found the whole scene pretty depressing. Luckily, there was a solution at hand. I returned my car, caught a Greyhound down to Laredo, and started hitching south.

SECTION 5

MEXICO CITY AND POINTS SOUTH

14

THE ZAPATISTA MINSTREL

Andrés Contreras

Mexico City has never thought of itself as corrido territory. One hears corridos here, as everywhere in Mexico, but the true city dwellers consider them quaint historical artifacts or look down on them as *música naca*, hick music. Since the city has millions of immigrants from the countryside, the top corrido bands draw an impressive audience, but their shows are unlikely to be covered in major newspapers. At best, they will get a brief puff piece in an afternoon paper that sells to the racing crowd, alongside ads for strip joints.

The Distrito Federal is a center of the Mexican music industry, and

a few corridistas have moved here for professional reasons, but it is not a place where someone interested in the contemporary corrido scene need spend much time. I was just passing through, taking the opportunity to chat with folklorists and music experts, hunt for records, and visit some friends. I was also keeping my fingers crossed, hoping against all probability that I would meet up with a shadowy vagabond who had become one of my minor obsessions: Andrés Contreras, "El Juglar de los Caminos" (the Minstrel of the Roads), as he calls himself on his cassettes. I had first heard Andrés's music in Mazatlán, from a friend who had been in San Cristóbal, Chiapas shortly after the Zapatista uprising of New Year's Day 1994 and had made a copy of a cassette that was being played on the main square. It featured an anonymous singer backed by a couple of other players, who introduced themselves as Los Tigres del Sur (the Tigers of the South) and occasionally roared between verses. The cassette had several corridos, including one telling the story of the guerrilla uprising, but what particularly caught my ear was a quirky bit of black humor, the corrido of a gringo captured by the army and mistaken for Subcomandante Marcos. (Marcos is famous for his blue-green eyes, which briefly led the government and press to speculate that he was a foreigner.) In the song, the gringo is arrested and tortured until he finally gives in and says that yes, he is Marcos. At that point, the soldiers say, "Okay, if you're Marcos, where are your troops?" and torture him some more. Eventually the whole thing is sorted out and the gringo flees back to the United States, where he lodges a formal complaint. Here the song breaks off for a brief dialogue: First comes a gruff voice, saying in Spanish, "Ay, what an ignorant gringo! Hombre, don't you know that here in Mexico we have a very good human rights office? Why didn't you make your complaint here?"

"*Oh no!*" the gringo shouts in a terrified falsetto. "*Bullshit!* . . . *¡No más Mexico! ¡No más Chiapas!*"

I was amused and fascinated. None of the songs on the tape were outstanding as poetry, but they were entertaining and timely, I knew of nothing else like them, and they had been sung in the streets of Chiapas in the middle of the Zapatista uprising, for an audience of local peasants. The singer was the closest thing I had come across to an old-fashioned, medieval minstrel, a folk historian singing his chronicles for the same people who were living them. My friend could tell me nothing about the singer, but when I passed through Guadalajara I crossed his trail a second time. There was a rally in support of the Zapatistas, who were about to hold a nationwide referendum to show the strength of their support, and I was asked by friends to come and sing a few songs.

214

When I arrived, they were playing a tape over the sound system, and I immediately recognized the voice and manner. I searched out the man who had brought the tape, and he told me that the singer's name was Andrés Contreras, and he had been in Guadalajara the previous week. The man had three more cassettes of Andrés's songs, which he copied for me, but said he had no idea where the singer could be found. "He is like that. He just shows up for a few days, sings in the main square and at the artists' flea market, then he is gone."

I did not have much hope of finding Andrés. Mexico is a big country, and I had no clues as to his routes and habits. However, the referendum was coming up, a large contingent of Zapatistas would descend on the DF, and I was as likely to find him there as anywhere. Anyway, it would be interesting to spend a little time with the Zapatistas. I had some connections from my brief sojourn as a peace observer in the rebel area, and they would know where events were happening. While I was at it, this was also a good opportunity to check out the political corridos of the urban left, the only corrido style that is really indigenous to the city.

My first day in town, I went down to the Zócalo, the plaza built on the site of the ancient Aztec city center and bordered by the ornate cathedral and the Palacio Nacional, the central government building. As Mexico's main square and civic forum, the Zócalo is a meeting place for protesters of all kinds, and also for vendors of lefty paraphernalia: Marxist pamphlets, T-shirts depicting Marcos, Zapata, and Che Guevara, and topical cassettes. One cassette seller had a couple of Andrés's more recent releases, and he told me that the Zapatista minstrel was likely to come through in the next few weeks, though one never knew for sure. He also had José de Molina's *De Chiapas con Amor* (From Chiapas with Love) and two volumes of *Viento Rojo* (Red Wind), an anthology of leftist songs that included corridos tracing the last hundred years of Mexican rebel actions, from the pre-Revolutionary Flores Magón brothers through Zapata and Villa, the 1950s Morelense guerrilla Rubén Jaramillo, the 1960s Chihuahan guerrilla Arturo Gámiz, and the 1970s Guerreran guerrillas Genaro Vázquez and Lucio Cabañas.

Most of these songs have had little currency outside Mexico City, except on college campuses and among organizations of left-wing intellectuals, and they represent a subgenre of corridistas that has had almost no overlap with the popular stars. Though the form, and at times the instrumentation, are similar, these songs fit not into the ranchera tradition but into Mexico's version of the "folk revival" that swept the middle-class and university communities of Europe and the Americas in

the 1960s. Inspired by Pete Seeger, Bob Dylan, and Joan Baez, and by the nueva canción poet-singers of Chile and Cuba, young musicians sought to harness their own folk traditions to the cause of the international youth rebellion. In Mexico, the charge was led by a gifted singer and songwriter named Judith Reyes, who achieved her greatest fame as the corridista of the 1968 student movement. (She was in her mid-forties at the time, only a bit younger than Seeger, and from a different generation than most of her listeners.) Her songs trace the history of that year, from "Corrido de la Represión Estudiantil del 26 de Julio" (Corrido of the Student Repression of the Twenty-sixth of July), to "Corrido del IV Informe del Gobierno de Díaz Ordaz" (Corrido of the Fourth Bulletin of the Government of Díaz Ordaz), "Corrido de la Ocupación Militar de la Universidad" (Corrido of the Military Occupation of the University), "Corrido de los Combates del Politécnico" (Corrido of the Battles of the Politechnic), and finally, "Tlatelolco, o Tragedia de la Plaza de las Tres Culturas" (Tlatelolco, or the Tragedy of the Plaza de las Tres Culturas), sometimes known as "Corrido del 2 de Octubre" (Corrido of October 2).

October 2 is a key date in Mexican history, though it has only recently been added to school curriculums. In 1968, as student protests were bursting out all over the Western Hemisphere, Mexico City was hosting the Olympic Games. President Díaz Ordaz took great pride in being the first Latin American head of state to have this honor, and he was damned if a bunch of rowdy radicals was going to interfere with his crowning achievement. His attempts to beat down the protesters culminated in the massacre of Tlatelolco. On October 2, thousands of people gathered in the Plaza de las Tres Culturas, in the north central part of Mexico City. The army surrounded them with tanks, posted sharpshooters in the windows of adjoining buildings, and simply mowed them down. No one knows how many people died—the army hauled the bodies away in trucks and buried them secretly—but estimates run between three and five hundred. As Reyes wrote:

> Qué fuerzas tan desiguales, hartos tanques y fusiles,
> Armados los militares, desarmados los civiles.

> Doce años tiene un chiquillo que muerto cae a mi lado,
> Y el vientre de una preñada, ¡Cómo lo han bayoneteado! . . .

> Piras de muertos y heridos, sólo por una protesta;
> El pueblo llora su angustia, y el gobierno tiene fiesta. . . .

(What unequal forces, all the tanks and rifles,
The armed military, the unarmed civilians.

The little boy is twelve years old, who falls dead at my side,
And the belly of a pregnant woman, how they have bayoneted
 it! . . .

Pyres of dead and wounded, just because of a protest;
The people cry their anguish, and the government has
 a party. . . .)

After Tlatelolco, as after Kent State in the United States, the peaceful protest movement lost much of its optimism and energy. The next wave would be guerrillas, both the urban revolutionaries of the League of the 23rd of September, the Frente Urbano Zapatista, and similar groups throughout the central and northern states, and the peasant rebel bands in the mountains of Guerrero, led by the schoolteacher revolutionaries Genaro Vázquez and Lucio Cabañas (the latter becoming the decade's foremost corrido hero). In Mexico City, and in bookstores and cafés near all the bigger universities, cassettes and albums carried on the protest tradition, alongside imports of the Cuban singers Silvio Rodríguez and Pablo Milanés, the Chileans Victor Jara and Violeta Parra, the Argentine Mercedes Sosa, and the Uruguayan Daniel Viglietti. This was the golden age of Latin America's nueva canción (new song) movement, and in Mexico the most prominent voices included Reyes, José de Molina, and Oscar Chávez. An actor in the popular new-wave film, *Los Caifanes,* Chávez became Mexico's protest music star, hitting with topical songs from all over Latin America, as well as poetic boleros and a revival of the early border song "La Mariguana," and he remains a favorite of Mexican intellectuals. (Of the three mentioned singers, he is also the only one who is still around: Reyes died in 1988 and de Molina ten years later.)

The idea of nueva canción, as of the folk music of Dylan and Baez, was to create a living, contemporary style out of the older folk tradition, and in Mexico the corrido was an obvious vehicle. As Chávez put it, when I met him in the office of his Pentagrama record company, "Mexican folk song, in many of its expressions, already carries a political cargo, a cargo of protest, a cargo of denunciation, in itself. Although the authors may not intend to—we don't even know who the majority of them were—they are setting down political and social acts and events. We have a richness of material, in this sense, that is astonishing. There

are corridos dedicated to Zapata, to Villa, and to so many characters, that are still relevant if you sing them today. They still have something to say, they still apply to contemporary situations. Now, it doesn't say much for our government that you can sing a song from sixty years ago and it's still relevant, but that's the way it is."

The only problem is that, as in the United States, there has tended to be a significant class difference between the urban folksingers and university students, on the one hand, and the workers and peasants who continue to keep the country styles alive as a broad, popular form. Like Pete Seeger, the Mexican protest singers were trying to create a music that, rooted in working-class culture, would reach across class lines, and they had moments of success. Still, I never met a regular ranchera/corrido fan who had listened much to Reyes or Chávez, and certainly never found a Chávez fan who bought albums of Los Tigres del Norte. Chávez himself is theoretically interested in what is happening in the working-class ranchera world, but he does not follow it closely. He was unaware of the more political work Los Tigres have been doing (aside from the unavoidable "El Circo") or of other topical corrido hits such as Los Huracanes' "El Sexenio de la Muerte" (The Presidential Term of Death). He was pleased to hear of such developments, but it is not his world. In the 1970s, as Los Tigres were hitting with their gangland ballads, Chávez was also concentrating on the corrido style, but the simultaneous revivals had no overlapping audience, nor did they share any themes. Chávez's only bow to the narcocorrido wave was his "Corrido de los Cocos" (Corrido of the Cokeheads), which begins by talking of a big drug bust, but quickly develops into a satirical analogy: Mexicans use the term *endrogarse* (to take drugs) to refer to the national debt, the idea being that the government shoots up loans without considering the consequences, and ends up addicting the country to foreign capital.

Chávez told me that he was working on an album of songs in support of the Zapatistas, but he had never heard of Andrés Contreras, nor did he plan to include any corridos. In fact, he expressed mixed feelings about the whole corrido genre: "Often it's a very pamphletlike, very elementary kind of song. But fine, that's the tradition." In sum, Chávez is part of another world. When he presented a benefit concert for the Zapatista delegation that evening, at a nightclub near the Rodeo Americano, the door charge was so high that there was little chance of anyone coming except the upper middle-class, liberal audience that has always been his bedrock of support. I went to the show and enjoyed it, but it had none of the rowdy spirit of a ranchera dance. It was a lefty folk concert, the sort of thing I grew up with around Harvard Square.

The next few days were taken up with the Zapatistas. I was staying with my friend Eduardo, whom I had met in Chiapas, and he was guiding one of the Zapatista delegations that was touring the capital. He would come home each evening with stories of meetings with leftist politicians, unions, or important liberal intellectuals. One day, he invited me along as a Zapatista group toured the Museum of Anthropology. It was a strange experience, with layers of irony so thick that it is hard to know where to begin: the Zapatistas are Indians, Mayans, and were being led through exhibits about their ancient history and "native customs," with explanations by a blonde anthropologist. They were small, dark people, wearing bandanas to conceal their faces, and they were fascinated to find replicas of their houses and traditional clothes displayed in this huge, modern building in the capital. They clustered around the dioramas of ancient Mayan monuments, chattering to one another in Tojolobal (I think), and listening in hushed fascination as the anthropologist spoke of the grandeur of the pre-hispanic culture. Then we clambered back into vans and went off to lead a march against the rise in electricity rates.

It was on the following day that Eduardo came home with a huge smile on his face, saying, "Guess who I met on the Zócalo?" It was Andrés, of course. As it turned out, he had not been with the Zapatistas at all. Instead, he had come to town as part of a group marching from Guerrero to protest the PRI's seizure of that state's governorship in an election marked by charges of ballot-box stuffing and vote buying. He was singing on the Zócalo and had told Eduardo I could meet him there the following afternoon.

I found Andrés on the east side of the plaza, standing behind a superannuated sound system that was blasting a distorted version of his latest tape. He had set up a half circle of cardboard display cards, with reviews, newspaper clippings, and a tribute to José de Molina, behind which he stood and sold cassettes. He had his guitar with him, a battered nylon-string acoustic with a microphone taped to its side, but he was not singing, just playing the tape over and over. He said he could not talk now, as he needed to make his living, but gave me the address of his hotel and said to come by the next morning at eleven.

The hotel was three blocks east of the Zócalo, and the posted price for a room was the equivalent of six dollars a night. I got there more or less on time and waited fifteen minutes while a man went up and fetched Andrés. Then we walked around the block to a cheap restaurant, accompanied by his lady friend, a small, round Indian woman named Berta, and her pet parakeet. We ordered three breakfasts, and the parakeet sat

on Berta's shoulder, eating bits of tortilla and drinking sips of Fanta, then moved over to perch on the brim of Andrés's straw hat.

Andrés was both bigger and louder than I would have guessed. He has a wide smile, showing a lot of silver-mounted teeth, and comes across as a *vago,* a boor and a braggart who delights in offending the bourgeoisie, as well as a street player supremely confident of his abilities. At forty-nine, he has completely committed himself to politics, going wherever there is unrest and playing in the most exposed areas, attracting equal attention from protesters, press, and police, who seem to enjoy jailing him almost as much as he exults in being jailed. (By his current count, he has been arrested more than fifty times.) He does not fit the classic model of a village corridista, the respected community member chronicling local events, but he exemplifies and exaggerates all the characteristics of the medieval *juglar,* or minstrel, the man who wandered into town on market day, sang rowdy, topical songs to attract the small coin of the peasantry, then blew his earnings in the tavern, drinking until he passed out and slept in the stable.

Perhaps the oddest thing about Andrés is his identification with the Mexican Indians. He looks Spanish, and his broad, blustery style is the antithesis of the traditional Indian manner, but he professes himself more comfortable among Indians than mestizos ever since childhood: "I'm originally from Mexicali, Baja California Norte, but my family emigrated to Sinaloa and Sonora, and that's where I came in contact with the country environment. I was living among the indigenous people— Yaquis, Mayos, Pápagos, Sopatas, Seris—the music, the customs, all of that, and that left its mark on me. So much so that when I went back to Baja California I didn't feel the slightest identification with the customs there. It disgusted me to hear how the people mix Spanish with English, that instead of saying '*sí,*' they said 'okay' or 'yes,' instead of saying '*mira,*' '*observa,*' '*ve,*' they said 'watcha' or 'looka.' All of that rubbed me very wrong. Right up to now, I have no identification with that scene, and still less with the music scene, where everyone wanted to sing in English. But in the country, people are very connected to the traditional music, and that always caught my attention. So my life went along like that, and I learned something about music in a lyrical way—that is, without studying it."

In 1968, as Chávez and the city singers were chronicling and inspiring the youth rebellion, Andrés was in military prison in Mazatlán. "I went into the army when I was seventeen years old. I still had some idealism about the official institutions; people said that the army was full of honor, of love for the fatherland, that the people who were soldiers had good manners, a good way of life, and that there were opportunities to

study and rise to other things. And when I arrived and saw that that wasn't true, that they were a pile of potheads, drug addicts, drunks, degenerates, sneak thieves, robbers—if you weren't careful they stole your shoes, your cartridges, your sheets—my reaction was to become undisciplined. There was a sergeant who treated me very badly, and I spied out where he went and knew that he would go to a certain cantina to drink, and I followed him there and when he went to the bathroom I gave him a few good kicks and a good beating, and then he left me alone. And then I didn't want to use marijuana and live in that environment, so they hassled me, and one day I shot one of them and that's how I ended up in the military prison, in the beginning of sixty-eight. And October second came, when the army carried out the massacre here in Tlatelolco, and by then I had stopped fooling myself. I said, 'This is completely rotten, this is bullshit.' "

Though far from pleasant, his military service was a key period in Andrés's life. In the liner notes to his *Tania la Guerrillera* cassette, he writes of being sent in June of 1969 to put down a group of guerrillas who had attacked a bank in Empalme, Sonora: "The 'transgressors' were captured in Corral Station, near Esperanza (Sonora), because of an informer in that town. When they were taken prisoners, the author heard them sing the 'Canto de las Madres Latinas' [Song of the Latin Mothers]; being captivated by the lyric and melody of this song, he requested the words from a professor, the chief of that troop asked him why he wanted them, and he replied that he wanted to sing them. I had the idea that this song was by some South American, and it was not until April of 1994 that I became aware that this song was composed by José de Molina."

While Andrés continues to name de Molina as one of his heroes, his own style is much rougher and funnier than that of the *nueva cancioneros*. His most requested number is a reworking of yet another song he heard while in the military. He was on patrol with a sergeant who was even more than usually vago, and who led the whole troop off to a cantina. Some local musicians were there and started singing "El Mono de Alambre" (The Wire Monkey), an old song in which the leader would make up verses about whomever was in the room, insulting them and telling them to go fuck their mothers, then everyone would join in the chorus. In Andrés's hands, "El Mono" has become a nine-minute epic:

> *Buenos días señores, somos agraristas,*
> *Chinguen a su madre los latifundistas.*
> *Por todo el país venimos cantando,*

Y a los vendepatrias la madre mentando.
Vamos a bailar, vamos a bailar el mono de alambre,
Y los diputados y los senadores, chinguen a su madre.

(Good day, gentlemen, we are agrarian rebels,
The big landowners can go fuck their mothers.
Throughout the whole country we come singing,
And "mother mentioning"* to the country-sellers.†
We're gonna dance, we're gonna dance the wire monkey,
And the congressmen and the senators can go fuck their
 mothers.)

It is not a corrido, but it comes from the same barroom minstrel tradition, and it includes one of my all-time favorite rhymes (it is apparently a favorite with Andrés as well, since he repeats it twice in the course of the song):

Allá en el DF mataron a Trotsky,
Que chingue a su madre Jacobo Zabludovsky.
Que vive Zapata y Rubén Jaramillo,
Que chingue a su madre Ernesto Zedillo.

(There in Mexico City they killed Trotsky,
Jacobo Zabludovsky‡ can go fuck his mother.
Long live Zapata and Rubén Jaramillo,
Ernesto Zedillo can go fuck his mother.)

The other verses celebrate everyone from the turn-of-the-century Flores Magón brothers to the present-day Zapatistas and EPR (the Ejército Popular Revolucionario, or Popular Revolutionary Army of Guerrero), and insult everyone from rich landowners and PRI politi-

* *Mentar la madre* is literally to mention the mother, but if you *mentar la madre* to someone, it does not mean you say, "I saw your mother the other day." As with the African American insult game the dozens, it involves a string of insults which need not mention a mother at all, though usually do.

† A *vendepatrias*, someone who sells out his country, is a common insult for politicians perceived as being bought by foreign capital, and suggests a link to the despised Santa Anna, who sold northern Mexico to the United States.

‡ Jacobo Zabludovsky is a well-known television commentator and was spokesman for the Salinas administration.

cians to the Televisa network, right-wing labor leaders, Bill Clinton, Pete Wilson, the Knights of Columbus, the Catholic church hierarchy, and finally the pope himself. These attacks on the church have become something of a specialty with Andrés, expressing a disillusionment that he claims began when he noticed that Santa Claus brought expensive presents only to rich kids. He moderated his attacks somewhat after seeing the support given to Chiapan Indians by San Cristobal's Archbishop Samuél Ruíz, and even wrote a corrido honoring Ruíz's exploits, but it is his mockery of corrupt churchmen that regularly draws the loudest, most satisfying gasps from listeners. To his great surprise, it has also earned the applause of many priests and nuns, and the address where he receives his mail is care of a church in a suburb of Guadalajara.

To Andrés, the anticlericalism is just one more link to his medieval forebears: "I read in school about the history of the minstrels, how these characters went from town to town singing their songs, and that they took their themes from the events they saw during their travels, and I said, 'When I grow up, I want to go around like that too.' The thing is, I didn't read the dark part, the frightening part of the life of the minstrels: they were hated by the church, many were burned alive, whipped, they put them in the stocks, they jailed them. But the people defended them, and I feel that, despite the risk they were running, they felt the people's appreciation, and they persisted until the church stopped persecuting them, and from that came what we know in Mexico as the corrido. Some of the minstrels became acquainted with the nobility in the castles, the feudal lords, who were very well educated, and they took up this work again, but with a higher level of refinement, and from that came the troubadours, who played a more elevated music than that of the minstrel. The minstrel's music is more rudimentary, more vulgar, of the lower classes, the people who didn't have access to the universities, who couldn't become refined."

Andrés did not turn to minstrelsy immediately on leaving the army. First he tried to lead a respectable life, getting a job, marrying, and having children. That fell apart somewhere along the way, though, and by 1993 he was living on the beach in Manzanillo, playing his songs for the tourists and making five hundred or seven hundred pesos in an afternoon and evening, a fortune for a busker: "It was a very nice, pleasant environment there, it was like a paradise to me. There were lots of little gringas on the beach and everything, and I enjoyed it so much that I finally said, 'I'm going to stay here.' But as we were celebrating the New Year, in the early hours of the morning, after the hugs and all of that,

we began hearing news of what was happening in Chiapas. And I threw away the Cuba libre I was drinking, I asked for a black coffee, good and strong, to sober me up, I grabbed my notebook and I began to write it all down. Right there, I wrote my first song about those events, and I began to pack my bags to go to Chiapas."

The song was a corrido in the pure, traditional style:

> Año del '94, el dia primero de enero,
> En el estado de Chiapas, surge un grupo guerillero;
> Salían indios por do'quiera que parecían un hormiguero . . .
>
> Desde la selva salieron en distinctas direcciones,
> Tomaron pueblos enteros, también abrieron prisiones;
> Buen susto que se llevaron, esos caciques ladrones.
>
> (In the year of '94, the first day of January,
> In the state of Chiapas a guerrilla group arose;
> Indians came out from everyplace, so it looked like an
> anthill . . .
>
> From the forest they went out in various directions,
> They took entire towns, also opened prisons;
> They got a good fright, those thieving caciques.*)

Andrés made his way to San Cristóbal de las Casas, the main town of the Chiapan mountain region, and began searching for someone who could give him the straight dope on the uprising. As he tells the story, this was a somewhat complex process: there were placards posted saying not to believe rumors, and to go to the official institutions for information, but when he tried that he was just fed a lot of foolishness. Then he went to the Office of Human Rights, but the woman behind the desk turned pale and said she could not help him. Finally, he went out on the edge of town, where the Indians lived, and "information rained down on me." He wrote song after song, and when negotiations opened between the Zapatistas and the government, he sallied forth to make his views heard.

"I said to my friends that I wanted to sing there in front of the cor-

* *Cacique* literally means a sort of tribal chieftain, but is usually used for a despotic boss of a town or organization, in this case the rural landowners who effectively own the police and local governments in much of the Mexican countryside.

224

don of soldiers. They said to me, 'No, don't do it, they'll kill you, that place is full of government agents, of troops, people from the State Department, the Federal Judiciary, Military Intelligence, as soon as you start singing they'll grab you and make you disappear. Better keep singing here for us.'

" 'No, I want to sing there, I want to shout at the government, by way of my songs, that I don't believe their lies. That's what I came for; I didn't travel thousands of kilometers to get frightened at the hour of truth. Whatever has to happen, let it happen.' And I went and stood there in front of the army. At first, yes, I was kind of scared; I stood there with my guitar, looking around like this: 'Will I do it or won't I?' And while I was looking, one of the officials who was there said to me, 'Hey there, my troubadour, sing us a song, we're very bored.'

" 'Really? Should I sing one for you?'

"So I started off with 'Selva Sangrienta' [Bloody Forest, his corrido of the uprising] and they showed no signs of aggression. I thought that with the first verses they would fall on me and haul me away, but no, what happened was that a cloud of journalists decended, so they couldn't all fit in the place, it got overcrowded, the mass of cameras was suffocating. And the soldiers were worried by the crush of journalists and asked us if we wouldn't do them the favor to go somewhere else, because we were almost trampling them, and the journalists took me to the press room in the Hotel Mazariegos, and I gave a lot of interviews. I thought they would provide a lot of exposure for my songs—what I didn't know is that a large proportion of those journalists were government spies and all the songs that I wrote about the conflict would be banned. The only people who published anything were the foreign press: they sent me articles where they even translated some of my songs into French, into Italian."

There are moments in Andrés's narration when I find myself wondering whether the events were really as dramatic as he recalls. I can imagine the Human Rights person paling at his approach, if only because he is obscene, gruff, and overbearing, but he does not seem like the sort of heroic figure who would march out in front of a line of soldiers and start singing revolutionary songs. It was only some weeks later, in the mountains of Guerrero, that I would get confirmation: people told me of how he had sailed into town in the wake of the Aguas Blancas massacre and sung his songs in front of the town hall, getting dragged off to jail and in danger of being beaten to death by the police until a supportive crowd surrounded the station and demanded his release.

Andrés told of several close calls during his stay in Chiapas: "In Tuxtla, the state capital, I went to sing in front of the Palacio de Gobierno. People crowded around, and the functionaries went in and out completely pissed off, they gave me some really dirty looks, made calls on their cell phones. A helicopter arrived, flying really low, like thirty, forty meters above the ground, showing machine guns, trying to frighten the people. I told the people not to be frightened, that we were singing, that there was no cause for alarm. The helicopter flew off, and in a while the army arrived and surrounded the square. Then I got a little scared, but I said, 'Okay, by now there's nothing to be done. Whatever happens will happen.' And I kept on singing, I paid no attention to the cordon of troops, and after a while they left.

"Another time, I was also singing and a troop of soldiers arrives, burning rubber, slams on the brakes, out jump the soldiers and surround me. I thought, 'Okay, nothing for it, this is it,' and I see a journalist running there from the corner, with her video camera going, and her blond hair flying, and when the captain saw her, who was commanding the unit, he spoke to the soldiers, he whistled and gestured like this, they leapt back into the truck and squealed out of there. Then I recalled a phrase of Napoleon's: that he was more frightened of one newspaper than of one hundred bayonets."

It is a phrase that Andrés treasures and likes to apply to his own work. He tells of walking into the jungle, planning to join the Zapatistas, but being told that he would be of more use to the fight as a singer than as a guerrilla. Then when he returned to Manzanillo to sing his new songs on the beach, he says that he was jailed for four days and a police commander told him, "Look, cabrón, you with that goddamn guitar, you're more dangerous than if you showed up with a thousand armed men."

Not all of Andrés's problems have been with his political enemies. He tells how, on the road from Guerrero with supporters of the left-liberal PRD (Partido de la Revolución Democrática or Party of the Democratic Revolution), some of his fellow marchers complained that his songs were too raunchy, especially "El Mono de Alambre." "I just told them, 'You're wrong. You think that we're a procession or a pilgrimage, you think we're going off to pray, and we're not going to pray, we're going to fight. Though I'm not a member of this party—I don't belong to any party—I know that it's a party of the left, and you're talking to me as if you were from the PAN [the traditional party of Roman Catholic conservatism], as if you were a priest.' And Felix Salgado Macedonio, the candidate who won the elections but who was robbed by

fraud, he liked that song a lot. He requested it twice, and when those gentlemen came along and bothered me, telling me not to play it, I told Salgado Macedonio, and he said to me, 'What kind of fight is this, where they don't let people sing real protest music? Look, if anyone else comes to bother you, tell them to go fuck their mothers, from me.' "

Andrés grins at the memory, and it strikes me that such moments are what keep him going. Certainly, his music has brought him few more solid rewards. He has recorded and issued all of his cassettes himself, and aside from a few streetcorner salesmen, he has been their sole vendor. The only one that really took off was that first cassette with Los Tigres del Sur, but its success was pretty much limited to Chiapas, and even there most of the sales were made by pirate operators who had better distribution networks than Andrés could command. His own sales are almost pitifully small: "I record my material and order three hundred tapes, I sell them, with the money I pay my travel expenses, lodging, food, getting around, and with part of what's left I order some more. Sometimes there's nothing left, I spend the money and I have to survive and get around on my *boteo,* that is I put out my little can and the people put in coins."

Still, Andrés does not have a bad life. I pay for breakfast, the first time I have treated a corridista rather than vice versa, but Berta insists on reclaiming the family honor by buying a round of sherry, though it is barely noon. She and Andrés seem to be a happy, if rather incongruous, couple, and their relationship is far stabler than is common with wandering minstrels. Their political commitments have been more of an asset than a burden, connecting Andrés to a larger audience than he would ever have been likely to find as a regular street singer. And he is only growing more prolific with the years. Mexican politics is not pretty, but it provides unlimited material for a satirist, and Andrés expects to go back into the studio in the next few days, with enough songs for two new cassettes.

Andrés's musical interests are broad, ranging from huapangos and pre-Columbian melodies to pop fare (he has a Clinton-Lewinsky song to the tune of the Texas swing standard "Allá en el Rancho Grande"), but the corrido remains his bedrock. He has written corridos of the massacres of peasants in Acteal, Chiapas, and in Aguas Blancas, Guerrero, of international events such as the arrest of the Chilean dictator Augusto Pinochet, of murders, and of natural disasters. "The corrido is the most representative style, and the one that reaches the people best," he says. "Through the corrido, the people can hear an unofficial version of events. But what's happening is that the government, the media, the

ones with the money, are trying to strip the corrido of this potential, so that it won't open the eyes of the people. So they promote corridos of killers, of assassins, of the drug traffickers—all the things that don't awaken people, but instead keep them even more idiotized."

When I point out that, in the last few years, groups like Los Tigres and Los Huracanes have also been singing about political subjects, Andrés is contemptuously dismissive. Unlike Oscar Chávez, he is well aware of what is being recorded by the pop groups, but does not see their work as politically significant. His critique echoes Enrique Franco's: "Those songs came out after everything was over, not in the moment. They come out when they can no longer do any harm, when instead of attacking the system they benefit it. Because the government, by giving space to those songs, says, 'Here we respect freedom of expression, we allow people to sing this, to sing that, to sing about Chiapas.' But they're singing about it years after the fact, so instead of waking people up it idiotizes them, because it makes people believe that the government is good, that the government respects civil liberties. But Los Huracanes, Los Tigres, they didn't put out those songs in ninety-four, or in eighty-eight [the year Salinas reputedly stole the presidential election].

"If anyone writes a song dedicated to a contemporary hero, a great social fighter who was assassinated, and in this corrido explains who assassinated him and how, the people with money will not give it a chance and the singer himself will be killed. José de Molina was a great singer of this type of music, and when Bill Clinton came here he wanted to sing in the Zócalo, and the government ordered him beaten so badly that it aggravated some illnesses he had and he died. In more than thirty years as a songwriter, he was never given any space by the publishers. So there is a clear demonstration of what those who have money are trying to do: to manipulate the corrido so that it won't awaken the people, but on the contrary will make them more ignorant."

As for Oscar Chávez and the other, more sedate nueva cancioneros, Andrés says that their work simply does not interest his audience: "Those are people who studied philosophy, letters, who went to conservatories. They became completely wrapped up in the bourgeois scene, the elite, and they write their songs in the elitist style. What they write is nonetheless a great truth, and because of that it reaches a certain stratum, certain people of the left, but not all. For example, if I try to play their songs in the Zócalo, I won't sell a single tape. I've tried it, because there are people who come to me and say, 'Listen, I like your tapes. Look, I have one here by Victor Jara, and I'll trade for yours, one for one.' I say, 'sure, let's do it,' and I make the trade, and I put out a big

pile of their tapes and play them, and the people don't pay any attention. On the other hand, I put out mine, I play them, and people crowd around and buy them. What it is, is that as a street singer I can reach the regular people better, the people who didn't have access to the universities, who couldn't go study in the Iberoamericana, in the Anahuac, proletarian people, who if I talk to them in the language of those authors we're talking about, they won't understand me."

Here, for a moment, is where Andrés meets Julián or Paulino: their ideals, politics, and career paths may be very different, but all know how to write songs for a mass audience. "Many people, they come over when they hear me singing, because they like music, they like corridos. They come with the idea that they're going to hear songs of El Señor de los Cielos, of killers, of drug traffickers, and what I try to do is to take advantage of this to sing them political themes, things that will wake them up. And often I can see that it's quite a shock for them. Suddenly they're hearing me tell Zedillo and the congressmen and senators to go fuck their mothers, they're hearing that the pope came here to make asses of the people, that he came to bless the bankers and those who are killing the indigenous peoples, the campesinos, the poor. When they hear that, they get all shook up, they get indignant, they want to kill me, they almost want the Inquisition to come back to burn me alive. But somehow the pill gets inside them, and many of them go away reflecting and thinking. If one or two people of the hundred or two hundred who hear me reflect on what I am saying, I feel that the event was worth something.

"If I put my ideas in writing, I don't see much chance that they would reach anyone, because a book, no matter how well written it may be, for all the fine rhetoric it may contain, is something silent, which just sits there, shut up. And since Mexicans are prevented by the system itself from becoming educated, from becoming cultured, if I present people with a book it won't catch their interest. So I present my ideas in songs, and even the people who don't buy will hear me. They'll want to kick the shit out of me, they say that I'm going to die—well, I already know that I'm going to die, you're going to die, we're all going to die, but what they mean is that they're going to assassinate me, death threats have rained down on me there in the Zócalo—but here we are. We'll soon have seven cassettes circulating. If they kill us, well, we'll live on in the material we've done."

We had finished our sherry, and Andrés had to go off to a recording session, but I was to see him once more before leaving the DF. The referendum was over, and the Zapatista delegations were massed in the

Zócalo, preparing to board buses and trucks for the long trek back to Chiapas. It was getting on toward midnight, and people were getting cold and impatient, when Andrés wandered up with his guitar. A small crowd gathered around him as he sang "El Mono de Alambre," the street kids howling with laughter at the dirty words and two older women looking shocked but moving in to hear better. The Zapatistas, exhausted from two weeks of travel, marches, conferences, and photo opportunities, mostly huddled near the trucks, sitting on their baggage, but a few got up to listen. Andrés handed his guitar to one of the masked delegates, then led the crowd in the Zapatista anthem. Someone requested his corrido of the uprising, and he sang it, sounding hoarse and tired, but making every word distinct. Behind him loomed the towering mass of the cathedral erected by the Spanish conquistadores on the site of the Aztecs' great pyramid. It was a haunting moment, the masked Indians clustered around and the street-roughened voice battling to tell their story over the grumble of the engines:

> *El indio en nuestro país siempre ha sido despojado;*
> *De sus tierras y riquezas, de su glorioso pasado;*
> *De su grandeza de antaño, solo ruinas han quedado . . .*

> *Adiós pueblos de Ocosingo, San Cristóbal de las Casas,*
> *También de las Margaritas, de Chanal y Altamirano.*
> *Culpable de ese desastre es el gobierno tirano.*

> (The Indian in our country always has been dispossessed;
> Of his lands and his riches, of his glorious past;
> Of his bygone greatness only ruins remain . . .

> Good-bye towns of Ocosingo, San Cristóbal de las Casas,
> Also of Las Margaritas, of Chanal and Altamirano,
> The one guilty for this disaster is the tyrannous government.)

CORRIDOS OF THE COUNTRY BUSES

Gabriel Villanueva

Voy a cantar un corrido, disculpen y no se enojen,
Pero es para operadores y empleados de Flecha Roja.
Estos manejan muy bien, son conductores muy buenos,
Cuando llegan a chocar, es por la falta de freno.

(I am going to sing a corrido, excuse me and do not get
 annoyed,
But it is for the operators and employees of the Red Arrow
 [bus line]
They steer very well, they are very good drivers,
When they have an accident, it is because the brakes fail.)
 —*"El Patas de Hule" (The Rubber Paws),*
 by Catalino Bahena Ortíz

My conversation with Andrés marked the beginning of a new phase of my travels. It was time to get away from the hit songwriters and recording stars and see how the corrido was doing on its original turf, sung by country singers for audiences of their peers. This was in some ways a little trickier, since I did not have names and telephone numbers to go by, and in some ways a lot easier: there are thousands of little-known artists singing corridos all over Mexico, from old-fashioned village chroniclers to the norteño trios that busk from cantina to cantina, to the musicians playing for tips on second-class buses. Buses are an ideal venue, since

they promise a captive audience eager for anything that will break the monotony of travel. While bus singers are not all that common in the north anymore, at least as far as I could find, they remain ubiquitous in Guerrero and Michoacán, so I changed my mode of transport and bought a ticket south.

The bus singers had a particular attraction for me, because I put in a few years as a busker myself. Starting in my late teens, I spent most of the next decade traveling around Europe, Asia, and the United States, earning my living on the trains of the Paris Metro, on movie queues, on café terraces, or wherever else there was a likely-looking crowd that might part with some cash. In Europe, this has become a rather degraded art: most of the players are either youngsters who will only be busking for a year or two, or hardened wastrels and layabouts who have given up on any hopes of making an honest living. (I was one of the former, aspiring to become one of the latter.)

In southern Mexico, there is far more professionalism. While most of the musicians I heard on the Mexico City subway were blind beggers, strumming a single monotonous chord or puffing on a harmonica as an excuse to ask for alms, the southern bus musicians include many of the finest rural performers. This is the most profitable, and often the only available, venue for their work, and many of them will spend their lives traveling from small town to small town, supplying local travelers with the same entertainment provided in the market squares of the Middle Ages. That entertainment is not limited to music; while I never saw a trained goat or fire-eater on a bus, there was no shortage of modern-day mountebanks. For instance, there was the man in a formal, navy blue suit who climbed onto my bus somewhere in the hinterlands of the Tierra Caliente. After greeting the driver as an old friend, he opened a sample case on the front passenger seat and pulled out a large jar of water with a live mud puppy swimming in it. He turned the jar a few times, so we could all see the creature wriggling, then pulled out a smaller jar containing a dead mud puppy preserved in a sickly greenish fluid. Holding this above his head, so it could be seen to the back of the bus, he went into his spiel:

"No, it is not a toad and it is not a frog, but it is an animal with which some of you may be familiar. We preserve it in ninety percent alcohol, with medicinal plants, and this forms the basic material for our ointment. I am a representative of Azteca natural medicines. You may have seen me on the coast, in Teloloapan, or near Acapulco, because all of this is my territory."

He started up the aisle, handing a jar of ointment to each passenger.

A man in the second row tried to shake his head and decline the offer, but the salesman gently placed a jar on the arm of his seat and went into another speech: "No one has to buy anything, you can just give the jar back to me when I have finished my presentation, but please take it for now. If people see one person waving it aside, then they do the same. The other day, a woman in the front row declined to take a jar and the whole bus followed her example. So please take the jars; you can give them back afterward, but please let me do my job."

He continued the distribution. The jars were about an inch high and two inches in diameter, with a green label giving an address in Mexico City and a list of ingredients. It was a sort of "tiger balm," more or less what one might expect to find in a natural medicine shop anywhere in the world, made from garlic, camphor, eucalyptus, and suchlike, with no mention of mud puppies or any other animal.

The Azteca representative returned to the front of the bus and continued his speech: "There is an old man who lives in a small village; he dresses like a campesino, with an old straw hat and huaraches, but every eighteenth of August people go to see him to get his secrets. Some might call him a witch or a *curandero*, but what he really is is a country doctor." Having established the medicine's link to rural lore, he now added a modern note: "Accept no imitations," he warned, holding up a similar jar with a blue label as an example of a false brand to be avoided. Then, "Every one of these jars is carefully sealed in plastic; if the seal is broken, do not use it."

Now it was time for a demonstration. He broke the seal with his teeth and opened a jar. Dipping his right index finger into the green paste, he jabbed it in his mouth and rubbed energetically: "If your teeth hurt, rub some of this ointment on your gums: it is designed to penetrate and give immediate relief from discomfort." He dipped up a bit more and rubbed it behind his ear: "If you have an earache, if you got some water in your ear and it is hurting, massage the area thoroughly with this ointment and the pain will go away." Likewise, he explained, one could rub his product on one's temples for a headache or on one's lower back for backache. As for asthma, "Doctors, the greatest doctors, have not been able to cure asthma, but this preparation gives relief. Just dissolve two spoonfuls in boiling water and inhale the vapor." He brought out charts and photographs, showing how arthritis came from eating red meat and the buildup of uric acid. The ointment, if taken internally in the proper manner, could improve kidney function and cure this as well.

And what was the cost of this wondrous vade mecum? "You can buy this in stores all over Mexico, but today I am making you a special offer.

233

I am not asking thirty pesos a jar, or fifty pesos for two—sixty pesos for two in some places. No, I will sell one jar for fifteen pesos, and two for *un ojo de gringa* [a gringo woman's eye]—you know what that is? A twenty-peso note, because it is blue."

Off he went to the back of the bus, and began collecting the money, or graciously accepting his jars back from the nontakers. Many people, including the old man sitting across from me, bought two jars. At two dollars the pair they seemed cheap, until one considered Mexico's minimum wage of roughly three dollars a day. Many of the riders looked as if they had been saving their coins for a while just to pay their fare, and the ointment was a significant investment. Of course, it would replace all sorts of more expensive medicines they might otherwise have had to purchase in the future.

In the front of the bus, the two conductors were turning the big jar, watching the mud puppy swim. When the pitchman finished his work, he joined them, and they stood around chatting. He had recently married, was not traveling as much, "but one still has to make a living." He donned sunglasses and danced along with the music on the radio, dropping his professional air now that he was off duty. Then we arrived at a small country town, and he disembarked to await the next busload of suffering humanity.

To me, the medicine man's performance was proof that I had come to the right place. A public that buys its medicine from a huckster displaying mud puppies and talking of village healers will be inclined to get its news from corridistas. And, in Guerrero in particular, there was no shortage of local news, much of it likely to be ignored by the mainstream media. The state vies with Sinaloa for the most violent reputation in Mexico: On the Costa Chica, the coast to the east of Acapulco, there are the Afromestizos, black Mexicans descended from African slaves, who are famous for their deadly family feuds. In the mountains, there are the guerrillas, both the EPR and the ERPI (Ejercito Revolucionario Popular Insurgente, or Insurgent Popular Revolutionary Army), the heirs of Lucio Cabañas. Then there is a long tradition of drug trafficking, and some of the most corrupt and thug-driven local governments in Mexico. And, as a fellow in Michoacán said to me, admiringly: "The Guerrerans are very fine people, very brave—they kill each other chest to chest."

All in all, Guerrero is prime corrido country, so rich that at first I was baffled by the variety of choices. I decided to start in Acapulco, going through whatever cassettes I could find in record stores or at pirate street stalls, meanwhile hoping to hit it lucky on a bus. I was particularly

looking for corridos of current events, which I had heard were more common here than elsewhere. To give people an idea of what I wanted, I asked each seller if they had any corridos of the Aguas Blancas massacre, the incident that brought Guerrero's political struggle to the eyes and ears of the outside world. On the morning of June 28, 1995, a group of campesinos from two small mountain hamlets were headed by bus and truck to Atoyac de Álvarez, the main town in the southern foothills of the Costa Grande. They were going to a demonstration called by the OCSS (Organización Campesina de la Sierra del Sur, or Peasant Organization of the Southern Mountain Range), demanding the release of an imprisoned activist. At the ford below the town of Aguas Blancas, a bunch of soldiers detained them, made everyone get out of the truck, then opened fire. Seventeen peasants were killed, and some twenty wounded. Governor Rubén Figueroa (whose father had been kidnapped in the most famous incident of the 1970s Cabañas uprising) tried to cover up the massacre, releasing an edited video that suggested that the campesinos had fired first, but someone leaked the full fifteen-minute tape to Mexican television. The public was thus treated to the sight of soldiers gunning down unarmed peasants, finishing off some of the wounded with bullets to the head, then planting pistols in the hands of the corpses. Figueroa, a close friend and ally of President Zedillo, was forced to resign, though criminal charges were filed only against the lower-ranking soldiers. The word on the street was that the governor had planned the killings in advance and that his secretary of government was in a helicopter above the massacre, helping to direct the assault.

I assumed that there must be plenty of corridos of Aguas Blancas—it had been big news and had all the makings of a corrido theme—but the only ones I had come across were one by Andrés and one collected by a Mexico City folklorist, Luz María Robles, from a bus singer on the Costa Grande. In Acapulco, I was told that yes, there had been two or three recorded, but they would be hard to find since the massacre was already old news. Finally, a record store owner hunted up a cassette by a local trio called Los Pajaritos del Sur (the Little Birds of the South), which included "Masacre en el Vado" (Massacre in the Ford). This seemed promising, and when I listened it turned out to be exactly what I had hoped. Composed by the group's leader, Gabriel Villanueva Noyola, it was the sort of corrido that has all but disappeared up north. It was eleven verses and some seven minutes long, a luxury not allowed in the mainstream music world, where songs must be short enough for commercial radio play. It was classical in format, beginning with the for-

mal declaration, "I am going to tune my guitar and sing you my corrido," and ending with a "Fly, fly little birds" despedida that highlighted the group's name, and the verses gave a vivid picture of the event:

> Dijeron los policías al grupo de campesinos,
> "Todos las manos en alto, si es que quieren seguir vivos."
> Ahí empezó la masacre y sonaron muchos tiros,
> Fueron 17 muertos, y como 28 heridos.

> (The policemen said to the group of campesinos,
> "Get all your hands up, if you want to stay alive."
> There began the massacre, and many shots rang out,
> There were seventeen dead, and some twenty-eight wounded.)

Los Pajaritos' musical approach was thoroughly traditional, the old *dueto* style that ceased to be commercial in most of Mexico after the ascendance of the louder and more danceable norteño, but which has held on here in the south. Two singers in close harmony were backed by rhythm guitar, bass, and the lead guitar that Guerrerans call *requinto*, whether or not the smaller requinto guitar is used.

The store owner knew nothing about Los Pajaritos beyond the fact that they were a local group, but in another store I found a newer cassette with the corrido of another government massacre, the killing of eleven reputed guerrillas in the hamlet of El Charco in June of 1998, and also one about some recent flooding in Chiapas. The woman who owned the second store told me that Los Pajaritos made their living on the buses, and one of the cassettes had a contact address in Ciudad Renacimiento, a working-class suburb over the first mountain from Acapulco. I decided that this was worth investigating, and the store owner directed me to a cab center where crowded taxis provided a sort of door-to-door bus service to Renacimiento. The only complication was that neither the driver nor any of the passengers had the slightest idea how to find the address: Renacimiento is divided into numbered blocks, but the numbers do not run in any apparent sequence. In the end, the driver gave up and let me off near a cantina, and the bartender directed me to a mason two blocks away who would have a numbered map. Fortunately, Los Pajaritos' address turned out to be just a ten-minute walk down the main street.

I strolled along, past small, neatly kept-up houses, until I reached one with an iron grille outside, and a hand-painted metal sign wired to it saying "Pajaritos del Sur." A young woman was doing wash in the small

courtyard, and I asked her if Señor Villanueva was home. She went into the house and reappeared with a young man, who invited me into the yard, gave me a glass of water, and went out to look for Gabriel. Meanwhile, I chatted with the woman, who turned out to be Gabriel's daughter and the young man's sister. She told me that her name was Nancy, that she made her living doing braids for tourist women on the beach, and that it was a very good job: "I get fifty or sixty pesos from Mexicans, but I can get fifteen or twenty dollars from American women, and during *spring break* I can do three heads a day." After about fifteen minutes, the young man came back and said he had not found Gabriel, but I was welcome to wait. I was lucky, he said. Normally, they would be out playing on the buses, but a man had come by just as they were leaving and asked Gabriel to help him prepare for a cockfight. Gabriel is an aficionado—there were several tiers of cages with fighting cocks at one end of the yard—and valued for his expertise in attaching the razor-sharp spurs to the cocks' feet.

We sat and chatted for another half hour, and then Gabriel showed up. He is a solidly built, dark man, obviously Afromestizo, with wavy hair and a handsome, friendly face. With the usual Mexican formality, he refers to himself as *un servidor,* "your servant," but he has the confidence and charisma of a born showman. I explained my project, and he invited me to come inside, away from the crowing of the cocks, and to ask him anything I wished.

Gabriel is forty-four, born in the tiny coastal town of Estero Verde and raised as a fisherman in the state of Oaxaca. From childhood, he was always singing and making up songs, and in his late teens he came to Acapulco to try his luck in the music business. For the first few years, he sang with show bands, but the money was not good and there were always ego problems with the bandleaders. Meanwhile, his family was growing. He had remarried several times, and was supporting six children. Finally, he decided to buy a guitar and try to accompany himself. He learned a C major chord, though it took him several days, then asked an accordion-playing friend if they could form a duo. To Gabriel's chagrin, the friend just laughed and said he would have to learn more before they could do anything. "But the day came when we had nothing to eat the next day, there was no money—six children to support, and my wife, and only fifty pesos, so real necessity—and a friend said to me, 'Go play on the buses. You sing well, I'm sure that the people will like you, and you have lots of pretty songs.'

"That friend gave me the inspiration, for which I give him thanks, because when someone encourages you it is a very fine thing. So I went

to the buses. But I was ashamed, to tell the truth, so when I got onto the bus I couldn't sing at all: I was just going 'hm, hm, hm' [clearing his throat], and a woman says, 'This muchacho calls that singing?' And then I remembered a song, 'El Asesino,' from Los Cadetes de Linares, who were recording at that time, and I began to sing that corrido. The key of C major is too high, but I sang it there, and thanks to God and the people I saw that it went well, because I got ninety pesos in that one bus. In *one* bus! I'm talking about seventeen years ago, and that was a lot, because a peon earned something like sixteen pesos a day, and that would be working hard. With those ninety pesos I and my family went to the Blanco [the local supermarket] and bought food for the whole week. I felt very contented; I said, 'All right, I'm going to sing on the buses.' "

Gabriel laughs as he tells the story, amused to look back on his younger self. He has done well in the intervening years: The living room is decorated with a line of his LP covers, tacked up on one wall, and a pile of amplifiers in the corner is crowned by a box holding a new electronic keyboard. He owns the house, a stable of fighting cocks, and another house nearby that he has given to one of his sons. He would be doing even better were it not for Hurricane Paulina, which flooded this whole area in 1997, filling his house almost to the ceiling and destroying hundreds of dollars' worth of sound equipment. (He also lost a box of cassettes that had been the only archive of his compositions.) The destruction was only partially balanced by the fact that the hurricane provided him with his biggest hit so far: he personally sold nine thousand copies of the cassette featuring his eight-minute corrido of the disaster.

By that time, his songs were well known in the region. In the months following his bus debut, he had learned more chords, then teamed up with the accordionist and made his first tape. It was just a home recording, but it got him thinking about doing a bigger project, and he eventually scraped together the money to record an LP. Its lead song was one of his own compositions, "El Corrido de los Pobres" (The Corrido of the Poor), telling of a group of peasants who seized a parcel of federal land. "They invaded this piece of land because people who are needy, well, the truth is that they don't have fear—necessity forces you to seize what is yours, to fight for a scrap of earth."

This was classic corrido material, but Gabriel is not picky. He writes songs about anything and everything that seems likely to interest his audience, from corridos of natural disasters and local valientes to romantic boleros and comic numbers. He says composing always came naturally: "I don't want to boast or anything, but frankly it is easy for me.

I never went to school, I don't know how to read or write, but I can compose you a song—if it takes me a long time—in half an hour, words and music. There are even songs that I've composed in two minutes: 'El Tiburoncito' (The Little Shark), a cumbia, I composed walking like from here to the door and back. And in front of a lot of people, because it was a true story: I caught this shark, a big shark in the lagoon—a shark shouldn't be in the lagoon, they don't come in there, but this one did—and when I caught it, a friend said to me, 'Listen, are you going to write a song about this?'

"I say, 'It's already done.'

"He says, 'No way.'

"I say, 'If you buy me a Coke here, I'll sing it for you.'

"And the people didn't want to believe it, but in what it took for me to go get my guitar, like from here to the door, which is about—call it six meters, but it isn't six meters—like that, in the time it took to go and come back, I took the guitar and sang it for them. All the people who were there were knocked for a loop, they said, 'It can't be! You already had it written when you caught the shark!'

"Look, the truth is, whoever God gives a gift to, that's his gift. I can't play accordion: I had an accordion for something like six months, and no. I have a keyboard there, and I can't play keyboard. I have guitars and I can't play requinto. But God gave me the gift to compose songs."

Gabriel also has the gift for selling his music. He may be unschooled and illiterate, but he is a singularly sharp businessman, as the record companies have learned. At first he signed a ten-record contract with the Odisa label, but he says that they witheld his royalties in order to keep him producing new material. After the third release, he was sick of their behavior and decided to quit, but his contract barred him from recording for anyone else. His solution was to use his sons, who were not bound by the arrangement, as front men: the next three albums showed only their pictures, and were issued under the name of Los 2 Pequeños del Sur (the Two Little Guys of the South). Odisa complained, but there was nothing they could do about it, and after three years they agreed to let him go. Since then, he has recorded for the Fracor and Karem labels, but always with single-album deals. He no longer even asks for royalties; any money the company makes from sales, it can keep: "I tell them, just pay my recording expenses and give me two thousand cassettes, then have three thousand more ready to ship to me in twenty-five days."

The numbers sound big for a performer whose normal venue is country buses, but Gabriel is an assiduous salesman and even functions

at times as agent for his labels' other releases. "I have a lot of business in Guerrero, in the record stores. I sell wholesale at a low price so that they won't pirate me: I tell the people who sell cassettes at street stands, 'I'll give you a good deal, even if I just make two little pesos, but don't buy pirate versions, because if you do it will get you in trouble. I'm the sales agent for the company, and if I catch you selling copies I'll make a complaint to Mexico City and the federal police will get after you.' But I've seen various pirate tapes of Los Pajaritos, of 'Ciclón Paulina' (Hurricane Paulina). They are around in other areas, places where I don't go myself."

Despite the range of material he writes and records, Gabriel always refers to his cassettes by their corridos and says that those are the numbers that ensure sales. "I depend on the people, and I sing the people the stories of the people. So when a misfortune happens, to put it that way, in this part of Guerrero, the people themselves urge me, they say to me, 'Hey, Gabriel, what's up with you? Write that corrido, *mano.*' "

Gabriel laughs, but he insists that he takes his job seriously. "I go and investigate personally, because you know that the newspapers don't tell the truth. And I, as a composer and as a citizen, well, I like to tell the truth. Because the people who live through something always know the truth, and if after a while they hear the corrido, they'll say, 'That's not how things happened.' In the case of Aguas Blancas, I went to Coyuca de Benítez [the nearest town on the highway] and talked with some friends from there, from the village, and they told me, 'Instead of putting "El Corrido de Aguas Blancas," no, put "El Corrido del Vado [the Ford] de Aguas Blancas," because the events happened in the ford, not in Aguas Blancas.' It's like that: things have to be the way they have to be."

In the case of his corrido of the flooding and landslides in Chiapas, Gabriel could not afford to make the trip, but he still tried to be sure of his sources: "I talked with people from here who went to help gather the dead, those who had been buried, those who were drowned. And then on the television they showed a woman with three children, they were up in the trees, they were rescued after three days, and I saw that on television, and all of that is in the corrido. I based it on what I saw on the television—not on what the commentator said, but on what I could see, because when they say something, maybe they are telling the truth and maybe not, but if you see it yourself, you know it's true."

Gabriel's most successful corridos are not the sort of thing one hears on the radio, full of dashing gunmen and sensationalized events. The fourteen verses of "Ciclón Paulina" simply list all the towns affected by the storm, give some general impressions of the destruction and the pain it caused, then tell of the aid tendered by the government and for-

eign donors. It is competently played and beautifully sung, but as far as the lyrics go it reminds me all too faithfully of the old British and North American broadside ballads, many of which were simply rhymed inventories of relevant facts sandwiched between a formulaic greeting and farewell. The only exception is one verse of supplicatory social comment:

> *La gente necesitada muy poco ha recibido,*
> *Al que no le pasó nada, tienen lleno los bolsillos.*
> *Hagan conciencia señores: ¿Qué van a comer los niños?*

> (The people in need have received very little,
> Those to whom nothing happened have full pockets.
> Have a heart, gentlemen: What are the children going to eat?)

All in all, it is not the sort of song that is likely to survive in popular tradition, or to be covered by other groups, but it is an example of the tried-and-true formula that for centuries was the corridista's basic product. It depends on timeliness and a sense for what the public wants to hear, and Gabriel is a master of both. His only problem is getting a record company to respond with the necessary speed. "Within fifteen days of Paulina, I went to record the corrido. I made a call to Mexico City, to the guy from the company, and I said to him, 'You know what? I have the corrido of Hurricane Paulina.'

"He say, 'And the other songs?'

" 'I have the whole repertoire. Don't worry about corridos, I have lots of corridos.'

" 'Then come on.'

"And we went to record. But I had just recorded the one about Aguas Blancas, it had been selling for four months, and the one with 'Desastre en el Sinai' [about another local hurricane]—I had recorded two records that day and they had brought out both at the same time. So the company did not want to bring out the one of Paulina, which was their mistake, and a big one. They dragged their feet for five months. After six months, the cassette came out, but it was already late, there were already other corridos of Paulina. I told the guy, 'They already beat you, mano, the other boys around here.' Of course, theirs didn't compare with the one I composed, but . . .

"He says, 'Well, here it is, now we've got it out.'

"Fine. I go and get a thousand cassettes. In three days, the thousand cassettes flew out and I made a call, 'I need two thousand.'

"I went and got two thousand more, and in eight days they were all

gone. I made another call, and said, 'I need three thousand.' Okay, another three thousand. Then, 'I need four thousand, but I want you to come and deliver them to me here at my house.' And they came and brought them. Like that, just imagine!

"He says, 'Okay, we were wrong, because we should have brought it out then. . . .'

" 'Of course, you have to get it out while it's hot.' "

Since then, the company follows Gabriel's advice. His meat is the major news events, the natural disasters and historic massacres, and he is doing well enough with them that he sees no reason to join the narcocorrido trend. It is not that he lacks appropriate material: Guerrero has long been a drug-producing area, and other local corridistas have written of traffickers, while Gabriel himself has turned out corridos of valientes and killings, some of which were undoubtedly connected with the drug world. Still, it is not really his thing: "A lot of friends have said to me, 'Why don't you record corridos of contrabandistas?'

"I say, 'Mano, the truth is, it's not that I'm scared, but to compose a corrido one has to focus on someone who is doing that,' to put it that way. To compose songs just because I imagine them, imaginary things, well, I think that's not right. They have to be real, and that's why I don't write about smuggling. Because if I mention someone who is in that racket, I could cause problems for him, and I wouldn't want either to get myself in trouble or to cause trouble for certain people. Because you have to be realistic, and I let my friends know who are involved in that racket—because each to his own, maybe I'm poor because I haven't headed down that road, but I feel contented as I am—I let them know, 'Look, this corrido business, it's like the newspaper: if something is not known, if I write you a corrido it will become known and you'll cause trouble for yourself. If the law isn't looking for you, they're going to start looking.' "

Gabriel enjoys recalling one instance in particular: "This happened with a friend who got in a fight with another friend, and he beat the other guy, fighting with machetes. He gave his rival seven *machetazos*, and after he killed him, like fifteen days later, we ran into each other—someone else introduced us, he said, 'Look, this is the guy that killed so-and-so.' And he said to me, 'Yes, it was me, I gave him seven machetazos.'

" 'No, well, that's fine. You were defending yourself, right?'

"And he says, 'Write me a corrido.'

"I said, 'I'll write it for you, but I assure you that the day that record comes out they'll take you prisoner.'

"So I wrote the corrido, and about two months later the *judiciales* grabbed him, because of the corrido. Because if something is under cover and you shake the hive, the bees get stirred up, no? This kid didn't want to believe me, but the family of the guy who was killed heard the record or the cassette, they listened, and two months later the police grabbed him, and it seems he had to pay about fifteen thousand bills before they let him go. Afterward, he saw me and he said, 'It's true, Gabriel, what you told me.' "

If Gabriel is concerned about these sorts of complications, it seems odd to me that he should have released a corrido about Aguas Blancas. Guerrero is still in the middle of a guerrilla war—in fact, the US government had just issued a travel advisory the week I got there, warning tourists of possible terrorist attacks in Acapulco. When I mentioned this, Gabriel said that, yes, some people had advised him not to write about the massacre, but he really did not see where there was a problem: "I don't make trouble for anybody, because everything that I say in the corrido came out on television, and television is international. I don't speak ill of one side, nor for the benefit of the other." Also, in this case, he did not rush to issue the song: he waited until the heat was off, after the official reports had come out. While his corrido tells of the massacre of unarmed peasants by the military, of the military's lies, and of the forced resignation of Governor Figueroa, it has the strengths and weaknesses of Los Tigres' Salinas corridos: it is topical enough to be of interest, but not particularly threatening to the powers that be.

Likewise, Gabriel's corrido of the killings in El Charco is careful to simply give the facts, as seen in the mainstream media. In this case, he made no attempt to go to the scene, and his corrido is careful to hedge its bets, saying only "They say that there are eleven dead and twenty-two arrested / In the village of El Charco, that's where my corrido was born." As he recalls, "It came out on the television about a massacre that happened against the campesinos, because they said there were some *encapuchados** who had a meeting there in the school and someone fingered them and the government fell on them, but the encapuchados had already left—according to the reports, but you know that they hardly tell you the truth in those cases. Anyway, when the government came, there were just ordinary campesinos and the soldiers began to kill people. The people from the town say that the federales began to throw

* The *encapuchados*, or "hooded ones" are the guerrillas, so called because they wear ski masks, or bandannas, to hide their faces.

the bodies in black bags and all of that, to get them out of there, and there were eleven dead and twenty-four arrested, including a woman schoolteacher who they say still hasn't been released—they said that the teachers were the ones who organized the meeting—but there now, what is the truth? Only the government knows, so it's pretty tough."

Gabriel is not a protest singer. He is a professional corridista, and he wrote about the Aguas Blancas and El Charco massacres because they were of interest to his audience. Indeed, he says that pretty much all the bus musicians had their Aguas Blancas songs, though only a few were recorded and those are long since sold out and forgotten. In his business, yesterday's corridos are like yesterday's papers: there is no reason anyone would expect to find a market for them. He does have a few older releases lying around, and as our conversation winds to a close, he sells me a couple of cassettes, the one with "Ciclón Paulina," and an early set of corridos of Guerreran valientes. He invites me to come out the next day and watch them play on the buses, then conducts me to the front gate. At the last moment, clearly worried that he has not fulfilled his duties as a host, he insists that I sit a moment while he sends a son out to buy sodas. As we are drinking, a car drives by with his latest cassette playing loudly through its window.

The next morning, I went to the bus station and caught a bus out to San Marcos, a small town about thirty-five kilometers west of Acapulco, which Gabriel had said was Los Pajaritos' normal starting place. They were not there yet, but it was clearly a popular spot: a small crew consisting of a dueto, a solo guitarist, and an Azteca salesman (this one hawking *aceite de vibora,* snake oil), was already sitting on benches in front of a soft-drink stand. Los Pajaritos showed up shortly before noon, along with another medicine man, and everyone sat around playing songs and exchanging shoptalk—comments about the harm alcohol does to a singer's voice, and about the previous partner of the dueto's blind requinto player, who had been giving him a false accounting of profits.

As buses came in, singers and salesmen went off to work, leaving in the same order in which they had arrived. Finally, it was just Los Pajaritos and me, and we shortly hopped a bus heading for Cuajinicuilapa, the main town of the Afromestizo region. I had expected Los Pajaritos to do what all the other bus musicians did, just play their songs and collect donations, but once again Gabriel impressed me with his business acumen. He started with a formal announcement: "We present, with pleasure, before you all, today and forever, the people's friends, Los Pajaritos del Sur, with my son Lorenzo playing the requinto, and your

humble servant, Gabriel Villanueva." Their show consisted of only three songs, but there was something for everyone, and Gabriel announced each selection as being on their new tape, available "in all of Mexico and the *unión americana*." First came the current corrido, "Tragedia en Chiapas," followed by a romantic bolero, "Maledición," and then, "because the old songs are good too," the Revolutionary-era corrido of General Felipe Angeles.

After the third song, Gabriel and Lorenzo went up the aisle, taking whatever coins people cared to give. Then Gabriel got out a sample cassette and, as Lorenzo passed out copies for the perusal of the customers, went into a parody of the medicine spiel: "There was a woman in Oaxaca last week who had corns on her feet, so bad that she could not walk. She put on this tape and began to dance, and her feet were healed. This cassette is not only musical, but medicinal. In stores, these cost forty pesos, but as a special offer, today only, we are selling them for just twenty pesos." They sold four, an impressive take considering the economic level of the passengers, but when we got off at the next stop, Gabriel told me that a couple of days earlier they had sold ten on one bus, Lorenzo selling the cassette with "Ciclón Paulina" while Gabriel sold the new one.

"Lots of people ask me, with all the records I've made, why I go on playing in the buses, but all of this is promotion and publicity. There's no promotion on the radio, there's no promotion on television—if the company knew how to advance your servant's career, it wouldn't be necessary for me to play on the buses, but the companies don't know how to advance an artist, simple as it may be. So, humbly, I get onto the buses. A lot of friends criticize me, but I'm one of those people who, if someone criticizes me, let them criticize me. I go on struggling; this is how I started, this is how I'll finish. Why not? I'm not ashamed, because every artist who achieves anything, it is because he keeps going and does it. I'm not relying on the company to do things. If they don't give me promotion on the radio, well, I present myself with my sons on the buses. We go around selling the record or cassette, we play it, and, thank God, whoever wants will buy it, and whoever doesn't won't—but tomorrow or the next day they'll go look for it in the store and they buy it there. That's my idea, anyway. And sure, I'm risking my life, because there have already been lots of accidents on the buses, but I go on earning my bread."

All in all, Gabriel has done well and is quite satisfied: "I make my whole living from music. Neither I nor my sons do anything else, because this music business requires time. If one has a job, then it's bet-

ter to forget about music, because if you work then you come home tired and you don't feel like writing a song. But me, I go out like this to play, I see a story, and there's the corrido. If I was in my house and at my job, then I wouldn't know what was happening. That is exactly why I like to travel from town to town: because that's where the stories are happening, and that's how one writes corridos."

GUERRILLA CORRIDOS

The Mountains of Atoyac

Guerrero tiene la fama de tener hombres valientes,
Ahí esta Lucio Cabañas pa' defender a su gente.

(Guerrero has the reputation of having brave men,
Lucio Cabañas is there to defend his people.)
—*"Lucio Cabañas," by José Luis M. Ramírez*
(recorded by Dueto Castillo)

From Acapulco to Atoyac is only some sixty-five kilometers, but it might as well be another world. Atoyac is the center of a lush, tropical farm region in the foothills of the southern sierra, surrounded by plantations of coconuts and coffee. There is a history of marijuana and opium cultivation as well up in the hills, but things have gotten tougher for that trade in the last few years. It is not clear exactly what has changed, but the most common theory is that the guerrilla war has sent so many police and soldiers into the backcountry, and focused so much attention on their actions, that it is difficult to arrange the usual deals. In any

case, the big troconas del año that once cruised the streets are no longer seen. Instead, there is truck upon truck of soldiers. They are everywhere, guarding official buildings or just riding up and down, guns at the ready. In general, they are well behaved, and there have been some efforts to "win hearts and minds," as the theorists of military occupation like to put it, but it is hard not to feel as if one is being watched pretty much all the time.

I had come to Guerrero at an interesting moment. A few months earlier there had been a state election in which the PRI governor, René Juárez Cisneros, was declared winner over the PRD's candidate, Felix Salgado Macedonio, by such a narrow margin that many people cried fraud. That had been the cause of the march from Chilpancingo to Mexico City on which Andrés entertained Salgado by playing "El Mono de Alambre." Now the Guerreran left was out in force, vowing to get the results overturned, and everyone was wondering whether the guerrillas would get involved. If they did, it was likely to be somewhere not far from Atoyac. The town's reputation as a leftist center reaches back to the days when Lucio Cabañas taught in the local elementary school. It was here, on May 18, 1967, that the massacre took place that caused his flight into the hills and the formation of his guerrilla band.

Cabañas has become a legend throughout Mexico, and especially here in the Sierra de Atoyac. There are even some people who insist that his death in 1974 was faked, that he is still alive, a modern King Arthur waiting in Cuba for the appropriate moment to make his return. He was the great corrido hero of the 1970s, celebrated in dozens of songs. The most popular were performed by the Dueto Castillo, a pair of brothers from a rancho in the hills of Tierra Caliente, who sang a whole cycle of corridos about his life and deeds, from "La Masacre de Atoyac" through "Cabañas No Ha Muerto" (Cabañas Is Not Dead), which speaks not of his personal survival but of the living power of his message. The Castillos now live in Mexico City and say that they were never particularly political, that they simply had so much success with their first Cabañas corrido that they continued to record sequels and other topical material. Be that as it may, their tapes still sell well around Atoyac, and their "Masacre en la Costa Grande," telling of the Aguas Blancas massacre, is universally known in the region.

I could not find the Aguas Blancas cassette in the record store in Atoyac. In fact, when I asked the owner for songs about the guerrilla war, all he had to offer me were the Castillos' 1970s-era recordings, their corridos of Cabañas and his contemporary Genaro Vázquez. I had the impression that my question made him a bit nervous, for which I could hardly blame him. In Atoyac, the guerrillas may be just over the

mountain, the counterinsurgency experts are out in force, and any stranger who comes around asking about the rebellion has to be regarded with suspicion. Everyone knows where the United States stands on the issue of leftist uprisings, so it is logical to assume that a gringo asking about guerrillas is a CIA agent.

I could see that I was going to need some local help if I hoped to talk to anyone. Andrés had given me the name of a leftist priest, Padre Máximo Gómez, but when I went by his church I was told that he would not be available till the following day. In the meantime, I wandered aimlessly, enjoying the feeling of being in a country town. It was a pleasant change from Mexico City and Acapulco. Atoyac does not have the timeless, nineteenth-century ambiance that still lingers in much of rural Mexico; there are modern buildings (my hotel was four stories high), and the clothing suggests a familiarity with city styles. Still, it is relatively quiet, and there are touches of an older lifestyle: when I stopped into a tiny restaurant for lunch, I was served hand-pressed tortillas, thick, yellow, and irregularly shaped, something I had never been given even in the Chiapan rain forest.

It was as I was taking a post-luncheon stroll, following one of the main streets out toward the edge of town, that I got lucky. I happened to notice a sign saying "press office," and when I stuck my head in the doorway I made the acquaintance of Victor Cardona, the hill-country correspondent for *La Jornada del Sur. La Jornada* is Mexico's main liberal newspaper, famously highbrow and intellectual, famously accurate, and read by everyone who hopes to get the real story of what is happening in the country. It is where Subcomandante Marcos sends his communiques, and has consistently provided the most thorough reporting on the Guerreran guerrillas, thanks to an intrepid reporter named Maribel Gutiérrez, who has tramped all over the highlands in search of EPR and ERPI connections. *La Jornada del Sur* is a new, southern branch of the paper, published out of Acapulco, and Victor is a young local guy who would be my final source for any story of what was really going on in the region. Whenever I needed help, I found him in his office, drinking endless bottles of Coca-Cola and chatting with whoever happened by.

That first meeting was relatively brief, as he was writing on deadline. Nonetheless, he seemed ready to believe that I was a corrido researcher rather than a government agent, and he gave me my first lead, sending me on a bus over ten kilometers of rough dirt roads through coconut plantations to meet a village schoolteacher, Professor Rubén Ríos. Rubén lived in the Colonia Miranda Fonseca, a straggling collection of small houses strung out along the road. The bus dropped me outside his place, and he was there in the yard, relaxing after his day's work. He

invited me to join him and fished out a book of Guerreran corridos, though all were too old to be very useful to me. He is himself a corridista, writing songs about life in the village, and he has also been a local radio personality, with two shows that were canceled for political reasons. He told me that he had not been trying to oppose the government or get involved in politics, but he did talk about what was happening in the region, and in Atoyac there is no middle ground: either you parrot the government line or you are considered a troublemaker.

Naturally, this state of affairs made him regard nosy outsiders with suspicion, and he started our conversation by sounding me out, asking my views on politics in general and Cuba in particular. My responses seemed to reassure him, though when he went into the house to get us some soft drinks, he told me on his return that his wife had asked if he was sure I was not a CIA agent. I assured him that I completely sympathized with her suspicions, and that anyway I was not looking for any sensitive information. I just wanted to know about corridos of the guerrillas, not about the guerrillas themselves. He said that yes, such songs were being written, but he did not know any. He added that in Atoyac even the corridos of Cabañas and Vázquez are still pretty controversial; in the last couple of years people have begun to sing them openly and you can buy cassettes in the stores, but until recently they were sung only at gatherings of close friends, after first checking to make sure there were no spies around. As for my chances of finding corridistas who would sing to me about the EPR, he thought it would be a while before anyone would trust me that far. I mentioned Padre Máximo, and Rubén said that, yes, he might be an exception, he had been very open about such matters. The padre was a brave man, though also controversial, and for more than just his politics: his church is not exactly a Catholic church, it seems, but something bordering on the evangelical, and no one knows quite what to make of him.

I took the bus back to town and had dinner with Victor, who introduced me to a couple of young norteño players. They did not know any guerrilla corridos—or at least did not care to admit to knowing any—but we spent a pleasant hour playing music, me trying out the bajo sexto and accompanying a couple of tunes on harmonica. If the trick to getting information in Atoyac was going to be hanging out, taking my time, and not pushing things, that was fine with me.

The following morning, I went to see Padre Máximo. His church is a large, white, modern building, on the high ground on the east side of town. He was out somewhere when I arrived, and a tiny old woman who was sitting reading in the courtyard of the rectory eyed me suspiciously and asked my business. When I said I had an appointment, she brusquely

ordered me to a chair, then handed me the outside page of a newspaper. I continued to look around, taking in the surroundings and checking to see if the padre was coming. She ordered me to read the paper she had given me, but this was a bit difficult, as it was only the cover picture, some advertising, and the soccer scores, all from October of 1995.

After a bit, Padre Máximo arrived, greeted me quietly, then gestured for me to follow him into his office. He is a tall man with a full head of neatly combed gray hair, a clipped mustache, and thick-rimmed glasses, gentle and soft-spoken, but with an air of absolute self-possession and authority. After settling me in a chair, he went to another room to find some manuscripts, then seated himself behind his desk and handed me three neatly typed sheets of song lyrics. They were titled "Tragedia de Aguas Blancas" (Tragedy of Aguas Blancas), "Tercer Aniversario de Aguas Blancas" (Third Anniversary of Aguas Blancas), and "Himno al EPR" (Anthem to the EPR). The first began:

> Ya me cansé de llorar por esto que ha sucedido,
> Mandaron a acribillar a indefensos campesinos.
> Bajaban de Atoyaquillo, con otros de Paso Real,
> Y los emboscó el gatillo del gobierno criminal.

> (I have already tired of crying over what has happened,
> They sent orders to shoot down unarmed peasants.
> They came down from Atoyaquillo, with others from Paso Real,
> And were ambushed by the trigger of the criminal government.)

The corrido went on to give the story of the massacre, along with some exhortations that Gabriel Villanueva would not have included:

> Oye hermano campesino, yo te quiero aconsejar,
> Vamos cambiando el destino, ó así nos van a acabar.
> No te fíes de su palabra, aunque usen grandes nombres.
> Hay muchos que no usan faldas, pero tampoco son hombres.

> (Listen, brother campesino, I want to advise you,
> We will change our destiny, or they will finish us off like this.
> Do not trust in their word, although they use fine names.
> There are many who don't wear skirts, but neither are they
> men.)

Frankly, the style reminded me more of Oscar Chávez, José de Molina, and the city protest singers than of a village corridista, but I had

clearly found someone who was not frightened to express his views about the government. "When I say that I had already tired of crying, that is because I cried," Padre Máximo says. "Because to kill more compesinos, who were not guilty of anything, who had nothing, for the government to do this out of pure evil—since I could not bring them to justice, well then, I could do nothing but cry and sing, right? That is all I can do, to give people spirit, and so that this will not be forgotten. The corridos will always be the literary expression of the people, because what one expresses in corridos, or in poetry, is what everyone is feeling, but not everyone wants to or can express it.

"Here, we are in an epoch of struggle. Most of the states of the center and north are in an epoch of diversion, they have already gone beyond the epoch of struggle, of revolutionary struggle, and now they can spend their time amusing themselves. So they write songs that aren't even songs, it's just sound. The old songs were something different, they were true songs, they expressed what was inside people, and the true corridos also expressed a feeling or something profound, a deeply felt way of living, even heroic. But today, no."

Padre Máximo was born into a campesino family in the high country of Jalisco. He began making up songs in early childhood, but could not write them down, as he had never been to school. He did not want to go, and in the end received a formal education only because an older brother kidnapped him to Guadalajara when he was ten and forced him to study. At that point, he raced through the standard curriculum, then became fascinated by philosophy, and finally entered the seminary. He excelled, and was sent to Rome, but he always had trouble with authority, so in the end he was sent off to be a village priest among the Amuzgo Indians on the border between Guerrero and Oaxaca, where he spent nine years. Even there he had difficulties: he was always standing up for the peasants, which annoyed the regional bishop, and finally he was dismissed from his post and spent three months selling sandwiches in a Mexico City park. Then he was called back to Acapulco to teach philosophy.

It is not hard to see what caused problems for the church hierarchy. First of all, Padre Máximo follows his own religious beliefs and does not much care what his official superiors think: "We are trying to arrive at Catholicism, because it is not the same thing to say, 'I'm a Catholic,' and to be a Catholic. There's the rub. This church here is part of the Catholic Diocese of Acapulco, but we don't accept the cock-and-bull stories they give us—sometimes when they get all worried they say that this church isn't theirs, that it's just mine, but when things are going well they say that yes, it is theirs."

Beyond theological disagreements, there is politics, and a way of addressing political issues that is a bit surprising. Sitting in his rectory, surrounded by his books, talking quietly and sketching his words with slow, graceful gestures, Padre Máximo could not be further from the rough manner of Andrés, but at times their lyrical styles seem quite similar. He recites a few lines of another piece he wrote after Aguas Blancas, a parody of a popular song that goes "Vamos llegando a Penjamo," (We are Arriving at Penjamo). His lyric begins:

> *Ya nos pasamos de pénjamos,*
> *Vamos rumbo a la chingada.*
> *El gobierno sigue matando,*
> *Y no hay ni quien le diga nada.*

(Now we have gone beyond [being] *penjamos* [a rather tortured
 play on words, in which *penjamos* will be understood as
 pendejos: asses, suckers],
We are going to hell [literally, to the fucked].
The government keeps on killing,
And there is no one who says anything to it.)

Padre Máximo has taken upon himself the task of disproving that last line. When the EPR made its first public appearance, a circle of masked, armed figures surrounding the crowd that had gathered on the first anniversary of the Aguas Blancas massacre, he was in the midst of delivering a memorial sermon: "When they appeared, everybody threw themselves on the ground—'What's happening?' 'What's going on?'— and I went to greet them and congratulate them. I have always hoped, for years, that the people would have a defender, because the official army defends the government and not the people. It shouldn't be that way, but that's how it is. So afterward the public minister of Acapulco came, because they saw that I was pleased and that I had greeted the encapuchados and I said to him, 'Yes, it made me glad, because now the people have someone to defend them.' And they were dumbfounded. They just stood there looking at me and didn't say a word."

Padre Máximo says that he writes songs whenever he is inspired by an event or a meeting, but only keeps copies if people are asking for them. His "Anthem of the EPR," for example, has been quietly circulated in the region and apparently is now being sung by the guerrillas themselves. It strikes me that this must be rather disturbing to some of his parishioners, and indeed I shortly get an example: At one point in

our conversation, we are interrupted by a man who has come to ask the padre's assistance on behalf of a young friend, a mechanic, a hard worker, who has fallen in debt to some loan sharks. Padre Máximo says that he can find people who will help, and the man thanks him, then asks what I am doing there. When I start to explain, he immediately leaps to the priest's defense: "They were accusing the padre on the radio of aiding the EPR. I called them and told them he was not, that I have known him for forty years. They don't know the difference between helping the poor and supporting the guerrillas." Padre Máximo nods, but the defense is not entirely accurate; his anthem's final verse and chorus are:

> *Todos los mexicanos que aman de veras la patria,*
> *Es tiempo que digan basta con las armas en las manos.*
> *Para que en favor del pueblo por fin se cumpla la ley,*
> *Aquí está el EPR, haber quien puede con él.*

> (All Mexicans who truly love their country,
> It is time to say enough, with arms in our hands.
> So that at last the law is upheld in the people's favor,
> Here is the EPR, just let someone try to take them on.)

These were not the kind of words I would hear from anyone else in Atoyac, but Padre Máximo is not like other people. "When the governor became aware of Aguas Blancas, he sent word to me that I should not talk about what had happened, and I said, 'Yes, I will talk about it.' And then [Governor] Figueroa came to see me, he was seated right here, telling me this, that, and the other. He wanted to come with his bodyguards, but no, here one comes unguarded. One doesn't come like the pope, who goes out among Christians in a bulletproof car—the shame of it! I am going to do my duty, and if they kill me, well, they'll kill me doing my duty. My father taught me that 'only hens and pigs die on the festival eve' (because they are eaten at the festivals); 'men die when God allows it and the cabrones seize their chance.' "

I said my goodbyes to Padre Máximo and walked down toward the south side of town. It had been an interesting interview, though the brave, quiet man in the book-lined rectory was not really the sort of corridista I had come to Atoyac to find. I was looking for a living folk tradition, for singers who were neither professional musicians nor literate community leaders, but just ordinary working people, set apart from their neighbors only by their ability to make up occasional verses. My

next port of call was the Coalición de Ejidos, the coordinating center for the local villages, where Professor Ríos had said I might try asking for a man named Laurentino.

I made my way to the Coalición, a cluster of small buildings in a field behind a large agricultural warehouse, and was directed to the cafeteria. This was a ramshackle structure of wooden boards with big gaps between them letting in the sunlight, furnished with a few folding tables and some rickety benches and chairs. Laurentino was sitting with a group of local farmers, drinking grape juice from paper cups. He was a small, stocky man with a couple of week's stubble on his wide, friendly face, and he was obviously puzzled to have a gringo asking for him. When I told him what I was after, he said he would be back in a few minutes, and left me in the care of a younger, clean-shaven man, who brought me into a side office and lectured me about the importance of the "songs of struggle." A sepia-tinted photo of Rubén Jaramillo hung on the wall behind him.

After about ten minutes, Laurentino returned with a boom box, and we went back to the cafeteria. He had brought a cassette of his music, but said he was not sure if he should play it for me. To my surprise, his hesitancy was sparked not by political concerns but by worries that I might steal his songs. I outlined my intentions as fully as possible: that I might want to use some of his lyrics in my book, that I might play them for other people, but that if anyone was interested in doing something more with them, I would tell them how to get in touch with him—though I could make no promises of recordings or anything like that. He seemed satisfied and bought me a grapefruit soda, then played the cassette. It was miserably recorded, with a cheesy electric organ supplying the accompaniment. The songs were all political: a version of the Dueto Castillo's Aguas Blancas corrido, two corridos in support of PRD candidates, and his corrido of last year's national conference of the UNORCA, a labor organization. His compositions were clearly designed to be sung at meetings, the last one intended as a finale for the UNORCA gathering:

> *Ya nos vamos compañeros, cada quien para su estado.*
> *De seguro lucharán para su campesinado,*
> *Y que el gobierno lo sepa que el pueblo ya está cansado.*

> *Ya con ésta me despido, la UNORCA así se propone,*
> *Solo quiero recordarles a toditas las regiones,*
> *Quiero que sepan a todos, ¡Viva Zapata cabrones!*

255

(Now we are leaving, comrades, each one to his state.
They will certainly keep fighting for their fellow campesinos,
And let the government know that the people are already fed up.

With this I say farewell, the UNORCA has these intentions,
I only want to remind all the regions,
I want everyone to know: Long live Zapata, you bastards!)

Laurentino had some work to finish, but told me to come back in a couple of hours. When I returned, I found him once again in the cafeteria, and he introduced me to another Coalición member, Arturo Ríos Morales. Arturo seemed very interested in my project and said he knew a singer who was exactly what I was looking for. The only thing was, he lived up in the mountains, in a village called El Quemado, and the only way to get there would be to catch the truck leaving Atoyac at 6:30 in the morning. I said that was no problem at all, and he promised to find the corridista and arrange for him to meet me the following day.

We all had another soft drink while Laurentino amused the cafeteria with a tale of travel to the United States. He had been up there only once, to pick crops in Oregon, and he turned the story into a small comic production: He had been smuggled up with sixteen other Mexicans, and they spent two days without eating, hiding in a little shack. Finally a man came and asked which of them spoke English. "I was hiding, I pulled my blanket over my head, because I don't speak any English, and the others were saying I did. The man said, *'You pick strawberries tomorrow?'*" Laurentino acts out a dialogue conducted with the help of sign language:

" *'You.'*

" *'Nosotros.'*

" *'Pick.'*

" *'Peek?* What?' [he mimes the action] '¡O! ¡Pizcar!'

" *'Strawberries.'*

" *'Fresas, ¡cabrón!'*

" *'Tomorrow.'*

" *'¿Mañana?* Oh, sí, sí, *yes!'*

"He went away, and I wasn't sure I had understood him right, but he showed up at six the next morning with a truck, and we climbed in. We were seventeen Mexicans and some American students. They paid us a dollar fifty per flat, and it was great, they paid flat by flat, instantly. Only we still hadn't eaten anything, so they sent me to the boss:

" *'We no happy.'*

" 'Why?'

" *'Eat lunch.'*

"The boss didn't understand, but I made signs to him that we didn't know where to go, what to do, or anything, so back we went into the truck and off to the supermarket. We saw some fried chicken, and we began to eat it, and then the police came and said they were going to take us to jail. The boss intervened, and they showed us that we first had to pay and leave, then we could eat. So we went out and sat on some grass, and back came the police. We were throwing the bones in the grass, as we do here in the country. So we had to clean up the garbage. Life is very difficult there."

Laurentino took me down a path behind the offices, through a stand of coconut palms, some potted mango trees, and a thicket, then over a small creek to the house where he lives. The house belongs to the Coalición, and in return for its use Laurentino and his family tend a small herd of cattle and goats. It was a lovely spot, with hammocks out under the palms, a couple of lazy dogs, and some gray brahma cows chewing at the underbrush. Laurentino brought me a cup of milk, freshly cooled from that morning's milking, and insisted that I play some guitar for his son. As I was playing, a ripe mango thumped down from the tree above me, splattering the guitar. We toweled the guitar off and split the fruit. Laurentino sang bits of another song, one he is composing about the fraud in the governor's election.

Laurentino's work had no exceptional literary merit, but that was not the point: he writes to express the feelings of his comrades in the workers' struggle. He told me that he wrote his first song in 1988, when Cuauhtémoc Cárdenas was cheated out of the Mexican presidency, and had been composing corridos ever since. Though a very different sort of person from Padre Máximo, and less given to long speeches, he said much the same things about his music: "Here in Guerrero, the corrido has been the form through which one makes the society aware of public opinion, and it's the best way to send a message to the region. We have many social fighters who are trying, through music, to tell the world, the state, the town, that we want a change, that we want the liberation of Guerrero."

Walking back to my hotel, I met Victor, the *Jornada* reporter, sitting at a café on the square drinking more Coca-Cola. He introduced me to his companion, Fabio Tapía, an artist and guitar player, who had organized a small local festival of corridistas a couple of years back. Fabio said he could fix me up with lots of singers, and suggested that we meet the next morning, but I explained that I was going up to El Quemado.

257

Victor asked if I knew anyone there, and I told him I had met Arturo. "You're lucky," he said. "That's a very good connection. If he wants to help you, you'll hear some interesting stuff."

I was up at 6:00, making my way through the dark streets to the restaurant where the truck to El Quemado would stop. When it arrived, it was a dented and road-scarred pickup, with wooden benches running along both sides of the truck bed and a tarpaulin roof that could be rolled down if it rained. We filled up with people and headed down to the main road, drove for a half hour in the direction of Acapulco, then turned off on a winding dirt track into the mountains. It was cold, way colder than anywhere else I had been in Mexico, and I had no appropriate clothing. My fellow passengers joked about my chattering teeth and offered me the corners of blankets, but the chill lifted with the sunrise, and I was able to devote my full attention to enjoying the ride. It was beautiful, the sun coming up over the mountains and the lush greenery everywhere, speckled with bright flowers. It never ceases to surprise me how quickly one can get away from any sign of the modern world: within a kilometer or two of the main road, the houses look like something out of the eighteenth century, with fences of woven coconut fronds, curious kids running out to see who is on the truck, and the ubiquitous chickens, pigs, and scrawny village dogs.

In El Quemado, the truck pulled up in the center of town, and there was Arturo, standing on his front porch in nothing but a pair of shorts, wiping the sleep from his eyes. He greeted me cheerfully and brought me through the house into his backyard, where we settled ourselves under a roof of palm thatch. Apparently such an outdoor shelter is called a *toro* around here, and, because it is invisible from outside the house, Arturo's is called El Toro Escondido, the hidden toro. More than simply his backyard, it serves as a local gathering place: there is a big cooler for soft drinks, and even a couple of video games just inside the back door. Arturo sends someone to find the musicians, and a couple of other people drift in to observe the goings-on. I am obviously well outside the normal run of visitors to El Quemado, and everyone is fascinated.

While we wait, Arturo's wife serves us breakfast—*huevos a la mexicana*, beans, and Coca-Cola—and Arturo tells me something of the history of El Quemado: The village became notorious in 1972, during the Cabañas rebellion. There was a battle nearby between the rebels and government troops, and the government decided that El Quemado was a rebel center. The whole area was under military occupation already, with villagers forced to show permits every time they wanted to leave or

enter. Then, on September 5, the order was given for all the heads of families to come to the basketball court in the center of town; anyone who did not show up voluntarily would be brought there by soldiers. They went as ordered, and were bundled en masse into helicopters and taken away. For the next few days, all were beaten and questioned. Some disappeared, some stayed in jail for four years. Finally, the government accepted that they were innocent, made a perfunctory apology, and released those who were still imprisoned. "Since then, no one in El Quemado has ever voted for the PRI, and we are known all over this region for our support of the PRD and the Coalición."

By this time, the singer has arrived, a slim, young-looking man named Tadeo, along with a friend whom he introduces as his guitarist (they have no guitar, but Arturo had warned me to bring mine). Tadeo is obviously nervous and uncomfortable. He answers my questions in small clusters of monosyllables, staying as close to "yes" and "no" as he can. He says that he originally sang tropical music, that he had a little band that played cumbias and boleros at dances, but now he is writing only corridos, because of all that is happening here in the mountains. He has a cassette with a couple of his more recent efforts and is happy to play it for me, but very reluctant to let me record the songs for my own use. "Many people have asked, and I have always said no. The reporters, everyone . . ." As with Laurentino, his worry is not that the politics will get him in trouble—in fact, he says that the soldiers encouraged him to write about a recent skirmish with the guerrillas—but that his compositions will get stolen. Other musicians have advised him never to let anyone record him, that people will take his songs and put their own name on them and make lots of money, and he will get nothing. Luckily for me, Arturo and the other men are on my side. They want word of El Quemado to reach the outside world, and reassure him that this is only for a book. I add that I will not make copies for anyone else and will not play my recording for any professional musicians. In the end, I think he only gives in because I am foreign: if I were Mexican, as he sees it, I would be more likely to have friends in the music industry and steal his work, but since I am going to el otro lado there is not so much danger.

The first corrido he plays me is of a battle that took place just down the road, in May 1997:

Vinieron dos helicópteros, y también dos avionetas,
La cosa era terrible, al oír las metralletas.
También se veía espantoso, al mirar tantas tanquetas

(Two helicopters came, and also two airplanes,
It was a terrible thing, to hear the machine guns.
It also looked frightening, to see so many tanks.)

Arturo explains that the skirmish took place in a small hamlet called Guanábano, right near the site of the Cabañas shoot-out, and everyone in El Quemado panicked, fearing a replay of 1972. Fortunately, a group of PRD deputies and reporters arrived, and the army was careful to be low-key, reassuring the locals that it was only there to protect them. Tadeo's corrido is thirteen verses long, giving a local view of the incident. It is a simple recounting of facts, with no hint of support for either side. Judging by his lyrics, he is representing a common peasant perception of any war: while many people will support the rebels, and some will support the government, the majority are usually frightened and apolitical, simply wishing that all the armed combatants would leave them alone.

Tadeo has another corrido of the same confrontation, this one much shorter and drawing the parallel to 1972. Once again, he describes the battle as simply a frightening experience, but the memory of what happened to the men of El Quemado affects him more personally, and this song is by far the strongest I heard from him. It starts by saying that now there have been two fights in Guanábano, then tells of the persecution that followed the earlier battle. Since Tadeo is in his thirties, he was a child in 1972, a fact he acknowledges in his lyric:

> Yo no recuerdo muy bien, pero así me contaron,
> Que en el pueblo de El Quemado había muchos soldados
> Que hicieron un asemblea, y ahí los agarraron . . .
>
> A todos los esposaron, y los echaron en avión,
> Llevándolos a Acapulco, y fueron puesto en prisión.
>
> Madres y niños lloraban a verse abandonado,
> Algunos padres volvieron, y otros no regresaron . . .

(I don't remember very well, but this is how they told it to me,
That in the town of El Quemado there were many soldiers
Who called an assembly, and seized them there . . .

They handcuffed all of them and threw them into a plane,
Taking them to Acapulco, and they were put in prison.

Mothers and children cried to see themselves abandoned
Some fathers returned, and others didn't come back . . .)

He recounts the details of the captivity, then ends with a salute to the local legend and martyr:

Lucio Cabañas murió, su nombre quedó en la historia.
Luchó con los campesinos, que Dios lo tenga en la gloria.
La gente mucho lo aclama, lo llevan en la memoria.

(Lucio Cabañas died, his name remained in history.
He fought with the campesinos, may God have him in glory.
The people acclaim him, they keep him in their memory.)

The listeners nod their agreement, and one urges Tadeo to sing the song he wrote about Arturo. Arturo had not mentioned this to me, but apparently he was arrested, held, and tortured for eight days in 1998. When I express interest, he goes into the house and fetches me a photocopy of a long story Victor Cardona wrote for *La Jornada del Sur.* The police picked him up in Acapulco and tried to force him to confess to kidnappings, assaults, and murders, and to implicate other community leaders in guerrilla activities. They beat him and used a favorite Mexican torture method, forcing soda water mixed with chili pepper up his nose, then held his head underwater until he passed out. When he came to, they held a pistol to his body, saying they were going to kill him. Finally, he confessed to various crimes and agreed to lead the police to where his "accomplices" were holding a kidnap victim. This made them bring him up to El Quemado, where people could see that he was a prisoner. Then, as he was being driven to the police headquarters in Atoyac, he managed to shout to some children outside a school, and they told a teacher, who contacted the PRD. A crowd surrounded the police station, and finally he was freed.

With his guitarist strumming a simple accompaniment, Tadeo sings his corrido of Arturo's imprisonment. It is one of his lesser efforts, only six verses long, but it gives a neat précis of the events, and a heartfelt testimonial to Arturo's good reputation:

¿Como pudo a ser posible, que lo hayan agarrado,
Si es un hombre honesto, en el pueblo muy nombrado?

(How could it be possible, that they seized him,
If he is an honest man, well known in the town?)

By now, Tadeo seems more relaxed. He is smiling, revealing a line of brown, cheaply repaired teeth, and he asks me to play guitar for him on a couple more songs. Someone has ordered up a few bottles of beer, and it is turning into a small party. After a while, Arturo asks if I would care for a tour of El Quemado: "I will show you the tourist district, the hotels, the cabarets, the casino. . . ." He is joking, but in fact, considering that it is an unpaved hill town of subsistence farmers who grow a little coffee, mangos, and livestock for sale in Atoyac, it is pretty well developed: There is electricity, and drinking water is piped down from a holding tank up on the hillside. There is full schooling, from kindergarten through high school, and two basketball courts, one of which Arturo grandly points out as "the Zócalo." As we walk, we pick up a small crowd, and everyone laughs at Arturo's tour-guide act. He is enjoying himself, pointing to outlying houses and giving them the names of elegant suburbs. Finally we sit down by the lower basketball court, and he engages me in a discussion of world politics, talking of Cuba and Bosnia while the other men listen respectfully. He invites me to stay, saying that I am welcome to spend as long as I like, and I promise to come back sometime in the future. For now, though, it is time to catch the truck on its way back down. It has gone on up to Cerro Prieto, the one remaining town before the road runs out, and now is making its return trip to Atoyac.

The trip back down was uneventful, but I was feeling great. This was a different sort of adventure: going up into the mountains, meeting these people, and hearing songs that had never been recorded, that were not written for the commercial market, but were real folk corridos designed to keep local history alive. I could sneer at my own romanticism—these people's lives are hard, and I had just heard Arturo's story of arrest and torture—and yet I could not help being excited to get into the guerrilla area, hear these tales of gun battles, and collect the unknown music of the outback (albeit an outback accessible by a two-hour bus ride). Plus, I liked Arturo immensely. His intelligence and humor, blended with his absolute commitment to El Quemado, made me want to spend far more time in his company, and I was not just being polite when I said I wanted to come back.

As the truck pulled into Atoyac, I heard a whistle and someone shouting my name. It was Fabio, the guy I had met the night before, and he took me all over town on a fruitless search for corridistas—he kept saying he could introduce me to sixty songwriters if I wanted, but we could not find any of them. Instead, he sang me a corrido he had composed, and pumped me for information on how to become a writer. He was full of plans, offering to arrange a party on the weekend and prom-

ising that he could bring lots of singers, but I was pretty dubious. Anyway, it had been a long day and I was exhausted. Eventually I extricated myself as politely as possible and headed off to bed.

Assuming that Fabio's fabled hordes of local singers would not manifest themselves, I had one more visit to make in the area. Laurentino had told me of a man in San Jerónimo, down on the main road, who he said had an interesting Aguas Blancas song. He told me the man's real name, but said that he was better known by his nickname, El Toshiro. Laurentino did not know his address, but suggested I ask at the bus station in San Jerónimo, and I finally found a taxi driver who said he could take me to him. He drove me through the center and down a narrow side street, then pointed out a husky, shirtless figure standing in a blacksmith shop and said that was my man. I went up to the smith and asked if he was El Toshiro, the corridista. He said no, he was not a singer. I then used the real name Laurentino had told me, and he said yes, that was him. I said Laurentino had sent me and had said that he had written some very fine songs, including one about Aguas Blancas. He admitted as much, though not with any friendliness, so I paid the taxi driver and followed him into the high-ceilinged front room of the house next door, where he left me sitting on a long couch under two crossed African swords.

El Toshiro was not pleased to see me: his songs are political, they could be dangerous for him, he knows nothing about me, I could steal his songs, they are strictly local and could not interest anyone else. He did bring out a cassette, though, and played it for me on his boom box. It had two songs, both backed by expert guitarists and showing him to be the strongest singer I had found on the Costa Grande. One was about Aguas Blancas, the other about a recent election in Atoyac, and they were as unusual as Laurentino had promised. Rather than attacking the PRI or the national government, they attacked the local PRD: the Aguas Blancas corrido accused María de la Luz Nuñez Ramos, a PRD politician who was Atoyac's municipal president at the time, of informing Governor Figueroa that the truckload of protesters would be coming to Atoyac that day:

¿Como supo María? ¿Quién le dió la información?
Los muertos son 17, Atoyaquilla cayó.
La política de María no tiene comparación.

(How did Maria know? Who gave her the information?
There are seventeen dead, Atoyaquilla fell.
Maria's politics is without comparison.)

The other song had the same target, accusing Nuñez and her allies of throwing a municipal election to the PRI by refusing to get behind the Coalición's candidate, a man named Zohelio, whom Laurentino had introduced me to at our first meeting. As I listened to the cassette, El Toshiro sat beside me, watching my face, never smiling. After hearing both songs, I carefully explained what I was doing and why. He asked whom else I had spoken with. Laurentino's name did not seem to cut much ice, but he was slightly more interested when I mentioned Tadeo. I played him an excerpt of the corrido about the skirmish in Guanábano, and he asked where I had recorded it. I said that I had been in El Quemado, in Arturo's house. Arturo's name clearly meant something, and he agreed to let me interview him. Stone-faced as ever, he sat next to me on the couch and talked quietly, seriously, carefully weighing every phrase:

"I have been a person of the left for many years, since the days of the Communist Party. I have followed the leftist line, up to the formation of the PRD, but we didn't enter into that." He distrusts the PRD, because many of its candidates are people who previously ran on the PRI ticket. To him, they are not genuine leftists, but simply profiteering politicians trying to catch the wave of popular discontent: "The PRD already has lost interest in the people, it is interested in winning. They want to get into power, whatever it takes, and that's what gave rise to those corridos."

El Toshiro says that his songs come to him as they are needed: "They rise in the steam, when we are making a campaign. One is involved in the movement, and one notices many things and begins to have ideas, and asking around, one gets to understand where things are at. And the songs make people aware. Sometimes people will pay more attention to a song than to a speech, because a song at least is cheerful, and they become aware of the situation. Speeches, well, they are already burnt out. They are always the same, pure demagoguery. And the corridos, more than anything, tell about past events that keep living on, and sometimes people become aware through them. I sing in meetings of the left, for the Partido del Trabajo [Labor Party], the PT, and just in gatherings of friends. Someone says, 'Come on, sing that corrido.' The only bad part is that sometimes one can suffer reprisals—I haven't, but the municipal president, for one, was not pleased with her corrido."

By now, El Toshiro has warmed a little. He lets me record his Aguas Blancas song, asking only that I not use his real name when I write about it. He seems pleased that his ideas might be circulated, that people even in another country might hear what he has to say. When I leave, he

shakes my hand, his grasp firm and friendly. For an instant, he even smiles.

The next morning, I shouldered my pack and headed out of town, stopping off on the way to have breakfast with Laurentino. When I arrived, he was not there, but his daughter said that I would find him and his wife somewhere over the ridge, herding the goats. I stumbled through thickets, jumped a stream, and finally caught sight of him, sitting comfortably on a small hillock. He was pleased to hear that everything had gone so well, and assured me that I would return to Atoyac. He knew I wanted to get an early start, but he still had to mind the goats for a while longer, and he had a favor to ask: he wanted me to go back to his house and record some blues guitar on a cassette for his son, so that the boy could learn some other styles. I was more than willing, so the son and I sat out under the mango tree, and I exchanged some blues licks for an elementary lesson in how to strum a huapango.

After an hour or so, Laurentino arrived, and his wife cooked some scrambled eggs and ham, which we washed down with the usual Coca-Cola. Laurentino was in a good mood: "I had been getting tired of writing," he said, "but your visit has invigorated me." I had the impression that most of the local singers felt that way. They are used to thinking that no one but their friends cares about their work, and it was inspiring to have an outsider show interest. We played a few more songs together, the son and I trying to match Laurentino's quirky sense of time. It was all very peaceful and pleasant, and I could not help thinking that this was an odd setting in which to be singing corridos of the guerrillas and the leftist struggle. Though, looked at another way, it could not have been more natural. This is exactly what the politics, the marches, even the guerrilla war are all about: the chance to live what I might consider a normal life, to be able to relax and play music under a mango tree, in front of a solid house, surrounded by goats and cows. Right now, the situation in Guerrero is in flux. The PRI's power is diminishing, the Coalición and its fellow organizations are growing daily, and Laurentino has reason to be optimistic. There is a long way to go still, but, for this morning at least, he is feeling good: "The struggle is a very pretty thing," he said, smiling broadly and strumming his guitar. "I like it very much."

NARCOCORRIDOS MOVE SOUTH

Apatzingán

Conocí a una joven bella de una familia rica.
Para casarme con ella, me volví contrabandista.
Necesitaba dinero para ser capitalista.

(I met a beautiful young woman from a rich family.
In order to marry her, I became a smuggler.
I needed money to be a capitalist.)

—"Penal y Juzgado," recorded by
Los Contrabandistas Michoacanos

"Hey, *amigo*! ¡Pssst! Yes, you, *paisano*. Come closer, I want to
chat with you about the bad things you think of the *raza*, of
my Michoacano countrymen. No, don't believe it. The news
reports are pure foolishness. They are people like you and me:
they are humble, hardworking, they work themselves to the
bone in order to get ahead. *Cristaleros* [people working with
crystal methamphetamines] from Michoacán, they have been
known to be both good or bad. Therefore, I feel *chingón*, I feel
fucking great to be a paisano of all the heavy *raza*. ¡*Cristaleros
michoacanos!*"

Introduction to "Cristaleros Michoacanos,"
as recorded by Raza Obrera

I was getting near the end of my corrido trail. I had visited most of the main regions and met most of the main composers. There were only two loose ends remaining: Michoacán, the southern capital of the drug traffic, and Teodoro Bello, the most successful composer of all. Michoacán is neighbor to Guerrero, so it was the obvious next stop. I hitched along the coast road, spent the night in Lázaro Cárdenas, then crossed the coastal range and made it up to Uruapan. In a way, Michoacán was even more unknown to me than Guerrero. There, I had at least been given a couple of names and been told what area was likely to be most fruitful. In Michoacán, my only guide was the corrido tapes themselves.

Judging by recorded corridos, Michoacán is second only to Sinaloa as Mexico's most famous drug area. However, this may have less to do with the actual amount of traffic (Sonora and Durango are certainly in the running) than with the huge number of Michoacanos who have settled in California. The record industry has recognized their buying power, and several of the most popular California corrido groups devote virtually all their lyrics to traffickers from Michoacán's Tierra Caliente (Hot Land). The most famous group of this sort is Los Originales de San Juan, who, while not themselves Michoacanos, have recorded album after album of songs that name-check towns like Apatzingán, Aguililla, and Nueva Italia, none of which rates even an index entry in the tourist guidebooks. Then there are the bands of genuine Michoacanos, such as Raza Obrera and Los Hermanos Jiménez, who play the area's bizarre new fusion sound: a blend of norteño accordion rhythms with the tinkling arpeggios of the *harpa grande,* the large harp that has long been popular in the local folk tradition.

I had been through Michoacán before, but only to the more typical tourist destinations—Paracho, Mexico's guitar-making center; Morelia, one of the great old university towns; and Uruapan, known as a center for Indian handicrafts. I also had some background on the state's older corrido tradition. Were it not for the drug traffic, Michoacán's corrido world would probably be quite similar to Guerrero's: old-fashioned in form, favoring guitars over accordions, and full of long epics about local events. Some experts have even argued that the corrido's origins are here, rather than in the north, that it is an accident of the printing and recording industry that Michoacán does not have a reputation comparable to Tamaulipas's or Nueva León's.

Alvaro Ochoa Serrano, at the university in Zamora, had showed me page after page of broadsheets he had acquired from an old corridista

who was the village chronicler of Jiquilpan, near Uruapan. Ochoa recalled seeing this man, Teodocio Cervantes Granados, in 1980, riding alongside a pretty young girl on a float in a parade for the Mexican Communist Party. He let me copy a sheet with two compositions, one a political piece presumably recited at the parade, and the other written about the event:

> *Cuando llegamos al estadio, yo no llegué avergonzado.*
> *Me sentí bien contento, iba una jovencita por un lado.*
> *Ella estaba jovencita, ya ven que yo soy un señor,*
> *Parece que nos pusimos de acuerdo vestir del mismo color.*

> (When we arrived at the stadium, I did not arrive ashamed.
> I felt thoroughly content, a young lady rode at my side.
> She was young, you can see that I am an older gentleman,
> It seemed that we had agreed to wear the same color.)

Cervantes did not sing his corridos. A village poet rather than a musician, he recited his lyrics at all important events in Jiquilpan. This tradition seems to have ended with him, however, and virtually all the Michoacanos I met regarded corridos as a northern import, newly arrived with the opium and methamphetamine business. Unlike Sinaloa, with its smuggling trade reaching back into the vague past, Michoacan only saw the arrival of big drug money in the 1970s, when marijuana became a prime export crop, and the business really took off in the 1990s. Giving me a lift to Morelia, a young friend of Ochoa's had chatted cheerfully about the drug boom. He said that at cockfights in Apatzingán, the narcos will bet a million pesos on a match. The local kids know that there is no way they will ever be able to earn that kind of money in any legal profession, so many of them turn to drug production. "You go into the *pueblitos,* and the houses look ordinary, but every one has a satellite dish outside, and if you go inside, the front room is full of Louis XIV furniture, with a huge television. This year, the fashionable car is a Silverado, but the narcos replace the stock motor with a hopped-up, European engine that costs thirteen thousand dollars." I was struck by the fact that even the price of the motor was now part of the local folklore.

In Uruapan, I settled down to buy corrido tapes and figure out my next move. There was a crafts fair going on, and foreign tourists crowded the main square, looking at traditional pottery, cloth, and miscellaneous indigenous tchotchkes. Meanwhile, I combed the farmers'

market for cassettes of the regional corrido groups—Los Hermanos Jiménez, Los Hermanos Gaspar, Alma de Apatzingán, Raza Obrera—and also Salvador Chávez and El Chaparrito de Oro, the reigning masters of an archaic style called the *balona*. In some ways, the situation was reminiscent of Sinaloa: the music stores are filled with local product, with hundreds of tapes I had seen nowhere else in Mexico. The difference is that the Michoacán labels have fewer connections in LA, and their music often includes traditional folk instruments like harp and violin, so they have a harder time breaking into the international market. There are exceptions—Raza Obrera is based in southern California and records some of the most extreme narcocorridos in the business—but most of the local cassettes are genuinely local and trace the regional history of the drug traffic as it has grown and evolved over the last couple of decades.

In Michoacán, the corrido has also had some competition from the balona, a story-song genre unique to the Tierra Caliente. Balonas are almost always comic, and all have exactly the same melody and structure, with a long, drawn-out "Ayyyy" beginning each phrase, and an invariable fiddle break separating the verses. Like the corrido, the balona was once regarded as a vanishing tradition but has received a boost from the drug trade, though its popularity is purely regional. The first *narcobalona* I heard chronicled the drop in marijuana prices that, combined with the pressures of government enforcement, threatened a narco depression in the late 1980s or early 1990s. Called "Mariguaneros en Crisis" (Marijuana People in Crisis) it was a very popular song in the region and gives a good sense of the local satirical tradition:

> Ay, encontrabas por la calle carros con vidrios oscuros,
> Ay, ahora ya eso a puso duro, hay muchos en la prisión,
> Otros mas en el panteón,
> Ay, uno que otro que anda libre ya no traen relojes finos,
> Ay, se les acabó ese don, andan cortando limón,
> Y otros vendiendo pepinos.

> (Ay, you used to see cars in the street with smoked-glass
> windows,
> Ay, now things have gotten hard, many people are in prison,
> Still others in the cemetery,
> Ay, one or another who is still free, now they don't wear fine
> watches,

Ay, that luck is over for them, they are harvesting lemons,
And others selling cucumbers.)

Fortunately for the traffickers, there was a solution at hand. If marijuana prices were down, other crops were still doing fine, and the northern drug lords were happy to expand their turf. The story is told in "Rayando Bolas" (Scoring Pods),* a harp-accompanied corrido recorded by Los Hermanos Gaspar:

> *Un compadre que yo tengo sinaloense,*
> *El me trajo la semilla de amapola,*
> *Me dió clases por sembrarla y abonarla,*
> *Que bonito siento andar rayando bolas.*

> (A compadre of mine from Sinaloa,
> He brought me poppy seeds,
> He gave me classes in planting and fertilizing them
> How good I feel, as I go along scoring pods.)

In recent years, marijuana and opium have been joined by yet another product: Michoacán is a major production center for *cristal,* crystal methamphetamine, the high-powered form of "speed" that is becoming a major problem in both urban and rural areas throughout much of the United States. There is a new wave of cristalero corridos, though all the ones I found were recorded by California-based groups. Singers in the Tierra Caliente have not yet caught up with the trend and indeed seem rather uncomfortable with it. I do not think the problem is so much that the drug is worse, but that the process is more foreign: corridos of mountain planters have a familiar feel, but it would seem strange to sing ballads of people slaving away in basement chemical factories. A *mariguanero* is a regular guy, the farmer over the hill who turned to illicit crops when he could not make ends meet with melons or cotton. As Alma de Apatzingán sings in the corrido "Sembradores del Cerro" (Mountain Planters): *"Antes allí en los ranchitos había maíz para la marrana,/Ahora ni maíz siembran, puritita mariguana."* (Before, there in the little ranchos, there was corn to feed the pigs, / Now they don't even

* To harvest opium, one waits until the petals fall from the poppies and the pods swell and turn dark green, then one scores shallow grooves in the side of each ripe pod. The sap oozes out, and the farmer collects this gum and dries it, after which it can be smoked, eaten, or refined into heroin or morphine.

plant corn, only marijuana.) In this world, a cristalero is as out of place as a computer programmer.

Nonetheless, it seems to have been the opium and crystal trade that brought the new wave of corridos. Maybe it is because the marijuana growers were too countrified and isolated, uninterested in norteño rhythms and modern trends, or maybe it is just a matter of changing fashion. Either way, when I got down to Apatzingán I found that everyone considered corridos to be a new, northern import. No one remembered Michoacanos singing them before the beginning of the decade, and they only got really popular around 1996 or 1997. Now, though, their dominance is absolute. Every business with a sound system, and all the big cars circling the plaza, were blaring norteño accordion, and all the musicians were following the money. Indeed, what struck me most strongly about the local scene was its blatant commercialism: where the northern composers consider corridos their roots and heritage, Juan Pérez Morfín of Alma de Apatzingán said that he personally preferred folkloric harp music, but had to sing corridos to keep up with the times. Meanwhile, José María "Chema" Garibay explained to me that he had always played and enjoyed *"la música gabacha"*—"Hotel California," "Theme from Arthur," and the hits of Chicago and Iron Butterfly—but now corridos were all he could sell.

Chema wears his hair long, in a modified 1970s pompadour, sports bright red suspenders, and plays drums and electronic keyboards in a group called Arácnida (Arachnid). If he lived in Mexico City or Monterrey, he would still be making his living playing rock covers, and earning decent money at nightclubs and weddings, but in Apatzingán there is hardly any market left for that music. As he explains the situation, his regular customers used to be the hacienda owners and businesspeople who sent their kids to good schools in the cities and had connections in the United States, and they followed the latest fashions in rock and pop. Now the big local money comes from drugs, and the customers are folks who grew up on the ranchos. "They are people who started with nothing, and songs in English just make them uncomfortable, make them feel stupid. Plus, the corridos talk about their world, their lives."

Chema has a small office a few blocks from Apatzingán's main square, where he works as a musical agent, setting customers up with anything from a brass band to a harp group to a disco deejay. He also writes songs on commission: at weddings, he specializes in composing corridos for the bride and groom (largely a matter of inserting names and personal details into a prerecorded template), and he has a regular stream of young traffickers coming to him in search of immortality. On

271

the whole, Chema is amused by his new clientele, and he laughs as he recalls a typical encounter with a young trafficker:

"I said to him, 'You have to give me your biography, tell me what I will write it about. For example, how many people have you killed?'

" 'No, well, I haven't killed anybody.'

" '¡Hujule! Fine, well, how many times have you been kidnapped? Or how many times have they stolen your shipments?'

" 'Ahh!' he says. 'That, yes. They once stole a shipment from me, they played a dirty trick. . . .'

" 'Okay, that's not much. So what else is there?'

" 'No, well, I've had a lot of cars.'

" 'What makes were the cars?' I was taking all the facts down at that moment, taking down his biography, to have a basis to write the corrido.

" 'No, well, a such-and-such, a such-and-which, a so-and-so. . . . Before I went up north, I always dreamed of having a new car, it was such an obsession for me that I would go to the agencies where they sold the new cars; I would sit there and watch them, the way someone sits and watches girls. I dreamed of cars, and I said to myself, "One day I'm going to buy them." '

" 'Okay, but what else have you done? Stuff that's relevant, that has some importance?'

" 'No, well, I went up north and up there I met a *pocha* [Chicana] named Erica, and this *pochita* helped me to get involved in the drug traffic. And I met other people, they also gave me some dough, they were very straight with me—that is, within the crooked stuff we were doing, well, they were straight, *machina*, as we we say in the scene—and one day I came back to my town and I began buying trucks.'

" 'Okay. Now leave me to it.' So those were all the facts, and I had to flesh them out with my own ideas, and in the end the corrido came out sounding like this:

> *Cinco carretas del año pasaron ya por mis manos:*
> *Una Ram Runner bonita, y un convertible Camaro,*
> *Lobo roja y la Cheyenne, y una verde Silverado.*
>
> *Antes soñaba con ellas, mirándolas en la agencia,*
> *Las miraba tan bonitas, que les hice una promesa,*
> *"Las voy a comprar a todas cuando deje la pobreza."*
>
> *Tuve que irme pa'l norte, ahí me encontré a mi reina,*
> *Erica ella se llama y es mi pochita paceña.*
> *Esa bonita chorreada me ayudó a ganar la feria . . .*

(Five brand-new cars have already passed through my hands:
A pretty Ram Runner, and a Camaro convertible,
A red Lobo, and the Cheyenne, and a green Silverado.

Before, I dreamed of them, seeing them in the agency,
They looked so pretty that I made them a promise:
"I am going to buy all of you when I stop being poor."

I had to leave for the north, that's where I met my queen,
Erica is her name, and she is my pochita from La Paz,
That pretty *chorreada** helped me earn some change . . .)

"And then I said to him, 'Look, I am going to write it as if you had
owned all of the cars at the same time.'
" 'But I didn't have them at the same time.' "
Chema's voice rises in irritation at the cluelessness of his client
" 'We're going to put it in the corrido that you had them at the same
time, *¡las hijas de la pala,*† *hombre!*' So then, that verse goes like this:

*El lunes ando en la Lobo, el martes en la Cheyenne,
Miércoles la Silverado, y en la Ram Runner el jueves,
Y el convertible Camaro, domingo, sábado y viernes.*

(On Monday, I drive the Lobo, on Tuesday, the Cheyenne,
Wednesday, the Silverado, and the Ram Runner on Thursday,
And the Camaro convertible Sunday, Saturday, and Friday.)

Chema was the first of half-a-dozen corridistas I met in the Tierra
Caliente, and what struck me most about them was their variety of styles
and backgrounds: Juan Pérez Morfín, a harpist whose group, Alma de
Apatzingán, has recently turned from folkloric music to corrido albums,
was a country character who seemed uncomfortable with the whole
process of being interviewed and doubly uncomfortable at being asked
about narco. Rafael Álvarez Jiménez was the PRI congressman for
Apatzingán, a politician through and through, tall and handsome, look-
ing me dead in the eye and giving me a firm handshake while assuring
me that the narcocorrido boom was over. (That interview kept being
interrupted by constituents coming up to say hello, lobby for the repeal

* *Chorreada* is a nickname for a wife or girlfriend, popularized in Pedro Infante's movies.

† A rather obscure exclamation: literally, "daughters of the shovel!"

of the much-hated daylight savings time, show me pictures of dancing horses, or hand me old cassettes of Alma de Apatzingán to distract me from all those nasty corridos.) Salvador Magaña was a keyboard player and record producer, with a surprisingly up-to-date studio where he can synthesize anything from a banda sinaloense to a full mariachi. He introduced me to another corridista, a young man with a ponytail named Leonardo Avalos, who lives most of the year in California and composes corridos of the rural *cristero* rebellion of the 1920s, family legends, and anything but narco themes (with the result that none of his compositions has been recorded). Los Hermanos Jiménez were nine brothers from a small rancho between Apatzingán and Nueva Italia who have the most popular band in Michoacán, a harp and electric keyboard ensemble that has recorded corrido albums for various international labels. Then there was Rafael Álvarez Sánchez, but I will get to him later.

I had plenty of time to acquaint myself with the local scene because it was Holy Week and I had decided to stay in Apatzingán until the Easter holidays were over. The only problem was that I had almost no energy. The Tierra Caliente was living up to its name, and every time I left my air-conditioned room, the heat would settle on me like a leaden mass. Even thinking was an effort, and I developed an automatic trajectory: down one block, across the main square, and into the shady courtyard of the Grand Hotel, where a fountain burbled and beer arrived in iced glasses.

There was really not much else to do. Certainly no one has ever called Apatzingán scenic. Due to Holy Week, there was a tourist information table set out on one side of the plaza in front of the city hall, with two teenagers manning it, but I never saw another tourist, either foreign or Mexican. When I stopped by, they were almost comically eager to help me, but corridos were outside their purview. I leafed through the booklets on their table, trying to seem encouraging, but found none that even mentioned Apatzingán. When I pointed this out, the young woman smiled sadly and said, "Yes, we are far from the sight of God."

The town plaza is a pleasant splash of greenery, suggesting what the area could look like with decent irrigation, but the rest of the town, and most of the surrounding valley, is gray and dusty. The buildings are squat, square cement boxes, built in the ugly, efficient style of the 1930s or 1940s. That date would make sense, as it is roughtly the period when Michoacán's favorite son, Lázaro Cárdenas, was president of Mexico. Cárdenas's populist administration is warmly remembered by poor people throughout the country, and in Michoacán he is a sort of secu-

lar deity. Not that Apatzingán seems particularly poor: I saw only one beggar outside the cathedral, everyone is nicely dressed, and the combination of relatives in the United States and agricultural production of all kinds seems to keep the money flowing. It is just monotonous in the extreme.

Still, it was a pretty good place to spend Holy Week. As I passed the plaza on Wednesday, I heard what sounded like firecrackers, and went to investigate. I found a group of teenage boys wearing skirts and hooded masks and cracking long whips as they solicited donations from passersby. According to the newspaper, they were the *"judas,"* as in Judas Iscariot, but according to the couple of people I asked, they were *"judíos,"* Jews, which makes more historical sense. Either way, they were harbingers of the theatrical event of the year, a full passion play, which was set to begin on Thursday afternoon. The schedule was posted on a large placard at the front of the plaza:

THE EXPERIMENTAL THEATER GROUP OF APATZINGAN
PRESENTS
The Supreme Work
"THE MARTYR OF GOLGOTHA"

Thursday, at 7:30 P.M., we would see the First Sanhedrin, the Last Supper, the Second Sanhedrin, the Prayer in the Orchard and Capture, and the Tribunal of Annas. Friday, at 3:30, would be the Tribunal of Caiaphas, the First Tribunal of Pilate, the Tribunal of Herod, the Second Tribunal of Pilate, then "3 Falls and Crucifixion."

I caught some of Thursday night's show, but Friday was clearly the big day. I was at the plaza promptly at 3:30 and spent the next few hours alternately searching for a hint of shade and nipping out to catch bits of the tribunals, full of pity for the actors in their thick wigs and robes. Around me, families in their Sunday best huddled under the trees and bought ices from the peddlers in front of the cathedral. Finally, Pilate washed his hands and Jesus was led off to be executed. The crowd surged alongside as he was led up a side street toward the lone hill on the east side of town. I had expected the judas to go to work on him, but as it turned out, there were other floggers specially assigned that job. The judas were there for crowd control, keeping the hurrying masses from interfering with the action by swinging their whips in wide arcs. As far as I could see, no one was hit, but it certainly kept us all in our places.

I had not taken note of the hill before (climbing even a block in that

heat had not been tempting), but it was perfectly suited to serve as Golgotha. It rose out of the dry plain, and a cobbled street climbed to a flat area where two crosses had already been erected. As Christ reached this plateau, dragging his cross and surrounded by his persecutors, pageantry gave way to surrealism. All the regional media wanted full coverage, so the crucifixion was crowded by jostling reporters with pads, microphones, and a TV camera, blocking the protagonists from view. We could hear the dialogue, booming over a speaker system, but nothing was visible until the cross rose into view, with Christ in his loincloth and crown of thorns. A staff was held up to his lips, bearing a sponge dipped in water and vinegar, then another bearing a microphone so we could all hear his last words, accompanied by a third with the microphone of the local television news. I could not help thinking that this was exactly how the crucifixion would happen today, and was curious to see how they would manage the ending. The performance was over, but Christ was still on the cross, and the crowd showed no sign of leaving as long as there was something to watch. I need not have worried. Joseph of Arimathea showed up with an assistant and lowered the body to the ground, then a couple of paramedics appeared with a stretcher, carried Jesus to an ambulance, and took off down the hill with the siren wailing.

I stayed up on the hillside, sitting on a wall and watching the sun set over Apatzingán. I had enjoyed the passion play, and especially the ending. It seemed like a symbol of everything that fascinated me about this trip. The great attraction of my corrido ramblings was the way they put me at the intersection of the old and new Mexico, and the surrealism of the pageant was just one more in a flood of odd and interesting anachronisms: medieval ballads about cocaine-filled 747s, harp and violin bands with accordions and electric rhythm sections, mountain peasants cooking crystal meth to earn money to buy fancy cameras to take pictures of themselves alongside dancing horses to send to relatives working in Silicon Valley.

The impression of worlds colliding was even stronger the next day as I watched a rehearsal of Los Hermanos Jiménez (the Jiménez Brothers). We were out at their family place, a cluster of houses on the Rancho El Ceñidor, a tiny patch of parched earth on the road to Nueva Italia that has the dubious distinction of being one of the handful of towns mentioned in "Cristaleros Michoacanos." Almost all the Jiménezes still live here, except during the months when they are out on tour. I rode out with Rodolfo, the one brother who lives in town, and as we drove through the tiny village center, we saw a small group of mummers performing in someone's front yard. One was in woman's clothes, another

was dressed as a bull, and they were performing a sort of folkdance-cum-bullfight to music blaring from a boom box. Rodolfo explained that this was an ancient tradition on Holy Saturday, and that even five or six years ago they would have had a live band and the cross-dresser would have been much more fancily done up. "The folklore is dying," he said, sounding genuinely troubled.

The Jiménez brothers themselves started out as a folkloric group, playing traditional, acoustic music for tourists in the coastal resort hotels. They managed to get a contract with RCA, but soon realized that they would have to modernize if they ever wanted to get beyond the regional circuit. In 1989, they added keyboards and electric bass, stuck pickups on the harp, and soon were known throughout the Tierra Caliente as "Los Reyes de los Corridos" (the Corrido Kings). Their current repertoire is made up of numbers like "Cosechas Michoacanos," the testament of a poor farmer who has gotten rich in the drug traffic and traded in his yoke of oxen for a pretty new SUV, and they have had the region's biggest corrido hit, "Corrido de Joselo." I had been hearing this song ever since my arrival in Apatzingán, and it puzzled me: though everyone said it was the most popular corrido in years, I had never heard of it outside the region, and I could not see what made it special—it was just a straightforward ballad of a guy who dies in a gunfight, with no particularly distinctive touches. When I asked the Jiménezes about this, they explained that the song's success stemmed from Joselo's own popularity: he had been very well liked, always giving parties and buying everybody drinks. Of course, he was a trafficker—or as they put it, "He made his living doing what we don't talk about."

The band's rehearsal space was the second floor of one of the brothers' houses. It was only half built, an open cement shell that will someday double the house's size, and meanwhile is the only place on the rancho where one can hope for a cooling breeze. The yard outside was full of citrus and coconut trees, and kids were sent out every once in a while to cut open a coconut or grapefruit and bring it to me or the players. The brothers were hard at work on a new arrangement of a traditional song: "It's not exactly a corrido," Rodolfo told me. "But it's a lot like a corrido; I don't know exactly what it is." As soon as they started playing, I was able to help out. It was a historic ancestor of the corrido form, the medieval Spanish *romance* of "Delgadina." The lyric tells of a princess trapped in an incestuous relationship with her evil father, and it is to Latin American folklore what "Barbara Allen" is to the folklore of the Anglophone north: the most popular European ballad to survive in the tradition. "Oh, sure," another brother said. "That makes sense; I

should have thought of it. All that about the princess—there were never any princesses in Mexico."

It was a bit eerie to hear the ancient verses, only slightly changed in their centuries of travel, sung in sweet harmony over the Jiménezes' full-throttle dance-band accompaniment:

> Papacito de mi vida, tu castigo estoy sufriendo,
> Dame un vaso de agua, que de sed estoy muriendo. . . .
> Cuando le llevaron el agua, Delgadina estaba muerta
> Tenía sus brazos cruzados, tenía su boquita abierta.
> La cama de Delgadina de ángeles esta rodeada,
> La cama del rey su padre de demonios apretada.

(Father of my life, I am suffering your punishment,
Give me a glass of water, for I am dying of thirst. . . .
When they brought her the water, Delgadina was dead,
Her arms were crossed, her little mouth was open.
The bed of Delgadina is circled by angels;
The bed of the king her father is harried by demons.)

Rodolfo sat on a table, reading the lyrics out of a notebook; Jorge sat behind him, driving the rhythm with his bass guitar; Rafael was in the corner, behind a full drum kit; Ignacio strummed guitar; Pancho carried the lead lines on his harp, his left hand plucking a regular bass pattern as his right fluttered across the treble strings; and José Luis, the one nonrelative, thumped out a sort of oompah accompaniment on his Korg keyboard. As they played, a chicken pecked among the electric cords, and kids poked their heads in to listen, looking as if they were magically suspended outside the window openings. The frame of another, half-finished harp lay in a corner, next to a portrait of the Virgin of Guadalupe. The rest of the floor was crowded with amps and instrument cases.

After the rehearsal, we drove across to the house of another brother, and Rodolfo explained that their family had been the first settlers of El Ceñidor. Their grandparents had ridden with Lázaro Cárdenas, and when he expropriated some of the big haciendas for communal ejidos they were among the earliest beneficiaries. The streets of the rancho are rutted dirt tracks, lined with houses built of bricks and gray, weathered boards, with tin roofs. The Jiménezes' houses look like all the others, except for the tour bus and equipment truck, and a big satellite dish outside Jorge's place. Some women and children are sitting under a

278

tree, watching a western on television. The stove is outside as well, under the eaves of the house; no one would want any extra heat inside. We lounge in the shade, on plastic chairs and hammocks, sucking scraped ice flavored with homemade tamarind preserves. A small naked boy, newly walking, totters from adult to adult, sucking on a piece of coconut. Cows and pigs are penned off to one side, chickens peck optimistically around the house, a dog sleeps under a chair, and a cat under a car. Even the trees are droopy, gray, and tired-looking. As for the Jiménezes, they are all big men (at one point, Pancho bounces his ample belly with both hands and declares it *"pura alma,"* pure soul), and they have no interest in wasted motion.

We languidly chat about corridos, but no one is saying anything very inspiring. The only person with any energy is Benjamín, the nonplaying brother, who is visiting from his home in Baja California. He says that there have been enough corridos about killings and dead men, that it is time to write about the living: "Really, it's true, there are lots of people who start doing illegal stuff and killing over nothing, just because they want to be made into a corrido. So I think they should write corridos about the people who are still alive, so that people will admire them. If someone does something good, let them write a corrido about him, so people will say, 'Look, that's the man from the corrido, he did that in such-and-such a place, that's the gentleman.' "

The other brothers nod, but they are unlikely to follow Benjamín's advice. As Rodolfo remarks, "Unfortunately, people like bloody stories, red-colored. These days the nota roja is what they want. If you write a corrido of a person who did a good deed, who leaves his mark on a community, on a town, a hospital, a sanitorium, that won't catch on. His family will buy the records, but other people won't. They only want songs with blood and bullets, where three or four people get killed—now, that's a good corrido."

"And in the corrido it can say six or eight people instead of three or four," I add, just to show I am paying attention.

The brothers smile and nod: "Yes, you add a little more so that it will sell better, that's right."

As we drive back to town, Rodolfo returns briefly to the conversation. He points out that, along with all the corridos of narcos and valientes they have also recorded "El Rey de la Tierra Caliente" (The King of the Tierra Caliente), a tribute to Rafael Álvarez Sánchez, and it is a perfect example of what Benjamín was advocating: a paean to a humanitarian and champion of the people, who happens also to be a dashing cowboy and irresistible lover:

279

Es hombre de buena ley, tiene leyenda en su fama.
Conquista flores hermosas del sureste hasta Tijuana,
Por Michoacán y Jalisco, y en la Unión Americana . . .

Un defensor de los pobres, de Apatzingán muy querido,
El no se sabe rajar, defiende a los campesinos,
Valiente rifa su vida, así pasó su destino.

(He is an upstanding man, his fame is that of legend,
He conquers lovely flowers from the southeast to Tijuana,
In Michoacán and Jalisco, and in the United States . . .

A defender of the poor, much beloved by Apatzingán,
He doesn't know how to back down, he defends the campesinos,
He bravely risks his life, this was his destiny.)

Not only is Don Rafael a fine example of the better sort of corrido hero, he is also a composer, and on my list of people to interview. I had been putting it off, thinking I already had enough local figures, but finding that he is a famous protagonist as well as a corridista shifts the balance. "Oh yes," Rodolfo agrees, "you can't leave without talking to him. He's a character." Rodolfo goes on to elaborate: Don Rafael is not only the father of the PRI congressman I had met, but of a reputed two hundred other children. He is also one of the foremost living writers of balonas, an old-style corridista, and a local legend.

He also turned out to be a very busy man, but I finally reached him on Sunday evening, and he said he would be at home Monday afternoon. I decided it was worth staying the extra day, and called him after lunch on Monday. He said he had reserved the whole afternoon for me, and began giving me directions to his house, then cut himself short, saying, "No, you are a guest in my country. I will come for you." A half hour later, he drove up in a pickup full of people, a local family visiting from South Bend, Indiana, whom he was giving a lift to the telegraph office. After dropping them off, we drove back to his house, easily identifiable by the large tiles spelling out his name over the front gate. There was a young woman waiting outside, and he paused a moment to speak with her, motioning me into the courtyard.

The courtyard was painted like a historical hall in a museum. On the right wall, reaching to the top of the second story, was a sort of family tree of houses: at the top was his grandparents' house, labeled "Birthplace of Rafael Álvarez Sánchez," then his parents' house, and then the

various houses he owned up until 1965, when he moved here. Below was a small text titled "Thoughts of Rafael Álvarez Sánchez," a plea for all people to live together in peace and harmony. On the front wall of the house were murals of the signing of the constitution and other historical events, while the left wall had portraits of Zapata and Villa.

Don Rafael joined me, explaining that the woman outside was one of his daughters, though not one he was familiar with. Seizing the opening, I say I have heard of his reputation, and ask how many children he in fact has. "Eighty-six," he replies, pausing for effect before adding, "registered." He smiles and shakes his head at the error of men's ways. "Of course, there are many more."

Inside the house, we walk down a hallway with three dormitory-style bedrooms on either side, into an inner court where a young woman is doing laundry surrounded by a crowd of chickens. The walls are covered with photographs: Don Rafael leading his red-clad troop of four hundred horsemen; on his prizewinning racehorse, which has its own corrido; in full charro regalia (multiple times); with Lázaro Cárdenas (three photos) and every other Mexican president up through Salinas, "the one who robbed the country of so many millions." He waits patiently as I look at all the pictures, commenting, "All the important people who have come to Apatzingán have been in this house. The only one here who is not important is I."

Don Rafael is indeed a character. He is some seventy years old, tall, straight, clear of eye, with a full head of hair and a mustache that shows only a sprinkling of gray. We go up an outdoor staircase and settle on the balcony, Don Rafael seated behind a wide wooden desk. He is obviously gratified to be interviewed and hints that he would be more than happy to dictate a full autobiography, complete with "intimate details," if someone were available to turn it into a book. I occasionally manage to get in a question, but for most of the next two hours he talks almost without a pause, the words rushing and tripping over one another and often rendered all but incomprehensible to me by his thick country accent.

While I am charmed and amused by his flamboyant egotism, and even more by his ornate pretensions of modesty, my amusement is balanced by a genuine appreciation of his work. Don Rafael has written some of the most popular balonas of the last few decades. They include the first balona I ever heard, "La Balona de los Norteños," a satire of the flood of Michoacanos going up north to get rich. It begins, "Ay, I will not leave my homeland for the United States / Ay, better to be a dog in my land than to be the gringos' cat," and goes on to make fun of the

emigrants who come back all puffed up with their success. In reality, the song says, they have just been washing dishes, "something they never did in their own house."

Don Rafael has also composed the best of the narcobalonas, "El Narcotraficante." Similar in attitude to "Los Norteños," it is the musical revenge of a traditionalist under siege from the new wave of flashy drug lords:

> Ay, mi camioneta es Cheyenne y mi carro Gran Marquis,
> Ay, fumo droga y me la inyecta, y me empolvo hasta las narices. . . .
> Ay, con corridos de la mafia me siento príncipe y rey.
> Ay, por dondequiera que yo ando, con el carro derrapando,
> Me dicen, "Ahí va ese güey."
> Ay, cinco dias yo ando libre, y seis años en el bote.
> Ay, todos me mientan mi madre, en la cárcel y en la calle,
> Me odian peor que a un tecolote.

> (Ay, my pickup is a Cheyenne and my car a Grand Marquis,
> Ay, I smoke drugs and I shoot up, and I powder myself up to
> the nostrils . . .
> Ay, with corridos of the mafia I feel like a prince and king.
> Ay, wherever I go, with the car skidding,
> They say, "There goes that bastard."
> Ay, five days I go free, and six years in the can.
> Ay, everybody insults my mother, in the jail and in the street,
> They hate me worse than an owl.)

As for corridos, he has written dozens, maybe hundreds, but these have had less circulation. He has no interest in current trends and is still writing about horse races and local murders, avoiding the drug world completely. He hands me typed lyrics for song after song, saying to take them with me: "If you find anyone who wants to record them, tell them to go ahead." This is unusual for a songwriter, most of whom jealously guard their work, fearing that someone will steal it and make a fortune. Don Rafael, by contrast, says he has many famous compositions recorded, but will not tell me their names because he gave them away to other writers and does not want to interfere with their business.

Frankly, few of the songs he shows me seem likely to be stolen by a major star. Many are tributes to small neighboring towns, and there is also a song about the monarch butterfly sanctuary in eastern Michoacán. There is a corrido of Lázaro Cárdenas, and two of Bill Clin-

ton and Monica Lewinsky, a subject that for obvious reasons is dear to his heart. He has got the story a bit mixed up, casting Monica as an evil blackmailer who entrapped the president in order to make her fortune, but the thrust of both songs is humorous and shows an open admiration for Clinton's amatory prowess. Don Rafael clearly feels that he has found a kindred spirit, ending "El Presidente Mujeriego" (The Womanizing President) with the lines, *"En los Estados Unidos le dicen Juan Charrasqueado / A Clinton por sus amores ya parece Mexicano."* (In the United States they call him Juan Charrasqueado* / Clinton, for his loves, already seems Mexican.)

The corridos that Don Rafael treasures most fondly, however, are not his own compositions, but the "sixty-six or sixty-seven" corridos that other composers have written about him. Over the course of the afternoon he sings a half dozen of them all the way through, and bits of several more, always commenting that he had no idea that the composer intended to write about him, or shaking his head and murmuring, "I am embarrassed even to hear these corridos." The songs themselves are a mixed bag, some primitive and others expertly rhymed. Most paint him as a brave cowboy and defender of the poor—without being able to separate fact from fiction, I gather that in his youth he was a partisan of the Cardenistas and helped to expropriate the holdings of rich *hacendados* and turn them over to small farmers. He is clearly not a poor man himself—he spoke of his plantations of cotton, lemons, and melons, the house which, "speaking in gringo terms," would be worth some one hundred thousand dollars, plus land, horses, and trucks—but likes to see himself cast as the protector of the little guys, the roughriders, and the old-fashioned cowboys. Some of the corridos speak specifically of his deeds combatting the rich landowners, but most portray him as a dashing charro, good friend, and indefatigable lover. One particularly traditional number tells of a race between two horses, "El Alazán y el Tordillo," the sorrel and the dapple gray. The gray is an established winner, the favorite of the hacendados, while the sorrel is an unknown backed only by our hero and his fellow cowboys. Naturally, the unknown wins, to the disgust of the *ricos: "Metralletas y pistolas a los charros apuntaron / Todos con pistola en mano, los Álvarez se cobraron."* (Machine guns and pistols were aimed at the cowboys / All with their pistols in hand, the Álvarezes collected their winnings.)

* Juan Charrasqueado was the picaresque hero of one of the most popular commercial corridos of the 1940s.

Then there is "El Rey de la Tierra Caliente," a song so fulsome that it would make any normal man purple with embarrassment. When I ask Don Rafael what he thinks of it, his response is typical: "It is very fine, I like it very much, because it speaks of the struggle for the lands, and it is true. Now, when I became aware of the title, I tried to change it. I said for them to put another title, something like 'Ranchero de Apatzingán,' or whatever. But the composer said, 'No, that's how it is.' He said, 'There has been no one else here who has fought for Tierra Caliente as you have. You have a very special standing. Who has been as great a charro as you? Who has defended the traditions as you have? Who has defended the *cuerudos*—which is the only mounted organization of rural defenders, who parade in Mexico City, in Morelia—as you have? Who has fought so hard for the farmers? Who has done more in the cinema here'—I've made something like sixteen movies—'than you have done? How many towns have been formed because of your efforts? So, you have to recognize that you are the King of Tierra Caliente. Where is there another?'

"Okay, I shut my trap. I simply said to him, 'Thou sayest,' as Jesus Christ did."

There was really no more to add. Don Rafael gave me a ride back to the center, and I settled down in my quiet courtyard, listened to the soothing splash of the fountain, and drank three beers, the bare minimum necessary for adequate contemplation of an encounter with a genuine corrido hero.

EL JEFE DE JEFES

Teodoro Bello

Soy el jefe de jefes, señores, me respetan a todos niveles . . .

(I am the boss of bosses, gentlemen, I am respected at
all levels . . .)

—*"Jefe de Jefes," by Teodoro Bello*

"After Enrique left, I met Teodoro. I already knew how he
composed, I already knew that I had a fighting cock there, that
he is versatile, and with time he has proved it. The same work
that [Enrique Franco and Paulino Vargas] did between the two
of them, he is doing by himself."

—*Jorge Hernández*

Before writing anything relevant about Teodoro Bello, I must first
explain how he almost got me killed. It was during my first month in
Mexico, when I was planning my journey into the corrido world and was
interviewed by a newspaper in Mazatlán. The reporter did a good job,
but was baffled by some of my pronunciations: in her story, Paulino Var-
gas came out as Apolinar Vargas, and Teodoro Bello as Pedro Rogelio.
This, naturally, troubled me. I had noticed that people often made me
repeat Teodoro's name two or three times, but I could not see what was
wrong with the way I said it. I received a copy of the newspaper article

while in Guadalajara, and was riding on a bus around 11:00 that night, mulling over the problem. "Teodoro Bello ... Teodoro Bello ... Teodoro Bello ... ," I murmured, trying to figure out what I was doing wrong.

Suddenly the man seated in front of me turned, looking very upset, then quickly left his seat and moved to the front of the bus. Momentarily mystified, I realized that, while I was contemplating my pronunciation, the man in front of me was only aware that he was on a nearly empty bus, late at night, and the guy behind him was murmuring, over and over, *"Te adoro, bello"*—"I love you, handsome." Fortunately, he was a peaceable type and smaller than I am, or who knows what might have happened.

None of which has anything to do with the man who is currently Mexico's most successful songwriter. Teodoro made his name with corridos and has gone on to write romantic songs, comic numbers, hymns, anything and everything. His work is recorded by the full spectrum of ranchera artists, from Los Tigres and their norteño compatriots to solo stars like Vicente and Alejandro Fernández. According to some reports, he is not only the most successful composer on the current scene, but the biggest seller in Mexican history, outstripping such hallowed names as José Alfredo Jiménez and the film composer Augustín Lara.

I had tried to reach Teodoro earlier in my journey, but he is frequently on the road, touring with his own band or doing whatever business is necessary for a popular composer. Now I found him at home in Cuernavaca, and he invited me to come and hear the story of his life.

Teodoro was born on a mountain rancho in Mexico state, in the mid-1950s, but most of his early years were spent on the streets of Mexico City. His family was desperately poor, and it was not an easy childhood: "I shined shoes, I sold chewing gum and candy, I ran errands, and I couldn't go to school. But I always said that someday I had to be a performer, because I loved to watch the performers on television, the singers."

When he was fourteen, he began to make up songs and sing them for his friends. "When they heard the songs, people said that they were pretty, and asked who had taught them to me. I told them, 'I wrote them,' and they didn't believe me. The songs seemed too good to them, and they said, 'No, no, that can't be.' They asked me, 'What year are you in school?'

" 'No, I didn't go to school.'

" 'Do you know how to read?'

" 'No.'

" 'Do you know how to write?'

" 'No.'

" 'Then, how did you write that song?'

" 'No, well, thinking. . . .' "

The positive reaction inspired Teodoro to try to sell some of his material: "I started going to the record companies, saying, 'Tell the artistic director that Don Teodoro Bello—or Teodorito Bello, or plain Teodoro Bello—is here. I am a composer who comes from the provinces, and I want to see if he will give me a chance, to show him my pieces. . . .'

"So, 'Come back tomorrow.' 'Come back another day.' I spent three months knocking on doors, and one day a gentleman, José Vaca Flores, a great composer and also a great maestro, listened to me. He says to me, 'Oh, muchacho you are a writer, it's sensational! Are the songs really yours?'

" *'Sí, señor.'* "

Vaca Flores was impressed, but still uncertain that the teenager in front of him could really have composed the songs he was hearing. In a story that recalls Hank Williams's first meeting with the publisher Fred Rose, he set the boy a test: "He says, 'Okay, I'm going to see if it's true that you're a composer. Look, I want you to write me a song called "Corazón de Tejas" [Heart of Texas], and another song called "El Último Rodeo" [The Last Rodeo].' He says, 'I'll expect you back here in fifteen days.' And he went out to eat. I stayed there, and at four in the afternoon he comes back, and he says to me, 'What gives, muchacho? You're still here?'

"I say to him, 'The thing is, you said for me to come in fifteen days, and the truth is that I don't have the money to pay my fare.'

"He says, 'What, you want me to lend you . . . ?'

" 'No, *señor*. I already have the songs, right now. I wrote them during the time you went out to eat.'

" 'What!? Let's see, sing them for me.' "

Teodoro sang the two songs, and Vaca Flores was astonished. He became Teodoro's mentor, arranging for "El Corazón de Tejas" to be recorded by Los Alegres de Terán, and "El Último Rodeo" by a new group called La Tropa de Michoacán. Neither was a hit, but Teodoro now had the confidence to continue writing, and songs seemed to pour out of him. He was not making a fortune, but he was getting recorded, and the little he earned was already beyond anything his family had imagined. His breakthrough only came in the 1990s, though, when he became the main writer for Los Tigres del Norte.

Teodoro's relationship with Los Tigres began almost by accident. Once again, the catalyst was Pepe Cabrera, who brought the band a cassette of narcocorridos recorded by a minor Sinaloan norteño group, which included "El Avión de la Muerte" (The Airplane of Death), Teodoro's saga of the arrest, torture, and spectacular suicide of a trafficker named Manuel Atilano. The police had been transporting Atilano to Sinaloa by plane when he seized control of the flight, denounced his captors over the radio, then forced them to crash near Badiraguato. The corrido was striking for its graphic details: *"De la nave reportó todo lo que le habían hecho. / Que con pinzas machacaron partes nobles de su cuerpo."* (From the plane he reported all that they had done to him. / That with pliers they crushed the "noble parts" of his body.) The song ended with a heroic touch: Atilano had planned to crash the plane into the police barracks, but changed his mind when he realized that there was a school yard next door, and instead crashed into a deserted hillside. The whole incident was recorded by the air traffic controllers and published in the press, and Teodoro says that he simply put the news reports into verse and set them to a melody.

Los Tigres' recording did not list a composer's name, since there had been no songwriting credits on Cabrera's tape, but it attracted a fair bit of attention and inspired Teodoro to approach the band with more songs. When Los Tigres played in Cuernavaca, he made his way to the band bus and presented Jorge with a cassette of several corridos. At the time, Enrique Franco was still Los Tigres' producer and principal songwriter, and they were not really looking for new corridistas, but Jorge kept the young composer in mind. When Enrique and Los Tigres parted ways, Jorge gave Teodoro a call, and the band's next single was Teodoro's "Pacas de a Kilo" (One-Kilo Packets), their most famous and influential corrido since "Camelia la Tejana" and "La Banda del Carro Rojo," twenty years earlier.

As we talk, Teodoro is sitting on a bed in his big new house in Cuernavaca, the mountain town that has been favored as a summer resort by the Mexican aristocracy since the days of the Aztecs. The house is still largely unfurnished, but it is modern and impressive, and there is a lush yard of orange trees outside, behind the high walls that guard all such elite retreats. It is a lovely spot, but Teodoro seems a bit out of place here. He has the money, but this is not his world. He yells out the window for one of his assistants to bring us oranges, with the sharp air of a man accustomed to giving orders, then tosses his peels on the bedroom floor and spits the seeds and pulp in a corner.

Teodoro is wearing a white felt cowboy hat, which he tells me cost

two hundred dollars ("It's cheap, but I also have some that cost five hundred dollars and three hundred dollars"), a white cowboy shirt, dress slacks, and alligator-skin boots. His belt has a Texas-sized gold buckle with a capital T on it, and his right hand has a large gold ring in the shape of a horse's head, and a gold bracelet with BELLO spelled out in diamonds. We had met two hours earlier, at the *palenque,* or cockfighting pit, in the middle of the Cuernavaca fairgrounds. Tonight, the fair's cockfighting and concert season begins, and Teodoro will perform with his band, Los Misioneros del Norte. I had waited while he did the sound check, singing over a radio microphone as the band played, and walking the circuit of the round tent to see how it sounded, then telling the engineer what adjustments were needed. Afterward he had brought me here to the unfurnished mansion, explaining that his home was full of family and we would be interrupted all the time. I ask him when he expects to have this place fixed up and to move in here, and he shakes his head dubiously: "No, I just bought this, but I think I'll stay in the old house. It's plainer, but I'm comfortable there."

More than any other composer I have met, at least any of the successful ones, Teodoro seems still to be haunted by the poverty and struggles of his childhood. There is a diffidence about him, an eagerness to please, to be liked. When he sings me a new song, he looks genuinely concerned with my opinion, as if it might not be good enough for me, and he keeps tossing bits of English into our conversation and remarking how much he likes my language. When the talk turns to his past work, or the corrido world, though, he sounds supremely assured and serious. Without the bravado of a Paulino Vargas or a Julián Garza, he also has none of their self-deprecating humor. He knows his songs are classics, and that is his great pride.

After learning the basics of his life, I ask him about "Pacas de a Kilo," the song that made Los Tigres once again the trendsetters of the narcocorrido world. The song defined a new style, setting the stage for "Mis Tres Animales" and hundreds of other compositions, including Teodoro's own "Jefe de Jefes." These are not corridos in the traditional sense, in that they tell no story, nor are they exactly corridos de amistad, since they are not about a named client. They are pure exercises in narco braggadocio, delivered in the first person and featuring involved wordplay, insider codes, and double entendres. Fans exult in their ability to figure out the real meanings of lines like "how cute my cows look with their little rams' tails," and trade clues as to which drug lord might best match the narrator. There are few classics in this style because, without a story line, it is hard to come up with a hook that will distinguish

one song from another. In the case of "Pacas de a Kilo," both Jorge and Teodoro insist that what made the song unique was its language: its innovative phrasing and self-consciously literary vocabulary captured the attention of an audience tired of the usual corrido clichés. Jorge says that he actually suggested that Teodoro look in the dictionary for new words, and while Teodoro says that the idea was his own, he agrees about the process.

"Listen," he says, then sings me the song's first verse as an example. His voice is light but pleasant, and I find myself paying more attention to the words than I ever have while listening to Los Tigres' infectiously pumping rhythms:

> *Me gusta andar por la sierra, me crié entre los matorrales.*
> *Ahi aprendí a hacer las cuentas, nada más contando costales.*
> *Me gusta burlar las redes que tienen los federales.*
>
> *Muy pegadito a la sierra tengo un rancho ganadero,*
> *Ganado sin garrapatas, que llevo pa'l extranjero,*
> *Qué chulas se ven mis vacas, con colitas de borrego.*

(I like to roam the mountains, I was raised among the thickets.
There I learned to keep accounts, just by counting sackloads.
I enjoy dodging the nets of the federales.

Right up against the mountains I have a livestock ranch,
Livestock without ticks, which I take abroad,
How cute my cows look, with little rams' tails.)

"That seemed strange to people," Teodoro says, his voice rising to emphasize his point. "It's a word game, a modern corrido, contemporary, which people had never come across. What's new about it is that those words were not used in corridos. For example, they didn't use *'costales,'* [sacks, or sackloads], *'matorrales'* [thickets]: there are lots of corridos that say 'they brought the stuff down from the mountains,' 'they killed him,' and that sort of thing, but none like this. And there are words that I disguise: for example, 'how cute my cows look with little rams' tails' is a disguise for the clump of marijuana, which looks like a ram's tail. So this is a way of not making it obvious for people—to say 'how pretty the marijuana plants look' is more drastic than saying, 'how cute my cows look with little rams' tails.' So that's what made the corrido hit, the oddity of it, and it's a prototype. Then it says, *'Los pinos me*

dan la sombra, mi rancho pacas de a kilo' (The pines give me shade; my ranch, one-kilo packets), and a lot of people say, 'Which pines?' Well, the pines of the countryside. But they get the morbo, the other idea— that he is being protected by great powers. But no, this corrido was born in the country, really, it's the pine trees of the countryside."

It is typical of Teodoro that he should point out the cleverness with which his song implies the drug world's connections to the highest authorities (Los Pinos is the Mexican White House), then deny any intent to make that connection. Throughout our conversation, he is always careful to insist, on the one hand, that all of his corridos are drawn from real life, and, on the other, that they do not have any meanings that might get him in trouble. In the final verse of "Pacas de a Kilo," the protagonist sings a despedida to all the main drug-growing states of the north, winding up, "If you want to meet me, I can be found around Juárez," but Teodoro resists any attempt to link the song to a member of the Juárez cartel—someone like Amado Carrillo, for instance. He makes a similar denial in the case of "Jefe de Jefes," which some newspaper commentators have cited as a Carrillo corrido because of a line that says "I know how to fly to the heights." In this case, I tend to believe him, since that line follows another that says "I navigate below the water," and the whole song reads like a pointedly generic portrait of an all-powerful *capo di tutti capi*. In this case, though, Teodoro's denials go even further, since he argues that the song is not even about a mafioso:

" 'Jefe de Jefes' was born from the idea that people should be great. You, as a writer, shouldn't be the assistant to the writer, you should be the boss of bosses, and 'Jefe de Jefes' is for the writer, the announcer, for the fireman, for the chewing-gum seller, the shoemaker: 'I'm the boss of bosses, gentlemen, I am respected at all levels'—I am speaking of *all* the levels. You can say, 'That guy makes sandwiches that are sensational, he's the boss of bosses in sandwich making.' "

Likewise, when Jorge Hernández sings "Jefe de Jefes," it is in part a personal declaration, a way of telling all the newer corrido groups that Los Tigres still rule. Nonetheless, there is plenty that stamps the protagonist as someone more sinister than a singer or a sandwich maker. As the first verse says: *"Mi nombre y mi fotografía nunca van a mirar en papeles / Porque a mí el periodista me quiere, y si no mi amistad se la pierde."* (My name and my photograph will never be seen in the papers / Because the newspaperman likes me, and otherwise he will lose my friendship.) The tone is threatening as well as laudatory, and no one but Teodoro and Jorge (who echoes Teodoro's exegesis) has ever argued that it is about anyone but a shadowy drug king.

The odd thing about Teodoro's protestations in this case is that he is completely straightforward about other narcocorridos. "I don't like drugs, thank God, but I sympathize with the business," he says. "And it's my business to say that the federales seized a truckload, or that they stole a shipment, or that so-and-so died. Often, people will chat with me, they say, 'You know, yesterday they put my cousin in prison because he was carrying ten kilos of coke.' So I like the plot, I'm interested by the way they arrested him, how it happened, and I write the corrido. For myself, I like writing true stories about what happened."

As an example, Teodoro sings a few bars of his "Corrido de Amado Carrillo," a hit for Los Traileros del Norte, pointing out that his lyric specifically mentions the televised reports of Carrillo's death, "so you can see how what I'm doing matches the press reports. There are many corridos that are fantastic, many people write fictious corridos about odd things, strange, that were never published. But I can sing you various corridos of mine, and you'll know if it really happened."

Teodoro begins to sing "Quién Tiene la Culpa" (Who Bears the Guilt), his finest corrido of a major news event. Another Traileros hit, it recounts the killing of Cardinal Posadas, the archbishop of Guadalajara, who was shot to death in the Guadalajara airport in 1993. The official story is that this killing was accidental, that the cardinal simply had the misfortune to be caught in crossfire between the rival gunmen of Chapo Guzmán and the Arellano Felix brothers (leaders, respectively, of the Sinaloa and Tijuana cartels). As with most such events, though, there are numerous rumors and complex theories involving a vanished briefcase, hints that the cardinal or his entourage were involved in trafficking, and questions of how the shooters managed to escape from such a well-policed area. Teodoro tells the story as a member of the public, giving the published facts—a machine gun roared, the cardinal died, the press said he was mistaken for Chapo Guzmán, there were seven dead, the killers escaped in a commercial airliner—then adds a chorus that shows his special genius:

> ¿Quién tiene la culpa, él que compra o él que vende?
> La droga es un cuento de nunca acabar.
> Mueren policías, mueren traficantes,
> ¿Quién sabe esta guerra, quién la va a ganar?
> Unos traen por kilos y por toneladas,
> Y yo no he podido ni un pase cargar.

> (Who bears the guilt, the buyer or the seller?
> Drugs are a never-ending tale.

Policemen die, traffickers die,
Who knows in this war, who will win?
Some carry it by kilos and by tons,
And I haven't been able to manage even a puff.)

Teodoro's work covers an astonishing musical spectrum, and once he was established as Los Tigres' main composer, he proved that he was good for more than corridos. They had big hits with a series of his love songs—"La Mesa del Rincón" (The Corner Table), "Agua Salada" (Salt Water), and "Nos Estorbó la Ropa" (Our Clothes Were in the Way), which went on to be an even bigger success for the ranchera cowboy star Vicente Fernández—and for a while their corrido singles tended to come from Francisco Quintero, Jesse Armenta, or another writer, Enrique Valencia.

Album tracks were another story: in the late 1990s, each of Los Tigres' CDs had from eight to twelve of Teodoro's songs on it, and these included some of his most interesting and innovative corridos. *Unidos Para Siempre,* for example, is most famous for "El Circo" and Teodoro's romantic "No Pude Enamorarme Mas" (I Could Not Be More in Love), but also included two of his best crime ballads, "Los Tres de Zacatecas" (The Three from Zacatecas) and "El Reportero" (The Reporter). "El Reportero" was Teodoro's attempt to show that he could handle the sort of social commentary that had been Enrique Franco's specialty: it celebrated a crusading reporter and ended with a strong condemnation of the officials who amass fortunes speculating with the Mexican economy, then store their wealth in foreign banks. "Los Tres de Zacatecas" was a more straightforward narco song, but set itself apart with an opening verse that is the catchiest encapsulation of police corruption on record:

Había un cargamiento de 300 kilos,
Que los migras atoraron,
Y cuando de pronto escuché la noticia,
Tan solo de 100 hablaron.
Oí el comentario porque estaba preso,
Por ilegal muy cautivo;
Mientras que los gringos hacían el reparto,
Yo estaba haciendo el corrido.

(There was a shipment of three hundred kilos,
Which the immigration authorities stopped,
And when, soon after, I listened to the news,
They only spoke of one hundred.

I heard the report because I was a prisoner,
Locked up as an illegal alien;
While the gringos were dividing up the shares,
I was writing the corrido.)

It was on the *Jefe de Jefes* album, though, that Teodoro proved himself
to be the most expert and versatile composer in the corrido form. Ten
of the album's eighteen corridos are his, and they show his unique
range and power. "El Rengo del Gallo Giro" is an old-style cockfighting
corrido, the sort of thing still common up on the Texas border. "El
Mojado Acaudalado" (The Wealthy Wetback), the album's second sin-
gle, is a Franco-Armenta-style immigrant corrido, the song of a mojado
who has enjoyed great success in the United States, but now is going
home to his beloved Mexico to spend his fortune. (Incidentally, the
recorded introduction includes a brief guest appearance by Teodoro's
six-year-old son.) Then there is the title tune, and several stark narco-
corridos: the self-explanatory "Lo Que Sembré Allá en la Sierra" (What
I Grew There in the Mountains), "Carne Quemada" (Burnt Meat), a raw
tale of betrayal, torture, and official collusion, and "El Plantón" (The
Stakeout), which recounts the plane crash and capture of Hector "El
Güero" Palma.

There are also two corridos that, though generally overlooked, fol-
low a line Teodoro pioneered in "Los Tres de Zacatecas." Both "Por
Debajo del Agua" (Under the Water, the Spanish equivalent of "under
the table") and "El General" (The General) explore corruption in the
US antidrug forces. This is not a common corrido theme, despite Mex-
icans' frustration at the hypocrisy of the US "war on drugs." There is a
pretty general acknowledgment that, although the gringos are the cause
as well as the victims of the drug trade and should be more careful
about criticizing their neighbors, cops tend to be more honest north of
the border. I heard plenty of Mexicans complain about the racism of
American immigration agents, for example, but never heard anyone
claim that they were easily bribed. That said, the average mojado does
not have the sort of cash that would sway a well-paid US government
official, and the big drug guys do. There are stories of border post com-
manders being offered up to a million dollars a month to let shipments
through, and a *Washington Post* story, widely cited in the Mexican press,
estimated that up to a quarter of the drugs crossing the border were
helped by payments to US authorities. All in all, one would expect this
to be a more popular subject for corridistas, but Teodoro's songs
remain fascinating rarities.

"Por Debajo del Agua" tells of a group of Mexican policemen, led by a Comandante Reynoso, who capture three truckloads of cocaine near Ensenada. Reynoso explains to the others that he was offered undreamed-of wealth by the traffickers, and that the DEA has already been bought off. Just then, shots ring out, six men die, and Reynoso ends up in the hospital—but that is only the warm-up: "Orders came from Washington to give a green light to the wrongdoers, / And in the hospital, the *comandante* was smothered to death." In the final verse, Teodoro explains that the news was never made public, but he found the whole story in the newspaper archives. His last line completes the picture, saying that the shipment is now for sale on *"el lado Americano."*

I tried to get more details out of Teodoro, such as whether he actually researched the song in newspaper archives, but he was not interested in following this line of questioning, so I moved on to "El General." This corrido tells a much more famous story: in February of 1997, General Jesús Gutiérrez Rebollo, who had been appointed the top drug-war liaison between Mexico and the United States, and whose integrity had been praised to the skies on both sides of the border, turned out to be in the pay of Amado Carrillo. (This story is the basis for a principal plotline in the film *Traffic.*) Gutiérrez claimed that he had only accepted Carrillo's money as a way of getting into the drug lord's confidence, but no one believed him and he is now in prison. No one, that is, except Teodoro. His song gives the general the benefit of the doubt and focuses its attention on the fact that, however much corruption may exist in Mexico, the money that is paying all the bribes comes from up north. He drives his point home in the song's penultimate verse:

> A diferentes países lo certifican los gringos;
> No quieren que exista droga, pues dicen que es un peligro.
> Diganme ¿quién certifica a los Estados Unidos?

> (The gringos certify various countries,
> They don't want drugs to exist, they say it is a danger.
> Tell me, who certifies the United States?)

It is a fair question (and has since been taken up, albeit in more diplomatic terms, by President Vicente Fox). In the specific case of Gutiérrez, Teodoro says that he now understands the general to have been guilty, but at the time he wrote there was still some question. He adds that this is one difference between a corridista and a reporter: that

a composer rarely has a chance to write a follow-up story and correct the facts. "I can't write so many versions of the corrido, because I am not that well informed about what happened. I just find out about the most commercial part, that he was arrested."

We have more to talk about, but it is getting late and Teodoro wants to go out to some land he is developing for his stable of fighting cocks. He politely asks whether I am busy, or whether I would be willing to ride along with him, and I jump at the opportunity. Behind the wheel of his new, silver Chevrolet Suburban, Teodoro seems more relaxed than in the formal interview situation. He questions me about my book, about my life, about what I think of Mexico. Like virtually all corridistas, he is a patriot: "I like to think I live in the richest country in the world. We have everything here in Mexico." I agree, saying that my two favorite countries are Mexico and Spain. He contemptuously counters that Spain is only the size of Chihuahua. (A slight exaggeration, but Mexico as a whole is indeed almost four times the size of Spain.)

Whatever subject comes up, Teodoro has a song that applies, and sings a few relevant lines. His recall, and his ability to come up with an appropriate lyric for every situation, beats anything I have experienced, and I find myself wondering whether this is the survival of an archaic skill, the awesome memory a minstrel had to have in the days when all popular culture was oral. Teodoro says that he now can read and write a little (like Paulino, he learned because of his wife), but I wonder whether his illiteracy may actually have helped him in his trade. I also wonder whether he will be offended by this question, and hesitate before posing it. To my relief, he takes it in his stride, and even seems rather pleased: "Yes, it has helped me. Yes, because I developed the skill of being able to memorize. There are lots of people who say, '*Hijole,* I have to write that down,' and they forget it, and I don't; I memorize it and that's that." These days, he records his songs on a home cassette machine and has someone transcribe them, but his primary archive is still in his head.

Along with his memory, he also shows off his facility for making up songs. He says that he is constantly composing, and that he can write whenever and whatever he needs: "I decide to write a song right now and I do it, because I'm a professional composer. It's like saying, 'Okay, the mason didn't know how to build that wall, it fell down, but now he does know how and he can build one, and then build another.' I have a speed that many composers don't have—some may be faster than me, but right now I don't know any—I write songs in twenty minutes, I have songs I did in three minutes. I've taken around three minutes to make up a song with a tape recorder, to record it as if I already knew it, and

then it has taken me an hour to learn it. Odd, isn't it? I mean, it just flew right out of me, and then I memorized it. Because I can say:

> *Voy a cantar un corrido, se lo digo a mis paisanos,*
> *Ayer tarde me encontré con un tipo americano. . . .*

(I am going to sing a corrido, I say it to my countrymen,
Yesterday afternoon I met with an American guy. . . .)

He glances over at me and laughs at my surprised expression. I attempt some approximation of a bow, in appreciation of the honor.

The drive is longer than I expected. Soon we are well out of Cuernavaca, rolling through thick, sun-dappled forest with occasional clearings from which one can see mile upon mile of wooded mountains. I say what a pleasure it is to be out in the country, how fresh the air smells, and how quiet it is. Teodoro enthusiastically concurs, and sings a snatch of "Temporada en la Sierra" (Season in the Mountains), followed by "Morir en Mi Tierra" (To Die in My Land). I comment on how pretty the songs are, and he looks very pleased: "You came here thinking of Teodoro Bello in a different way: you didn't know that I was like this, or that I wrote that sort of thing. Why? Because you said, 'No, he's a man who just writes tough corridos.' And that's true, I do that, because my business is writing songs and the corrido is what's functioning for me. And I'm letting it function, because *business is business.* But people are mistaken about Teodoro Bello. People think that I make my living writing about drugs, and it's not true. I make my living writing songs. I don't make it writing narco songs, I make it writing songs about everyone, about the way of the world, of the people. To write a good song is a very beautiful thing."

After maybe an hour, we turn off on a rutted dirt road and pull up in a clearing surrounded by tall pine trees. There is a log house, and in front of it a line of wire cages, each maybe two meters high and a meter on either side, each holding a fighting cock. Teodoro takes me down the line, pointing out the beauties of certain birds. The house holds still more, waiting for their cages to be built: in all, there are some three dozen fine-looking cocks. Recalling that Reynaldo Martínez and Gabriel Villanueva are also *galleros*, I ask Teodoro why it is that corridistas are attracted to the sport. "Well, it's a *hobby*," he says. "It's as if I liked boxing, it's as if I liked basketball or swimming—there are also artists who like those—and me, I like the cocks." He adds, laughing: "And it costs a lot of money."

As he struts around, a small man with a barrel chest, I cannot help

thinking that Teodoro looks quite a bit like a fighting cock himself. He is proud of his land and his birds, but I do not have the sense that he is genuine gallero any more than that he is a genuine lord of the manor. He is a country boy with a lot of money, spending it on all the things he always wanted, but they do not quite fit yet. Still, he also seems to be enjoying it all, and there is something infectious in his enthusiasms, his excitement in having these toys and the power to acquire more.

Teodoro takes me on a tour of his land. Over to one side of the property, two men are building a wall, smashing boulders with sledgehammers to make rocks of the right size, and he insists on taking the hammer and showing them and me that he knows how to do the work. He is actually pretty good, though it is clearly a case of the boss showing off. Back at the cabin, he finds two cans of V8 juice for us, as well as a deck of tarot cards, which he cuts with practiced expertise, then shows me a couple of card tricks.

After maybe half an hour, we climb into the SUV and head back to town. The radio is playing a series of Los Tucanes' hits, and Teodoro says he likes much of Mario's writing, but Los Tucanes will never be as big as Los Tigres. He recalls a concert in Mexico City where Los Tigres drew two hundred thousand people and he flew above the crowd in a helicopter. It was like nothing he had ever seen in his life. They are, of course, the kings. I agree and add that, as their main composer, he is now a king himself. "Yes, it's true," he says. "But the other composers as well, they are all generals. I don't think I'm the best. I can't. If I were to put myself above the others, I would stop writing—and I want to keep writing."

By the time we get to Cuernavaca it is already dark, but Teodoro's show will not start until midnight, so he invites me to have dinner at a VIPs, a popular chain restaurant. The menu is illustrated with photographs of the restaurant's offerings, and Teodoro orders by pointing to the picture of the dish he wants. The waitress says that they are out of that, and suggests that he select something from the printed options underneath, but Teodoro instead mulls over the photos some more and points to another. The food is mediocre, the decor plastic, the clientele proudly middle class. A little girl is eating with her family at a nearby table, and when she jumps down and starts wandering around, Teodoro welcomes her over with warm affection. He does not know her, but treats her like a favorite niece, and she responds with big smiles before going back to join her folks.

The conversation is winding down, but Teodoro wants me to understand how much he appreciates my visit and the importance of my

book. He calls me, in English, "My friend Elijah," making me repeat my name until he gets the pronunciation right, and asks how many copies of the book I will send him. I say I do not know if it will be coming out in Spanish, and he says that does not matter, to send him some anyway. He would be very happy to read about himself in a book, and he is sure I will have a lot to say about him.

I agree, and he says it is very important to be getting the words of the composers, that no one appreciates their work. Then, to my surprise, he adds, "There is one composer that it's a pity you won't be able to interview—Chalino Sánchez." I would not have expected Teodoro, with his polished and ornate style, to be a Chalino fan, but he says, "Oh yes, for corridos he was very strong." I ask if there are other composers he particularly admires, and, like Paulino and Julián, he reaches back into the past: "I was always very fond of the work of José Ángel Espinoza, 'Ferrusquilla.' He is a very good composer, and he is cool to be around, he greets you and he is humble—and I know others who are less important and don't treat one that way. Nowadays, all of them are, 'Hi, Teodoro! How are you? You're the *jefe de jefes*.' But before, they looked at me like this, kind of sideways, as if they didn't want to. When 'Pacas de a Kilo' came out, there were composers who said to me, 'Listen, mano, what a lucky roll you threw,' as if that corrido was a fluke. I said, 'No, I'll show them that there is still a lot of Teodoro to come.' And, thank God, we're doing well, the people believe in me, and to me that's what's really important: that the people don't turn their backs on me, that when they hear me they come back to see me and say, 'Listen, Teodoro, I like your music.' "

Teodoro has to go home and change into his stage clothes, and I go back to my hotel to rest awhile before heading over to the palenque. I had found the hotel the previous evening, fairly late, and as far as I could tell I was the only customer who had ever rented a room there for a full night. It was cheap and clean, and only a couple of blocks from Cuernavaca's main square, and my singular status earned me the front room, with a large window on the street. The disadvantage of this was that the miniskirted young women who gave the place most of its business spent their free time chattering on the front steps, but I had quickly become accustomed to the laughter and arguments, and rather liked the place.

Teodoro was scheduled to sing around midnight, so I arrived at 11:30. I had never seen a cockfight, and he had assured me that I would enjoy it, that it was *"muy bonito."* The cockpit looked like a small boxing ring, circled by a low barrier adorned with advertisements for brandy

and tequila. It was surrounded by twelve tiers of metal folding chairs, then bleachers for the less well-heeled sportsmen. The tent was far from full. This was the first night of the fair and, as a performer, Teodoro is only a moderate draw. As for the cockfight fans, maybe this was only a warm-up for the big fights to come later in the month, or maybe the size of the crowd was typical. When I got there, Teodoro was down by the pit, betting on every fight. I seated myself about eight rows up and tried to make some sense of what was going on, without much success.

As far as I could tell, the fights were all pretty similar: the two cocks would be positioned by their owners, released, and would leap at each other, fluttering wildly for a couple of seconds, then one would fall and the owners would separate them and prepare for the next round. Whatever damage was being done, it was happening too fast for me to see. Eventually, after going at each other a few times, one of the cocks would be carried off limp and bloody, and uniformed teenage girls would start circulating in the stands, taking bets for the next match. Sometimes both of the cocks would be pretty much destroyed; in one match they ended up in such bad shape that their owners propped them up, face-to-face, in the middle of the pit, then waited till one pecked the ground. As the guy behind me explained, the one that pecked first was the loser. All in all, it was not much of a spectacle, and I was more than ready by the time Teodoro eventually took the stage, around 1:45. By that time the crowd had dwindled to a couple of hundred people, half the survivors having left immediately after the last fight.

Despite the small audience, Teodoro gave a full show. His band is young and energetic, and he sang a broad selection of his biggest hits. He dedicated "El Reportero" to me, and "El Rengo del Gallo Giro" to "all the cocks," and he introduced each number with a list of the stars who had made it popular, usually including either Vicente Fernández or Los Tigres. The guys behind me noticed that I was taking notes, and became very excited when I told them about my project. Teodoro is a hometown favorite, and they questioned me at length to make sure I was giving him the credit he deserved, meanwhile passing me paper cups of tequila mixed with orange soda (or some such combination; I never quite figured it out). They were proud that a gringo should be there, documenting their local boy. "This is good for Mexico and for you, both of us."

I was sleepy, but enjoying it all. It seemed like a proper ending for my journey: not a huge bash with thousands of fans, but a small crowd of guys drinking, chatting, and applauding a singer whom they consider one of their own.

I do not remember whether I somehow found a cab, or whether Teodoro had me driven back to my hotel. It was well after 3:00 in the morning, and even the working girls had gone off to sleep. The streetlight outside my window was bright, and I lay and watched the shadows on the wall, listening to the faraway grumble of car engines over by the plaza and the occasional, irregular footsteps of the last homebound drinkers. The verse running through my head was not from any familiar hit; I was treasuring a couplet from my afternoon drive:

> *Voy a cantar un corrido se lo digo a mis paisanos,*
> *Ayer tarde me encontré con un tipo americano.*

It was nothing dramatic, no drugs, no guns, no heroism or betrayal—not even the beginning of a story—but it was mine, and the two lines played over and over in my head as I drifted off to sleep.

301

BIBLIOGRAPHY

ON CORRIDOS AND MUSIC

ASTORGA, LUIS A., *Mitología del "Narcotraficante" en Mexico*, Plaza y Valdes, Mexico, 1995

AVITIA HERNÁNDEZ, ANTONIO, *Corrido Histórico Mexicano* (5 vols.), Editorial Porrúa, Mexico, 1998

AVITIA HERNÁNDEZ, ANTONIO, *Corridos de la Capital*, Conaculta, Mexico, 2000

BERRONES, GUILLERMO, *Ingratos Ojos Mios: Miguel Luna y la Historia de el Palomo y el Gorrión*, Universidad Autónoma de Nuevo León, 1995

CARRIZOSA, TOÑO, *La Onda Grupera: Historia del Movimiento Grupero*, Edamex, Mexico, 1997

DICKEY, DAN WILLIAM, *The Kennedy Corridos: A Study of the Ballads of a Mexican American Hero*, Center for Mexican American Studies, The University of Texas at Austin, 1978

FRANCO-LAO, MÉRI, *Basta! Canciones de Testimonio y Rebeldía de America Latina*, Biblioteca Era, Mexico, c.1974

HERRERA-SOBEK, MARIA, *Northward Bound: The Mexican Immigrant Experience in Ballad and Song*, Indiana University Press, 1993

LÓPEZ CASTRO, GUSTAVO, *El Río Bravo Es Charco: Cancionero del Migrante*, El Colegio de Michoacán, Zamora, 1995

MCDOWELL, JOHN H., *Poetry and Violence: The Ballad Tradition of Mexico's Costa Chica*, University of Illinois Press, 2000

MENDOZA, VICENTE T., *El Romance Español y el Corrido Mexicano: Estudio Comparativo*, Ediciones de la Universidad Nacional Autonoma, Mexico, 1939

MENDOZA, VICENTE T., *El Corrido Mexicano*, Fondo de Cultura Economica, Mexico, 1954

NAVARRETE, CARLOS, *El Romance Tradicional y el Corrido en Guatemala*, Universidad Nacional Autonoma de Mexico, 1987

ORTIZ GUERRERO, ARMANDO HUGO, *Vida y Muerte en la Frontera: Cancionero del Corrido Norestense*, Hensa Editores, Mexico, 1992

PAREDES, AMERICO, *A Texas-Mexican Cancionero*, University of Illinois Press, 1976

PAREDES, AMERICO, *With His Pistol in his Hand: A Border Ballad and its Hero*, University of Texas Press, 1958

QUIÑONES, SAM, *True Tales from Another Mexico*, University of New Mexico Press, Albuquerque, 2001

RAMOS AGUIRRE, FRANCISCO, *Historia del Corrido en la Frontera Tamaulipeca (1844–1994)*, Fonca (no date)

REYES, JUDITH, *El Corrido: Presencia del Juglar en la Historia de Mexico*, Universidad Autonoma Chapingo, Mexico, 1997

SIMONETT, HELENA, *Banda: Mexican Musical Life across Borders*, Wesleyan University Press, Hanover and London, 2001

STRACHWITZ, CHRIS, and PHILIP SONNICHSEN. *Corridos & Tragedias de la Frontera*, CD booklet, Arhoolie/Folklyric 7019/7020

OTHER WORKS

ASTORGA, LUIS A., *El Siglo de las Drogas*, Espasa Hoy, Mexico, 1996

IGLESIAS, NORMA, *Entre Yerba, Polvo y Plomo: Lo Fronterizo Visto por el Cine Mexicano* (2 vols.), El Colegio de la Frontera Norte, Tijuana, 1991

KRAUZE, ENRIQUE, *Mexico: Biography of Power*, Harper Perennial, New York, 1997

LEÓN CRISTERNA, JOSÉ MANUEL, et al., *Sinaloa: Historia, Cultura y Violencia*, DIFOCUR, Culiacán, 1993

LÓPEZ, JAIME, *10 Años de Guerrillas en México: 1964–1974*, Editorial Posada, Mexico, 1974

MARTÍNEZ CARBAJAL, ALEJANDRO, *Masacre en el Vado de Aguas Blancas*, Editorial Sagitario, Acapulco, 1996

MARTÍNEZ CARBAJAL, ALEJANDRO, *Ejército Popular Revolucionario*, Editorial Sagitario, Acapulco, 1998

MENDOZA, ELMER, *Trancapalanca*, DIFOCUR, Culiacán, 1989

MENDOZA, ELMER, *Cada Respiro Que Tomas*, DIFOCUR, Culiacán, 1991

MÉNDEZ ASENSIO, LUIS, *Caro Quintero: al Trasluz*, Plaza & Janes, Mexico, 1985

NACAVEVA, A., *Diario de un Narcotraficante*, Costa-Amic Editores, Mexico, 1980

NACAVEVA, A., *El Tráfico de la Marihuana*, Costa-Amic Editores, Mexico, 1984

POPPA, TERRENCE E., *Drug Lord: The Life and Death of a Mexican Kingpin*, Pharos Books, New York, 1990

SHANNON, ELAINE, *Desperados: Latin Drug Lords, U.S. Lawmen, and the War America Can't Win*, Viking, NY, 1988

SUÁREZ, LUIS, *Lucio Cabañas: el Guerrillero Sin Esperanza*, Roca, Mexico, 1978

TRUEBA LARA, JOSÉ LUIS, and ART, *García Ábrego*, Editorial Posada, Mexico, 1996

GLOSSARY

BAJO SEXTO: a 12-string guitar, tuned lower than a regular guitar, which is the principal rhythm instrument in norteño music.

BANDA: literally, band; specifically, a current ranchera style featuring brass instruments, particularly popular on the West Coast of Mexico and in California.

BARRIO: neighborhood; in the United States, specifically a poor, urban Latino neighborhood.

CABRÓN: literally a male goat, and by extension from the horns, a cuckold; in Mexico, it is usually an insult if used as a noun, but frequently a compliment if used adjectivally, denoting strength and power.

COMPADRE: literally, godfather (though not in the Mafia sense, which would be *padrino*), but also used for any particularly close friend. Frequently shortened to *compa*.

CONJUNTO: literally, band; in the United States, there is a tendency to use this word for the norteño music played in Texas, but I do not use this terminology, and have never heard it used in Mexico. There is a unique Texas sound, just as there is a Monterrey sound, a Sinaloan sound, and now an LA sound, but by any musical standard the East-West divide is more defining than the national boundary.

CORRIDO: a ballad or story song, apparently derived from the verb *correr*, to run. There is an academic definition developed in the mid twentieth century, which insists that a corrido must begin by giving the date of the events it relates, then relate those events in a certain way, and end with a *despedida*. Among regular ranchera listeners, this definition is unknown, and I have accepted the current, popular use of the word, vague as it may sometimes be: As far as I am concerned, whatever the corrido fans call a corrido is a corrido.

CORRIDO DE AMISTAD: literally, friendship corrido; a corrido that, rather than telling a story, simply says what a great guy the protagonist is.

CREMA DE SEDA: cream of silk; the shiny shirt fabric especially popular among Mexico's West Coast drug chic crowd, often showing pictures of guns, marijuana leaves, los tres animales, or the Virgin of Guadalupe.

CUERNO DE CHIVO: literally, goat's horn; an AK-47, so called because of its curved forward grip.

CHARRO: the Mexican cowboy, but it is more complicated than that. There is a whole charro culture, built up around horsemanship, clothing, music, and who knows what all else. Charros typically wear big sombreros and lots of silver, and hold rodeo-style competitions known as *charrerías*. There is also a charro film genre, roughly equivalent to the singing cowboy movies of Gene Autry and Roy Rogers.

CHICANO/A: in United States usage, a chicano can be any US citizen who traces his or her roots to the early Spanish settlers or to Mexico. In Mexican usage, it implies a strong degree of Americanization, or a political viewpoint based on identification with the Chicano community. A Mexican will speak of a neighborhood in the US as having no Mexicans, only Chicanos, and another as being Mexican, though both may be largely populated by US citizens with Mexican backgrounds.

CHOLO: urban Chicano or Mexican street guys, especially in southern California. There is a whole cholo culture, which I know far too little about to try to explain, even if space permitted.

EL DF: the *Distrito Federal*, or Federal District; this is how Mexicans usually refer to Mexico City (much as gringos sometimes call their capital "DC").

DESPEDIDA: literally, farewell; the traditional ending for a corrido, in which the singer takes his or her leave of the listeners.

DUETO: like trio, this can simply refer to the number of players in a group (two, in this case), but also to a style of music. Duetos feature two guitars (or guitar and requinto) and two singers in close harmony. These days, such a group will frequently have a bass player and sometimes other musicians, but remains a dueto if it has the dueto sound.

EJIDO: a collective rural community, owned by the residents as a group. The ejidos were formed in the post-revolutionary era as an attempt to compromise between traditional Mexican concepts of land use and the European system of personal ownership of property.

EL OTRO LADO: literally, the other side; a common Mexican way of referring to the United States.

ENCAPUCHADO/A: literally, a hooded person; a common way to refer to the Mexican guerrillas, from their ski masks or bandannas.

GOMERO: an opium grower or trafficker, from the gummy black sap, or goma, that is harvested from the opium poppies.

GRINGO/A: any non-Latino citizen of the United States; the word can be used insultingly, but need not be.

GÜERO/A: literally, blond; frequently used as a general term for white people, and by extension gringos and Europeans in general, but it is also used for blond or light-skinned Mexicans.

MANO: a friendly form of address, shortened from *hermano*, brother.

MARIACHI: the most familiar Mexican country style; originally played with various kinds of guitars and violins, but now usually including two or three trumpets. Mariachi musicians typically wear matching charro outfits, and their music is the most socially respectable form of ranchera.

MESTIZO/A: a person of mixed Spanish and Indian background, now often used for any Mexican who is not considered Indian.

MOJADO/A: from *espalda mojada*, literally, wetback; an illegal immigrant. In Mexican usage, this word has nothing like the pejorative connotations it has in English. It does suggest a degree of poverty and manual labor, and many people would not care to be called mojados, but others are comfortable with the term and there is virtually no negative connotation to the word's adjectival form—any Mexican who traveled illegally to the US would say he or she crossed the border or worked *de mojado*.

MORBO: literally, sickness unto death, but it can also mean a weird attraction ("she's ugly, but she has a certain *morbo*"), or a particular style of speaking, a twist one gives to language.

MOTA: one of many slang terms for marijuana

NACO/A: hick

NARCO: drug trafficker; also an all-purpose prefix for anything drug-related.

NORTEÑO/A: literally, northern; a style of music distinguished by the use of accordion and bajo sexto, mostly consisting of polkas, waltzes, and *cumbias norteñas*. It sprang up around the Texas border region in the 1940s, swept rural Mexico and much of Central America with the force of rock 'n' roll, and is still widely considered by respectable and educated Mexicans to be hick junk.

LA NOTA ROJA: the crime news

PUEBLO: people, or town; in common usage it is sometimes hard (or even impossible) to separate the two meanings and translate the word as one or the other.

QUEBRADITA: a dance style especially popular in Los Angeles and some northern Mexican cities, associated with banda or tecnobanda music, and taking its name from a move in which the male dancer dips his partner backwards until her hair brushes the floor.

QUINCEAÑERA: a fifteenth birthday party, which is a major rite of passage for Mexican girls, celebrated with great excitement and no expense spared.

RANCHERA: ranch music, the general term for Mexican rural pop, roughly

309

equivalent to "Country and Western." The classic form of ranchera is mari-achi, and the contemporary scene is still full of achingly romantic singers in the old style, but the hottest sounds in ranchera (at least to my ears) have long been norteño and banda.

RANCHO: sometimes ranch, sometimes village, though the latter usage is more common in Mexico's north.

REQUINTO: a three-quarter-size guitar, with a cutaway body, used to play the instrumental lead in Mexican *duetos* and trios. Among people who cannot necessarily afford requintos, the word is also sometimes used generically for the lead guitar part, even if played on a normal guitar.

ROCK EN ESPAÑOL: rock in Spanish. There is currently an attempt in the United States to market this as a style in itself, as if Spanish-language heavy metal were more like Spanish-language rap, oldies, or punk than like other heavy metal (or rap, oldies, or punk).

ROMANCE: a medieval Spanish ballad form, which bears roughly the same rela-tionship to the corrido that the medieval English ballad bears to the cowboy song; that is, there is a clear line of influence, but also obvious stylistic dif-ferences.

LOS TRES ANIMALES: literally, the three animals; drug slang popularized in a song by Los Tucanes de Tijuana. The animals are the parakeet (cocaine), the rooster (marijuana), and the goat (heroin).

VAGO: the dictionary says vagrant or loafer, but in Mexico the word is usually used for a good-natured rascal, fun and not too serious.

VALIENTE: literally, a brave man. In Mexico it denotes a classic character rather like a Wild West gunfighter, but by no means necessarily in the past. There are still plenty of people who consider themselves valientes, especially after a few drinks.

NOTES AND DISCOGRAPHY

The travels described in this book were made between March 1999, and January 2000. The ages and descriptions of the artists and environment are from that time, and have not been updated. My visits were not made in exactly the order in which they appear in this book, which was rearranged somewhat to fit the larger story of the modern corrido, but they all happened within that period of time and within each chapter I have stuck to the original order of events. There have been thousands of corrido albums released in the last 30 years, and I cannot provide anything resembling a complete discography, but here are a few relevant selections, and a few background notes.

CHAPTER 1

Gaytan y Cantú's recording of "El Contrabandista" has not been reissued. I heard it thanks to Chris Strachwitz, who has a copy in his voluminous library of Mexican 78s. "Carga Blanca" is available on several different albums by Los Alegres de Terán.

"Contrabando y Traición" is available on Los Tigres del Norte's *Contrabando y Traición* (Fonovisa 2563), and on various collections of Los Tigres' hits. Joe Flores's original recording is not currently available—I have never even seen a copy.

CHAPTER 2

My capsule biography of Pancho Villa is largely drawn from the little pamphlets that are sold on street stands, and I do not vouch for its accuracy. My interest was in his legend, which seems to me to be what is relevant to my story.

Paulino's corridos are available on hundreds, if not thousands of albums. Of the songs highlighted in this book, "La Banda del Carro Rojo" is on Los Tigres' album of the same name (Fonovisa 5029) and various collections; "Lamberto Quintero" is on various collections of Antonio Aguilar's hits; "La Tumba del Mojado" is on Los Tigres' *Internacionalmente Norteños* (Fonovisa 5003); "Al Filo del Reloj," is on Los Tigres' *Corridos Prohibidos* (Fonovisa 8815), along with five more of Paulino's compositions; "Los Super Capos" is on Los Invasores de Nuevo León's *Leyendas* (EMI Latin/dlv 615). To hear Paulino sing his own compositions, the best generally available choice is Los Broncos De Reynosa: *Exitos de Paulino Vargas* (Peerless/Eco 094).

CHAPTER 3

Luis Astorga's *El Siglo de las Drogas* was my main source for information on Sinaloan drug trafficking through the years. I could not find a place in the body of the text for one more story he tells: According to the muralist David Alfaro Siqueiros, the painter Diego Rivera made a unanimously accepted proposal to the Mexican Revolutionary Union of Painters, Sculptors and Engravers that they officially smoke marijuana, "to thus arrive at the elevated levels of plastic arts of Mexico's prehispanic antiquity."

I assume some people will disagree with my characterization of Mexico's drug situation. I must repeat that yes, drugs are dangerous, and yes, there is illegal drug use in Mexico as well as an export business. However, when one compares the US and Mexico, a representative study found that 4.31% of Mexicans between the ages of 18 to 25 said they had smoked marijuana at least once, as opposed to 52.2% in the US. For cocaine, the percentages were 0.52% in Mexico and 19.4% in the US. As for heroin, its use in Mexico was statistically insignificant. This study is a decade old, but even if the numbers of users in Mexico have tripled or quadrupled, they are tiny compared to the numbers in the United States. Drug-related violence and corruption are another story, but I would argue that they have their roots in the situation north of the border, and what one finds in Mexico is an effect, not a cause.

For a taste of banda music, I would recommend any collection of Banda El Recodo's hits, or El Coyote's *Concedeme*, but there are hundreds of other options as well. For more information, I recommend Helena Simonett's book, cited in the bibliography. The Malverde cassettes I cite are, as far as I know, available only at the chapel. As for Elmer Mendoza's books, *Un Asesino Solitario* is widely available in Mexico, but his other work is virtually impossible to find outside Sinaloa, and pretty rare even there.

CHAPTER 4

As I signal in the text, I am greatly indebted to Sam Quiñones for the basic facts of Chalino's life, and also to Helena Simonett. I also spoke extensively to Nacho Hernández and Pedro Rivera, as well as to Pepe Cabrera. For those wishing to know more about Chalino, I strongly recommend Sam's book, *True Tales from Another Mexico.*

"El Crimen de Culiacán" is available on Chalino's *Nieves de Enero* (Musart/Balboa). This was his most popular album, but is not typical, consisting mostly of songs he did not write, with more of a pop ranchera feel than his earlier releases. To hear the pure, unadulterated Chalino sound, check out something like *Al Estilo Norteño* (Kimo's CDs 021) for an accordion album, or *A Todo Sinaloa* (Musart 744) to hear him with banda.

Pepe Cabrera's recent recordings are on his own Once Ríos label, and can be hard to find outside Sinaloa. "La Mafia Muere" is on Los Tigres' *Corridos Prohibidos.*

CHAPTER 5

Both the autobiographical "El As de la Sierra" and José Alfredo Sauceda's Chalino tribute, "Ha Muerto Chalino Sánchez," are on El As's *El Helicoptero Negro y Mis Corridos* (Titan 9910). This is available in the US, though it may be hard to find outside California.

CHAPTER 6

The only group on Discos Uriarte to make it successfully across the border, at this writing, is the guitar-and-tuba trio of El Canelo de Sinaloa y los Dos del Sitio. Their *De Cerro a Cerro* (Cintas Acuario 538) is well worth a listen—the ultimate Sinaloan rancho recording.

Miguel y Miguel's CDs are widely available. I highly recommend *Cruz de Madera* (EMI Latin), with their hit, "Sonora y sus Ojos Negros."

CHAPTER 7

"Mis Tres Animales" and "El Güero Palma" can be found on *14 Tucanazos Bien Pesados* (EMI Latin 34975); "La Piñata" and "No Solo de Traficante" are on *Tucanes de Plata* (EMI Latin 56922); and "El Paro," "La Pelo de Angel," and "El

Error del Graduado" are on *Los Mas Buscados* (EMI Latin 96599). Since this book was written, Los Tucanes have gone on to provoke a fight with Los Tigres, recording a satiric corrido called "Los Gatos Rayados" (the Striped Cats). I think this is a mistake, but no one asked me.

CHAPTER 8

"También las Mujeres Pueden" is on Los Tigres' *Jefe de Jefes* (Fonovisa 80711); their version of "Los Dos Plebes" is the title song of Fonovisa 6017; "Las Monjitas" is on any hit collection by Grupo Exterminador, and also on a fine anthology, *Pa' Compas Pesados* (Fonovisa 2231), which also includes Los Hermanos Jiménez, Banda El Recodo, and Los Huracanes del Norte.

Francisco's own records, issued under the *nom de guerre* "El Vampiro y sus Fantasmas," are hard to find outside Los Angeles, and none too easy there.

CHAPTER 9

Pedro Rivera's "Violencia en los Angeles" is the lead song on Cintas Acuario 162; "Brian Barker" is on *Corridos de Hierba* (Cintas Acuario 588). Jenni Rivera's "La Chacalosa" is the title song of Kimo's KM-107. Lupillo Rivera's "El Pelotero" is on Volume 4 of the *Puros Corridos Perrones* series, which is subtitled *Y Sigue la Malandrinada . . .* (Kimo's CAN-413). At that time, he was still billing himself as Lupe Rivera. "Veinte Mujeres" is on his *20 Super Exitos* (Sony).

CHAPTER 10

Enrique Franco contributed so many songs to Tigres albums during the 1980s that virtually any one will be full of his work. Of songs highlighted here, "El Otro Mexico" is the title song of Fonovisa 85043, "Los Hijos de Hernández" is on the Grammy-winning *Gracias America . . . Sin Fronteras* (Fonovisa 2571), and "Jaula de Oro" is the title song of Fonovisa 5044. The masterpiece of Enrique's collaboration with La Tradición del Norte is *Corridos Para los Buenos, los Malos, y los Feos* (BMG US Latin 52122), and "Voy a Hacerme Ciudadano" is on their earlier release, *De Cuerpo Entero* (BMG US Latin 41036).

"El Deportado" can be found on an excellent anthology of early corrido recordings, *Corridos & Tragedias de la Frontera* (Arhoolie/Folklyric 7019/7020).

CHAPTER 11

"Vivan los Mojados" is on Los Tigres' album of the same name (Fonovisa 2567); "El Circo" is on *Unidos Para Siempre* (Fonovisa 6049); "Ni Aquí Ni Allá" and "El Sucesor" are on *Jefe de Jefes*. "La Discriminación" and the Monica Lewinsky corrido "El Presidente" are on Norteños de Ojinaga's *Corridos Pa' mi Pueblo Vol. II* (Fonovisa 9775).

CHAPTER 12

Val and Pete, the yodeling cowboys, can be found on the anthology *White Country Blues, 1926–1938: A Lighter Shade of Blue* (Sony/Columbia Roots 'N' Blues); "The Killer" is available on *Cisco Houston: The Folkways Years* (Smithsonian/Folkways 40059)

Julián Garza's songs have been recorded many times, both by Luis y Julián and by all the other groups in the northeast. The classic recording of "Pistoleros Famosos" is by Los Cadetes de Linares, and is available on several of their collections. "Era Cabrón el Viejo" is the title song of EMI/Disa 23314. (Luis y Julián have since capped this hit with a sequel, "El Hijo del Viejo," the title song of EMI/Disa 28655, in which El Viejo's son objects to their previous song, and vows to kick their asses at the first opportunity.)

CHAPTER 13

Anyone interested in norteño music needs some of Ramon Ayala's classic recordings, which include many of Reynaldo Martínez and Chago Iracheta's finest corridos. Among the many collections are *Corridos Famosos* (Freddie 1098), and *15 Exitos Norteños* (Freddie 1290). Beto Quintanilla is the Valley's current corrido king, and has many cassettes on the Discos RYN label, out of McAllen, Texas, and Los Cachorros de Juan Villareal are similarly prolific. Arhoolie Records has a superb catalogue of Texas players, from early 78 reissues to current recordings, including the best of Flaco Jiménez's work and a good Steve Jordan album. The best Jordan choice, however, is *20 Grandes Exitos* (Freddie 2029).

CHAPTER 14

Oscar Chávez's recordings, largely on the Ediciones Pentagrama label, are widely available in book and record stores near the larger Mexican universities, and in the US through Arhoolie Records. Judith Reyes's political corridos have been reissued, but the recording is very hard to find. As for cassettes by Andrés Contreras, the only place I have ever found them is in Mexico City, at the stands in front of the Cathedral on the Zócalo.

CHAPTER 15

Los Pajaritos del Sur's cassettes are easily found in Acapulco and the surrounding towns. Other than that, it's difficult, though Arhoolie is currently contemplating a US release.

CHAPTER 16

The Dueto Castillo's cassettes and LPs have been the most visible albums of topical Guerreran corridos. It is possible to find their recordings in Mexico City, if one is lucky, and they are all over the place throughout Guerrero and Michoacán. Their corrido of the Aguas Blancas killings, "Masacre en la Costa Grande," is on *Masacres en Guerrero* (AMS 480). None of the other corridistas mentioned in this chapter have recorded commercially.

CHAPTER 17

"Rayando Bolas" is on Los Hermanos Gaspar's *12 Corridos Macizos* (Or. 0034)."Mariguaneros en crisis" and Rafael Alvarez Sánchez's "El Narcotraficante" have been recorded by a Michoacan balona singer named El Chaparrito de Oro, but are currently unavailable. Rafael's balona of "Los Norteños" is available on a cassette by the balona singer Salvador Chávez, *Valonas del Valle de Apatzingán* (Alborada Records 1510). Los Hermanos Jiménez's "Cosechas Michoacanos" is on the anthology, *Pa' Compas Pesados* (Fonovisa 2231), and "El Rey de la Tierra Caliente" is on *La Receta: Los Reyes de la Musica de Arpa* (Fonovisa 2294).

CHAPTER 18

Teodoro Bello's songs are all over Los Tigres' recent albums, as well as albums by hundreds of other artists. Of those quoted here, "Pacas de a Kilo" is on Los Tigres' hits package *16 Kilates Musicales* (Fonovisa 9191); "Los Tres de Zacatecas" is on their *Unidos Para Siempre* (Fonovisa 6049); and "El General" is on *Jefe de Jefes*. "Quien Tiene la Culpa" and "El Corrido de Amado Carrillo" are on Los Traileros del Norte's *Corridos de Mi Tierra* (Fonovisa 2266).

INDEX

329

PERMISSIONS